THE
GEORGIANS

+➤✦◄+

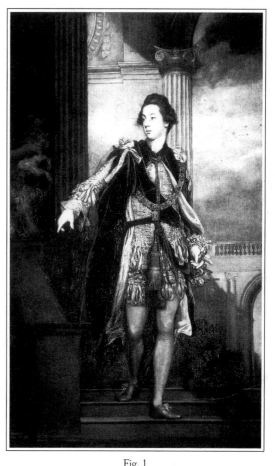

Fig. 1
REYNOLDS
of Carlisle 1769
LE HOWARD
TION

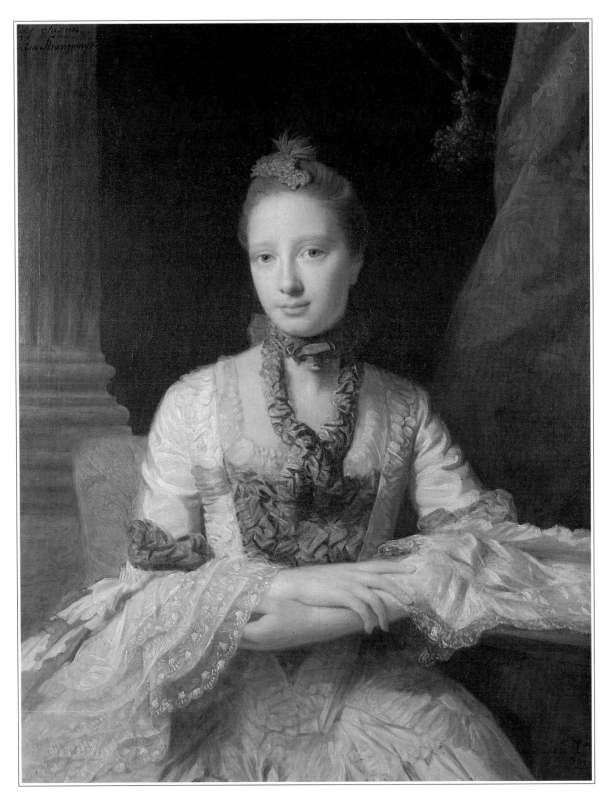

Fig. 2
RAMSAY
Lady Susan Fox-Strangways 1761
FROM A PRIVATE COLLECTION

THE GEORGIANS

EIGHTEENTH-CENTURY PORTRAITURE & SOCIETY

DESMOND SHAWE-TAYLOR

'. . . the portraits . . . must seem to speak to us of them-selves, and, as it were, to say to us – Stop, take notice of me: I am that invincible king, surrounded with maj-esty – I am that valiant commander who struck terror every-where; . . . I am that high-spirited lady, whose noble manners command esteem, etc – I am that vir-tuous, courteous; and modest lady, &c. – I am that chearful lady, who delight in smiles and joy &c. And so of others. *In a word, the attitudes are the language of portraits, and the skilful painter ought to give great attention to them.*'

Roger de Piles, *The Principles of Painting*, 1743, pp. 169-70.

BARRIE & JENKINS

LONDON

In memory of
JOCELYN SHAWE-TAYLOR

First published in Great Britain in 1990 by
Barrie & Jenkins Ltd.,
20 Vauxhall Bridge Road,
London SW1V 2SA

British Library Cataloguing in Publication Data
Shawe-Taylor, Desmond, 1955-
The Georgians: eighteenth-century portraiture and
society.
1. British portrait paintings, 1680-1820 – Critical
studies
I. Title
759.0941

ISBN 0-7126-2146-6

Designed by David Fordham

Printed in Great Britain by Butler and Tanner, London and Frome
Typeset by SX Composing, Rayleigh, Essex

CONTENTS

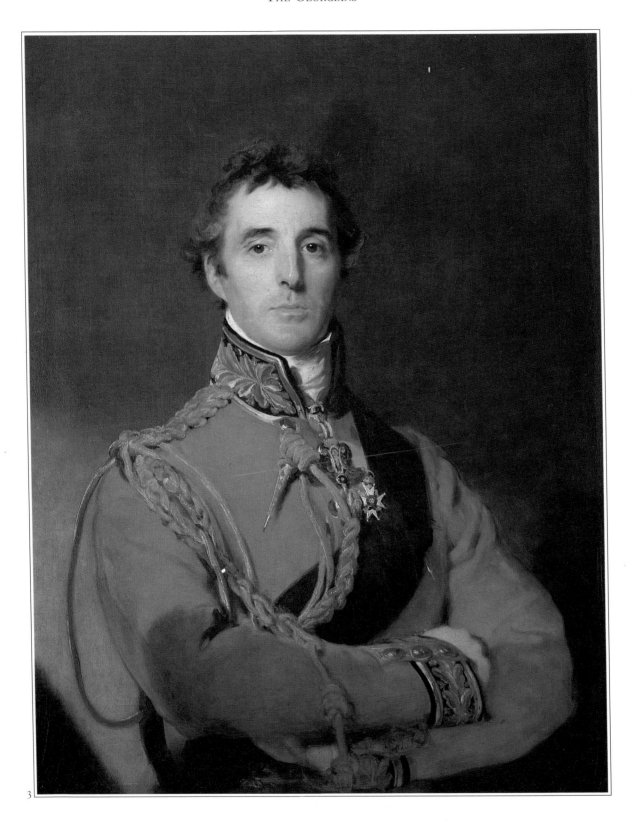

3

CHAPTER I

THIS MILL-HORSE BUSINESS

'I begin to be really uneasy at finding myself so harnessed and shackled into this dry mill-horse business . . .'
Sir Thomas Lawrence, Letter of 1801.[1]

'PORTRAITURE IS ALWAYS INDEPENDENT OF ART AND HAS LITTLE OR nothing to do with it. It is one of the staple manufactures of the empire. Wherever the British settle, wherever they colonise, they carry and will ever carry trial by jury, horse-racing, and portrait-painting.'[2] So it appeared to Benjamin Robert Haydon in 1817; a hundred years later he might have added Gilbert and Sullivan to his list. Haydon was an idealistic young artist striving to make his way as a History painter when this thought occurred to him. Similar thoughts had occurred to others in the same position. Henry Fuseli dismissed portraitists as 'coat and waistcoat painters', while James Barry saw their prosperity as a 'mess of potage for which these Esaus sell their birthright', a transaction in which 'well-deserved glory is meanly sacrificed to a factitious thirst for lucre and vanity.'[3] William Blake's put-down is more concise and crushing: 'Of what consequence is it to the Arts,' he asks airily, 'what a Portrait Painter does?'[4]

Penniless visionaries may perhaps be permitted some professional jealousy, but it comes as a surprise to find that, in unguarded moments, even thriving portrait painters themselves regarded their art either as a lucrative trade to be cynically pursued, or worse, as mere drudgery. Thomas Gainsborough boasted of 'picking pockets in the portrait way', and John Hoppner invented the term 'potboiler' to describe his routine production, while George Romney complained of being shackled to 'this cursed portrait-painting' and, in the quotation that heads this chapter, Sir Thomas Lawrence described the art to which he owed his European fame as a 'dry mill-horse business'.[5]

Fig. 3
LAWRENCE
*The 1st Duke of Wellington c.*1815
BY COURTESY OF THE BOARD OF
TRUSTEES OF THE VICTORIA AND
ALBERT MUSEUM

7

What did everybody have against this seemingly inoffensive occupation? The answer lies partly in the idea of portraiture itself, and partly in the particular circumstances of the British exponent. According to the international artistic theory of the period, there was a hierarchy of genres of painting which ranked portraiture *below* what is called *history painting*, a term which includes religious, mythological and allegorical as well as strictly 'historical' subjects. History painting enjoyed this special pre-eminence because it was imaginative, and because it dealt with Man in general rather than with one particular man, and thus gave the artist greater latitude for 'improving' upon Nature.

This hierarchy, like many things in the eighteenth century, is expressed in terms of social class. All arts in the period aspired to the status of a 'liberal art', which means, in Dr Johnson's words, an art 'worthy of a gentleman'.[6] To qualify, an art had to be more intellectual than manual: to involve more *thinking* work, which does no dishonour to a gentleman, than *real* work, which does. By a lucky chance the ancient Athenians had decreed that only those of noble birth could take up painting; this, and other considerations, led most theorists to give it the benefit of the doubt.[7] But, when a writer like Lord Chesterfield allows painting and sculpture to be 'justly called liberal arts', because they are 'connected with history and poetry',[8] he is only thinking of history painting. He would probably have agreed with the Earl of Shaftesbury, who writes, in downright terms, that portraiture is 'not so much as a liberal art nor to be so esteemed', and its practitioners are 'mere mechanics', since it requires 'no liberal knowledge, genius, education, converse, manners, moral-science, mathematics, optics, but [is] merely practical and vulgar. Therefore not deserving honour, gentility, knighthood conferred [a reference to the recently knighted portraitist Sir Godfrey Kneller].'[9] The surprising thing for us is Shaftesbury's instinctive association of intellectual accomplishments, such as 'design', 'mathematics' and 'optics', with nobility, to be contrasted with the 'practical and vulgar', the 'mere mechanics'. To be a portrait painter, to be one of the 'trading artists' as Shaftesbury once calls them, is to be just that – in trade.[10] Popular jibes of the period refer, as Haydon does in the quotation above, to the 'Art' of portraiture as a 'manufacture', or call the portraitists themselves 'phiz-mongers' – purveyors of physiognomies instead of fish.[11]

On their own these conventional theoretical stigmas would not have put out the British phiz-monger any more than they did Velazquez, Van Dyck or any other post-Renaissance portraitist. But there are other indications that in England in the eighteenth century the portraitist was regarded as an especially mule-like hack. The Frenchman, Abbé Le Blanc gives a typical reaction to their work:

> *The portrait-painters are at this day more numerous and worse in London than ever they have been ... at some distance one might easily mistake a dozen of their portraits for twelve copies of the same original. Some have the head turned to the left, others to the right: and this is the most sensible difference to be observed between them. Moreover, excepting the face, you find in all, the same neck, the same arms, the same flesh, the same attitude; and to say all, you observe no more life than design in those pretended portraits.*[12]

Abbé Le Blanc was visiting England in 1737-44 which was an unfortunate time; by common consent, English painting was then at a peculiarly low ebb. The only controversy arose over whether the nadir should be put at George I's accession in 1714 or at some time in the 1740s 'when the names of Hudson and Hayman were predominant'.[13] But how could such a situation have developed at any time? To answer this question it is necessary to examine the consumer in the portrait trade as well as the producer.

On the one hand there is an absence of any real court patronage. The Georges, summoned from their petty princedom in Hanover, were notoriously drab and philistine in everything except music. George I took no interest whatsoever in his adopted country and scarcely even mastered the language. His son George II could speak enough English to make remarks like, 'I hate bainting and boetry, neither the one nor the other ever did any good', which is not encouraging for bainters. There was the post of King's Principal Painter, on a salary of £200 a year, but such a monarch is unlikely to be fussy about the incumbent. So one could say that just as Philip IV deserved Velazquez and Charles I deserved Van Dyck, so George II deserved John Shackleton.[14] Even when more worthwhile painters inherited this job – Allan Ramsay from 1761 to his death in 1784 and then Sir Joshua Reynolds – their royal portraits are a relatively insignificant part of their work. Ramsay painted some fine designs, but the main business of the royal studio was in 'manufacturing' copies for foreign embassies at £50 each. He once went abroad leaving his pupil Philip Reinagle fifty identical pairs of Kings and Queens to finish. It is not surprising that afterwards Reinagle could never think of portraiture again 'without a sort of horror'.[15] Reynolds felt that the job of Principal Painter was of 'not so much profit, and of near equal dignity with His Majesty's rat catcher'.[16]

Royal indifference did not mean that there was no patronage for portraiture, far from it. Another Frenchman, André Rouquet, who worked as an enamellist in London from 1722-52, wrote in 1755 of the 'prodigious number of portraits' commissioned:

> . . . it is amazing how fond the English are of having their pictures drawn: but as peoples fortunes are more upon a level in England than in any other country, and as the very best painters take only ten or twelve guineas for a bust, this moderate price is no hindrance to the custom of frequently making a present of one's picture.[17]

Other sources confirm that inexpensive portraiture reached a vast public from all ranks of society.[18] Such a demand creates an industry. Le Blanc said portrait painters had never been so numerous; attempts to put a figure on it range from Reynolds' estimate towards the end of the century that there were 800 painters working in London, most of whom were portraitists, to Horace Walpole's wild claim in 1759 that there were two thousand portrait painters alone.[19] This impression of quantity rather than quality extends to each portrait painter's output, for, as Rouquet puts it, their aim is 'not so much to paint well, as to paint a great deal'.[20] Nor can this vast market be expected to have especial discernment. To wish to have your portrait painted requires no interest in or knowledge of

art. The average patron is more concerned with a good likeness than a good picture.[21] As Hazlitt put it, in 1816, 'persons of rank and opulence . . . wish to be painted as Mr. and Mrs. Such-a-one, not as studies of light and shade'.[22]

As the patron's requirements were modest so was the expected remuneration of ten or twelve guineas. In European courts, where art had thrived for the previous few centuries, it was usual to make a point of paying *beyond* what the labour strictly required. The sum was not crudely calculated nor was a bill presented; the prince or courtier's generosity was rather put on its metal, and he was expected to lay out what we still call *a princely sum*. Our portraitists, on the other hand, had fixed prices, one half paid in advance, the other upon delivery. The price depended upon the labour, calculated, to all intents and purposes, in man-hours. Nothing could be more demeaning than this to the aspiring *liberal* artist. This is why Allan Cunningham, a biographer of artists, especially scoffs at Reynolds for calling on Michelangelo's name, for 'invoking him by his works – and making five guineas an hour in the belief that the severe majesty of Buonarotti was at least dimly seen among the curls and flounces, laced waistcoats, and well-powdered wigs of his English nobility'.[23] For Cunningham, efficient time-and-motion calculations, as much as the constraints of laced waistcoats, make Reynolds' invocation of Michelangelo seem presumptuous.

Fixed prices meant fixed sizes. Almost all portraits in the period were painted on the following standard-format canvases: 30×25 inches, called a *head* (or sometimes, confusingly, a *three-quarter*); 50×40 in., a *half-length*; 94×58 in., a *full-length*. All artists agreed in pricing these three sizes approximately according to the ratio: x, 2x, 4x. There were some 'half-sizes' in between: a 36×28 in. format was called a *kit-cat*, after the club, and a 55×44 in., a *Bishop's half-length*, because it gave room for his Grace's lawn sleeves – and was also, incidentally, useful for children.[24] Lawrence used some extra-large canvases for whole lengths (the most common is 106×70 in.). Any canvas not of these dimensions has been cut or is of a special non-standard size sometimes used for group portraits.

Patrons, ideally, are not mere paymasters, they also constitute an artist's audience. In a princely or papal court newly-commissioned works were shown in semi-public galleries, crowded with courtiers, many of whom were art lovers and themselves potential patrons. An alert seventeenth-century cardinal would know perhaps a third of Poussin's entire output and nine-tenths of Bernini's. Poussin and Bernini could not afford, therefore, to repeat themselves. But even if a British portrait painter chose to produce some especial masterpiece it might only be seen by the relatively small number of the sitter's acquaintances and family. The squire who had his portrait taken might know only two works by his chosen artist: if his portrait looked to the right and his neighbour's looked to the left, that might seem to him adequate by way of incident.[25]

With money to be made, but only through volume production, it is not surprising that few artists chose to produce especial masterpieces. According to Rouquet the popular artist 'is obliged to work extremely quick, consequently he draws a great deal worse, by having a great deal

Fig. 4
RAEBURN
Mrs Scott Moncrieff
THE NATIONAL GALLERY OF
SCOTLAND

more business'.[26] To work quickly most artists found it expedient to delegate. The only part of a portrait that a sitter could guarantee was painted by the master himself was the part he had actually watched being painted – the face. Everything else could be left to assistants. The most common assistant was the specialist drapery painter, used to some extent by almost every portraitist except Mavericks like Hogarth.[27] Some of these, like Gainsborough's nephew, Gainsborough Dupont, were groomed for private service and followed their masters' changes of style with absolute fidelity. Such well-supervised assistants could be found in almost any Baroque studio, and their contributions should be regarded as dilution rather than contamination. Then there is the crowd of presumably less supervised specialists, such as those in Kneller's studio where, when 'he had finished the face, and sketched in the out lines of the shoulders, etc., the picture was given to the artist who excelled in painting a hat, and when the hat was fixed upon the head or tucked under the arm the canvas was consigned to the painter of the periwig', and so on, all apparently 'upon as regular principles as the fabricating of carpets at Kiddermin-

ster'.[28] At least Kneller thought that the face must be drawn first, for it can 'never be set right on the figure if the Drapery and Posture be finished before'.[29] This, you might think, went without saying, except that in yet more Stakhanovite studios postures were actually painted in *advance*, and faces added later. A specialist in such pre-packed postures was Sir Peter Lely's assistant, John Baptist Gaspars, called *Lely's Baptist* because like the saint he prepared the way for his master.[30] Similarly a portraitist called Sir John Medina went on a tour of Scotland with a stack of postures already prepared, for 'heads and half lengths that he shoud want'.[31]

Finally there are the drapery specialists who are entirely independent artists, with their own studios (and probably their own assistants), sub-contracted by face-painters. Peter Toms is an example of one of these 'painter taylors', whose services were employed at the same time by Francis Cotes and Reynolds.[32] But by far the most famous and successful was one Joseph van Aken, described here by Rouquet:

> *When a portrait painter happens to have a little business, it is usual for him to employ other hands in the painting of the drapery. Two rival artists took it into their heads to hire entirely to themselves another painter whose name was Vanhaken, to be employed in the drawing of the drapery: this man had real abilities, and might have done much better things, but chose to confine himself to his branch, because he was always sure of business. The two painters agreed to pay him eight hundred guineas a year, whether they could find work for him to this amount or not; and he on his side engaged to paint no drapery but for them. . . . The two rival painters who had thus engrossed Vanhaken, occasioned a good deal of confusion among the rest of their brother artists, who could not do without his assistance. The best of them knew not how to draw a hand, a coat, or ground; they were obliged to learn it, and of course to work harder. Sad misfortune!*[33]

Before this special deal there is other evidence that Van Aken worked for at least five different artists.[34] While Van Aken's better clients, Hudson or Ramsay, might send their portraits to be clothed, accompanied by a drawing of the pose and perhaps a dress to copy from, it is safe to assume that others left the matter entirely up to him – according to the portrait print-maker and diarist, George Vertue, 'for severall portrait painters he designed & composd their dispositions of pictures in a much better and more Ellegant Manner then they coud most of them'.[35] Rouquet goes on to tell us that before the monopoly of two 'he used to have canvasses sent him from different parts of London, and by the stage coaches from the most remote towns in England, on which one or more masks were painted, and at the bottom of which the painter who sent them took care to add the description of the figures, whether large or small, which he was to give them'.[36] This is not just drapery painting; postures and backgrounds are thrown in. Vertue confirms Rouquet's account when he refers to portraits being sent to be 'drest *and decoratd* by him' (my italics).[37] It is certain that he did not vary his style of drapery painting to depend in any way on that of the original face-painter.

Rouquet was a friend of Hogarth, who was the first to make the mechanics of the trade public knowledge. In a print showing the funeral of Van Aken in 1749 Hogarth satirised his clients' humiliating dependence by showing a procession of face-painters as mourners. Later, in his

Apology for Painters, Hogarth talks of the successful portrait painter in terms very similar to Haydon's: 'if one of these people is industrious in this kind of manufature he cannot fail of getting a fortune nine parts in ten of such picture (and perhaps the best . . .) is the work of the drapery man . . . and all the reputation is engrossed by the fizmonger for what is only contained in [an] oval of about five inches long.'[38]

Subtlety of characterisation cannot be expected of a portrait, nine-tenths of which is executed (and probably devised) by someone who has never even seen the sitter. As early as the 1730s an English translation of Gerard de Lairesse's treatise complained of artists that 'when the Face was finished, they had no further Regard to the Life, but chose a Posture, at Pleasure, out of Drawings or Prints, without considering whether it suited the Person', or even 'whether the Head match'd the Body'.[39] Many years later Reynolds is supposed to have made the same complaint: 'Most of our portrait painters fall into one general fault. They have got a set of postures, which they apply to all persons indiscriminately.'[40] In Lely's workshop poses actually had numbers, with 8 the highest recorded![41] One can imagine how convenient it would be to send a head round to Van Aken and ask for a 'Number 6' underneath. This will of course affect the painting of the head itself. For convenience a composite view was de-vised, which could look equally well on any of the eight or so available postures beneath (see *FIG. 5*). The head is viewed at an oblique angle, but only half-heartedly, for the bulging outline of the cheekbones and the in-dentation of the eye socket are smoothed out into a regular oval shape, almost as if the face were viewed frontally. This is to help the join: a regular oval peg must fit into a regular oval hole, with the wig acting as a useful cushion. It is not accidentally that Rou-quet refers to portraitists painting 'masks'.

A fundamental of serious figure painting is to 'set' the head well, to make it seem the logical anatomical conclusion of the pose of the rest of the body. One of the most important parts of Reynolds' revolution in portraiture is to vary the set of the head, employing everything from the frontal view (see *FIG. 72*) to the lost profile (see *FIG. 98*), including novelties of tilt and view-point. Ironically it is Reynolds who confesses to the worst excess of the mindless and the dis-located in portraiture. Northcote tells how in his earlier days Reynolds had collaborated with a 'body-man' and together they contrived to make 'great dispatch and pocketed the money pretty fast'. On one occasion, however, Reynolds thought the 'military air' of a head might be improved by a 'fierce cocked hat'. This dashing head was unfortunately set on a standard posture, which included a hat held under the arm, with the result that the picture went home with two hats![42]

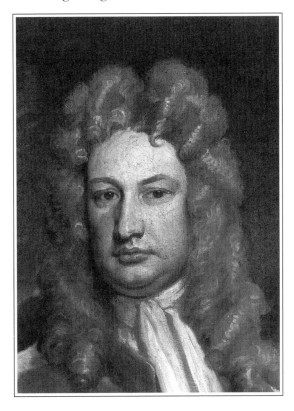

Fig. 5
KNELLER
Admiral Sir Charles Wager
(detail)
THE NATIONAL MARITIME
MUSEUM, LONDON

When considering the case of Van Aken, the question which suggests itself is, why didn't he set up as a portrait painter on his own? The answer is probably given by Gainsborough when he advises his friend Jackson to take up the same speciality, for 'whilst a Face painter is harrased to death the drapery painter sits and earns 5 or 6 hundred a year, and laughs all the while'.[43] The particular harassment Gainsborough has in mind is dealing with sitters. As the third most important quality requisite for a portrait painter Vertue lists 'an affable and obliging Temper, with a share of pleasant Wit,' which 'may be necessary to Every artist but more especially to the portrait painter'.[44] Every artist has to deal with the gentry, from whom they hope for most of their commissions, but no other type of artist has to deal so closely as the portraitist; in no other art is there so much opportunity to curry favour, or such danger of causing offence.

Everything must go smoothly, from the sitter's first expression of interest to the delivery. Times of sittings must be arranged, without muddles or double-bookings; for this Reynolds and Romney (and presumably many others) kept 'sitter's-books'. These now provide invaluable documentation, yet their orginal function would have been roughly that of a surgery receptionist's diary. Once arranged the sitting should seem to be a genteel social occasion. The artist's lodgings must be respectable, 'fit for a person of distinction', so as to be such that the sitter might consider visiting privately, even if, as Hoppner complains, the rent is a 'burthen, under which the demands of our profession compel us, quarterly, to groan'.[45] It is no use living, like Dr Johnson's *protégé*, Mauritius Lowe, in a garret so squalid that a rich potential customer was obliged to fly in horror.[46] Most fashionable portraitists had elegant waiting rooms or galleries at their studio, hung with portraits. Here were jointly advertised the artist's skill and the sitter's consequence, for the latter liked to have 'their pictures exposed for some time in the house of that painter who is most in fashion'.[47] Reynolds hung uncommissioned 'show-piece' portraits and left around a collection of prints of his works so that the sitter could choose a posture.[48] In the same way Gainsborough's friend Philip Thicknesse proposed that his own portrait should serve 'as a decoy duck for customers'.[49]

The tedium of the sitting itself was to be kept to a minimum, so it was understood that the painter kept the sitter amused with conversation. According to Vertue, one reason why pupils were often kept away from actual sittings was that they might there learn 'words that may not be so proper' during the 'conversations of persons that sett for their pictures, with Master painters', which were carried out with 'an equallity, as companions or friends'. Perhaps more to the point the pupil might also hear 'some immoderate praises . . . bestoy'd on the Mr. that may make the servant. Blush' – abject flattery in fact.[50] Kneller excelled in these ancillary arts, with a 'pleasant conversation finely entertaining when a Painting, that it is always observed that his performance is with so much facility. that no seeming confinement to sitting (as is usual) that People go away with more sprightliness than they came'.[51] This partly refers to Kneller's famous speed of execution, a quality admired in portrait painters for its obvious convenience, as well as his pleasing manners.[52]

Fig. 6
ROMNEY
Sir Christopher and Lady Sykes
1786
PRIVATE COLLECTION

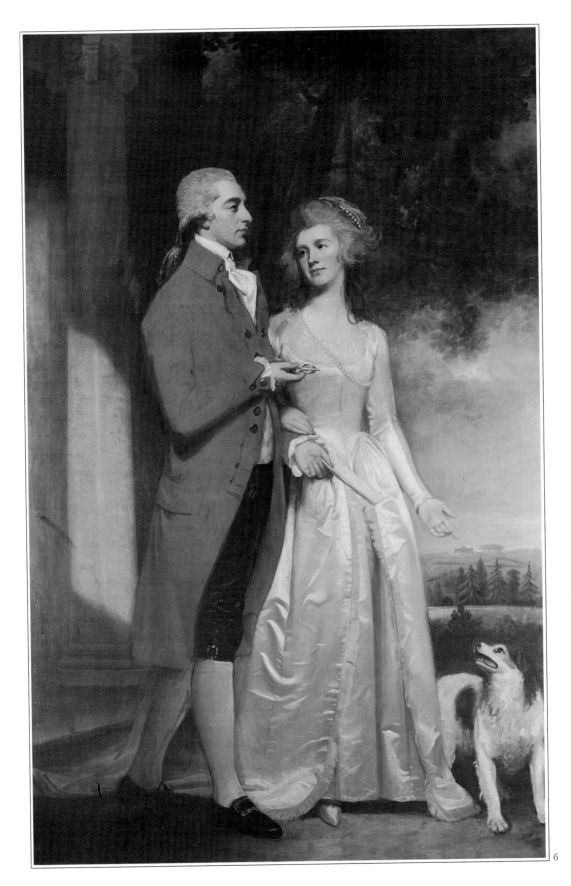

6

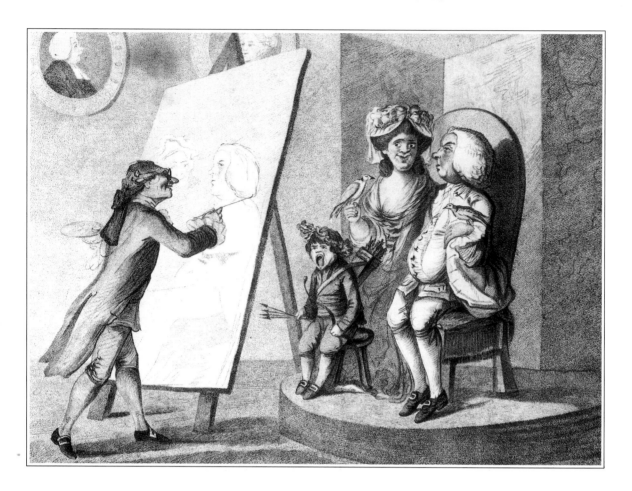

Fig. 7
WILLIAM DICKINSON
(after Henry Bunbury)
A Family Piece, stipple 1781
THE BRITISH MUSEUM

Though all agree that an artist must have 'a pleasent wit', there are surprisingly few descriptions of sittings. Captain Dalrymple tells us in 1802 that Angelica Kauffmann asked him to 'talk during the whole time, and upon such subjects as interest me most. By this means the countenance becomes more animated and of course can be drawn to much greater advantage'.[53] But we have no sample of her own conversation upon such occasions. All commentators agree that Reynolds' manners were remarkably bland and unobtrusively agreeable. A caricature of 1781 shows a portrait painter, probably intended to be him, grinning doggedly at a nightmarish family, while he labours to immortalise the hideous mother and balling son as Venus (with two doves) and Cupid (*FIG.* 7).[54] This could be intended to illustrate the line in Goldsmith's poetic description of Reynolds: 'To coxcombs averse, yet most civily staring'. Evidently some gallantry was required to make the party swing: one William Wissing, 'when any Lady came to sit to him, whose Complexion was any ways Pale, he would commonly take her by the Hand, and Dance her about the Room, till she became warmer, by which means he heightened her natural Beauty, and made her fit to be represented by his Hand'.[55] A similar 'glow of countenance' was achieved by the Marquess of Granby having a bout or two of fisticuffs with the stout painter Francis Hayman before his sitting.[56] But the artist had also to remember his place: it was

16

regarded as 'rather presuming' when Sir Thomas Lawrence, like Angelica Kauffman, suggested to Queen Charlotte that she might talk to give animation to her features.[57]

The need for a patter is best summed up by Vertue: 'I can't think otherways of an erroneous Portrait Painter, when painting to the life – then of a Tooth drawer, who chatters to gain your favour and patience while he is doing a business of necessity for if Portrait Painters were dumb I dare boldly say of fifty pictures that are painted & please, there would hardly be one.'[58]

The real test of an artist's plausible volubility lay in his deflection of criticism. The sitter had to be deferred to, of course, however silly and ill-informed. Ignorant ciriticisms drove one Henry Cooke to deface his work and return it with the fee; another painter used to storm into his assitant's room, 'vent his passion', and then 'return to the company, put on an obliging agreable air, [and] with the countenance of satisfaction wait their pleasure & censures'.[59] Reynolds just pretended not to hear.[60]

The long-suffering portrait painter had not only the sitter to contend with: it was common to bring friends to a sitting. Though a portraitist might be shy of being overlooked by other painters, he or she had little choice with the general public.[61] The case of Reynolds is probably typical: 'No one ever dropped in but the friends and acquaintance of the sitter – it was a rule with Sir Joshua that from the moment the latter entered, he was at home – the room belonged to him'.[62] These friends were the real tormenters, for their flattery of the sitter usually took the form of contrasting the perfections of nature with the inadequacies of the rendering.[63] The portrait painter and poet Sir Martin Archer Shee concludes in effect that his colleagues earn their money, for though they 'bask in Fortune's ray':

> *Yet teizing follies torture all their hours,*
> *Disturb their studies, and impede their powers;*
> *Pretending critics round their eazel stand,*
> *And fops and ladies dictate to their hand.*
> *Elements of Art*, 1809, Canto III, ll. 105-8.

There is of course more to watching painters at work than merely being a pest: it is a particular pleasure, subtly different from enjoying the completed work. The pastime began life as regal therapy in the seventeenth century – Philip IV watched Velazquez; Charles I, Van Dyck; Charles II, Lely – and spread downwards in the eighteenth. Artists, including Kneller and Reynolds, even set up mirrors so that sitters could watch their own likenesses emerging.[64] Portraiture is in fact something of a performance art. This means that painters who work fast are encouraged, and especially those who move towards a likeness by daring leaps. It is clearly impossible now to reconstruct the performance itself, but some traces of it are left in the final work – a tantalising effect of unfinish, perhaps suggesting that the artist has been begged to leave off, so as not to bury a striking effect with further work. Most great portraitists are showmen of the brush and masters of the barely finished. This is most true of Velazquez, but it also applies to Kneller, Gainsborough and Lawrence, as well as some of Reynolds' work.

We have seen how portrait painters dealt with their sitters; how did they attract them in the first place? The most important way was through the recommendation and promotion of a nobleman or woman.[65] 'The painters of England are less solicitous about studying their profession,' wrote one John Shebbeare in 1755, 'than finding a blear-eyed patron, who, with zeal for what he can neither see nor understand, may impose upon others, and swell him into high reputation.'[66] The grander the nobleman and the wider his influence, the more people he can persuade to sit for his pet portraitist. In the 1730s Vertue writes: 'its more remarble now that several noblemen have their particular painter or favorite which is wholly at their promotion – and recommendation'.[67] An astonishing number of portrait painters are mentioned as being under such protection, from the most famous, Reynolds, whose career was said to have been launched by Lord Mount Edgecombe, to the most obscure.[68] Henry Tilson (1659-95) was recommended everywhere by a wealthy Mrs Green, who 'procurd him a deal of Business' so assiduously that he fell in love with her, but shot himself when he supposed his love was unreturned.[69]

If a patron is not forthcoming, or not up to it, another means of acquiring notice is to paint some famous person. A king or queen is, of course, a trump card, but then sittings have to be granted; Kneller's reputation was made when his patron, the Duke of Monmouth, procured for him a 'share' in a sitting by Charles II for Sir Peter Lely.[70] If even this cannot be obtained, an 'original' portrait can be cobbled together from others' work and from glimpses of their Majesties. This is the 'false imposition' which, in the 1730s, made the names of Joseph Highmore (1692-1780) and 'a little cringing creature Mr. Worsdale' (James Worsdale c.1692-1767).[71] If you're not the little cringing type you can make an impact by painting some more accessible celebrity: Jean-Baptiste van Loo got by without any 'importunate invitations from any Noblemen or grandee of Court' through the fame of his portraits of the actors Owen McSwiney and Colley Cibber.[72] Hogarth's *Captain Coram* (*FIG.* 53) was described by Vertue as 'another of his efforts to raise his reputation in the portrait way from the life'.[73]

Another ticklish question of professional ethics was: should the portrait painter advertise? Hogarth was unique in having a tradesman-like shop-sign outside his studio, illustrating Van Dyck's head.[74] Advertisements in newspapers were regarded as similarly vulgar, but there was no clear division at the time between what was advertisement and what news. An artist could pay for a 'gossip' item which might state, for example, that Mr Hudson had just finished a portrait of X or Y, which can be seen at such an address etc.[75] They could furthermore write (or get their friends to write) elaborate eulogies of their own work (what in the eighteenth century were called *puffs*), again to be paid for by the beneficiary, not the paper. Mr Puff, in Sheridan's *The Critic* (1779), mentions six different modes of puffing, ranging from the 'Puff Direct' to the 'Puff by Implication'. Vertue in 1742 gives an excellent example of 'Modern methods of making a man noted' (or what Mr Puff would call the 'Puff Oblique'): two friends of the miniature portrait painter Lens sat in

opposite boxes of a crowded theatre; one held up an example of Lens's work, the other shouted across to ask who had painted it, and, when told, to ask where this *Mr Lens* lived. When the first puffer pretended not to know, they both appealed to the audience to ask if anyone knew his address, 'that we may know where to find such an Ingenious Man'.[76] It is easy to see why it was so often claimed that the craze for a particular portraitist had little to do with real merit. So Hogarth writes of Van Loo that he was told by friends that the English are to be run away with, and sure enough they were right, for with his grandeur and puffing he monopolized all the people of fashion in the kingdom.[77]

Hogarth's remarks tell us why advertising, and every other artifice, was so important in enhancing the portraitist's reputation. In the same passage he explains that 'Portrait Painting ... hath allways been engrossed by a very few Monopelisers whilst many others in a superior way more desirving both as men and artists are every were neglected and some starving'.[78] The vast and widely-spread market for portraits did not mean a spreading of the rewards. Almost throughout the century there were 'monopolisers', whose trade and whose rewards were far in excess of their rivals'. Kneller, Reynolds and Lawrence were the principals, but Van Loo, Hudson and Ramsay all enjoyed the status briefly, in a disputed period between the death of Kneller in 1723 and Reynolds' consolidation in the early 1760s. This was because portrait painting, more than the other arts, was subject to fashion. As Rouquet observes, once the portraitist is in vogue, 'fashion, whose empire has long ago subverted that of reason, requires that he should paint every face in the island'.[79] Fashion makes a volatile and a fickle market, dictated by the few that lead (and perhaps know) and the many that follow (and don't). 'You English see with your ears,' said Canova.[80] It is easy to see how this makes the world of portraiture unstable and faddish. One week you have to bribe a footman to obtain a sitting, the next a darling artist is forgotten.[81] It was regarded as a remarkable thing that Reynolds managed to win the public back after a period of relative neglect, not once but twice: after the rage for George Romney (around 1775-80) and that for John Opie a few years later.[82] Opie himself wasn't so lucky: he used to recall how one day the road he lived in was blocked by the carriages of the nobility coming to have their pictures taken, the next it was as if his house harboured the plague.[83]

So, even at the top of the profession, the life of the portrait painter was uncertain and beset by non-artistic considerations, which he or she ignored or despised at their peril. And while on the Continent thriving history painters could beam reflected glory on their inferior colleagues, in Britain there was no demand for anything except portraiture. As early as the 1650s the poet Lovelace wrote lamenting that no one in England showed any interest in his friend Lely's historical pictures:

> Now my best Lilly *let's walk hand in hand,*
> *And smile at this un-understanding land;*
> *Let them their own dull counterfeits adore,*
> *Their Rainbow-cloaths admire, and no more;*
>
> Peinture, 1659 ll. 101-4.

19

Similar references to the exclusive and *in-artistic* nature of the British interest in portraits are everywhere to be found.[84] It was also a commonplace that artists who had painted masterpieces abroad could be 'spoiled' in Britain, by neglect of their histories and by too thriving and too uncritical a market for their portraits. Van Dyck, when asked to explain the poor quality of his later portraits, is supposed to have said, 'I Workt a long Time for my Reputation, and I do it now for my Kitchen.'[85]

It is sometimes suggested that our surprise at the professionalism described above is 'post-romantic', unhistorical; that at the time it was regarded as only natural for the heirs of Michelangelo and Raphael to be daubing phizes to pre-prepared, numbered poses. There is some truth in this objection, but it must be remembered that much of our attitude of amused, incredulous dismay is echoed in the period, by those, like Hogarth and Haydon, with axes to grind and also by those, like Vertue, without. 'The want of Ambition in Art', this latter writes, 'thus shows its declineing State. small pains & great gains is this [the] darling modish study –'[86]

Does this state of affairs persist after the bleak years of the middle of the century? Certainly hostility to portraiture persists, but, even according to the evidence of its detractors, some improvements can be detected in the art. At first glance Hazlitt's 1816 tirade reads much like a re-printing of the Abbé Le Blanc's:

> The 'numbers without number' who pay thirty, forty, fifty, a hundred guineas for their pictures in large, expect their faces to come out of the Painter's hands smooth, rosy, round, smiling; just as they expect their hair to come out of the barber's curled and powdered. It would be a breech of contract to proceed in any other way. A fashionable Artist and a fashionable hair-dresser have the same common principles of theory and practice; the one fits his customers to appear with éclat in a ball-room, the other in the Great Room of the Royal Academy. A certain dexterity, and a knowledge of the prevailing fashion, are all that is necessary to either. An Exhibition-portrait is, therefore, an essence, not of character, but of common-place.[87]

But there are differences. The use of the word '*éclat*', for example, suggests that however much Hazlitt wants Regency portraiture to appear a commonplace, he is obliged inadvertently to concede that it is a flashy, stylish commonplace, rather than a drab one. Similarly when Northcote calls Lawrence a 'man-milliner painter – a meteor of fashion', he cannot suppress a twinge of envy at the obvious glamour of his target.[88] Finally there is the question of money: Rouquet had mentioned ten to twelve guineas, whereas Hazlitt is talking of fifty or a hundred. It may still be a mill-horse business, but there is evidently a plentiful supply of oats.

CHAPTER 2

THE ADDITION OF CHARACTER

'I'D RATHER BE AN APOTHECARY THAN AN *ORDINARY* PAINTER!' THE young Joshua Reynolds is supposed to have said at the outset of his career in 1740.[1] Odd, you might think, that he chose portraiture. In fact he had no choice; whatever exalted ambition he might have, it was only through portraiture that he could hope for the encouragement to realise it. In part as a result of Reynolds' strange and downright resolve not to be an 'ordinary painter', the world of portraiture transforms itself in the thirty or so years that follow. Even the French acknowledge this: Mercier, a visitor to England in the 1780s, finds a very different artistic life from that observed by Rouquet or Le Blanc, one indeed 'worthy of the great days of the Flemish and Italian schools'. The English, he says, 'excell in portraits, and nothing surpasses the portraits of *Regnols*, of which the principal examples are full-length, life-size, and on a par with history paitings.'[2] While the first half of the eighteenth century presents a picture of unrelieved drudgery, the second half, at least in most people's view, presents one of prosperity, idealism, fame and glory. It is possible to detect the roots of this improvement in the earlier part of the century; equally, large traces of drudgery are still complained of well into the second half. It is finally a question of how one wishes to look at the same material. In his *Idler* no. 20 of 1758 Dr Johnson describes a military engagement from the French and English points of view, so that it is scarcely recognisable as the same event. In the same way it is possible to find throughout the century another view of portraiture to counteract that of the first chapter, one that makes the art seem more *liberal*, more lucrative and more glamorous.

According to the poet William Hayley, 'the emoluments of portrait painting may be said both to support and to ruin a great artist'.[3] This epitomises the high-minded view, favoured by meddlesome *literati*; for most people emoluments might not be everything, but they couldn't do any harm. The prices commanded by portrait painters give a crude but solid indication of the esteem in which their art was held by the public. To read an intricate pattern of rising and falling prices throughout the century is obviously treacherous, since it depends so much on the burgeoning careers of individual artists. It also takes no account of the transactions of lesser, obscure and provincial portraitists, such as the travelling limner in Goldsmith's *The Vicar of Wakefield* who took likenesses for fifteen shillings a head. (Chapter XVI) However, by reading the price levels of those 'basking in Fortune's ray' a broad pattern certainly emerges. All the prices that follow are in guineas, which is a pound and a shilling (or 105p), and are for *heads*; for the two main larger sizes (*half* and *full-length*) the figures can be roughly doubled and trebled or quadrupled respectively. In the early years of the century prices are respectable, but not spectacular. Kneller charged a constant 15 guineas a head for the last thirty years of his life, which is less than the 20 Lely was asking in 1670. Jonathan Richardson put his price for a head up to 20 in 1730, which was to remain the highest price for nearly thirty years. During the 30s and 40s prices begin to drop slightly, though this is a sag rather than a slump, merely indicating that in these years nobody quite replaced Kneller and Richardson in reputation. Hudson in 1740 charged 12 guineas, and Rouquet's estimate price for the best portraits in about 1750 was 10-12 guineas. In provincial Bath in 1738, William Hoare was considered well paid at a mere 5 guineas a head.

The only decisive part of the pattern is the dramatic rise in prices towards the end of the century. The upturn comes in the later 1750s when both Reynolds and Hudson make a series of rapid price rises. In 1751 Reynolds joins his rival at 12 a head, and in 1757 they both move up to 15 to equal Kneller's record. But this is where Reynolds pulls away, overhauling Richardson at 20 in 1759, and in 1764 breaking the century's record with 30 guineas a head. In the same period Ramsay had risen from 12 to 22. Reynolds' final increases come a decade later to 35 in 1777 and 50 in 1779. During the 1780s Reynolds competed with Gainsborough and Romney, both at the summits of their careers, charging 40 and 30 guineas respectively by the end of the decade. Some thirty years later, admittedly after national inflation, Lawrence was charging 200 guineas a head. In addition to the full-lengths at four times the price, there are also special extra large sizes: Reynolds received 500 guineas for his *The Cottagers* in 1788 (*FIG.* 131); Lawrence £1,500 for a portrait of Lord Gower's wife and child.[4] It is difficult to callibrate these figures in modern currency. Even the 200 guineas Reynolds charged for a full-length at the end of his career can be made to seem a minuscule sum – hardly more than one hundredth part of the cost of a bejewelled masquerade dress, or an astronomic sum – what a farm labourer might earn in ten years.[5] The balanced truth is that it was quite a lot. The artist of course only receives this money if the portrait is accepted. Reynolds, we are told, 'did not contradict a friend, who,

in his presence, averaged the price of all his portraits, since his becoming fashionable, at only 10*l*. 10*s*. [10 guineas] each'.[6]

This pattern partly records the meteoric rise of Reynolds, but it also describes portraiture itself 'making good' after the 1750s. Nothing records the change in attitude better than the people who are left behind by it. In her diaries of 1779, Fanny Burney records encounters with an elderly figure of fun called Mr B—. He is, she writes, 'notorious for his contempt of all artists, whom he looks upon with little more respect than upon day-labourers, the other day, when painting was discussed, he spoke of Sir Joshua Reynolds as if he had been upon a level with a carpenter or farrier ... "I knew him many years ago in Minorca [1749], he drew my picture there, – and then he knew how to take a moderate price; but not now, I vow, ma'am, 'tis scandalous – scandalous indeed! to pay a fellow here seventy guineas [Reynolds' price for a half-length] for scratching out a head!"' When someone answers that '"he has improved since you knew him in Minorca; he is now the finest painter, perhaps, in the world"', the reply is: '"a very decent man he is, fit to keep company with gentlemen; but, ma'am, what are all your modern dabblers put together to one ancient? nothing ... not a Rubens among them!"'[7] We guess from this passage that to everyone else present, including Fanny Burney herself, Mr B— is a buffoon, in his blind prejudice in favour of the foreign old masters and in his nostalgia for the old illiberal days when painters *were* upon a level with carpenters and farriers and charged accordingly. Burney was a friend of Reynolds, so she might be said to be prejudiced herself, but it is clear from her tone that to a 'modern' sensibility Reynolds' work *is* comparable with that of Rubens and he is *obviously* 'fit to keep company with gentlemen'.

This brings us again to the potentially noble or *liberal* character of the art. It would be generally agreed in the eighteenth century that there were certain adjuncts to a liberal artist, manifestations of an intellectual love of art for its own sake: collecting, writing about painting, or being acquainted with poets and men of learning. It comes as a considerable surprise to find how many portraitists throughout the century fulfill some or all of these criteria, be their own work never so dull and mechanical. Shaftesbury contrasted modern painters – 'illiterate, vulgar, scarce sober' – with their ancient rivals, who could discuss their own works on paper and did so *for themselves*.[8] At the same time flourished Jonathan Richardson (1665-1745) who, as it turned out, could write far better than he could paint, leading some to wonder how he could comment upon the old masters so well and imitate them so little.[9] On his own, and in collaboration with his son Jonathan II (1694-1771), he produced an excellent guide to the art of Europe (1722), general introductions to the appreciation of painting (1715 and 1719), some poetry and a commentary on Milton's *Paradise Lost* (1734). Richardson also amassed a superb collection of old master drawings, which sold at his death for over £2,000.[10] In this he was not alone: Lawrence, trying to persuade a dealer to give him preference in the purchase of drawings, writes in 1823: 'Remember, that although beneath some names in the list, (and particularly the two last,) I am still the successor of Sir Peter Lely, the Richardsons, Sir James Thornhill, (the

former possessor of my Rubens), Hudson, Sir Joshua Reynolds, and Benjamin West.'[11] He means that he is their successor in *collecting* not painting. Reynolds, one of the two he singles out, amassed a collection of old master drawings and paintings, which after his death fetched over £12,000.[12]

Painters can boast other intellectual accomplishments: Sir Peter Lely, Sir Godfrey Kneller and Sir Thomas Lawrence were friends of some of the brightest wits of their age. Allan Ramsay (1713-84), son of the poet of the same name, was a considerable writer as well as painter, publishing widely-praised essays on taste, archaeology and general philosophic issues. Hogarth wrote vociferous, if quirky, polemics on painting and aesthetic theory. James Northcote (1746-1831), an obscure painter, spoke so well that his conversations were recorded by no less an author than William Hazlitt. Finally there is Sir Joshua Reynolds, collector, club-mate of Johnson, Goldsmith and Garrick, first President of the Royal Academy and author of the *Discourses* (1769-90).

A strange insight is given in the *Discourses* into the contrast between the British and the continental artist. Reynolds is shocked by an artist he met in Rome, 'of great fame throughout Europe', revealing to him that he had not been to see Raphael's frescos in the Vatican for fifteen years. In Reynolds' view he ought to have paid his homage 'at least once every month of his life'. (*Discourse VI*)[13] We can imagine on the one hand the Italian, probably trained to impeccable draughtmanship and technique, in a country where art is revered, surrounded by the world's masterpieces, and yet treating the Vatican as the Londoner is supposed to treat Westminster Abbey. On the other hand there is Reynolds, receiving a hopelessly flawed training in what was regarded as a mechanical trade, and who yet, from his northern exile, was almost *oppressed* by his awe of the old masters, and whose observations upon them are still worth reading today. Reynolds was certainly not as erudite as Allan Ramsay, but his learning was of a more specialised visual nature and he was the first to appreciate that, with a bit of ingenuity, it could be put to use in his art.

The latter part of the eighteenth century was called, in the words of a contemporary, 'the era of exhibitions'.[14] In 1826 Sir Thomas Lawrence writes that the 'salutary effects of yearly competition, and its advancing knowledge, are indeed incalculable. Great as our Reynolds, in *every* situation, must have been, I am as certain of his rapid improvement, from the contemplation and comparison of his works in public, as I am of that benefit from the same cause, which has lifted me from mediocrity and neglect'.[15] For Edmund Burke it was exhibitions 'to which we owe almost all the art we can boast'.[16] Burke claimed that the idea was originally Reynolds'. This is not true: he may have been the principal beneficiary, but the idea originated, as did so many things, with Hogarth.

In 1747, Hogarth and his associates decided to donate works to make a permanent display at Thomas Coram's charitable foundation, the Foundling Hospital, as reciprocal publicity for painters and foundlings alike. Temporary exhibitions, a far greater boon for artists, began at the premises of the Society for the Encouragement of Arts, Manufactures and Commerce in 1760. These exhibitions lasted in various rooms till 1778,

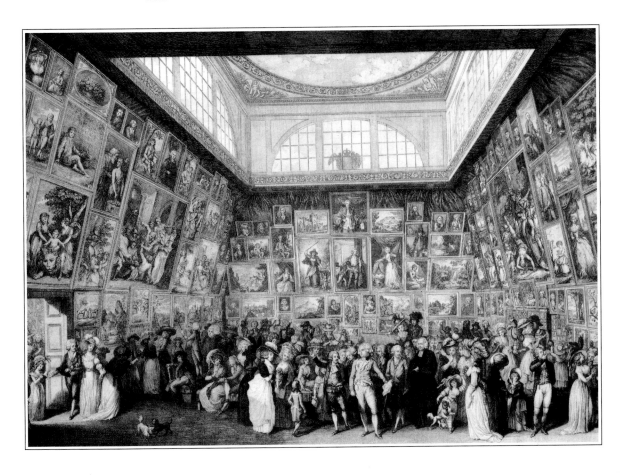

Fig. 8
PIETRO MARTINI
(after J. H. Ramberg)
*The Exhibition of the
Royal Academy, 1787,*
engraving and etching
ROYAL ACADEMY OF ARTS

but after the first year the majority of artists exhibited at Spring Gardens in a group called the Society of Artists, whose yearly exhibitions survived until 1791. By this time, however, it had been replaced by the most important venue of all, the Royal Academy, which first opened its doors in 1769 (see *FIG.* 8). In short, for most of the last years of the century there were *at least* two exhibitions annually, as well as those organized by individuals in their studios or in hired rooms. These shows grew dramatically in size: the 1760 exhibition had 130 works on show, the 1785 Royal Academy had 500. They similarly rose in attendance: the 1761 Spring Gardens exhibition received an estimated 20,000 visitors, forcing the Society of Artists to set a shilling admission charge for the next year to prevent overcrowding. In 1779 it was reported that 'the rage to see these exhibitions is so great that sometimes one cannot pass through the streets where they are'; while the Royal Academy exhibition of 1780 took £500 in entrance fees in *one* day, and altogether sold 20,000 catalogues.[17] The portraitist could now conceive works to be seen by a wide public, in a great hall and in direct competition with other portraitists and history painters. Great ideas need no longer rot in rural domestic obscurity.

It is probable that the exhibitions encouraged men and women of fashion to order full-lengths in greater numbers than before, since the chance to appear in public would appeal to the sitter as well as the artist; Hazlitt mentions appearing with *éclat* in the Royal Academy as part of the

contract. It was evidently easy to 'borrow back' a commissioned portrait for exhibition, and, though it would appear in the catalogue as simply 'A Portrait of a Lady' etc., everyone seemed to have known who was depicted. In the 1770s and 1780s Reynolds regularly exhibited over ten paintings, once in 1788 as many as 18, of which 15 were portraits. He seems to have made a careful selection of each year's production to produce a balanced sample of his grander efforts: a few female full-lengths in the Grand Style, perhaps a heroic military portrait, or a famous intellectual, and a child or two. A fundamental question is: to what extent did Reynolds, or any of his contemporaries, conceive of a special 'exhibition portrait'? Was exhibiting perhaps the reason for the revival of the 'fancy' or 'historical' portrait? No definite answer can be given, but it seems that Reynolds wished to show at least one such 'fancy' portrait every year. This is implied by a 1767 letter from his friend Edmund Burke to the painter James Barry: 'Reynolds,' he writes, 'though he has I think some better portraits than he ever before painted, does not think mere heads sufficient, and having no piece of fancy finished, sends in nothing this time.'[18] It is also significant that at the first exhibition of the Royal Academy in 1769, in many ways the most momentous of the period, Reynolds exhibited four portraits, *all* of which were 'fancy' or 'historical'.

Members of the public who failed to fight their way into the year's exhibition could be reached through the thriving trade in the reproductive print. The artistic success stories of the eighteenth century – Alexander Pope or William Hogarth – were often accounted for by the mass-market for books and prints found among the prosperous middle classes. The nobility are still the principal patrons of portraiture, but artists may also now take advantage of this second and larger market. As with exhibitions, their motive is not profit, since this went to the print-maker, but fame and general self-promotion. By far the most popular technique for portrait reproduction was the mezzotint. The peculiarity of mezzotint was that it was the first *non-linear* print-making process and was therefore suitable for reproducing the broad effects of oil-painting. Reynolds' handling of the brush was thought especially easy to 'catch' in mezzotint (see *FIGS* 9 and 10).[19] Reynolds is supposed to have said of McArdell, his most prolific and successful scraper, 'by this man, I shall be immortalized'.[20]

Some mezzotints were ordered by the sitter for distribution among friends, but more often the prints were undertaken commercially and sold in print shops to a mass audience. Their success was prodigious: in 1770 Horace Walpole complained of the rage for prints of English portraits . . . 'I have been collecting them above thirty years, and originally never gave for a mezzotinto above one or two shillings. The lowest are now a crown, most from half a guinea to a guinea.'[21] The rage even spread to the Continent, sensationally reversing the balance of payments in this department. In 1778 the value of British prints exported was put at £200,000, and those imported at £100.[22] Reynolds' designs were to be seen as far afield as Italy, and lithographs after Lawrence's *Calmady Girls* were apparently hung in humble French farmhouses.[23]

A pure love of art does not altogether explain this success: tabloid-style curiosity played a part. It might be the features of some notorious

footpad or jail-breaker, famous writer or fashionable actress that excited the public, as much as a fine design. Henry Raeburn complained that his print of Sir Walter Scott was elbowed out of the limelight by an image of a favourite black boxer.[24] Even Mr and Mrs Such-a-one, as Hazlitt calls them, might not be utterly obscure. Such people, in the eighteenth century, could have had some share of fame as what was called 'men or women *of fashion*'. This notwithstanding, it is evident that some prints *were* valued primarily because of the portrait, not the portrayed.

Rising prices, a thriving print market, exhibitions – these are all things which began in earnest in or around 1760. This was a time when expected standards, as well as working conditions, improved. 'Now to succeed in the art,' Reynolds is supposed to have said in the 1770s, 'you are to remember that something more is to be done than that which did formerly; Kneller, Lely, and Hudson, will not do now.'[25] Most eighteenth- and early nineteenth-century writers give Reynolds himself the credit for this, for it was he, to use Walpole's phrase, who 'ransomed portrait-painting from insipidity'.[26] The artist usually singled out to epitomise the insipidity is Thomas Hudson. So Reynolds is to be found 'emancipating his art from the shackles with which it had been encumbered in the school of Hudson'.[27]

Hudson is rather small beer as an art-shackler; the more formidable antagonist, according to Reynolds' partisans, was Sir Godfrey Kneller. This is, of course, a struggle of reputations; Kneller died the year Reynolds was born. But his reputation in the first half of the century was stratospheric: an outraged art-lover stormed out of Reynolds' studio after the latter had questioned Kneller's worth, spluttering 'Shakespeare in poetry, Kneller in painting, damme!'[28] This seems today an absurdity, particularly as it involved an undervaluing of Van Dyck. Reynolds claimed that in his youth 'a man who placed Van Dyke above Kneller would have been scoffed at'.[29] There were even stories of painted periwigs being added to Van Dyck portraits to bring them up to date.[30] A hundred years later, for those brought up on Reynolds, Kneller's reputation was a false idol, which it had been Reynolds' mission to overthrow.[31]

Sir Godfrey Kneller and Sir Joshua Reynolds are the principal knights of eighteenth-century portraiture, till joined by Beechey, Raeburn and Lawrence in the Regency period. From the point of view of the general morale of the British portraitist there is an important distinction between them. It was commonly admitted that Kneller was despised outside Britain, though this was usually accounted an oddity of the continental taste.[32] Abbé Le Blanc is especially acid: 'you would blame me,' he

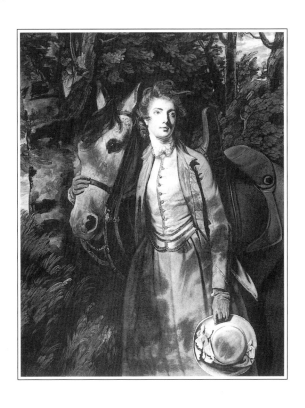

Fig. 9
WILLIAM DICKINSON
(after Reynolds)
Lady Charles Spencer, mezzotint
1776
FITZWILLIAM MUSEUM, CAMBRIDGE

writes, 'if I acknowledged any other merit in this German, than the judgement he shewed in choosing England for the place to exercise his talent in.'[33] The fact of his being German, and of the English seeming to be his dupe, was peculiarly wounding to the national sensibility. With Reynolds the case was different; he enjoyed international fame, and was the first native-born artist to do so. As we have seen from the snippet of conversation recorded by Fanny Burney, Reynolds was sometimes championed by his friends as the greatest artist in Europe.[34] Northcote epitomises Reynolds-mania when he asks 'whether portrait painting will ever be carried much further than Sir Joshua has carried it,' and decides, 'I have my doubts.'[35]

Evidently the status of the portrait *painter* rose during the eighteenth century; what about the art itself, was there anything to be done for portraiture in the artistic theory of the time? As we have already seen, its problem was that a portrait, unlike a history painting, could seem to be a *mere* copy of a *particular* person, without thought or general edification. In a broad way the problem of the 'mere copy' was countered by such remarks as Lovelace's:

> *So that th'amazed world shall henceforth finde*
> *None but my* Lilly *ever drew a* Minde.
> *To my Worthy Friend Mr Peter Lilly, 1649 ll. 31-2.*

In fact th'amazed world found that henceforth almost *all* portraitists, at least in the opinion of their writer-friends, drew 'minds', 'souls', 'feelings' or some other inaccessible part of their sitters.[36] Hazlitt even felt that portraiture should be praised or damned according to the degree to which it 'gives the soul or the mask of the face'.[37]

Such a view is encouraging but hopelessly subjective. More specific attempts to answer the problem of the particularity of portraiture divide roughly into two categories, approaching the problem from opposite ends, both of which are suggested in Hazlitt's definition of portraiture as 'a sort of cement of friendship, and a clue to history'.[38] On the one hand portraiture finds a moral purpose in strengthening the 'ties of social existence'.[39] This is what Dr Johnson has in mind when he writes:

> *I should grieve to see Reynolds transfer to heroes and to goddesses, to empty splendor and to airy fiction, that art which is now employed in diffusing friendship, in reviving tenderness, in quickening the affections of the absent, and continuing the presence of the dead.*
> *The Idler, no. 45, 24 February 1759.*

The problem with this is that the portrait is contingent upon the man; when the dead friend is forgotten, or the tenderness is cooled beyond reviving, the portrait loses its message. A serious theory for portrait painting has obviously to find an aesthetic value independent of the sitter, as William Combe was able to do in 1777:

> *Portraits . . . have, from the insipid and uninteresting style in which they were generally painted, been considered as mere Trash and Lumber by all who were ignorant of the Originals. But, by the Genius of many modern Professors of Eminence, that Insipidity is vanished; and, by their Hands, a Portrait is now interesting even to the Stranger, and . . . will be interesting to future Ages.*[40]

This universal interest seemed in the period to allow portraiture to qual-
ify as 'honorary history painting', a title often claimed for the best por-
traits in the eighteenth century, especially those of Reynolds.[41] James
Barry, for example, says of Reynolds' *Mrs Siddons as the Tragic Muse* that it
gives an idea of that 'confined history, for which Apelles was so cele-
brated by the ancient writers'.[42] But it might seem as if the title of 'con-
fined history' depended wholly upon the treatment of the subject of *The
Tragic Muse*, and not on the depiction of Mrs Siddons – in fact as if such
portraits were to be admired for deserting portraiture altogether. Nor
does Barry cater for the vast majority of portraits, which have no myth-
ological subtitle.

For the middle style of portraiture, which is neither mere 'Lumber' nor
fully mythological, an interesting defence is proposed in the fourth of
Henry Fuseli's lectures as Professor of Painting at the Royal Academy in
1810. While assigning to portraiture its conventional place far below that
of history painting, Fuseli makes an exception for 'the characteristic por-
trait', represented by a list of distinguished practitioners including
Reynolds, whom he calls 'that power which, in our days, substantiated
humour in Sterne, comedy in Garrick, and mental and corporeal strife . . .
in Samuel Johnson. On that broad basis, portrait takes its exalted place
between history and the drama'.[43] Fuseli does not require specific myth-
ological impersonations, all he requires is that a portrait should contain
ideas. Indeed for him these *precede* the particular sitter: Reynolds starts
with the idea of 'humour', 'comedy', 'mental and corporeal strife' and
uses Sterne, Garrick and Johnson to 'substantiate' them.

It is also worth noting that the difference between an idea and a per-
sonification is not a hard and fast one: when a poet writes, in a similar
vein to Fuseli, that Reynolds knew how to trace . . .

> *Youth's vivid blush, impassioned, warm,*
> *And Innocence in Childhood's form.*

does he mean *Innocence*, the allegorical figure whose attribute is a lamb, or
just innocence?[44]

Either way this is to read a portrait historically, as a vehicle for uni-
versal ideas which can be interpreted separately, and which have been
almost *attached* to the individual sitter, like an attribute. William Combe
writes of Reynolds:

> *This Addition of Character, whether Historical, Allegorical, Domestic, or Pro-*
> *fessional, calls forth new sentiments to the Picture; for by seeing Persons repre-*
> *sented with an appearance suited to them, or in employments natural to their*
> *situation, our ideas are multiplied, and branch forth into a pleasing variety,*
> *which a representation of a formal Figure, however strong the resemblance*
> *may be, can never afford.*[45]

According to this passage the viewer's ideas can 'branch forth' whether
the portrait contains something as universally understood as an Allegory,
or something more private from domestic or professional life. This focus
of intellectual interest in the portrait is called its 'Character', and it can be
added to the sitter. In this way the gap between the individual and the
general is closed: a character is like a mantle of universally understood

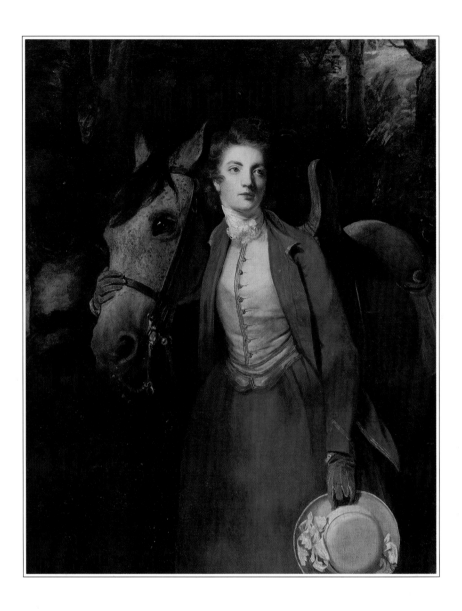

qualities, assumed by a sitter, and yet perhaps arising out of their 'domestic or professional life'.

There is one other point upon which all theorists are agreed, and that is that portraits are and should be flattering. Mr Carmine in Foote's farce *Taste* of 1752 puts it succinctly: 'where Nature has been severe, we soften; where she has been kind, we aggravate'. (Act I, scene 1)[46] Even in this province, however, serious writers do not talk simply in terms of what one might call the 'plastic-surgery' of idealisation. It is the 'general character', not the face, which must be flattered. Jonathan Richardson considers it 'absolutely necessary to a good Face-Painter' . . .

> *To divest an Unbred Person of his Rusticity, and give him something at least of a Gentleman. To make one of a moderate Share of good Sense appear to have a Competency, a Wise Man to be more Wise, and a Brave Man to be more so, a Modest, Discreet Woman to have an Air something Angelical . . . in such a manner as is suitable to the several Characters.*[47]

According to Cunningham, if Colonel Charteris (a notorious rapist) had sat to Reynolds, he would have given him 'an aspect worthy of a President of the Society for the Suppression of Vice'.[48] This means, of course, that portraiture expresses not so much ideas as ideals.

Idealisation, general ideas and individual character: this is a mixture which in the twentieth century would curdle. For us character means something unique, perhaps also enigmatic and contradictory, certainly not something which could be 'added' or which could be identified with the ideals of a certain class or type of person. Our expectation is summed up by E. M. Forster's demand that novelists draw 'three-dimensional' as opposed to 'two-dimensional' characters. Writers in the eighteenth century, however, were commended for a quite opposite quality: 'In the writings of other poets a character is too often an individual;' writes Dr Johnson, 'in those of Shakespeare it is commonly a species.' (*Preface to Shakespeare*, 1765) In *Rasselas* of 1759 the same idea is elaborated:

> *'The business of the poet . . . is to examine, not the individual, but the species; to remark general properties and large appearances: he does not number the streaks of the tulip, or describe the different shades in the verdure of the forest.'*
>
> Chapter X.

This is evidently practice as well as theory throughout the eighteenth century. The majority of characters in the literature of the period embody a single quality, often announcing themselves by their names: Squire Allworthy, Sir Fopling Flutter, Lady Teasle etc. Particular details may be admired in characterisation, but they all tend towards some reasonably simple sum. Addison is commended for observing that his Sir Roger de Coverley possessed 'that singularity, that wherever he visited he always talked to the servants the whole way he went up stairs' – a tiny detail, but one which does not make the *sum* of Sir Roger anything more complicated than a *good-natured country squire*.[49]

This does not just apply to writers: artists too had better not be caught numbering the streaks of the tulip! So, for example, Reynolds maintains that the highest painter, 'like the philosopher, will consider nature in the abstract, and represent in every one of his figures the character of its species'. (*Discourse III*, 1770)[50] Reynolds would have appreciated Robert Moore's perceptive observation that in his work a 'strongly delineated individual is translated into the representation of a type without losing any of his individuality'.[51]

Such a view of character makes life considerably easier for the professional portrait painter. During three or four sessions of an hour each how could they ever learn much about what we might call the 'psychology' of their sitters? But their 'character', in the eighteenth-century sense, this is something much easier. It might be drawn from a prior knowledge of their age, profession and status or even some slight acquaintance. Failing this, the first sitting could then yield a taste of their conversation, manners and inclinations.[52] During the completion of the portrait the artist may discover many details of feature and minor tricks of expression, which will bring out the likeness but not alter the sum of the general character.

This conception of character also makes life somewhat easier, or at least more rewarding, for the modern viewer of eighteenth-century portraiture. To read character in the Forsterian sense pre-supposes much prior knowledge. The painter must know the sitter, as must we, if we are to assess the justice of the psychological likeness. This may be possible with a handful of Reynolds' friends – Garrick, Goldsmith or Dr Johnson. Even then Reynolds' *Dr Johnson* is going to be something quite different from Boswell's. This Reynolds himself admits when he prefaces his own *written* descriptions of Johnson by saying, 'the habits of my profession unluckily extend to the consideration of so much only of character as lies on the surface, and is expressed in the lineaments of the countenance'.[53] If this is the case with the intimately-known Dr Johnson, what of Lady Sarah Bunbury, about whom we know not much more than that she liked to play cricket and eat beefsteaks? If the eighteenth-century portraitist is painting the species, then particular details of this kind are less relevant: the elucidation of the portrait lies with ideas and ideals of the period, which can be found, overtly or otherwise, in novels, plays, essays and casual correspondence. These may be more illuminating than what one actually knows of the individual sitter. The meaning of a female portrait is more likely to be understood through contemporary ideals of chastity, for example, than through the discovery that a particular sitter turned out a few years after the sitting to be a notorious adulteress.

During the Romantic movement the single-quality characters of the eighteenth century came to be despised as lacking in depth and humanity. So Northcote complains that 'Fielding has oftener described *habits* than *character*' and that his Squire Western in *Tom Jones* is 'merely the language, manners, and pursuits of the country-squire of that day'.[54] The changing attitudes can be seen most strikingly contrasted in William Blake's anotations to Reynolds' *Discourses*. In his *Fifth Discourse* of 1772 Reynolds warned that a 'romantick imagination' had led critics to find impossible subleties of contrary expression in works of art. In his view, students should not allow themselves to be non-plussed by this literary convention. In their own works they should stick to *one* dominant characteristic. This was to follow the practice of the ancients who, though they supposed Jupiter to possess all the characteristics of the subordinate deities, nontheless 'confined his character to majesty alone'. Blake is furious at the passage. 'False!' he roars, 'The Ancients were chiefly attentive to Complicated & Minute Discrimination of Character; it is the whole of Art.'[55] Reynolds' idea of character may seem limited, but it is flexible and effective: it can express general ideas, as well as particular traits, and can do so with the confidence of being understood. Blake's conception brought about the decline of portraiture, for with the best of intentions one complicated & minute discrimination of character ends up looking much like another.

CHAPTER 3

HEROES IN A PAINTED FIELD

'Pictures too like, the ladies will not please;
They must be drawn too here, like goddesses.
You, as at Lely's too, would truncheon wield,
And look like heroes in a painted field;'

William Wycherley,
Prologue to *The Plain Dealer*, 1676.

'THE GREAT, AND CHIEF ENDS OF PAINTING', RICHARDSON WROTE in 1719, 'are to Raise, and Improve Nature, and to Communicate Ideas; not only Those which we may receive Otherwise, but Such as without this Art could not possibly be Communicated.'[1] How is this communicating done? The usual answer to this question in the eighteenth century, in any other country but Britain, would be by *allegory*. Allegory was a species of hyroglyphic; an international visual language, to be understood with the help of 'dictionaries', like Cesare Ripa's celebrated and wildly popular *Iconologia* (first published in Rome in 1593 and translated into English in 1709) (*FIG.* 12). Its potential for portraiture can easily be guessed. The Dutch theorist and painter Gerard de Lairesse recommended, for example, that emblematic figures should accompany every sitter: one of Justice with a Burgomeister, Mars or Hercules with a General, and Arion on a Dolphin with the Director of a Marine Insurance Company.[2]

Hercules is one of the companions for a General in a Kneller sketch for the commemoration of the Duke of Marlborough's Victory at Ramillies in 1706 (*FIG.* 11), which gives some idea of the language of allegory in operation. It is to be 'read' as follows: the Duke brandishes a baton of command and manages a rearing horse, which threatens to trample upon a *Dog of War* and *Discord*, both fawning and cowering in despair, and upon a sun-shield, the emblem of Louis XIV. Behind the horse *Flanders*, with some cast-off manacles, gratefully offers up to the Duke a model of her fortress, which burns in the background; *Hercules*, looking up admiringly, carries the keys. Ahead of the Duke's horse the sun rises and the smoke

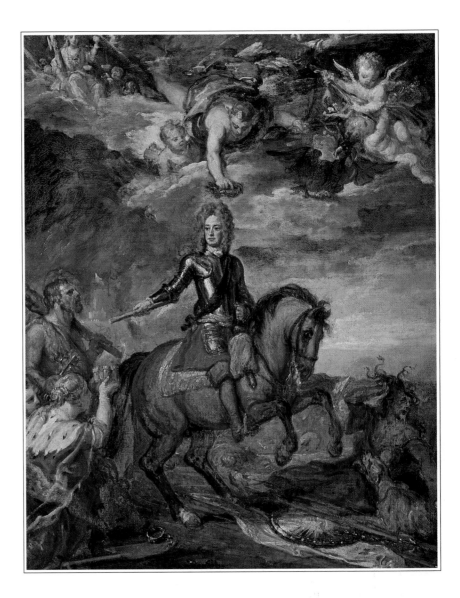

Fig. 11
KNELLER
*Triumph of the Duke of
Marlborough* 1706
NATIONAL PORTRAIT GALLERY,
LONDON

and thunder-clouds gradually clear. In the sky *Justice* sits; *Fame* blows her trumpet; *Mercury* plunges down to crown the Duke with a laurel wreath; *Jupiter's* eagle looks on, and a winged *Cupid*, with British sympathies, wrests the palm of Victory from a wingless Francophile.

There is every evidence that the British of the eighteenth century found this kind of allegory as silly as we do. 'Ah! shun insidious Allegory's snare!' William Hayley begs his favourite, Romney, in 1788, advice with which most would concur.[3] The problem with an allegorical figure is that it is an empty shade with a visiting-card, or, as Horace Walpole put it, 'a poor decomposition of human nature, whence a single quality is separated and erected into a kind of half deity, and then to be rendered intelligible, is forced to have its name written by the accompanyment of symbols'. 'How much more genius', he goes on, 'is there in expressing the passions of the soul in the lineaments of the countenance!'[4]

Mythological figures have slightly more reality than allegorical ones,

34

in that they were once at least *believed* to exist. In practice, however, Classical theology has very little to do with their rôle in Baroque portraiture, which is essentially allegorical: Hercules appears not because his labours took him to Ramillies, but because he symbolises *Heroic Virtue* (see *FIG.* 12). Furthermore the combination of mythological with real figures threatens a hornet's nest of anachronisms and unintentional absurdities. Addison, in *The Spectator* no. 523 of 1712, laments that a great man could not be celebrated without mixing a 'parcel of School-boy Tales with the Recital of his Actions . . . To make Prince *Eugene* a Favourite of *Mars*, or to carry on a correspondence between *Bellona* and the Marshal *De Villars*, would be downright Puerility, and unpardonable in a Poet that is past Sixteen . . . In short, I expect that no Pagan Agent shall be introduced, or any fact related, that a man cannot give Credit to with a good Conscience.'[5] A correspondent to *The Connoisseur* in 1755 points out that 'if Socrates . . . be admitted to Westminster Abbey, he would be induced to fancy himself in a Pantheon of the heathen gods (see *FIG.* 13). The modern taste (not content with introducing Roman temples into our churches, and representing the Virtues under allegorical images) has ransacked all the fabulous accounts of the heathen theology to strike out new embellishments for our Christian monuments.'[6]

Mention of Westminster Abbey and Addison's phrase 'a good Conscience' may point to a further unacknowledged reason for this distrust: namely that allegory and mythologised portraiture thrive in foreign, especially Roman Catholic, countries.[7] To the Protestant Briton it seemed yet another example of continental bombast and superstitious credulity. This is certainly the impression given in Rowlandson's *Place des Victoires, Paris* (1783) (*FIG.* 14), by the man gazing, in transports of idolatrous patriotic zeal, at the statue of Louis XIV. The statue, a superb parody of the allegorical triumph in art, is as absurd as its worshipper: the helpless frenzy of *Envy*, with his handful of snakes, is an unwarranted reaction to a light prod in the stomach, while Louis' self-satisfaction and his effete Roman mini-skirt are both, in some indefinable way, unheroic.

Rowlandson's watercolour also illustrates the general point that it is not just in the matter of allegory that British art shows signs of Francophobia. It is perhaps a feature of all cultures that artists define themselves with reference to a rival, but especially so in British eighteenth-century relations with 'the old enemy'. Towards the end of the previous century the France of Louis XIV was, undisputedly, the dominant cultural and military power in Europe. This military supremacy was ended by the campaigns of the Duke of Marlborough in the War of the Spanish Succession (1703-14), and especially by the battle of Blenheim in 1704. For the next hundred years Britain was frequently at war with France: the Seven Years' War, fought mainly at sea or in colonial territories (1756-63); the

Fig. 12
'Heroic Virtue'
from the *Iconologia*
of Cesare Ripa, 1709
CAMBRIDGE UNIVERSITY LIBRARY

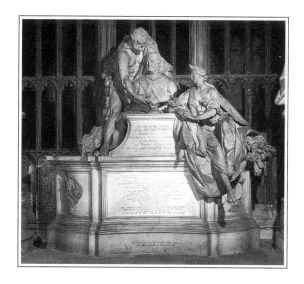

Fig. 13
ROUBILIAC
Monument to Admiral Sir Peter Warren
WESTMINSTER ABBEY

Fig. 14
ROWLANDSON
Place des Victoires, Paris 1783
THE SUTTON PLACE
FOUNDATION

years when the French joined in the American War of Independence (1777-82); the Wars of Revolution (1793-1802), and the Napoleonic Wars (1803-15). The principal invasion scares occurred in 1759, 1779 and 1797. So the majority of *sitters* in this chapter were engaged in fighting the French; whether the majority of *artists* consciously adopted an un-French style of painting is a more difficult question. It is certainly true that the reaction against the Baroque, a movement which would now be called *Artists-Against-Louis XIV*, did not take place until the mid-1720s, a decade after his death. By this time there was a similar reaction in France (though leading in a very different direction), so the issue is not altogether nationalistic. On the other hand, however, British art at the height of the Seven Years' War was slavishly French. In all essentials Kneller's sketch commemorating a British victory could be distinguished from an equivalent French work only by its inferior quality.

One artist who wore his national prejudice with pride was William Hogarth, who even adopted the pseudonym 'Britophil' to sign essays in favour of British art. He launches an attack on Frenchness and mythological-portraiture in his *Marriage à la Mode* of 1743-5 (*FIG.* 15). Hanging on the wall in Scene One, alongside Catholic scenes of martyrdom, there is a portrait of the vain spendthrift Lord Squanderfield in battle as Jupiter. This portrait appears, in a contemporary's words, to 'be designed as a ridicule on the unmeaning flutter of *French* portraits, some of which (particularly those of *Louis XIV*) are painted in a style of extravagance equal

36

at least to the present parody by *Hogarth*'.[8] This flutter, Hogarth im-
agines, must be caused by a wind of some kind, so he includes a cluster of
'Zephirs' – puffing cherub heads – in the top corner, but they blow in the
wrong direction. Below is a cannon recently discharged, positioned so
close to the figure's midriff as to imply some compliment to my Lord's
potency. In his left hand Lord Squanderfield holds Jupiter's thunderbolts,
conventionally shown in art as a handful of zig-zag arrows.

Allan Ramsay's contemporary (and perfectly serious) portrait of
Charles, Baron Cathcart (1740) (*FIG.* 20), is in many ways remarkably
similar to Hogarth's parody. Both have features appropriate to the mili-
tary scene: an imposing figure, taking up as much of the picture area as
possible, and a fluttering cloak billowing out in the storm of battle. In
both paintings there is a contrast between the general darkness and
isolated areas of light – flashes reflecting off the armour like fireworks,
highlights coursing across the drapery like jumping sparks. As in a poet's
epic simile, war is here likened to a thunder-storm, with dark clouds and
flashes of lightning. In this way Ramsay *implies* what in Hogarth's parody
is stated – that the figure should be identified as Jupiter. Even the cross-
ing-over of highlights under Lord Cathcart's brooch reminds the viewer
of Jupiter's hand-held thunderbolts.

Fig. 15
HOGARTH
Marriage à la Mode, Scene 1 1743
REPRODUCED BY COURTESY OF
THE TRUSTEES, THE NATIONAL
GALLERY, LONDON

These effects are helped along by the use of armour – an obviously anachronistic battle-dress in the eighteenth century. Its persistence in portraiture seems intended to suggest the antiquity of the lineage of the wearer: below his portrait in *Marriage à la Mode*, Lord Squanderfield points to his family tree, the trunk of which grows out of the armour-plated bowels of William the Conqueror. When looking at the *eighth* Baron Cathcart we are reminded by his armour that the first *five* or so barons would have gone on the rampage so clad.

Lord Cathcart is characteristic of a tradition of British military portraits, one which Reynolds takes over and revolutionises in his *Captain Robert Orme* of 1756 (*FIG. 16*). The image of war as a storm is here made more palpable: the deeper blackness in the sky is an amalgam of storm clouds and smoke, belching up from the field of battle in the background. Sunlight breaks through dramatically, like the flash of gunpowder. Captain Orme's face takes its colour from his tempestuous surroundings: the right side is in shadow, like the sky behind, but the left is bright and 'over-exposed', as if the light beside it were too dazzling for us to make out details, such as the line round his nose.[9] Allowing the face to 'soak up' the dramatic atmosphere around it is an old Rubens device, which suggests that the hero is 'in his element' in the midst of fire, storms and blinding explosions. In the same way Lawrence, in his *Duke of Wellington* of c.1815 (*FIG. 3*), plants two brilliantly shining round highlights in the Duke's eyes, as if he were staring at the blaze of battle, with a keen and imperturbable scrutiny.

The juxtaposition of these two portraits draws attention to the now forgotten science (or pseudo-science) of physiognomy, by which a person's character is read in his face. Again, Addison may be left to explain the matter in his own words:

> *I have seen a very ingenious Author on the Subject [of physiognomy], who founds his Speculations on the Supposition, That as a Man hath in the Mould of his Face a remote Likeness to that of an Ox, a Sheep, a Lyon, an Hog, or any other Creature; he hath the same Resemblance in the Frame of his Mind* . . . I remember in the Life of the famous Prince of Conde the Writer observes, the Face of that Prince was like the Face of an Eagle, and that the Prince was very well pleased to be told so . . . when his Courtiers told him . . [this], he understood them in the same Manner as if they had told him, there was something in his Looks which shewed him to be strong, active, piercing, and of a royal Descent.'*
>
> *The Spectator*, no. 86, 1711.

Courtly portrait-painters can thus not only *tell* their sitters that they are 'strong' or 'piercing', but, through physiognomy, they have also the means to *paint* it. This is exactly what Reynolds has done with his *Captain Orme* and Lawrence with his 'piercing' *Duke of Wellington*, staring at the battle as an eagle is supposed to be able to stare at the sun. Both figures have an eagle's low, sloping shoulders, long neck and face, high-arched brows, staring eyes and deep eye-sockets.[10] The chief human aquiline characteristic is, of course, a long nose, and Nature had provided one in

Fig. 16
REYNOLDS
Captain Robert Orme 1756
REPRODUCED BY COURTESY OF
THE TRUSTEES, THE NATIONAL
GALLERY, LONDON

*Addison is probably thinking of della Porta (*FIG. 17*).

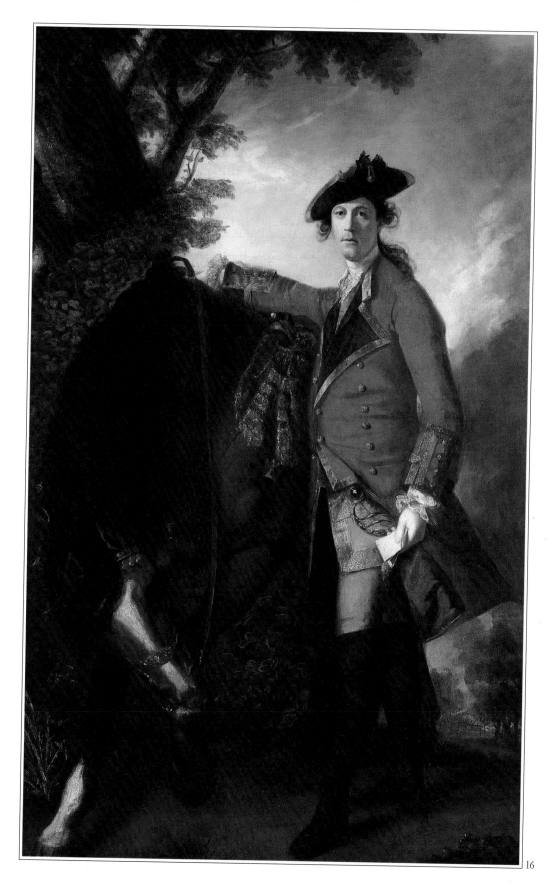

16

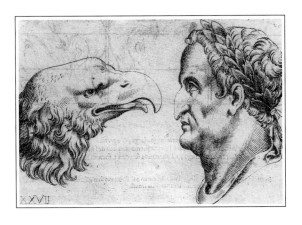

Fig. 17
GIAMBATTISTA DELLA
PORTA, plate from
Della fisonomia dell'huomo 1598
CAMBRIDGE UNIVERSITY LIBRARY

Fig. 18
KNELLER
Captain Thomas Lucy 1680
THE NATIONAL TRUST,
CHARLCOTE PARK

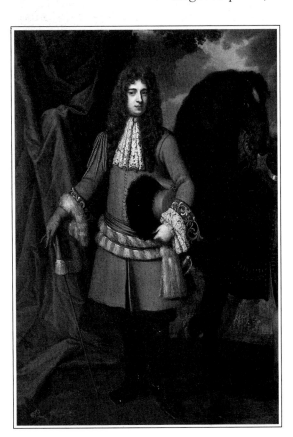

both these cases – Wellington was commonly referred to as 'Old Nosey'. Under Orme's nose Reynolds has placed a lifting and projecting upper lip, curling like the beak of a bird of prey.

A few years after Reynolds' *Captain Orme*, in 1759, Horace Walpole writes of Reynolds that he 'is bold and has a kind of tempestuous colouring; yet with dignity and grace'.[11] The 'tempestuous colouring' is obvious here; to make sure of his 'dignity and grace' Reynolds employs an old formula of full-length military portraiture, exemplified by Kneller's *Captain Thomas Lucy* of 1680 (*FIG.* 18). In examples of this kind a captain stands before us with a gentlemanly ease and assurance, while a servant holds his horse, and a parade (or sometimes a battle) goes on behind. To understand such an image one has to remember that the most constantly mentioned characteristic of the soldier in eighteenth-century Britain is not courage, or technical skills such as the ability to judge distances, but good manners. Boswell admitted that 'my great plan of getting into the Guards was not so much to be a soldier as to be in the genteel character of a gentleman'. (*Journals*, 25 January 1763) Mary Wollstonecraft contemptuously likens soldiers to women, for 'the business of their lives is gallantry; they were taught to please, and they only live to please'.[12]

The formula in Reynolds' portrait is slightly different from Kneller's. Captain Orme stands before us, not hat-off to be introduced or to have his portrait painted, but ready to deliver some vital dispatch to his commanding officer, who waits just where we, the viewers, stand. This means that the battle is not a separate backdrop but an integral part of the action: the captain will return to the fray as soon as he has understood his latest instructions. Captain Orme has not forgotten his good manners, it is simply that his gentlemanly ease and assurance now make a thrilling demonstration of *sang froid*.

Orme's uniform has an unnatural stiffness, an effect found in many subsequent military portraits and arising from Reynolds' idea that 'grandeur is composed of straight lines'.[13] Here 'grandeur' is composed of *Captain Orme's* taut outlines, particularly the almost rigidly straight line of coat edge running down between the figure and the horse. An element of eighteenth-century uniform that helped compensate for the absence of picturesque armour was brocade, with its hard glinting metal threads. Though

ineffectual against musket shot, these threads were almost as good as armour for the painter seeking effects of splintered highlight. Captain Orme wades knee-deep in engulfing shadows, but his brocade flashes like lightning. Though restricted to small areas, these highlights are of thick, tangible oil paint – sharp, intricate and ribbed – as if real gold thread had been stitched onto the canvas, an effect Reynolds learned from Rembrandt. Orme's coat edges seem to stand proud of the surface, almost as if the canvas had been slashed and the sides of the wound had curled outwards. It conforms to Reynolds' view that a figure should appear 'sharp and cutting against its ground . . . in order to give firmness and distinctness to the work'.[14]

The advice, quoted above, occurs in a Reynolds footnote to a poem called *The Art of Painting*, originally written by Charles du Fresnoy and translated into English by William Mason. A passage in the poem reads:

> *Fair in the front, in all the blaze of light,*
> *The Hero of thy piece should meet the sight,*
> *Supreme in beauty; lavish here thine art,*
> *And bid him boldly from the canvas start;*[15]

Fig. 19
REYNOLDS
Colonel John Hayes St Leger 1778
THE NATIONAL TRUST,
WADDESDON MANOR

As the word 'bold' suggests, this dashing conspicuousness is a military as well as an artistic virtue. To be conspicuous on a battle-field helps your subordinates to see you; it is also, in an obvious way, unwise and therefore heroic.

It is interesting to compare the intricacies of *Captain Orme* (*FIG.* 16) with the very similar but more succinct effects in Reynolds' later *Colonel John Hayes St Leger* (1778) (*FIG.* 19). Both figures cut a dash against the background, like a hero's red coat in the thickest hurly-burly, but in the former it is by fragmented contrasts of light and dark, and in the latter by broadly massed contrasts of colour. *Colonel St Leger* is made up of clean blocks of bright light and brilliant red. There are areas – on the legs, waistcoat and sword-strap – where not the slightest variation of colour or texture is detectable. Throughout, the paint is marble smooth and flat (though thick), as if it had been spread down evenly, like plaster with a trowel. The edges are sliced trim, all giving the figure a spit-and-polish parade-ground gloss. The dapper St Leger (who was thought by some to be all 'coxcombry and insolent hauteur') reminds us of the military fop, Colonel Sweetpouder, in Brooke's *The Fool of Quality* who 'never had the rudeness to attack his enemy, without white gloves'.[16]

In contrast to Ramsay's *Baron Cathcart* (*FIG.* 20) one can see how Reynolds' later 'combat

Fig. 20
RAMSAY
Charles, 8th Baron Cathcart 1740
PRIVATE COLLECTION

portrait' requires a vastly simplified treatment of the face. In the midst of the action we do not have the leisure to contemplate the minutiae of highlights, folds and bone-structure that Ramsay provides. St Leger's face is daringly turned away, so that the actual features only just articulate the edges of a smooth, unvarying mass of light on the cheek and forehead. There seems to be no more detail than could be smeared in a hurry with the flat of the thumb. According to Reynolds, if a portrait painter 'is desirous to raise and improve his subject' one of the things he can do is to leave out 'all the minute breaks and peculiarities in the face'. (*Discourse IV*, 1771)[17] In addition to generalising the sitter, this device effectively re-educates the viewer. Those expecting *mere* portraiture, who therefore scarcely bother to look further than the face, find themselves subtly short-changed, and are thus obliged to look at the rest of the figure and at the background. In this way they come to read the painting as a *whole*, as they would a history painting.

In the same year that Reynolds worked on *Captain Orme* (1757) (*FIG.* 16) his friend Edmund Burke published his *Philosophical Enquiry into the Origin of our Ideas of the Sublime and Beautiful.* It is clear that the ideas expressed therein were very close to Reynolds' own; the book appears on the table in Angelica Kauffmann's portrait of him (1767), and it is even possible that Burke consulted Reynolds during its composition.

Burke examines the agreeable *frisson* that may be gained by contemplating objects of terror; this he calls 'the sublime'. The military portrait clearly fits the bill: the sitter is in danger, and we experience a pleasing terror in witnessing the scene at a safe distance. We have already seen Reynolds heightening the sublimity by bringing the conflict forward, so that it is no longer seen through the wrong end of a telescope. But Burke goes on to list many other subsiduary qualities – darkness, power, obscurity – which, if the imagination dwells on them, also terrify and which are therefore also sublime. These things Reynolds studiedly introduced into military portraiture. We have already seen his use of *Darkness* (see Burke's Part II, Section VI). *Power* we find in Orme's bucking charger – Burke actually quotes, as an example of this form of sublimity, the Book of Job's description of a war-horse which could well apply here:

> *whose neck is clothed with thunder, the glory of whose nostrils is terrible, who swalloweth the ground with fierceness and rage.*
>
> 1759 edition, Part II, Section V.

However, the most significant vehicle of the sublime for portraiture is *Obscurity*, dealt with in Part II, Sections III, IV and V. Burke maintains that 'in painting a judicious obscurity in some things contributes to the effect of the picture', because 'dark, confused, uncertain images have a greater power on the fancy to form the grander passions than those which are more clear and determinate'. The same idea is expressed in a pictorial analogy when Burke discusses Milton's famously obscure description of Death: 'it is astonishing with what a gloomy pomp, with what a significant and expressive uncertainty of strokes and colouring he has finished the portrait of the king of terrors.'

Reynolds took this advice to heart in all his military portraits, but the 'expressive uncertainty of strokes' in the background of *Colonel Morgan* of 1787 (*FIG.* 21) is especially striking. The neatly painted, serried ranks of troops, which we expect, have here been replaced by a single spectral and apocalyptic horseman, drowning in a vaporous sea.

The 1798 portrait of the Prince of Wales by Sir William Beechey (*FIG.* 22) comes close to beating Reynolds and Burke at their own game. The brocade, painted with a hard

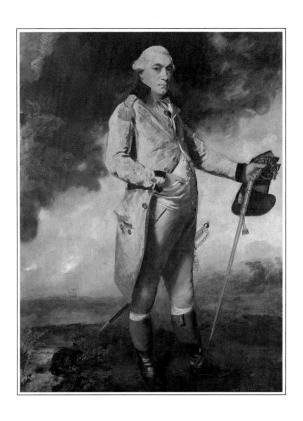

Fig. 21
REYNOLDS
Colonel George Morgan 1787
NATIONAL MUSEUM OF WALES,
CARDIFF

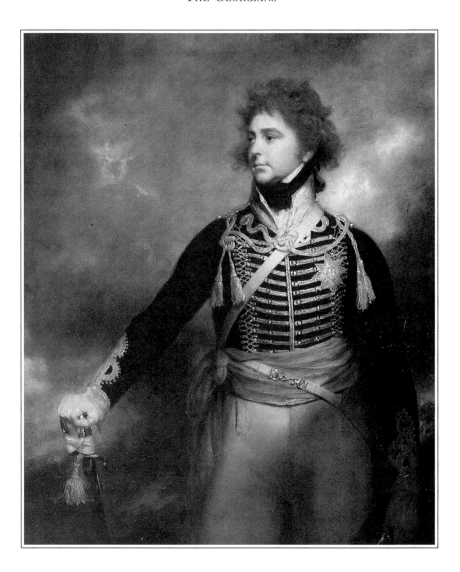

Fig. 22
SIR WILLIAM BEECHEY
Prince of Wales 1798
ROYAL ACADEMY OF ARTS

Rembrandtesque crust, resembles a breastplate, catching the light. This
tangible precision only makes its effect because of the sublime *imprecision*
of the surrounding atmosphere – an element as difficult to define as Mil-
ton's chaos. It is not just that one cannot see clearly; one cannot imagine
the *feel* of the substance all around. It seems to be an amalgam of earth,
smoke, clouds and sky, too palpable for cloud, too nebulous for earth, in
one part fumblingly evocative of distance, elsewhere seeming to cast a
shadow onto the Prince from in front, and to spill out into the room,
choking the viewer with acrid fumes.

An obvious difference between Beechey's *Prince* and Reynolds' *Colonel
Morgan* is that in the latter there is a free, exposed-looking scrubbing of
paint, not just on the background but also on the figure. It was generally
believed in the eighteenth century that the brushwork in a painting could
mirror its subject. Jonathan Richardson writes in 1715, 'Generally if the
Character of the Picture is Greatness, Terrible, or Savage, as Battels,
Robberies, Witchcrafts, Apparitions, or even the Portraits of Men of such

Characters there ought to be employ'd a Rough, Bold Pencil [paint-brush].'[18] According to this view, the touch of the brush can convey a mood or an atmosphere, a medium through which a figure or event is perceived. Richardson's use of the word 'bold' is not accidental either. It was common to draw an analogy between a 'bold' method of painting and a bold or courageous sitter. Steele writes in *The Spectator* no. 244 of 1711 that men mistake a 'wild extravagant Pencil for one that is truly bold and great' in the same way that they mistake 'an impudent Fellow for a Man of true Courage and Bravery'. It may seem far-fetched to us today that a style of painting could suggest a characteristic, but it was widely accepted in the eighteenth century. In Gibbon's words, 'style is the image of character'. (*Memoirs of my Life, Introduction*)

In addition to looking bold, Reynolds' handling makes Colonel Morgan look somewhat rough-and-ready. Strictly speaking he is in the wrong service for this characteristic, for the idea of a rough *sailor* was a commonplace, but not a rough soldier. The tars took great pride in the contrast between their manly scruffiness and the 'frippery French'. Reynolds may have borrowed it as a generally *British* military trait. There was a feeling that a military image should not be inappropriately 'smartened-up', as when Addison wrote: 'Sir *Cloudesley Shovel's* Monument [in Westminster Abbey] has very often given me great Offence: Instead of the brave rough *English* Admiral, which was the distinguishing Character of that plain gallant Man, he is represented on his Tomb by the Figure of a Beau, dress'd up in a long Perriwig, and reposing himself upon Velvet Cushions under a Canopy of state.' (*The Spectator*, no. 26, 1711) Reynolds wishes here to convey the virtues that might be suggested by the phrase 'plain rough *English* colonel', and yet allow us, looking 'through' his technique, to see polished boots, a gleaming cane and a very smart-looking uniform.

Probably the first thing that strikes the viewer in front of this portrait is that Colonel Morgan looks cross. His brows slope inwards, shading his eyes, his lips pout, and the corners of his mouth are drawn down. A visitor to the 1761 Society of Artists exhibition wrote of *Captain Orme* (*FIG.* 16) that he was 'ready to mount his horse with all that fire mixed with *rage* that war and the love of his country can give' (my italics).[19] If the portrait of Captain Orme expresses a becoming patriotic rage, how much more does that of Colonel Morgan (*FIG.* 21). We tend to think of the business of organised fighting as being too impersonal to admit of emotions such as anger, yet in eighteenth century writing one frequently encounters phrases such as 'frowning with just wrath', 'heroic rage' or 'martial indignation'. This is a controlled, righteous form of anger, but anger nonetheless. Even if contemporary viewers didn't have this rather literal-minded conception of real battle-field emotions, they would find it appropriate in a work of art, as a metaphorical attribute of a warrior. Of another Reynolds warrior portrait the poet William Combe wrote:

> *A deep and solemn look he wore,*
> *As if attentive to explore*
> *Some dark design of* Briton's *Foe,*
> *How to prevent th'approaching blow;*[20]

45

23

Many a guilty foreigner has twitched nervously in front of *Colonel Morgan*!

Seen in this more symbolic or abstract light, one begins to see Colonel Morgan not so much as a participant in warfare, but as a personification of it. As he towers over us, the clouds of black smoke disgorged into the sky seem pointedly to mass themselves behind his frown, like an angry, negative halo around his head. It is as if his fury had gathered them. This immediately reminds the viewer of the power over nature of the classical divinities, of Aeolus, Neptune or Zeus the 'cloud-bearer'.

This type of semi-personification would be quite familiar to an eighteenth-century audience from poetry. Consider, for example, Edmund Waller's description of the Duke of York, Admiral of the Fleet in the Dutch Wars:

> *The Dutch, accustomed to the raging sea,*
> *And in black storms the frowns of heaven to see,*
> *Never met tempest which more urged their fears,*
> *Than that which in the Prince's look appears.*
> *Fierce, goodly, young! Mars he resembles, when*
> *Jove sends him down to scourge perfidious man.*
> *Instructions to a Painter,* ll. 205-10.

Very similar ideas are expressed for the benefit of the Senior Service in Reynolds' *Admiral Viscount Keppel* of 1780 (*FIG.* 23), a year after the second major invasion-scare and the sitter's own triumphant acquittal on a charge of cowardice. Here Reynolds' old friend stands on some cliffs facing out to sea, his body making an imposing, rounded mass, uniformly dark against the streak of sunset. He appears somewhat as William Hayley had described him in the previous year:

> *O ye! our Island's Pride! and Nature's boast!*
> *Whose peerless valour guards and gilds our coast.*
> *Epistle to Admiral Keppel,* 1779.[21]

He too seems resolute and almost comically bad-tempered: his eyebrows jut forward in a luxuriant hedgerow-frown, his upper lip overhangs and the sides of his mouth are drawn down. Reynolds' source for this flirtation with the grotesque is the face of Neptune in Bernini's *Neptune and Triton* (*FIG.* 24), a cast of which was owned by the Royal Academy and which Reynolds himself sketched.[22] A dense sky of deep blue swirls and collects around Keppel's head, as if awaiting orders. Only change his sword for a trident and this is Neptune personified.

Just because they ridiculed overt allegory and mythology, it does not follow that eighteenth-century audiences despised all symbolic content as such. William Melmoth, for example, considers mythologies quite

47

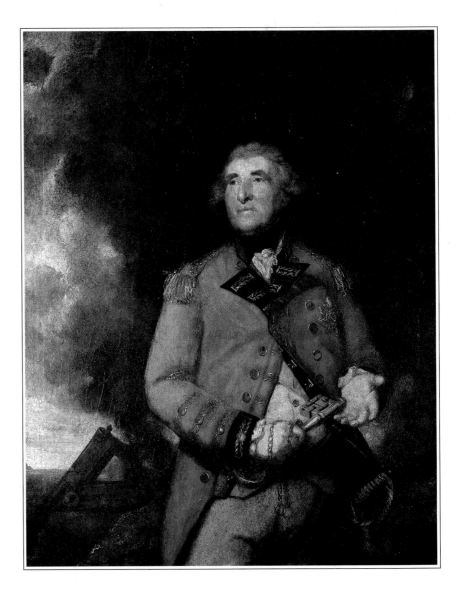

acceptable if they make their appearance not 'in person or as agents' but (as in these paintings and the Waller poem) 'to enter only in simile, or allusion'.[23] Writers also prefer their visual alertness to be flattered. Shaftesbury, for example, in 1713 asks whether the figure of *Virtue* in *The Choice of Hercules* should be given the attributes of Minerva, and concludes: 'though . . . it would on no account be proper to have immediate recourse to the way of emblem; one might, on this occasion, endeavour nevertheless by some artifice, to give our figure, as much as possible, the resemblance of the same goddess'.[24] Similarly, in Horace Walpole's view, artists were more to be commended for making themselves understood by 'wit' than by 'symbol', where 'wit' means that cunning by which ordinary objects can acquire a special significance,[25] a cunning which must be matched by the viewer. It is by what Shaftesbury would call 'some artifice', and Walpole 'wit', that we think of Neptune in front of *Admiral Keppel*.

Walpole's idea of 'wit' is best demonstrated by Reynolds' 1787 portrait of a great hero of the day, Lord Heathfield (*FIG.* 25), who as Governor of Gibraltar defended the rock against a Spanish siege lasting from 1779-83. In his hands he holds a massive key, the emblem of Gibraltar and an appropriate symbol for someone who has held a fortress against attack. A chain attached to the key is firmly wrapped around Heathfield's hand, while he holds its shaft in a fist-like grip and taps his other hand with it deliberately, in contemptuous dismissal of those trying to steal it from him. Behind him, seen through the usual configuration of smoke, is the rock itself, with a tipped-up cannon pointing towards the besiegers. A key is also the attribute of St Peter, who was so named by Christ because he was the *rock* (*petros*) upon which the Church was built. In Reynolds' portrait Lord Heathfield has become St Peter, the rock upon which Britannia builds her Mediterranean interests.[26]

Even more than in previous examples, if the audience shies away from this simple iconographic puzzle much of the humour is lost, especially in the witty appropriateness of Lord Heathfield's expression, with his face turned up and away, towards a heavenly light, with drooping eyebrows and glistening eyes, like a rough-and-radiant old Rembrandt saint (compare *FIG.* 51).

Reynolds here paints ironically: he does not seriously mean us to take this gruff old soldier for St Peter. Irony, though common in literature, is exceedingly rare in painting. When painted irony *is* detected, the viewer tends to suppose that because what is meant is different from what is being said, it must therefore mean the downright *opposite* – in other words that *Lord Heathfield* is a mock-heroic. This is, of course, unthinkable. In fact literature and daily usage accustom us to hearing things which are not literally or even seriously meant, but where something approximating to the literal meaning is intended. So one could imagine the translation of this image into the language of the period as: 'The Governor, like a *British* St Peter, clasps his *Keys* and surveys his *Rock* . . .', a sentence which one readily apprehends is neither fully serious, nor actually mocking.[27] Lord Heathfield's wistful, absent-minded expression also reminds the viewer of what, in the eighteenth century, would be called the warrior's 'sacred love of his country'.

Patriotism and warfare are habitually described in the period in quasi-religious terms. William Hayley could almost be said to take the Trinity's British sympathies for granted:

> *Thou! God of Hosts! whose sacred breath imparts*
> *Valour's unclouded flame to British hearts;*
> > *Epistle to Admiral Keppel,* 1779.

Similarly the poet Thomas Tickell describes an imaginary national shrine where there were buried (with, he implies, equal honours):

> *Stern patriots, who for sacred freedom stood;*
> *Just men, by whom impartial laws were given;*
> *And saints, who taught, and led, the way to heaven.*
> > *To the Earl of Warwick,*
> > *On the Death of Mr Addison,* II. 40-2.[28]

Such ideas find their clearest visual expression in Sir Thomas Lawrence's *John Philip Kemble as Coriolanus* of 1798 (*FIG. 26*).[29] This is strictly speaking a theatrical portrait, showing Kemble in a famous Shakespearian part. The simple explanation for the scene was given in the 1798 Royal Academy catalogue: after his banishment from Rome, the disguised Coriolanus arrives at the hearth of the Volscian, Tullius Aufidius, to offer his services to his country's worst enemy. Hence the fire in the background and the wrapped-around cloak. However, Lawrence has looked beyond this unedifying Shakespearian episode to the mythical hero of the burgeoning Roman republic, and to the idea of patriotism in general.

To do this he has used the now familiar conventions of the military portrait: the low viewpoint, swirling smoke and darkness, the light on and around the head, and finally the expression of formal anger and resolution. The fire and the monument in the background, though glimpsed through Burkian obscurity, do not look like a hearth; they look like the giant brazier in front of a Roman altar. According to Ripa's *Iconologia*, 'Love of Ones Country' is to be symbolised by a 'vigorous young Warriour, [usually shown in Roman armour,] standing upright, amidst Flame and Smoak, on which he looks with a resolute Countenance; [he] carries a Crown in each Hand, and being just upon the brink of a Precipice, yet marches courageously over Spears, and tramples upon naked Swords'.[30] Coriolanus carries no crown, since the plot would not admit of it, but the curls on his head are gelled out to look as if he is wearing one. Apart from the trampled weapons, all Ripa's other elements – the flame and smoke, the resolute countenance, the precipice – are present in this picture, although there is little justification for them in Shakespeare.

At the time this work was being painted William Pitt was attempting to patch a treaty with the French, after disastrous reversals in the Revolutionary Wars and with the century's third threat of invasion.[31] In this context, Lawrence's message is obvious: the British shouldn't be loitering at the enemy hearth, flirting with perfidious Volscians; they should be worshipping at the national shrine. Or, as William Hayley put it at an earlier moment of national crisis:

> *Let anger scorn the rancorous debate,*
> *The low and little jars of private hate,*
> *And noble sacrifice each selfish aim,*
> *On the bright Altar of Britannia's Fame*
> *Epistle to Admiral Keppel*, 1779.[32]

In this painting the light, the expression, and the altar-fire were there to remind contemporary viewers that it was not just Patriotism, but 'Sacred Patriotism' they were contemplating.

There is another device by which Coriolanus is made to seem an object of worship: his drapery, lighting and pose are so arranged that he resembles a *term*, an example of which is glimpsed in the background. A term is a single figure, whose form is half way between sculpture and architecture and often forms an altar to Pan, or some other pagan divinity. Below a fully-sculpted head, at the neck, shoulder or waist, the body turns into a pillar which tapers down to the ground. Coriolanus has

Fig. 26
LAWRENCE
John Philip Kemble as Coriolanus
1798
GUILDHALL ART GALLERY,
LONDON

26

exactly such a form. His lower half is made up of two tapering straight lines, the black cloak effectively concealing any details that might distinguish it as anatomy, rather than smooth architectural form. The simple, regularised rounding of the cloak at the neck similarly produces the 'architectural' shape of the top of a standard head-and-neck term.

Returning to Reynolds' *Admiral Keppel* (*FIG.* 23) with Lawrence's painting in mind, it is possible to see similar devices: a rounding-off of the outline, concealing anatomy (especially details like the hands) in drapery and blanketing shadow, suggesting a semi-sculptural, semi-architectural form. In the case of *Admiral Keppel* Reynolds chooses something more appropriate for a seaman, namely the figure-head of a ship.

Kemble as Coriolanus (*FIG.* 26) is invaluable for the interpretation of the military portrait, because, being a theatrical piece, or 'a sort of half-history picture' as Lawrence called it, he can let himself go, more than he could in a portrait commissioned by a real soldier.[33] It also draws attention to the fact that though patriotism was an unofficial cult in the eighteenth century, everyone knew that its originators and purest exponents were the ancient Romans. 'Well, are you to be an old Roman? a patriot?' Robert Walpole would ask troublesome politicians, 'You will soon come off of that and grow wiser.'[34] Letters to the papers on military subjects were often signed 'Britannicus', 'Scipio', 'Honestus', 'Historicus' or even 'Coriolanus alter' (another Coriolanus).[35] 'There are letters every day with Roman signatures,' complains Mrs Dangle in Sheridan's *The Critic* (1779), 'demonstrating the certainty of an invasion, and proving that the nation is utterly undone.' (Act I, scene 1)

Fig. 27
Apollo Belvedere
VATICAN MUSEUM

This is one part of a general consensus in the period that the British were the legitimate heirs of the Romans, especially those of the Republic. This is one of the resonances produced by the most frequently discussed device of military portraiture: the adoption of a pose from a heroic antique sculpture. For this resonance to be appreciated it is essential that the audience recognise that an antique borrowing has taken place, even if they cannot give chapter and verse. One antique sculpture that even a novice might recognise is the *Apollo Belvedere* (*FIG.* 27). Two celebrated portraits in the period, Ramsay's *Norman, Chief of MacLeod* of 1747 (*FIG.* 28) and Reynolds' *Commodore Augustus Keppel* of 1753-4 (*FIG.* 29) borrow their pose from this statue, as has been often noted.[36] The hallmark of the *Apollo's* pose is the extended *left* arm, originally holding a bow. As this weapon was obsolete, both derivations reverse the pose and make the emphatic limb the *right* arm, extended in a pointing, commanding gesture.

Fig. 28
RAMSAY
Norman, 22nd Chief of MacLeod
1747
MACLEOD OF MACLEOD
COLLECTION, DUNVEGAN CASTLE,
ISLE OF SKYE

Apart from this similarity, the two works could hardly be more different, the essential point being that Reynolds attempts to do justice to the classical, heroic and sculptural quality of the original, while Ramsay simply borrows the pose. The heroism of *Commodore Keppel* is of a type we have already seen in other Reynolds portraits. The portrait implies a narrative: Keppel was once wrecked off the Brittany coast, and here we

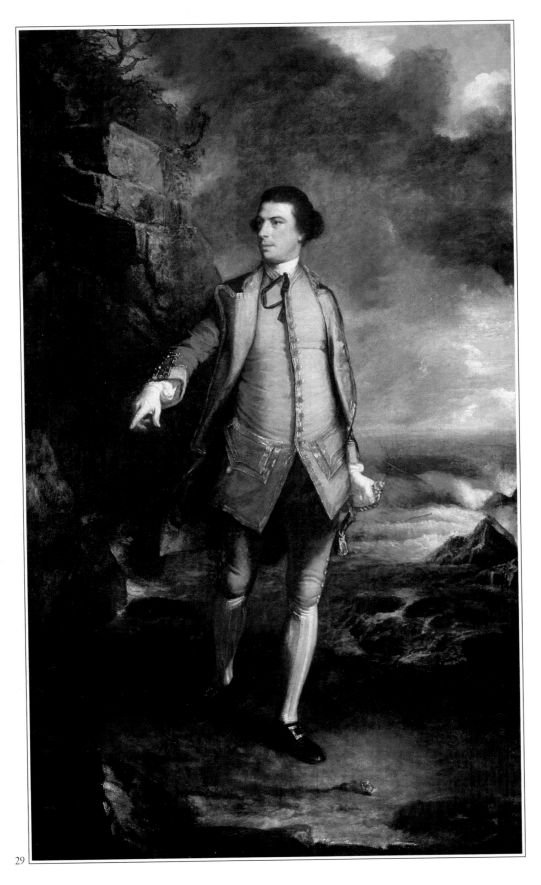

29

see fragments of wreckage in the background and the commodore rallying his men with admirable authority in the face of adversity. The stormy landscape is sublime: waves crash against rocks, the sky heaves and blackens and gaunt trees clutch at sheer crags.

While Ramsay allows light to shine through his figure, around the arm and between the legs, giving them a 'cut-out' appearance, Reynolds loses the contours on the left side, to clothe the figure in darkness.[37] His figure seems to thicken and expand into the background, while its distinctness is sporadically retrieved by glistening Rembrandt-style brocade. To use Reynolds' own words, it has 'that breadth of light and shadow, that art and management of uniting light to light, and shadow to shadow, so as to make the object rise out of the ground with that plenitude of effect so much admired in the works of Coreggio'. (*Discourse V, 1772*)[38]

Elsewhere in the *Discourses*, Reynolds argues that painting a figure so that you seem to be able to walk around it is a *mistake* because it militates against 'that fulness of manner which is so difficult to express in words, but which is found in perfection in the best works of Correggio, and we may add, of Rembrandt'. (*Discourse VIII, 1778*)[39] For this Rembrandt-like fullness it is paradoxically necessary that the figure should *sink into* the ground, as well as 'rising out of it', like the bulky figure of Commodore Keppel, half immersed in the background shadows, as if floating on a brackish stream – his garments, like Ophelia's, growing 'heavy with their drink'.

We have seen painterly qualities in *Commodore Keppel* which are obviously intended to match the heroic drama of the *Apollo Belvedere*; is there anything in it to suggest sculpture? At first sight the answer is firmly no: the stiff edges of the coat and waistcoat slice up the figure, with sharp straight lines and invading shadows. This is the very opposite of the rounded forms and smooth transitions of nude sculpture. What Reynolds may have intended with his *Commodore Keppel* is an echo of clothed Roman sculptures, such as the Vatican *Augustus Caesar* (FIG. 30).

This immediately broaches the problem of Roman dress. Its advantages in the intimation of antique virtue are obvious, but then so are its disadvantages: like the mythological portrait, it can look pompous and silly. One need only consider Rowlandson's *Place des Victoires* (FIG. 14). There is also the paradox, which Reynolds points out, that while 'we make no difficulty of dressing statues of modern heroes or senators in the fashion of the Roman armour or peaceful robe', the same is not true in painting; 'Indeed we could no more venture to paint a general officer in a Roman military habit, than we could make a statue in the present uniform.' (*Discourse VII, 1776*)[40] This situation invites a com-

promise whereby a figure is painted in 'present uniform', but with adjustments suggestive of a 'Roman military habit'. The drapery clasped over the shoulder in Ramsay's *Baron Cathcart* (*FIG.* 20) is an example. This is also how Reynolds absorbs the effect of an antique military sculpture – the *Augustus* – in his modern painted portrait. Keppel's coat – a hopelessly un-Roman garment – is blown open, and to a large extent concealed. His waistcoat, of uncertain grey-bronze colour, is wrapped taught round the chest and stomach, like a Roman breast-plate. A prominent fold along the top of the pockets detaches the lower half, which spreads like a Roman

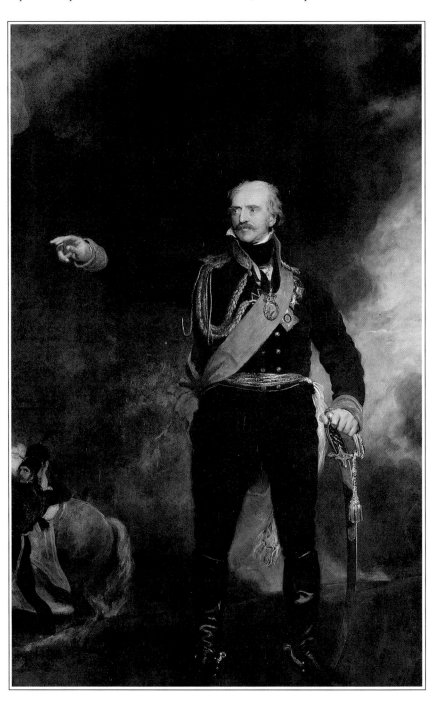

Fig. 31
LAWRENCE
Field Marshal von Blücher
1814
Reproduced by Gracious
Permission of Her Majesty the
Queen

skirt (such as the one seen under Augustus' swath of drapery). It is also from martial monuments like the *Augustus* that Reynolds derives Keppel's hugely expanded chest and stomach, carried on quite dainty legs. The idea of Keppel's pointing gesture of command may have come from this particular antiquity, a play on his Christian name – Augustus.

It is significant that Lawrence, Reynolds' undisputed heir in this field, uses exactly these two statues – the Vatican *Apollo* and *Augustus* – for his *Field Marshal von Blücher* (1814) (*FIG.* 31), the unpunctual victor of Waterloo. This work was painted for the greatest military pantheon of the period, the Waterloo Chamber at Windsor Castle, which displays portraits of the European potentates and Generals responsible for the overthrow of Napoleon. The pose of *Field Marshal von Blücher* is superficially similar to the *Apollo*, but is in fact derived from a reversal of the Vatican *Augustus*. Like his sculptural model, Lawrence has swelled his figure's trunk almost to a pillar; like Reynolds, he has detached and almost disembodied a pointing Michelangelesque hand, glowing against the dark.

Seeming to embody the qualities of a famous antique sculpture, seeking a Rembrandt-like 'plenitude', lighting a uniform to flash like a blade against the background: these are all ways of making a painted figure emphatic, conspicuous and grand. For heroes in art must seem superior to real men. As Reynolds explains, the painter 'cannot make his hero talk like a great man; he must make him look like one'. (*Discourse IV,* 1771)[41] The artist must also make his figure quite literally 'larger than life'. According to Lord Shaftesbury, a subject 'of the heroic kind' requires 'such figures as should appear above ordinary human stature'.[42]

There is one way in which painting is a flattering magnification-mirror which is so obvious that it is easy to overlook. Full-length portraits are life-size; that is to say the height of the painted image measures exactly that of the sitter. But the figure is usually shown *set back* a few paces, where they should strictly be perspectively diminished. Were the average military sitter to walk out of his frame he would be seven foot tall by the time he bounded down into the room. As Lairesse explained, this effect can naturally be accentuated by setting the figure especially far back.[43] This is Reynolds' way of correcting Nature in this 1753 portrait of the Commodore, popularly known as 'little Keppel' (*FIG.* 29).[44]

In Reynolds' *Colonel St Leger* (*FIG.* 19), we seem to see the figure from a low viewpoint, and one especially close to the picture surface, a principle explained by Reynolds himself.[45] We find ourselves looking steeply *down* on St Leger's boots and *up* at his head. This has the effect of accelerating the perspective and therefore exaggerating the stature of the figure. It also subtly distorts his anatomy: the upper half of the figure, especially the head, is made to taper like a scimitar, as if seen far up in the air. The thighs on the other hand, at eye level, are considerably enlarged. Their fullness, seen through clinging boots and breeches, suggests the rounded, polished marble thighs of the *Apollo Belvedere* (*FIG.* 27), the statue from which the pose of the whole figure is taken. Curiously, these same Apollonian thighs were the subject of much discussion in the period, being considered to be too long. Reynolds' view on the subject is given in 1780, two years after this portrait. He feels the criticism to be unjust for 'it

Fig. 32
RAEBURN
The MacNab c.1802
BY KIND PERMISSION OF
GUINNESS PLC

must be remembered, that Apollo is here in the exertion of one of his peculiar powers, which is swiftness; he has therefore that proportion which is best adapted to that character'. (*Discourse X*, 1780)[46] *St Leger* has therefore an appropriate distortion of anatomy, founded on the best authority, to convey a god-like swiftness.

Warfare provides the best chance of bringing narrative, or 'History', into portraiture. There are even contemporary British examples of 'true' historical pieces, including likenesses – such as Edward Penny and Benjamin West's *Death of General Wolfe* (of 1763 and 1770 respectively). It is not therefore surprising that the military genre is one of the most innovative of portraiture, so much so that ideas developed here were transferred to convey the power and authority of the civilian nobleman. This power has a particularly military flavour in recently feudal societies like Scotland. The feudal system depends upon the nobleman's ability to muster and lead a private army; the lord of the manor is also tribal commander. So we find examples such as Henry Raeburn's *The MacNab* of *c.*1802 (*FIG. 32*), where a military portrait, showing the sitter wearing the uniform of his regiment, is adjusted to convey a more atavistic authority – that of the clan chief.[47] Raeburn's devices immediately recall such battle-field portraits as Reynolds' *Colonel Morgan* (*FIG.* 21): a background plunges behind the figure, with dripping rocks, bare branches like discarded antlers, mountains and glens made sublimely obscure by drizzle. From our cowering viewpoint we tremble at the MacNab's sour grimace – an attribute of warlike defiance – and at the pistol he is just beginning to raise in his right hand. This portrait is intended to illustrate the Stuart motto, which still occurs on some pound coins, *nemo me impune lacessit* – 'nobody insults me with impunity!'. It also celebrates the fierce independence of the highland lairds – all Ossianic nostalgia, for the clan system had been systematically dismantled after the Forty-Five Rebellion.

Feudal power was not even a memory south of the border, yet its imagery informs the full regalia portrait. In Reynolds' *Earl of Carlisle* of 1769 (*FIG.* 1), there is a plumed helmet and lightly clasped sword, and the now familiar low viewpoint, resolute expression, and a commanding gesture based on the *Apollo Belvedere*. The surrounding architecture in the *Earl of Carlisle* is entirely imaginary. In the eighteenth century it was very rare for a life-size portrait to have a recognisable setting, as became common later. Oversize arches and stairways here provide an air of classical grandeur, to complement their Apollonian master. The sequence of Ionic columns, approaching us, has a more specific meaning: for a noble family

is often called a 'house', and its members occasionally likened to columns. 'Like a column left alone', writes Thomas Edwards, in his 1748 *Sonnet on a Family-Picture*, 'Amidst our house's ruins I remain'.[48] This particularly applies to the male heir, who will shoulder the title or family name from the previous generation and, it is hoped, unload it onto the future, like a column in a colonnade. (This is the meaning of the monument in Beverley Minster, where an only son's death is lamented in the symbol of a broken Corinthian column.)

The most remarkable example of the use of a quasi-military flavour for a civilian is Lawrence's 1794 portrait of Lord Mountstuart (*FIG.* 34). There is here the familiar low viewpoint, a metallic glint on the figure against blackness behind, and something almost apocalyptic in the swirling clouds. There is, furthermore, the characteristic reference to sculpture in the rolling marble-like folds of the inside of the cape, as it passes round the hand. This time the source is not an antique god, but a Baroque female saint: *Sta Susanna*, in the church of Sta Maria di Loreto, Rome, by the Flemish seventeenth-century sculptor, Duquesnoy (*FIG.* 33).

Lawrence's *Lord Mountstuart* is a precocious celebration of the Byronic ideal of 'romantic travel'. He suggests that during the sitter's visit to Spain he had not only worn local costume, but somehow soaked up Iberian history and culture. To express this idea Lawrence has concocted an elaborate and virtuoso tribute to Spanish painting. In spite of sculptural hints, the figure is mostly blotted out, and altogether outlined with most impenetrable black, to make a broad, simple silhouette, like Velazquez' *Admiral Pulido Pareja*, a picture brought to England in 1790 *FIG.* 35).[49] Furthermore the face has Velazquez' water-droplet highlights, and even the features of the Spanish King Philip IV. But it is primarily the background that generates the oppressive and brooding atmosphere of peculiarly Spanish sombreness. Lawrence reminds the viewer of those landscapes by Velazquez and El Greco, where daylight is rendered by dark, void skies and bleached earth, almost like moonlight. To do this he has suggested a passage of time from sunset to full night. A last strip of sunset spreads faint threads of light across the heaving landscape, like foam on the back of a huge dark wave. And yet the figure reaches above the clouds to a clear night sky, with a pale static glow around him, against the turquoise-black. A specifically Iberian setting is suggested by a glimpse of the Escurial, in the shadow of the hill, looking like a moonlit palace of ice, or like El Greco's visionary Toledo.

Immediately after his death Lawrence's biographer, D. E. Williams, writes of another

Fig. 33
DUQUESNOY
S. Susanna
S. MARIA DI LORETO, ROME

Fig. 34
LAWRENCE
John, Lord Mountstuart 1794
PRIVATE COLLECTION

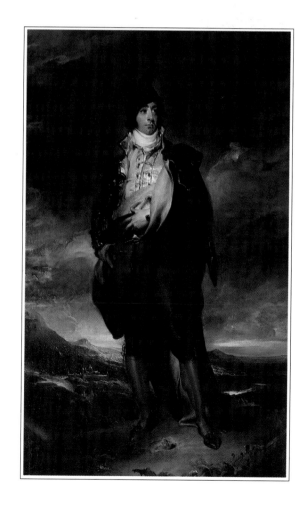

portrait that it has a robe 'thrown in thick and graceful folds over his chest and shoulder, in the style of some of the old Spanish portraits'. This description could well apply here; as could Williams' enthusiastic characterisation of this deliberately sombre mode: 'Sir Thomas Lawrence occasionally delighted in departing from his gay and fashionable style of modern portraits, and in imitating a more severe style, into which, however, he infused all his elegrance and with more or less of his brilliancy ... and establishing a style in a medium between the black masses and deep shadows of Titian and Vandyck, and the modishness now in vogue.'[50] However, at the time of its exhibition at the Royal Academy of 1795, this portrait was said to want brilliancy.[51] They obviously failed to appreciate its almost Goya-like, Romantic melancholy.

All this may seem a long way from Hogarth's Lord Squanderfield (*FIG.* 15). Yet, though Hogarth mocks and Lawrence embraces foreign influences, they are both part of a recognisably British portrait tradition, in which is stressed the dark, the stormy and the portentous, and in which the dashing hero is shown as simultaneously at one with, and master of, these turbulent elements.

CHAPTER 4

THE MAN OF FEELING

I would not enter on my list of friends
(Though graced with polish'd manners and fine sense,
Yet wanting sensibility) the man
Who needlessly sets foot upon a worm,
William Cowper, *The Task*, 1785, Book VI.

O F COURSE COWPER MUST BE EXAGGERATING, BUT THIS IS STILL A remarkable way of choosing friends! If asked where he might start to look for such people, the poet would without doubt answer, in the country. For in the Georgian era a remarkable change takes place in the way in which the country gentleman is perceived.[1] To begin with he is regarded as a boorish oaf, like the squire Pope teases Miss Blount with in his 1714 *Epistle to Miss Blount, on her leaving the Town, after the Coronation [of George I]*,

Who visits with a gun, presents you birds,
Then gives a smacking buss, and cries – No words!
Or with his hound comes hollowing from the stable,
Makes love with nods, and knees beneath a table;
Whose laughs are hearty, tho' his jests are coarse,
And loves you best of all things – but his horse.
11.25-30.

At the other extreme there is Mr Desmond, the eponymous hero of Charlotte Smith's 1792 novel, who is happy to see himself as one of the 'common country Squires', and yet is distinguished by education, revolutionary philanthropy, gentleness and such fine sensibilities as would make Werther feel a lout.[2] There is a similar shift of perception in portraiture.

As Pope's description suggests, and as the portraits show, the principal activity of a counry gentleman early in the century is sport. The image of the aristocratic hunter at this period is very little different from the full-regalia portrait. Gavin Hamilton's *Duke of Hamilton Hunting* (FIG. 37) derives from Michael Wright's feudal and military *Highland Chieftain*

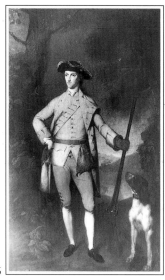
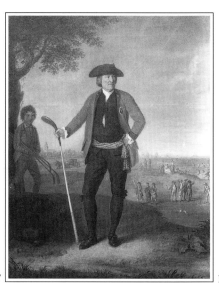

36

37

38

(*c.*1660) (*FIG.* 36), which would have belonged admirably in the last section. Even David Allan's 1787 portrait of William Inglis, enjoying the entirely bloodless sport of golf (*FIG.* 38), still recalls the *Highland Chieftain*. Though hunting is sport, it carries so many significant overtones of rank that the dignity and not the pleasure of the activity tends to be stressed. A gun, like a sword, is an emblem of feudal power, and to hunt implies having land; indeed hunting was actually illegal for anyone who owned less than £100 a year's worth.[3]

For most of the century one thing which distinguished all 'country' portraiture (sporting or otherwise) was the degree of informality. This is partly a manifestation of *decorum* – the matching, in art, of manner to subject. Alberti stipulates that the 'ornaments of Town houses [should be] more grave than those of the country'. (BOOK IX, PART II)[4] By the same token at a country-seat a certain relaxation of formality was expected, not just in the architecture or ornamentation, but also in dress and manners. These things can be seen most clearly in later portraits, such as Gainsborough's *William Poyntz* of 1762 (*FIG.* 39). Lolling against a willow-trunk with his panting dog, legs crossed, body listing off the vertical, Poyntz embodies carelessness and relaxation. He wears his own hair, tied back but not powdered, and an informal hunting coat; in short the sort of costume which French visitors regarded as inadequate even to distinguish a gentleman from a brewer.[5] Furthermore, instead of standing out from the background, with the daring conspicuousness of the commanding officer, he imperceptibly melts into it. The yellows and browns of his clothes are colours which also occur in the landscape. His outline is soft, occasionally blurred, and never especially contrasted in tone with the background. There is no object about his person, not even his gun, with the 'rasp' of military portraiture. Poyntz is part of the landscape; he is in his 'natural' element.

Though Poyntz is relaxed, his expression is proud (even fierce) and uncommunicative. We are not altogether to forget the £100 a year. This

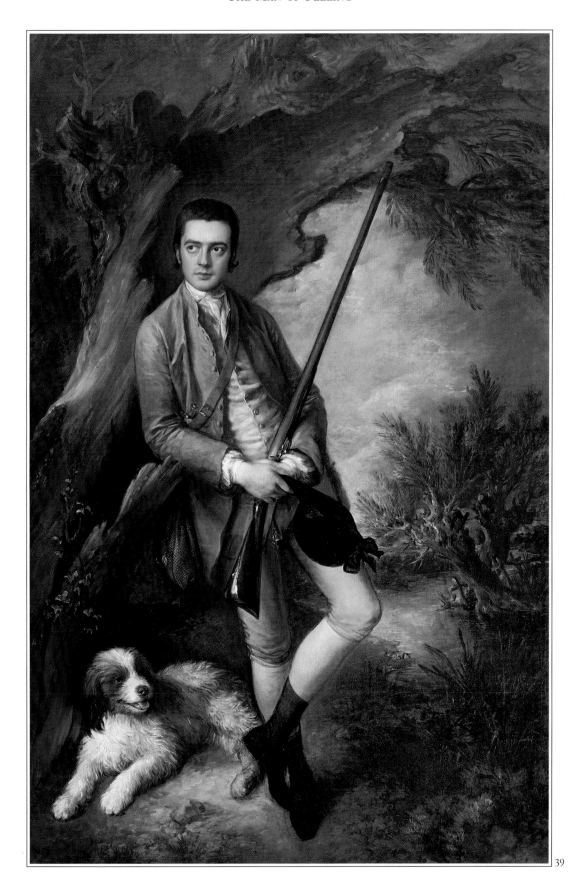

39

careless pride also expresses a quality traditionally ascribed to the country gentleman as his image improved – sturdy independence. It was a favourite device in the later years of the century to contrast the honest country squire with the foppish and hypocritical courtier. The former owns his own land, is dependent upon no man for advancement, and need not therefore, like the latter, lie, flatter or faun. Such a one is Matthew Bramble in Smollett's *Humphry Clinker* (1771), who resolves to take his nephew to a minister's levée 'that he may see, and learn to avoid the scene; for, I think, an English gentleman never appears to such disadvantage, as at the levee of a minister'.[6] Poyntz's portrait shows an English gentleman appearing to *advantage* in the country – informally dressed, direct, proud, perhaps even a bit rough-and-ready.

There is here a party-political dimension: the group of parliamentary members who represented the counties called themselves the 'Independents' because their candidature (and usually their seat, since most elections were uncontested) depended upon agreement between local squires rather than the patronage of a power-broking peer. They were thus independent of the ministry or opposition factions.[7] But the image of simple rustic virtue was so universal that all factions tried to appropriate it, even the power-brokers themselves. Sir Robert Walpole paraded the fact that he dealt with the pigs and chickens of his estate before the business of the realm; and George III, the first Hanoverian to gain any affection from his subjects, did so in the latter part of his reign by promoting an image of himself as 'Farmer George', the simply country squire.[8]

The quality most often, but not most logically, connected with the country and its informal dress is what was called 'British Liberty'. A favourite eighteenth-century myth depicts Britain as the only country in the world where, however exalted a man may be, he cannot be insolent; and however humble, he need not be servile. As Goldsmith wrote of the British:

> *Pride in their port, defiance in their eye,*
> *I see the lords of human kind pass by,*
> *Intent on high designs, a thoughtful band,*
> *By forms unfashion'd, fresh from Nature's hand;*
> *Fierce in their native hardiness of soul,*
> *True to imagin'd right, above controul,*
> *While even the peasant boasts these rights to scan,*
> *And learns to venerate himself as man.*
>
> The Traveller, or a Prospect of Society, 1764, 11.327-334.

Compared to other countries in the period there is some reality behind the myth, but the advantages of British Liberty were more to be felt by the country gentleman than by Goldsmith's self-venerating peasant. There was in Britain a free press, the present-day system of justice, and an embryonic parliamentary democracy, though with a franchise limited to male householders and with a public ballot. British Liberty would certainly mean something to a squire like William Poyntz, whose life, liberty and property were protected from the ravages of an absolute monarch. As the costume specialist, Aileen Ribeiro, puts it, 'the feeling of independence from any vestige of absolutism, and pride in what were

considered to be the real freedoms of our political and legal institutions, were to be reflected in the relative simplicity of informal English country clothing'.[9]

A direct confrontation between town and country is to be found in Rowlandson's *Meeting of a Bath Beau and a Country Beau* (*FIG.* 40). A similar contrast could be imagined if a meeting were to be arranged between Lord Cawdor, as presented by Reynolds' portrait of 1778 (*FIG.* 41), and the Captain Wade of Gainsborough's 1771 portrait (*FIG.* 42). Reynolds' portrait is a cunning re-use of his earlier *Captain Orme* (*FIG.* 16). He has replaced the plunging horse with a dog, made the right arm point instead of resting on the saddle, and put the left hand half in a pocket. In spite of this sly piece of creative economy the moods of the portraits could not be more contrasted: a breezy but serene sky replaces war-clouds, and instead of the almost straight lines and 'cutting edges' of *Captain Orme*, the clothes are here curvaciously outlined, decorative and velvety, a brightly-coloured version of the soft effect in Gainsborough's *William Poyntz* (*FIG.* 39). There is even a suggestion of comedy in the dog's inquiring – without any sense of urgency – after the stick his master points to, and looking over his shoulder, with a retriever's curious habit of rotating the head through the vertical rather than the horizontal axis. Gainsborough's *Captain Wade* (*FIG.* 42) may also derive from Reynolds' *Captain Orme* (*FIG.* 16).[10] It certainly has many elements in common with it: the low viewpoint, the tapering blade outline, the crackle of gold, the splash of pure red and the way the shoulders push up through clouds. In Gainsborough's portrait the red is contrasted with a washed-out paleness behind, and the clouds are a full-sailed cumulus, seeming to bouy up the figure. The setting has been changed to the sort of architectural terrace that is common in civilian formal portraiture.

Captain Wade was the Master of Ceremonies at Bath, the epitome, therefore, of the well-mannered soldier. The contrast between his portrait and Lord Cawdor's exposes a range of contemporary controversies about manners and mores. Take dress, for example: Lord Chesterfield considered an interest in clothes to be 'so far from being a disparagement to any man's understanding, that it is rather a proof of it, to be as well dressed as those whom he lives with: the difference in this case between a man of sense and a fop, is, that the fop values himself upon his dress, and the man of sense laughs at it, at the same time that he knows he must not neglect it'.[11] Lord Cawdor might by these rules qualify as a man of sense; Captain Wade looks a bit like a fop.

Posture is another accomplishment taken very seriously in the Georgian age, as was first brought to scholars' attention by Alastair Smart's article, 'Dramatic Gesture and

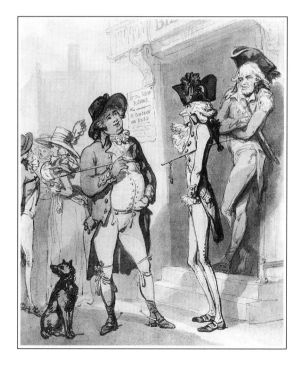

Fig. 40
ROWLANDSON
Meeting of a Bath Beau and a Country Beau
REPRODUCED BY PERMISSION OF THE BIRMINGHAM MUSEUM AND ART GALLERY

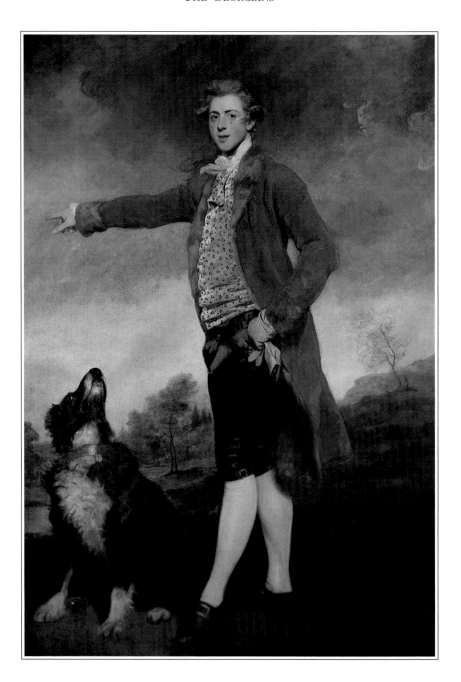

Fig. 41
REYNOLDS
John Campbell, 1st Baron Cawdor
1778
CAWDOR CASTLE, SCOTLAND

Expression in the Age of Hogarth and Reynolds'.[12] Lord Chesterfield, for example, reminds his loutish natural son that 'it is most certainly true, that your dancing-master is at this time the man in all Europe of the greatest importance to you. You must dance well, in order to sit, stand, and walk well; and you must do all these well in order to please'.[13] Captain Wade's upright carriage, extended foot and hand on hip suggest an orchestra waiting to strike up a minuet. In Nivelon's *The Rudiments of Genteel Behaviour* of 1737, the components of the gentlemanly stance are listed: the head must be erect, shoulders back, chest full and round, arms falling easy but not close to the sides, one hand supported on the sword

hilt and, most important of all, both feet must be turned outwards.[14] Captain Wade has obviously been reading Nivelon and rehearsing in front of a mirror! Altogether he resembles the hero of *Sir Dilbery Diddle, Captain of Militia* (1766), an anonymous piece of doggerel:

> *'O charming,' says she, 'how he looks, all in red;*
> *How he turns out his toes! how he holds up his head!'*[15]

Lord Chesterfield's series of letters to his son were written between 1738 and 1768. By the time they were published in 1771, they had become out of date. Their wisdom looked like the cynical, worldly wisdom of the Augustan Age. The point is made in a letter of Fanny Burney, of 1774, which compares Mr Stanhope, Lord Chesterfield's son, with a South-Sea Islander who visited London and charmed its society, called Omai:

> *The conversation of our house has turned ever since upon Mr. Stanhope and Omai – the first with all the advantages of Lord Chesterfield's instructions, brought up at a great school, introduced at fifteen to a Court, taught all possible accomplishments from an infant . . . – proved after it all a mere pedantic booby; – the second with no tutor but Nature . . . and appears in a new world like a man who has all his life studied the Graces, and attended with unremitting application and diligence to form his manners, and to render his appearance and behaviour politely easy, and thoroughly well bred!*[16]

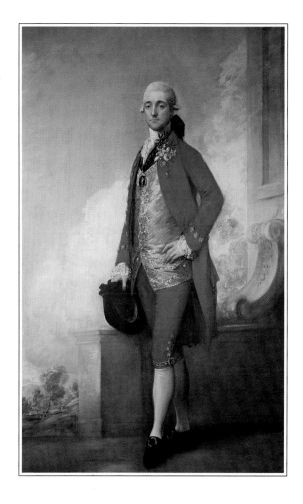

Fig. 42
GAINSBOROUGH
Captain William Wade 1771
THE VICTORIA ART GALLERY,
BATH CITY COUNCIL

In his 1776 portrait of Omai (*FIG.* 43), Reynolds captures this easy grace, of bare feet naturally finding the correct angle. The toga-like drapery and the pose – with its faint echo of the *Apollo Belvedere* (*FIG.* 27) – suggest that, for Reynolds, the antique is a time of uncorrupted art and manners, comparable to those of 'primitive' societies. This accords with a widely-held view that the antique and the dancing master were antagonists. Shaftesbury recommended to painters that they should aspire to that 'antique species of grace. Above the dancing-master', where there is to be seen 'no toe twisted out, no chin held up'.[17] The same point is made by Hogarth in his *Analysis of Beauty* Plate 1 (1753): a dancing master, standing smugly to attention, measures himself against a piece of antique sculpture, which demonstrates Hogarth's ideal 'line of beauty'. Students of the Royal Academy actually received lectures in anatomy, showing that turned-out toes were 'contrary to the intent of nature'.[18] The antique is not the only champion of true grace: Dr Beattie says of Reynolds that his portraits opposed 'those who conceive grace to consist in erect position, turned out toes, or the frippery of modern dress'.[19] Beattie might point to *Lord Cawdor* (*FIG.* 41) to illustrate his thesis. For, while Captain

Fig. 43
REYNOLDS
Omai 1776
FROM THE CASTLE HOWARD
COLLECTION

Wade (*FIG.* 42) is quite as stiff as Hogarth's dancing master, Reynolds' sitter, in much the same pose and with his feet in the safe 60-70° band, contrives to sway elegantly, his legs concave, his chest swelling. Nor does his pose seem the result of conscious art; its grace is the result of knowing the rules, but applying them with an easy, unconscious assurance (or 'laughing at them but at the same time knowing he must not neglect them', as Chesterfield might put it).

The prevailing mode at this date for extreme devotees of fashion, or *macaronis* as they were called, was to appear exaggeratedly tall and slim,[20] a fashion also parodied in Rowlandson's *Meeting of a Bath Beau and a Country Beau* (*FIG.* 40). The starved-looking Wade is like the fop in Hayley's *The Triumphs of Temper* of 1781:

His finer form, more elegantly slim,
Displays the fashionable length of limb:
Canto II, ll. 135-6.

Lord Cawdor by contrast appears pleasantly well-fed.

The real contrast between these portraits is one of implied character. By his manner and dress, as well as his position, one can tell that Captain Wade belongs to the fashionable *ton*, as it was called, which was associated with a certain lack of affable good humour. His half-closed eyes, brows raised quizzically, and mouth obstinately refusing to smile recall Chesterfield's advice: 'a man who has been bred in the world, looks at everything with coolness and sedateness'.[21] The sneer may be the constant expression of the over-dressed, but there is evidence of a positive sneering fad towards the end of the eighteenth century. In Fanny Burney's *Cecilia* of 1782, there is one Mr Meadows, a 'man of the *ton*, who would now be conspicuous in the gay world', who epitomises sophisticated boredom – he is head of a sect called the 'Insensibilists'. (*Cecilia,* Book IV, Chapter II) A sample of his conversational style will illustrate: 'No, said he, yawning, one can tolerate nothing! one's patience is wholly exhausted by the total tediousness of every thing one sees, and every body one talks with. Don't you find it so, Ma'am?' (Book IV, Chapter VII) Even as a sixteen-year old girl, Fanny Burney had confided to her diary: 'Insensibility, of all kinds, and on all occasions, most *moves my imperial displeasure*'.[22]

For Fanny Burney and those outside *tonish* circles, the true gentleman is distinguished by a liveliness of expression, an 'air of sensible good-humour'.[23] The heroine of Fanny Burney's *Evelina* (1778) receives two offers to dance in close succession. One is from a young man 'who had for some time looked at us with a kind of negligent impertinance,' who

'advanced, on tiptoe, towards me; he had a set smile on his face', whereas the other's 'air and address were open and noble; his manners gentle, attentive, and infinitely engaging; his person is all elegance, and his countenance the most animated and expressive I have ever seen'. (Volume I, Letter XI) No guesses as to which is Mr Right. This is the ideal to which Lord Cawdor (*FIG.* 41) conforms. In comparison with Captain Wade's (*FIG.* 42) distant *hauteur*, his face is 'open' (to use Burney's word), pleasant and animated; his lips slightly apart, his cheeks filling out with his smile, his eyes wide and acknowledging. The particular virtue which these pleasing manners imply is stated in a passage in Fanny Burney's *Camilla*. The *tonish* but redeemable Sir Sedley has just saved the heroine from an unspecified death connected with runaway horses:

> *His natural courage, which he had nearly annihilated, as well as forgotten, by the effeminate part he was systematically playing, seemed to rejoice in being again exercised; his good nature was delighted by the essential service he had performed . . . his heart itself experienced something like an original feeling, unspoilt by the apathy of satiety, from the sensibility he had awakened in the young and lovely Camilla.*

> Book VI, Chapter III.

'Feeling, courage and good nature' make up the cardinal virtues of the true gentleman, according to the eighteenth-century view, but the greatest of these is good nature. This is also the virtue most applicable to *Lord Cawdor*. A dog is virtually the symbol of good nature: according to Henry Brooke, there is a 'sort of instinct, by which a strange dog is always sure to discover, and to apply to the most benevolent person at table'.[24] Sir John Hawkins, a contemporary writer, said of the hero of Fielding's *Tom Jones* that he had the virtues of a Newfoundland dog – not very rational, but good for tickling under the ears.[25] For the Augustans, good nature was far from being a despicable *beastly* virtue, indeed it was the highest expression of the rational. Lord Shaftesbury writes of his philosophic mentor, Whichcote, that he was a 'truly Christian Philosopher, whom for his appearing thus in defence of Natural goodness, we may call the preacher of Good Nature'.[26] The religious tone is deliberate, for even the divinity, even the God of the Old Testament, is, according again to Shaftesbury, simply the 'best-natured Being in the world', however it may have appeared to the Moabites.[27] The English particularly tried to get themselves a name for this quality: in *Émile* (1762) Rousseau remarks tartly, *Je sais que les Anglais vantent beaucoup leur humanité et le bon naturel de leur nation, qu'ils appellent* good natured people; *mais ils ont beau crier cela tant qu'ils peuvent, personne ne le répète après eux.*'[28]

Lord Cawdor is an example of a refinement of good nature which belongs to a new type of man, who makes his first appearance in the Georgian era – 'the man of feeling'. The phrase comes from the title of what would now be called a 'cult book' by Henry Mackenzie, which came out in 1771 and which Robert Burns said he prized next to the Bible.[29] Mr Harley, the 'man of feeling' himself, lives a retired country existence and is, as the title suggests, a man of tender heart and ready benevolence. He is also rich and a landowner. There is nothing revolutionary about this new sensibility: indeed the hero is first introduced when the narrator and

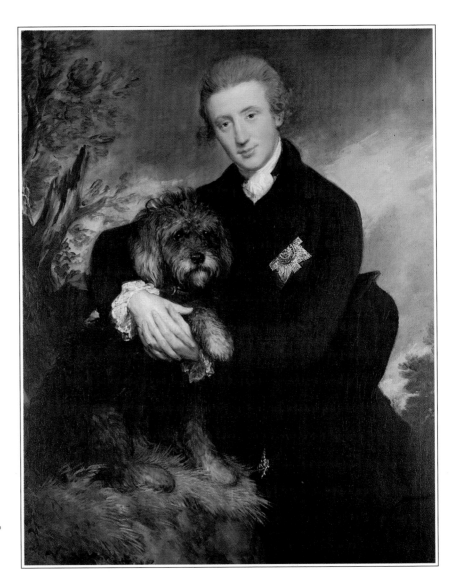

Fig. 44
GAINSBOROUGH
Henry, 3rd Duke of Buccleuch 1770
IN THE COLLECTION OF THE
DUKE OF BUCCLEUCH AND
QUEENSBERRY KT.

his friend, a curate, are out shooting – not what we think of as a 'feeling' activity. When some birds disappoint them by flying away before they can be shot, the two guns sink exhausted, wipe the sweat from their brows and meditate upon the vanities of life. In this receptive, philosophic frame of mind they first notice Mr Harley's country seat. This inconsequential and slightly whimsical opening suggests that shooting is perhaps a distraction from subtler joys of the country, but certainly not a contradiction. It plays much the same rôle as it does in Turgenev's *Sportsman's Sketches*. In the same way Reynolds' *Lord Cawdor* reminds one of a shooting portrait, though the gun has been left at home. A dog also figures prominently in the opening of *The Man of Feeling*; he is in fact the first named character – Rover – 'an excellent dog, though I have lost his pedigree'. (Introduction)

Henry Mackenzie's book is not an isolated phenomenon: there are a few earlier and innumerable later celebrations of the new ideal. It was in

the year before its publication that Gainsborough painted one of the most striking 'portraits of feeling', his *Henry, Duke of Buccleuch* of 1770 (*FIG.* 44). The decisive symbol in this portrait is the only mark of rank in an otherwise informal costume: the star of the Order of the Thistle. It is not the star itself that is interesting, but the fact that it is half-concealed by a lapel. The Duke refrains from turning his full glory upon us, and instead beams down a more temperate, benign aspect, as he leans casually on a bank. His 'glory' is hidden by what in the eighteenth century was called, approvingly, 'condescension' – the kindly consideration for inferiors. He tips his head and leans down towards us, with soft, enquiring eyes and a faint smile. A comical-looking dog is a familiar emblem of good nature. The way the Duke cuddles it suggests almost a child's affection for his pet, and the dog itself seems to be offering a paw for us to shake. Everything about the image is modest and obliging – gentle in an almost feminine way.

The Duke of Buccleuch acknowledges our presence and graciously puts us at our ease. He resembles Lord Orville, about whom Evelina writes: 'so steady did I think his honour, so *feminine* his delicacy, and so amiable his nature! I have a thousand times imagined that the whole study of his life, and whole purport of his reflections, tended solely to the good and happiness of others'. (Burney, *Evelina*, Volume II, Letter XXVIII) *Evelina* was published eight years after Gainsborough's portrait, yet its characterisation of Lord Orville is a restatement of widely-accepted ideals which go back to Richardson and beyond. It is this sugary ideal that Jane Austen parodies in her Mr Lesley, who has a 'heart which (to use your favourite comparison) was as delicate as sweet and as tender as a Whiptsyllabub'. (*Lesley Castle,* Letter the Third)

The fundamental idea is that nobility is not *just* a matter of blood, but a 'Principle of Virtue', to use *The Spectator's* phrase. (*The Spectator*, no. 537, 1712) This idea is constantly repeated, nowhere more pungently than among the followers of Rousseau, who on the one hand agree with their mentor that there is nothing more useless than a gentleman, and on the other maintain that 'the character of a gentleman is the most venerable, the highest of all characters'.[30] It depends what is understood by the term. The exalted – but, for the well-born, inconvenient – conception of a gentleman is naturally a middle-class invention. But if there are only middle-class writers, like Burney and Richardson, to describe high-society, so there are only middle-class painters, like Reynolds and Gainsborough, to paint it. It is easy to understand why someone like the Duke of Buccleuch, whose pedigree was well-enough known not to be insisted upon, might favour the additional praise which this gentle image implies. The Duke was evidently a benevolent man in life: his friend Sir Walter Scott remarked that 'his name was never mentioned without praises by the rich and benedictions by the poor'.[31]

Eccentricity was another characteristic believed to be peculiarly British. As Addison put it, 'our Nation is more famous for that sort of Men who are called *Whims* and *Humourists*, than any other Country in the World'. (*The Spectator*, no. 371, 1712) Not only are there more of them about but they are a good thing. As the Abbé Le Blanc noted, 'without doubt no

country in the world affords a greater number of singular men than England . . . the English make a merit at least, if not a virtue, of this singularity', for they regard it as 'the effect of their liberty'.[32] Sir Roger de Coverly, in *The Spectator*, who for much of the century epitomised the ideal of the gentleman, is called 'a whimsical Country Knight' who was 'a great Humourist in all parts of his life'. (*The Spectator*, no. 101, 1711) Mr Harley (the Man of Feeling) is called 'a whimsical sort of man'. (Introduction) Another such is Matt Bramble in *Humphry Clinker* (1771), whose 'singularities . . . afford a rich mine of entertainment', and who 'affects misanthropy, in order to conceal the sensibility of a heart, which is tender, even to a degree of weakness'.[33] Matt Bramble shows perhaps most clearly the Sternian connection between eccentricity and strong benevolent feelings: 'His blood rises at every instance of insolence and cruelty, even where he himself is no way concerned; and ingratitude makes his teeth chatter. On the other hand, the recital of a generous, humane, or grateful action, never fails to draw from him tears of approbation, which he is often greatly distressed to conceal.'[34]

Gainsborough's *William, Viscount Gage* of 1777 (*FIG.* 45), exhibits the same range of characteristics. He stands with head and body facing us directly, without the 'twist; the affected contrast' in the turn of the neck, common in portraiture.[35] This posture indicates simplicity, *straight-forwardness* and honesty. His face is wide, well-lit, 'open' and smiling, to indicate benevolence. The sturdy tree-trunk he leans carelessly against could be a symbol of his true 'heart of oak', to use Garrick's phrase. He could illustrate that 'old *English* Plainness and Sincerity, that generous Integrity of Nature, and Honesty of Disposition, which always argues true Greatness of Mind', and which Steele felt was 'in a great measure lost amongst us'. (*The Spectator*, no. 103, 1711)

Viscount Gage is not only plain and sincere, he is also 'singular' in his cheerful, careless and downright air. Like Sir Roger he is 'something of a humourist'. Without this brief fashion for the lovable eccentric, Raeburn's *The Reverend Robert Walker skating on Duddingston Loch* of 1784 (*FIG.* 46) is an impossibility. This is a unique image full of whimsical (as opposed to satirical) comedy. The joke takes off from Walker's Dutch connections: as a minister at the Scots church in Amsterdam, he had written on 'kolf', the Dutch ice-hockey-like version of the Scots golf.[36] In art kolf appears in countless seventeenth-century frozen river scenes, the most famous of which are by Avercamp. It is from such paintings that Raeburn derives the light, pinkish snow-haze in his background, blending the earth and sky.[37] Avercamp's scenes also include skaters among the 'kolfers'. They are usually shown in black silhouette against the ice, leaning stiffly with one leg cocked up, like cartoon characters. Even to our eyes these figures are absurd, but people in the eighteenth century were far more robust in regarding Dutch art as good comedy. Walker's stiff, balletic pose seen in strict profile is similarly comic.

In order to make a mere detail in Dutch landscape painting available for quarter-life-size portraiture, Raeburn has employed a device from Velazquez. As in his *Admiral Pareja* (*FIG.* 35), the figure appears to consist of a shape cut out of black paper and stuck on over a light and indistinctly

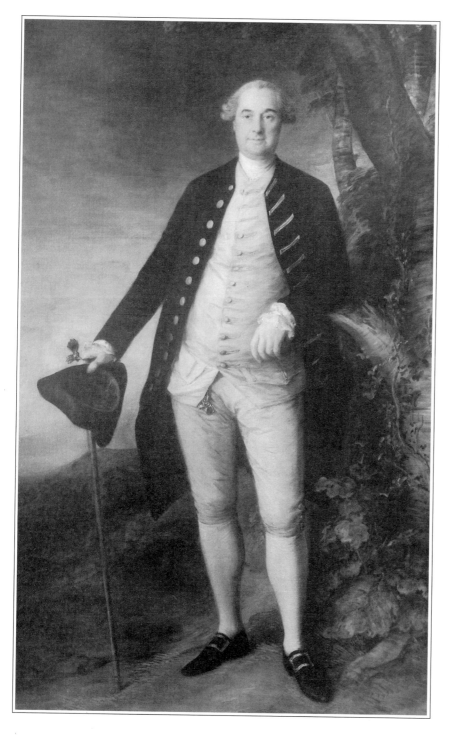

Fig. 45
GAINSBOROUGH
William Hall, 2nd Viscount Gage
1777
TRUSTEES OF THE FIRLE ESTATE
SETTLEMENT

painted background. The visual joke depends upon a reversal of our ex-
pectations: we expect the figure, as the main object, to look three-dimen-
sional, to have a light side and a dark side, and to be detailed in execution;
we do not expect it to be flat, black and minimal. We might further expect
the foreground to be lighter and the background darker, rather than vice
versa.

Fig. 46
RAEBURN
The Revd Robert Walker Skating
on Duddingston Loch 1784
NATIONAL GALLERY OF SCOTLAND

The Revd Walker is the first sitter in this chapter who is not a member of the landed-gentry. But the clergy can be lumped with noblemen as potential eccentrics: one has only to think of Parson Yorick in *Tristram Shandy*, created by that pioneer of the whimsical and sentimental, the Reverend Laurence Sterne. The case is different, however, for anyone who had made their money recently by trade. Merchants or industrialists were called 'cits', after their ghetto-like quarters in the City of London, and were habitually sneered at, especially if they were seen to hanker after the countryside. This was out of their sphere, above their station. It was, however, frequently noticed by foreigners that trade was less despised in Britain than on the Continent. Voltaire in his *Lettres Philosophiques* writes of meeting in England, on the one hand, a dignified Quaker tradesman who has retired to the country, and on the other a peer's younger brother who deigns to busy himself with commerce. (Letters 1 and 10)[38] The idea of the dignity of trade gains a special fillip in the 1770s, when a spate of semi-philosophic novels feature a wealthy merchant who retires to the country and outdoes the local squires in all the rustic virtues of benevo-

lence and sentimental lacrimosity. Mr Fenton, the father figure in Brooke's *The Fool of Quality* (1767-70), is the most influential example. At the same time (in the early 1770s), in order to depict the famous brewer, Sir Benjamin Truman (*FIG.* 47), Gainsborough adopts the convention of the bluff country squire, posed foursquare, clasping his stick and giving every appearance of being firmly rooted. His slightly grim expression should be understood in this context as a 'singularity', a gruffness indicative of honesty. His benevolence is guaranteed by the landscape, and by the glow of light pouring down off his forehead.

There is another pastime, besides sport, which might lure the eighteenth-century gentleman into the countryside, and that is philosophical contemplation. Closterman's *Anthony Ashley Cooper, 3rd Earl of Shaftesbury and the Hon. Maurice Cooper* of *c.*1700 (*FIG.* 48), shows the philosopher lecturing to his brother who leans affectionately on his shoulder, wearing a compromise between a Restoration dressing-gown and an ancient toga. This is a good-humoured, affectionate chat, but also a quest for Truth: the two faces catch the light to suggest the 'enlightenment' of Truth, as they look up and away out of the frame, to follow Lord Shaftesbury's gesture. It is also of importance that the figures and their temple are standing in a dense and remote wooded glade. Shaftesbury's later work, *The Moralists: a Philosophic Rhapsody* (1709), is a dialogue between Theocles and Philocles, the embodiments of theology and philosophy: the former gratefully apostrophises the 'Fields and Woods, my Refuge from the toilsome World of Business', which favour 'thoughtful Solitude' and meditation into 'the Cause of Things'. He goes on to give the definitive statement of rational Augustan Nature-worship:

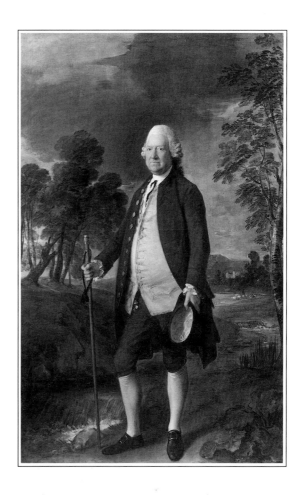

Fig. 47
GAINSBOROUGH
Sir Benjamin Truman 1770-4
THE TATE GALLERY, LONDON

> *O Glorious* Nature! *supremely Fair, and sovereignly Good! All-loving and All-lovely, All-divine!* . . . *O mighty* Nature! *Wise Substitute of* Providence! *impower'd* Creatress! *O Thou impowering* DEITY, *supreme* Creator! *Thee I invoke, and Thee alone adore.*[39]

This is, of course, an imaginary pagan speaking, who may be allowed some latitude in matters of orthodoxy; still, the Christian reader is later reassured:

> *All Nature's Wonders serve to excite and perfect this Idea of their* Author.[40]

Which means God. Nature is here, and throughout the earlier part of the eighteenth century, revered as an aspect of God. Lord Shaftesbury's characters are not really looking *at* Nature; they are looking *through* it to

the principle behind it, the Divine Being. To use Addison's words, he has elevated this 'vernal Delight' into a 'Christian Virtue'. (*The Spectator, no. 393, 1712*)

An image of country-contemplation from the other end of the century, Joseph Wright of Derby's 1781 portrait of Sir Brooke Boothby (*FIG. 49*), could hardly be more different. Nature is here thicker, danker and more autumnal, and the sitter has penetrated the depths of a forest to recline by a brook and read or think. On the spine of his book is written the name 'Rousseau'. Sir Brooke Boothby was a friend of Rousseau's and had sponsored the publication of his *Rousseau Jugé de Jean-Jacques* in 1780.[41]

Fig. 48
CLOSTERMAN
*Anthony Ashley Cooper, 3rd Earl of Shaftesbury with his brother the Hon. Maurice Cooper c.*1700
NATIONAL PORTRAIT GALLERY

But it is probably not this specific work which is intended: if it had been it would have been easy to write the title as well as the author. The book is intended to convey nothing more specific than 'Rousseau's philosophy', to be culled from all his writings. By a contrived accident the index finger of one of Boothby's hands points to the name, while that of the other points to his temple, to underline the fact that he is contemplating his mentor's ideas.

With Rousseau, and especially his educational tract *Émile* of 1762, Nature-worship takes on a different aspect. No longer is Nature the manifestation of God, it is now all-in-all and capable, without the aid of man-made dogmas, of teaching the true system of social justice and personal morality. It is for this reason that Boothby seems to be smearing the pages of his book in the mud: it is from the earth, from Nature, that they absorb their wisdom. This is also the reason for the most remarkable feature of this portrait, the fact that the sitter has thrown himself upon the ground. Instead of standing and contemplating God through Nature, like a Christian and a Gentleman, Boothby reclines on a river bank, 'absorbing' revelation, like the book, from below.

What is the ethical system to accompany this new divinity? The answer is what William Godwin calls the 'culture of the heart', the lesson of feeling.[42] The mouthpiece of Rousseau's homespun faith in *Émile* is the Savoyard Vicar, who finds his rules for life 'not in the principles of a lofty philosophy', but 'at the bottom of my heart, written by Nature in indelible characters'.[43] Mackenzie's hero reaches a similar conclusion:

> But as to the higher part of education, Mr. Harley, the culture of the Mind; – let the feelings be awakened, let the heart be brought forth to its object, placed in the light in which nature would have it stand, and its decisions will ever be just.
>
> The Man of Feeling, 1771, Chapter XL.

It is these 'awakened feelings' that have misted over Boothby's sparkling, tear-laden eyes and given him his dreamy half-smile.

The immediate source for Boothby's pose, as has been noted by others, is an Elizabethan miniature of a melancholy knight reclining under a tree, a work which in eighteenth-century eyes would be regarded as a whimsical curiosity.[44] In his article on this portrait, Frederick Cummings argues that the Elizabethan theme of melancholy is preserved in Wright's derivation. But there is nothing melancholy in Boothby's expression, and the philosophy it espouses is, at least at this date, supremely optimistic.

What is certain is that men do not usually recline in art, unless they are dying or have some other obvious excuse; otherwise it seems nerveless, yielding, unmanly. Though men may not lie down in landscape, women do; one has only to think of the countless reclining nude Venuses of Venetian art, which this figure resembles in pose and even, somewhat, in anatomy. This is yet another example of the *femininity* of the man of feeling. It is not surprising that Mackenzie's hero also disports himself in this unseemly way: 'he would sometimes consort with a species of inferior rank, and lay himself down to sleep by the side of a rock, or on the banks

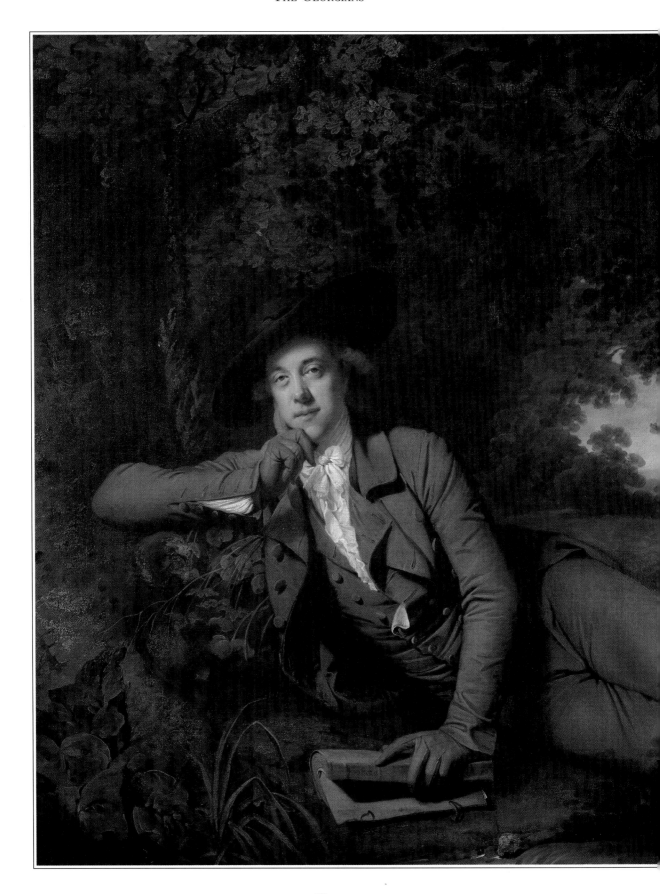

Fig. 49
WRIGHT OF DERBY
Sir Brooke Boothby 1781
THE TATE GALLERY, LONDON

of a rivulet.' (*The Man of Feeling*, Chapter XXXIV) And later we read of Mr Desmond 'stretched on the ground his head resting on his arm, (from which a book seemed to have fallen)', while his hat and hair concealed his face.[45] Mr Desmond is unhappy about many things, but when seen in this posture he himself tells us that he is enjoying a '*resverie*' and indulging himself in 'pleasing dreams'.[46] Boothby may be so tender-hearted as to incline to tears, but in this portrait we can be sure that he is enjoying the pleasing dreams of the immediately pre-revolutionary period: dreams of universal brotherhood, freedom and a 'natural' order of society.

Mention of revolution, the French Revolution, brings us to the twilight of the Man of Feeling. This popular current of the 1770s and 80s was in no way checked, but rather swelled, by the American War of Independence, the colonists enjoying wide and open support in Britain among all classes. The 1789 Revolution was a different thing. In many ways it represented a realisation of the liberals' best hopes. Indeed Charlotte Smith's *Desmond* of 1792 carries the Man of Feeling over to France to give his blessing to the new order. But this novel, like the writings of Mary Wollstonecraft, William Godwin and many others, is more radical though less generally popular than Mackenzie's or Henry Brooke's Rousseauian novels. Nothing of the sweet optimism of the 1780s survives the Terror or the twenty-three years of pan-European warfare with revolutionary France which followed. The next four decades or so in Britain are years of unparalelled reaction, in politics and manners. The heirs of Rousseau and his English followers either recant, like Wordsworth, or become marginal exiles like Shelley and Byron. In retrospect it seems surprising that propertied gentlemen should ever have been so enthusiastic about Rousseau's egalitarian philosophy, with such delirious fantasies as the suggestion that game should be freely available to all who wanted to hunt it.

It will be noted that a high proportion of paintings and quotations in this chapter involve Scotsmen: the sitters, Lord Cawdor, the Duke of Buccleuch, Revd. Walker; the writer Henry Mackenzie; the painter Henry Raeburn. This may be because Rousseau stayed in Edinburgh during his 1766 visit to Britain, or it may be because of something intrinsic in the Scots character, though it doesn't seem to be the MacNab's style (*FIG.* 32).[47] Certainly the last word on the subject may be given to the Scottish poet Robert Burns, from his song *For a' that and a' that* of 1795. This is the 'last word' in more ways than one, since 1795 is already past the time that such sentiments would be endorsed by the portrait-classes, for whom universal brotherhood represents a *mésalliance*:

> *Then let us pray that come it may,*
> *As come it will for a' that,*
> *That sense and worth, o'er a' the earth*
> *Shall bear the gree, and a' that.*
> *For a' that, and a' that,*
> *It's comin yet for a' that,*
> *That man to man the warld o'er,*
> *Shall brothers be for a' that.*
>
> ll. 33-40.

CHAPTER 5

A SIMPLE DOMESTIC
CHARACTER

I am completing, with other pictures, a portrait of the King in his private dress – perhaps my
most successful resemblance of him, and the most interesting from its being so entirely of a
simple domestic character.
Sir Thomas Lawrence, Letter of 1 July 1822.[1]

THE PORTRAIT LAWRENCE IS REFERRING TO IN THIS LETTER IS THE astonishingly intimate image of George IV, now in the Wallace Collection (*FIG.* 50). The king is on our level, looking directly at us, with an affable smile. He sits on a sofa, with some papers, his top-hat and gloves beside him, as if he is just settling to some light administration before dinner. Like many examples in the last chapter, the king has no part of his body turned sideways; with his open legs, and arm flopped along the sofa-back, he seems to be making himself as flat and wide as possible. We see him and everything else front on, giving again the impression of a 'straight-forward' man. A king could never be shown in this guise, were there not already a tradition of informal indoor portraits, onto which this could be grafted.

This tradition marks out common ground to be shared by condescending aristocrats and aspiring professionals. Confident of his birth and lineage, an intellectually inclined nobleman could consider it an honour to appear as a man of learning. The attitude is best summed up by Lord Chesterfield's remark in 1747: 'There are two sorts of company', he says; one is the *beau monde*, and the other 'consists of those who are distinguished by some peculiar merit, or who excel in some particular and valuable art or science. For my own part, I used to think myself in company as much above me, when I was with Mr. Addison and Mr. Pope, as if I had been with all the princes in Europe.'[2] Appearing in a portrait like one of those 'who excel in some art or science', is an oblique way of keeping their exalted company.

This tradition can really only be understood by considering a maverick

50

portrait by Hogarth of someone not even pretending to be noble, Captain Thomas Coram (*FIG.* 53). This remarkable painting burst upon the London art world in 1740 at a time when, as we have seen, portraiture was at its lowest ebb. In many ways the work remains outside the mainstream. Hogarth intended it as a raucous blowing of his own trumpet, as he himself relates:

> upon one day at the academy of St martins lane I put this question if a any at this time was to paint a portrait as wel as *Vandike* would it be seen and the person enjoy the benefit – they knew I had said I believd I could. the answer was made by Mr. Ramsey and confirmed by the Rest possitivly No.[3]

Captain Coram is not the work of a man trying to reincarnate Van Dyck, yet it is a manifesto nontheless. It was not commissioned: the inscription states that Hogarth painted it at his own cost and donated it to the Foundling Hospital, where it has been publicly shown ever since. In *Captain Coram* Hogarth parodies the pompous conventions of portraiture. This is nothing new, and it would appear again (*FIGS* 65 and 15); what is peculiar here is that Hogarth attempts to replace these empty formulae with something else, something of substance. And for Hogarth substance means moral ideas.

The butt of the joke is one of Hogarth's favourites – the Baroque, and like all good parodies this deals not with an individual work, but with a type, a range of conventions. The steps leading up to the figure, strewn with attributes, the column, four times life-size, the drape hanging down out of nowhere, the glimpse of sea – these are all formulae of Baroque portraiture. So too is the vigorously animated figure, with its billowing, fluttering coat. The raising of the right hand, with a finger slightly pointing (and the left hand in sympathetic semaphore) is intended to recall the Popes who bless from their Baroque tombs. The stiffness of Coram's coat, its winding edge, lapel curling over, cuffs standing open by themselves – all these things mimic the stiff Papal alb, as rendered in animated bronze by a Bernini or Algardi.

According to Ireland, writing in the 1790s, 'the fantastic fluttering robes, given by contemporary painters, were too absurd for him [Hogarth] to imitate'.[4] But these elements are parody, not imitation, because they are absurdly at odds with the sitter, and the real facts of the scene. The coat, for example, is stiff not because it is precious bronze, but because it is a common seaworthy great-coat of sturdy, coarse cloth.

Hogarth is taking a risk that the mockery may not all attach itself to the pompous conventions; some might reciprocally attach to Captain Coram's failure to come up to scratch. For Hogarth tells us in no uncertain terms that his sitter is plebean. His clothes are coarse, he sits at a simple table with his hat cast on the floor, and he clutches his gloves, as if he thought we had our eyes on them, rather than dangling them languidly with the middle fingers. Veins stand out on his coarse hands, his cheeks are red, and his crown is white like a halo where the hat has kept the sun off. Unlike today, sunburn was a sign of vulgarity in the eighteenth century, and particularly associated with sailors: 'I take it for granted', observed Sir Walter Elliot of Admiral Croft, in Jane Austen's

Fig. 50
LAWRENCE
King George IV 1822
REPRODUCED BY PERMISSION OF
THE TRUSTEES OF THE WALLACE
COLLECTION

Persuasion (1818), 'that his face is about as orange as the cuffs and capes of my livery.' (Chapter 3) All this would be forgivable were it not for Captain Coram's feet: give or take an inadquate 10° or so, they are parallel.

How could such an image not give offence? How could it be intended as a tribute to the sitter? Part of the answer lies in the eighteenth-century concept of raillery. As commonly used in the period, the word 'raillery' simply means insult. But strictly speaking it meant that species of endearment when someone *appears* to be insulting another, but is in fact subtly praising them. 'I do not know any thing which gives greater Disturbance to Conversation, than the false Notion some People have of Raillery,' Steele writes in 1712. Instead of offensive jests the man who 'railles well' should form his 'Ridicule upon a Circumstance which you are in your Heart not unwilling to grant him, to wit, that you are Guilty of an Excess in something which is in it self laudable'. (*The Spectator*, no. 422, 1712) In a later number there is an example of this principle, whereby 'an Irony is looked upon as the finest Palliative of Praise; and very often conveys the noblest Panegyric under the Appearance of Satire'. (*The Spectator*, no. 551, 1712) The device thrives in panegyrics because readers know that these are by convention flattering. So they are not put out when they encounter criticisms; they simply wait to see them turned neatly inside out and made into panegyrics.

Portraiture is also by convention flattering, so viewers know that if they encounter apparent criticisms, they must do their own turning inside out. In this way Hogarth's *Captain Coram* contains the 'noblest panegyric under the appearance of satire'. Each criticism can be turned into a compliment – the plebean posture suggests vigour, the tanned complexion, experience, and the coarseness of dress, a rough-and-ready honesty and freedom from vanity. Even so it is unlikely that such an image would have been hung as a public tribute, were it not that there was a literary tradition of the virtuous, but almost misanthropically plain-spoken, sea-captain. Captain Manly, 'of soldier-like weather-beaten complexion' in Wycherley's *The Plain Dealer* (Act II, scene 1, 1676) is the most famous; but another, after the date of Hogarth's portrait, has remarkably similar virtues. In a poem of John Collier, an old soldier, fallen on hard times, asks:

> *Send me, kind heav'n, the well-tanned captain's face,*
> *Who gives me twelvepence and a curse, with grace;*
> *The Pluralist and Old Soldier*, ll. 25-6, 1763.[5]

These are exactly Coram's characteristics: a superficial roughness, even rudeness, but pure charity underneath. The Foundling Hospital, a home for abandoned bastard babies who would otherwise die on the streets, was something brought about by Coram's money and energy. Originally Hogarth intended a statue of Charity above (still just visible in the finished work), but finally he expressed the idea by showing Coram gripping the seal of the Royal Charter for his hospital.

Perhaps the most daring piece of raillery in this portrait lies in the face. In order to convey Coram's weather-beaten resolution, Hogarth has turned to Rembrandt, who was something of a rôle-model for him. Of his own portraits he writes that they 'met with the like approbation

Rembrant's did, they were said at the same time by some [to be] Nature itself by others exicrable'.[6] Hogarth is identifying with an outsider, for, at this date, Rembrandt had not the reputation he enjoys today. What Vertue was to say of another Rembrandtesque portrait, in 1745, applies here: 'it appears like an old mumper [beggar], as Rhimebrandts heads usually do' and certainly not 'the true characteristic of a fine Gentleman'.[7] Comparing Hogarth's head to a late Rembrandt *Self-Portrait* (*FIG.* 51), which was in England at the time, one can see the same thick, dry, plaster-like paint, especially in the hair, and the same sharp crust of eyebrows, highlights and crudely-scored wrinkles.[8] Though partially lost in the general roughness, there is a pronounced furrowing between the brows and across the top of the nose which gives an unmistakable expression of anger. This is entirely deliberate and appropriate: to create an institution like the Foundling Hospital means feeling benevolence; it also means

51

feeling indignation that such institutions should be necessary in the first place. And Captain Coram evidently has his crusty side.[9]

There is a further clue slipped in by Hogarth to suggest Coram's virtue. Playing over the globe on the floor there is a brilliant reflection of a four-paned sash window, though, as Omberg notes, no such window appears in the scene.[10] To the casual observer the effect looks probable enough, and yet it has a further hidden significance, for the highlight makes a shining cross-shape apparently voyaging across the Atlantic ocean. This is an allusion to the mission to the West Indian Negroes sponsored by the Society for the Promotion of Christian Knowledge, of which Coram was a Governor.[11]

Captain Coram does not have the look that is going to appeal to the average eighteenth-century gentleman. For this reason its direct impact on portraiture was slight. The Hogarth portrait which has far more impact on the mainstream of British portraiture is a smaller half-length of the same date, depicting a certain George Arnold (*FIG.* 52). Like Coram, Arnold is the embodiment of middle-class respectability: his face is all warts and heavy features, his head is cocked, his shoulders and arms hunched forward, his stare direct, and hat stoutly defended with both hands. These ideas are discreetly

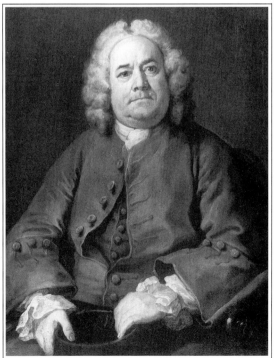

52

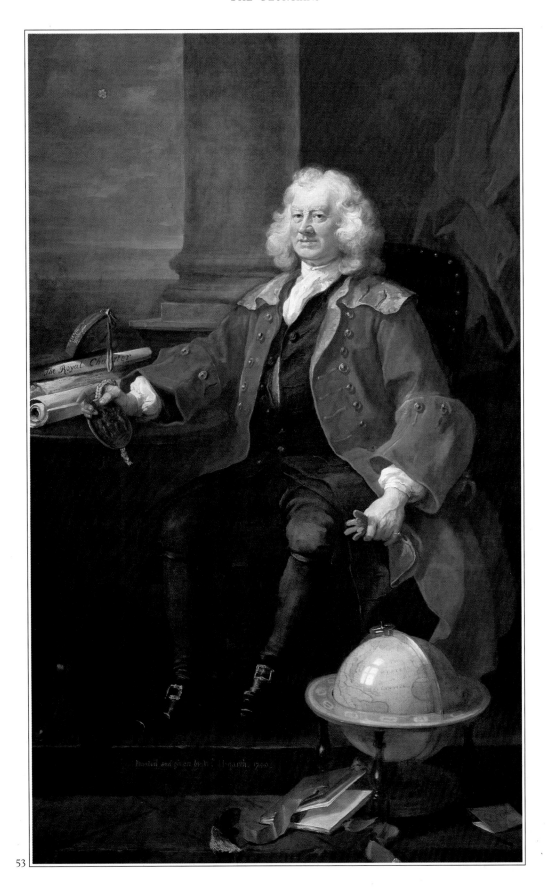

53

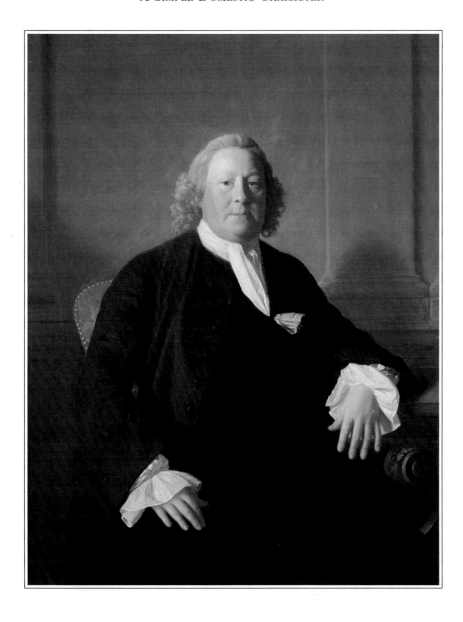

Fig. 54
RAMSAY
*Sir Hew Dalrymple, Lord
Drummore* 1754
SCOTTISH NATIONAL PORTRAIT
GALLERY

diluted by Hogarth's friend, the fashionable portraitist Allan Ramsay, for his *Lord Drummore* of 1754 (*FIG.* 54). The features are similar, though Ramsay contrives to explore their contours more discreetly. The eye-sockets, double chins and wrinkles are only hinted at by the highlight on the left, and by soft shadows, without actual lines or edges made with the brush. The forthright posture is retained, given swagger by a half-eclipse version of the Velazquian black silhouette, already encountered. Refinement is smuggled in by having an imaginary viewpoint a few steps back from that implied in Hogarth's portrait, as well as by the hint of pilasters and the sober restriction of palette to black, white, buff and red.

Hogarth was never an important 'competitor' in the fashionable portrait market. At the time *Lord Drummore* was painted, Ramsay's principal such rivals would have been, from the older generation, Thomas Hudson and, from the younger, Hudson's pupil Joshua Reynolds. We have

Fig. 53
HOGARTH
Captain Thomas Coram 1740
THE THOMAS CORAM
FOUNDATION FOR CHILDREN, THE
FOUNDLING HOSPITAL

already seen that Hudson was a more important painter than he deserved. In 1751 Vertue reckoned him the busiest in London, though he finds Ramsay 'much superior in merit than other portrait painters'.[12] Hudson's 1747 portrait of Charles Jennens, the librettist for Handel's *Messiah* (*FIG.* 55), gives a reasonable idea of his capacity. The face is here described by the easy formula of a light side and a dark side. So is Lord Drummore's; the difference is that Hudson's shadow is deep and clinging, and it runs in an unbroken line down the right side of the face. Far from suggesting the fullness of three dimensions, this shrinks the face, making it seem narrow and folded up. In the Ramsay the shadows are less dark and have a reddish blush to them, their edges are softer and they are less intrusive.

Reynolds' contribution to this mode is the downright and disputatious-looking *Rt. Hon. John Hely-Hutchinson* of 1778 (*FIG.* 57). Reynolds was fascinated by the pattern of light and dark across a painting, considered almost abstractly. In 1782 he recalls how, to study any striking effect of chiaroscuro in Venetian paintings, he 'took a leaf of my pocket-book, and

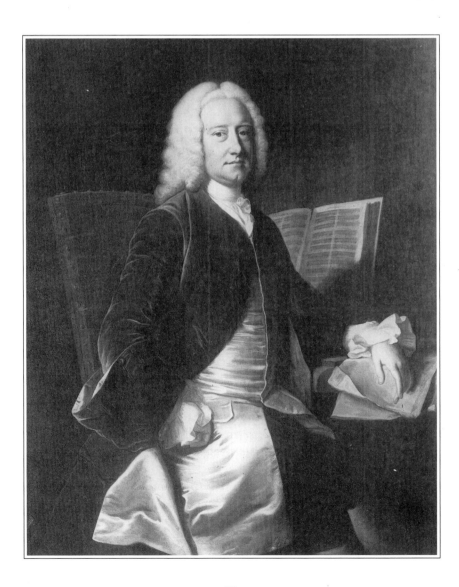

Fig. 55
HUDSON
Charles Jennens 1747
PRIVATE COLLECTION

darkened every part of it in the same gradation of light and shade as the picture, leaving the white paper untouched to represent the light, and this without any attention to the subject or to the drawing of the figures'.[13] Unlike *Lord Drummore*'s simple silhouette, Reynolds' painting is a concoction of contrived masses and contrasts of light and dark, such as he might have admired in a Titian altarpiece. But the head is characteristic in its avoidance of the usual light-side dark-side scheme of modelling. Hely-Hutchinson has tiny fringes of shadow under his nose, chin and right eyelid; but otherwise he is an almost uniform mass of light, beaming on us like a full moon. Most late Reynolds portraits strive for a large, unbroken area of light on the face; often, as here, against a dark patch behind. His usual method is to turn the face away, to slide the features to the edges, and present a broad, glowing cheek, as in *Colonel St Leger* (FIG. 19). With profiles a bland glow of light is customary: according to Lairesse, in correct lighting 'a great Mass of Light remains together [on the profile face] ... not broked by any Ground-shade, but united by the

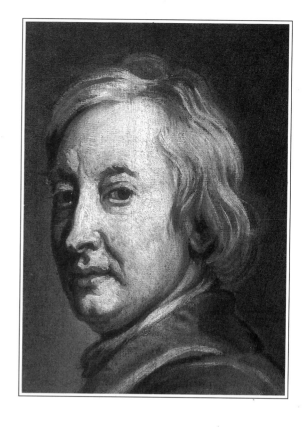

Fig. 56
KNELLER
John Dryden (detail) 1697
Trinity College, Cambridge

Roundness; which shows us how to represent rising Nature, and cause a becoming Relief'.[14] The profile's 'becoming relief' is further attained by settling for a vivid impression of low-relief rather than a feeble impression of full-relief: in other words the face is painted as if squashed almost flat, like the barely-salient profile on coins or medallions. None of these things usually occur in portraits where the face is viewed frontally; indeed the posture itself was regarded as the 'least picturesque of all natural positions'.[15] However, Reynolds choses the 'unpicturesque' 'full-face', and imagines the head minted frontally on to a coin, with the same conventions as a profile relief: as if it is pressed flat like a mask. The result is wide, with low-relief forward projections implied by the faint smudges of half-shadow. The only painter previously to have employed this widening and flattening of the face was Holbein. It is perhaps significant that only two years before this portrait Reynolds executed his famous parody of Holbein's *Henry VIII* (FIG. 142). As Lairesse's remarks suggest, Reynolds' effect in *Hely-Hutchinson* represents 'rising nature' with more *fullness* than the deeply-shaded Hudson. It is also much more communicative: the sitter seems to be squashing his face up against the glass of the frame in order to talk to us.

One curious feature of Ramsay's *Lord Drummore* (FIG. 54) is the way in which much of the face is picked out in white highlight, something which in oil-painting is usually reserved for eyes and lips alone. Ramsay's technique here recalls those drawings, executed on grey paper with white and black chalks, where the white is an essential part of the modelling, not

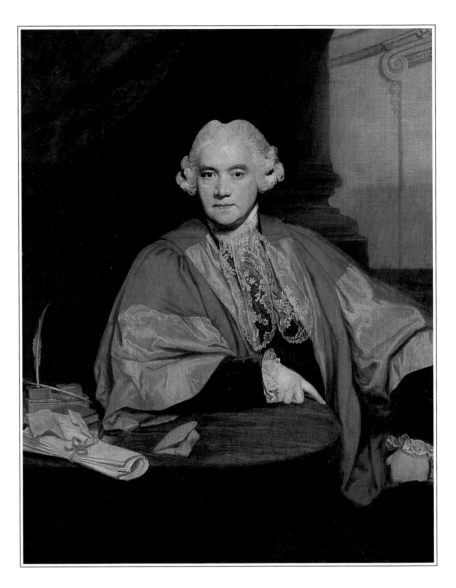

Fig. 57
REYNOLDS
*The Rt. Hon. John Hely-
Hutchinson* 1778
NATIONAL GALLERY OF IRELAND,
DUBLIN

just a finishing touch. This small detail is a symptom of a transformation taking place in portraiture at this time (1754); besides the development of more 'natural' informal postures, there was also an important change in the way artists handled paint. This shift could be called the 'pastel revolution'. Pastel painting thrived as a cheap speciality, especially in the 1740s, before it began to influence, in about 1750, the more prestigious medium of oil.[16] The best indicator of this upgrading is Francis Cotes (1726-70), who began to make his name as a pastellist in the late 40s and, by the time of his early death, was Reynolds' principal rival in full-length oil portraiture.

However literary they may sometimes seem, English writers and artists were very attentive to what might be called the *culinary* side of painting: the arrangement of the palette, the handling of the brush, the texture of the paint, the quality of the surface, and so on. In addition to being a window onto the world, a painting should have in itself an

appetising look. One characteristic that was generally admired was 'breadth', an application of paint which is neither finicky, hesitant nor watery. Some, however, felt that breadth could run to excess, as was sometimes suggested in the case of Kneller. The viscous ribbons of oil-paint trailed over the face by his broad brush (see *FIG.* 56) were regarded by some as mannered and imprecise. The word used to describe this is 'square' – 'Kneller always drew his pictures square,' Rouquet writes in the 1750s, 'but this was a vicious affectation, since it is not founded in nature.' Similarly sloppy, in Rouquet's view, is the trick of leaving the canvas apparently unfinished. Ramsay, on the other hand, 'brought a rational taste of resemblance with him from Italy'.[17] Edward Edwards, writing in 1808, similarly sees the contrast between Ramsay's and Kneller's treatment of the face as a 'calm representation of nature' re-placing a 'mannered affectation of squareness'.[18] But at the time Ramsay's more scrupulous, less painterly, shaping of the face was regarded with suspicion by some of the older generation. Vertue in 1739 writes that Ramsay's work is 'neither like the valuable Manner of Dahl Kneller Lilly Riley Dobson Vandyke Rubens or Titian – however it is rather lick'd than pencilld. neither broad, grand, nor Free, has more of the finishd labourd uncertain – or modish French, German, &c. dutch way'.[19] According to this view, Ramsay has sacrificed breadth, which means that his works are 'laboured' and over-detailed, having an unappetising, 'lick'd' surface.

Pastels offer a valuable compromise between the two extremes of excessive breadth, on the one hand, and an over-polished, shiny finish, on the other. Even if highly finished, pastels are pleasantly matt, for 'having their surface dry, they partake in appearance of the effect of Fresco', at least according to Francis Cotes, 'and by candle light are luminous and beautiful beyond all other pictures'. (*The European Magazine*, 1797)[20] A dry, powdery surface is obviously pleasing in itself, as well as being flattering to the sitter's complexion; this was a time when both sexes applied cosmetic powder to hair and face. The dryness gives a misty, luminous atmosphere over the face. In William Hoare's *Self-Portrait* (*c.*1745) (*FIG.* 58) everything has been carefully finished, all marks of chalk-stick have been dusted away, and yet the impression is not of a 'lick'd' finish, but of a velvety, powder-puff softness.

Another pastel of twelve years later, Francis Cotes' portrait of his father (1757) (*FIG.* 59), shows a freer touch with the chalk, seen in the broad, porous highlights over the cloak and in the touches of orange and blue, rubbed and blended into the face.

The 1750s is the great decade for pastels. For not only were there the local practitioners, but during the years 1753-6 the Swiss pastellist Jean-Étienne Liotard appeared in London and 'diverted the torrent of fashion from the established professor', that is, Hudson.[21] It is around this date that Allan Ramsay sought to reproduce some of the pastel effects in oils. In his *Dr William Hunter* of 1758-60 (*FIG.* 60) the background is fluffed up like a luminous cloud, and the face is drawn with innumerable but faint parallel strokes of the brush. No feature is delineated sharply, and indeed some important outlines are missing, yet the general shape is clearly seen

Fig. 58
WILLIAM HOARE
Self-Portrait, pastel *c.*1745
ROYAL ACADEMY OF ARTS

through a kind of gauze of strokes: it is as if Ramsay were not painting skin itself, but a gentle down of light clinging to it.

Pastels were informal by their very nature: they were cheap, they seldom showed more than head and shoulders, and were regarded as something between a sketch and a full painting. Like a sketch they can even suggest movement, by a kind of blurred double-outline. By imitating pastel Ramsay gives the same informal, transitory feel to his oil, which suits the animated gesture, the communicative expression, the generally light tone and unfinished background. There is also a particular effect, here and in *Lord Drummore* (*FIG.* 54), of an atmospheric clothing to the figure, which is produced by the face and hands being almost identical in tone and colour to the background, rather than contrasted as one might expect.

Reynolds was also affected by these technical developments but, after a great deal of experimentation, his mature solution was very different from Ramsay's. In his *Sir Joseph Banks* of 1773 (*FIG.* 61) there is no sign of any fluffing up with the brush, the drawing of the face is simple and its surface is smooth. Yet this smoothness is without the unpleasant gloss that Vertue warned against, for 'embedded' in it are varied colours and mottled patterns. Reynolds has looked at the effects of pastel, such as can be seen in William Hoare's *Self-Portrait* (*FIG.* 58), where the drawing is simple and the forms rounded and smoothed, as if the head were of half-polished marble. High quality marble can look matt, even if highly polished, for the light reflects from a mottled pattern of tiny flakes *inside* the semi-transparent stone. This is the effect that Reynolds seeks in the medium of oil by covering dabbed, mottled layers of paint on the face

Fig. 59
FRANCIS COTES
The Artist's Father, pastel 1757
ROYAL ACADEMY OF ARTS

with a smooth, thin and transparent layer. The source for this technique in *Sir Joseph Banks* lies in the work of Rembrandt, who has also taught the techniques of depicting deep-pile velvet and fur, the soft mottling of the background objects and the halo of light round the figure. Rembrandt also lends an appropriately Dutch (and therefore 'maritime') look to this portrait of a famous sea-explorer.

As with many of the portraits in this section the viewer here seems almost to intrude upon the sitter. Sir Joseph Banks, disturbed at his work, smiles bluffly at us and begins to lever himself onto his feet to greet us – an idea taken from Rembrandt's *The Syndics*. On the papers can just be read the last line of a Horace *Ode* (Book I, no. vii). Erudite eighteenth-century viewers, who could supply the rest of Horace's sentence, would find themselves reciting in front of this portrait . . .

> *O fortes peioraque passi*
> *mecum saepi viri, nunc vino pellite curas;*
> cras ingens iterabimus aequor
> O ye brave heroes, who with me have often suffered worse misfortunes, now banish care with wine! *Tomorrow we will take again our course over the mighty main.*

(Loeb Classical Library Translation)

This passage supplies exactly the devil-may-care blend of *bonhommie* and endeavour, of wine and adventure, that Reynolds seeks to match. We are to imagine ourselves having suggested a jaunt to Botany Bay, which Banks has met with cheerful readiness and a slight frown of resolution.

Of the Regency generation of portraitists it is Raeburn who is most at home in this direct and down-to-earth genre, as can be seen from his

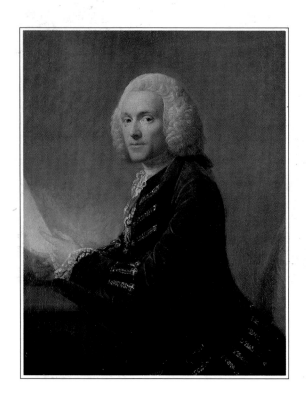

*c.*1798 portrait of John Robison, the professor of Natural History at Edinburgh University (*FIG.* 62).[22] The Scots are again well represented in this tradition, because of their links with France and the enlightened Parisian world of the *philosophes,* where learning was combined with the elegance and urbanity of 'men of the world'. Raeburn's *Professor Robison* obviously resembles the two Reynolds portraits in its composition and characterisation. Raeburn's application of paint is, on the other hand, much more direct than Reynolds'. Smooth areas of colour, especially the pure white, seem to come straight from the tube. The wide flat face of the brush everywhere leaves its shape: in unrounded contours and squared, Lux-flake details. The clean sharpness of the outlines gives an effect of great focus and precision, yet the eye is forced to accept a sketchy shorthand of brushwork. The simplification is sometimes teasingly blatant: one cannot follow the stripes of the cloak and, where it folds, its under and upper sides run together without a line. This

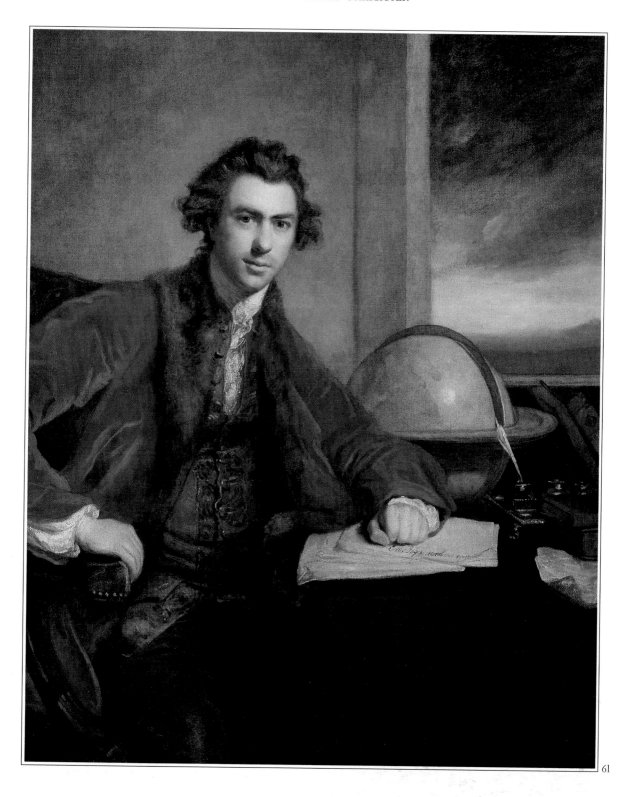

61

Fig. 62
RAEBURN
Professor John Robison c.1798
THE UNIVERSITY OF EDINBURGH

garment is an informal dressing-gown, the conventional garb for a thinker at work. With the white turban-like cap, there is an echo of Rembrandt patriachs and scholars, though Raeburn seems to have washed off the varnishy, old-master patina which lends such a venerable air to *Sir Joseph Banks*.

'In you, sir,' Reynolds is supposed to have said to the youthful Thomas Lawrence, 'the world will expect to see accomplished all that I have failed to achieve.'[23] Lawrence's 1828 portrait of the architect Sir John Soane (*FIG. 63*) could be said in most ways to justify Reynolds' confidence. Like the sitters of the Reynolds portraits in this section, Sir John Soane is informally presented, kindly and communicative. According to Northcote, Reynolds 'has succeeded in giving such momentary action and expression as would have surprised both Titian and Vandyke could they have seen his works; they painted hours, Sir Joshua moments'.[24] Sir John Soane's expression, with his head tilted and thrown back, a quizzical

smile just lighting the features, is, if anything, more 'momentary' even than Sir Joseph Banks' (*FIG.* 61). But it is in technique that Lawrence could be said to assimilate the same tradition as Reynolds and to handle it with more assurance. As in Reynolds' work, expressive accents are learned from Rembrandt: the broadly painted left hand, for example, with prominent tendons and dipped in a pool of light, which spreads over the chair-arm in a glow of ribbed gold; the deep red halo steaming off the back of the chair; or the veil of light over the face, which seems to lift the shadow out of the wrinkles of the otherwise old and leathery-looking skin, as if a candle were shining *through* some translucent substance from behind. Even the inordinate width of upper-eyelid is a Rembrandt trick of physiognomy, to give a patriachal dreaminess to the expression.

Reynolds' real disadvantage in this comparison is that, as was generally acknowledged, he couldn't draw.[25] With some exceptions his drawings are undistinguished and his paintings lack a graceful, *linear* treatment of detail. A virtue is made of this necessity by Reynolds' use of bold elementary shapes (another Rembrandt trick): so, for example, Sir Joseph Banks' body makes a sphere like the globe beside him, and his face is an undeviating egg-shape. Even the details of hands, nose and eyes are similarly treated; not very ornamental, but bold and broadly effective. The black silhouette of Sir John Soane's suit, on the other hand, has a snaking outline – never stiff, never abrupt – making a pleasingly varied, slightly attenuated shape. His face, even with its simple bulb-flame of light, is similarly *decorated* by drawing: the features, especially the line of shadow on the side of the face, have a sort of wobble which gives rhythm and animation to the expression. The contrast can best be seen in the hands. One of Banks' hands is a simple fist, fringed with shadow and the other a fingerless hook, gaining purchase on the chair-arm, whereas the hands in Lawrence's portrait, even with their Rembrandtisms, have delicately opening fingers, with curling slivers of shadow to separate them. Rubens is the ultimate inspiration for this curvacious dexterity, which quickens even the extremities in Lawrence's portraits (see *FIG.* 124). It is only when taking the eye off these felicitous details that one notices the lack of a certain hearty emphasis, to be found in Reynolds' work, a quality which may not be very suave but which demands attention – with all the subtlety of a man thumping the table.

The 'simple domestic' portrayal of Sir John Soane brings us back to Lawrence's *George IV* (*FIG.* 50) with which the chapter opened. It is Reynolds' paintings such as his *Hely-Hutchinson* (*FIG.* 57) that are the immediate source for such a face, with its glow, its cheery assertiveness and its unnatural roundness and flatness, as if the cheeks had been pulled forward like a mask. Unlike Reynolds' work, however, the face is covered with linear subdivisions, all of them nearly the same size and all tending towards a circular form – the little domes of the lightly dimpled cheek or chin being roughly the shape of the eye-socket, and so on. Thus, instead of features that seem to be adrift in a wide, uneventful globe of face, the features and the spaces between them make a coherent pattern, at once expressive and ornamental.

Fig. 63
LAWRENCE
Sir John Soane 1828
BY COURTESY OF THE TRUSTEES
OF SIR JOHN SOANE'S MUSEUM

For all his 'private dress', George IV was not sitting as a mere private gentleman, nor is this altogether the 'simple domestic' portrait Lawrence claims. A flattened, widened and fully-frontal face is a standard sign of authority in art. It is this device that gives the iconic, impersonal dignity of a Christ, a Jupiter or, as here, a king. Thus the Henry VIII of Holbein (*FIG.* 143) stares straight out of a Mercator's projection of a face, impaled between symmetrical strips of flock wallpaper. George IV's head is also placed at approximately the centre of the image, set off by storm clouds, and framed by a grand arch which looms surprisingly just behind his drawing-room sofa. In the same way there looms behind this intimate and affable image the suggestion of Olympian authority, of a Jupiter enthroned. A *Jupiter ridens* perhaps, but a Jupiter nonetheless.

CHAPTER 6

THE CHILD OF MODESTY

In gay content a sportive life she led,
The child of Modesty, by Virtue bred:
Her light companions Innocence and Ease:
Her hope was Pleasure, and her wish to please:
William Hayley,
The Triumphs of Temper, 1781, Canto I, ll. 57-60.

'WHY, REALLY, MA'AM, AS TO YOUR BEING A LITTLE OUT OF sorts, I must own I can't wonder at it, for, to be sure, marriage is all in all with the ladies; but with us gentlemen it's quite another thing!' So the presuming Mr Smith begins to consider proposing to the heroine in Fanny Burney's *Evelina* (1778, Volume II, Letter XIX). He chooses the wrong moment to bring it up, but the idea he expresses is a commonplace: for women marriage is all in all. Later in the century Mary Wollstonecraft laments that 'women have no other scheme to sharpen their faculties'.[1]

Portrait painting reflects this state of affairs. One need only look at the occasions that give rise to a portrait commission in the first place. For men, it may be membership of a club, succession to a title, or some achievement; for women it is marriage.[2] There are some specifically nuptial portraits of men; sitting for one was part of Willoughby's wedding preparations in Jane Austen's *Sense and Sensibility* (Chapter 32), but almost *all* portraits of women are in some way nuptial.

It is not that women have nothing else in their lives; it is that everything else bears upon their marriage. Marriage is their reward; their duty is domesticity. As Richard Steele pronounces, 'the utmost of a Woman's Character is contained in domestic life . . . All she has to do in this World, is contained within the Duties of a Daughter, a Sister, a Wife, and a Mother'. (*The Spectator*, no. 342, 1712) This is a view that Mrs Barbauld confirms in the next century: 'Men have various departments in active life; women have but one, and all women have the same, differently modified indeed by their rank in life and other incidental circumstances. It is to be a

wife, a mother, a mistress of a family.'[3] Both these writers confirm the impression gained from the portraits of the period that if a sitter is shown as a sister, a mother or even a daughter, this is but an augury or aspect of her fundamental duty – as a wife.

The purpose of such images is of course to suggest that the woman in question is (or will make) a good wife, which slightly presupposes that she is chosen for her worth rather than her wealth or lineage. But then this is the great age of the 'free' marriage – the love-match. According to Henry Brooke, 'In England our actions are as free as our hearts; and the sensibilities of mutual love between those of the sexes who feel that tender and inchanting passion, constitute the principal happiness of which life is capable.'[4] A French visitor in the 1780s confirms the impression that this freedom was regarded as a uniquely English thing. 'At twenty years old' he writes, 'an English girl is her own mistress, she can leave her father's house and marry as she pleases. There are no convents here to lock her up in.'[5] Free love of a chaste kind, this is the new message exported by the gallant *milord*, Conte Robinson, in Cimarosa's *Il Matrimonio Segreto* (1792), and by the pert English maid, Blonde, in Mozart's *Die Entführung aus dem Serail* (1782). It could, of course, be pointed out that immense pressure was brought to bear in the period to marry 'prudently' – for money and with parental consent. It could be objected, quite rightly, that operas and romantic novels do not depict real life, but then neither does portraiture. The matter is summed up, with a comic flourish, by Edward Talbot's tale in Jane Austen's *Love and Freindship* of 1790:

> 'My father, seduced by the false glare of Fortune and the Deluding Pomp of Title, insisted on my giving my hand to Lady Dorothea. No never exclaimed I. Lady Dorothea is lovely and Engaging; I prefer no woman to her; but know Sir, that I scorn to marry her in compliance with your Wishes. No! Never shall it be said that I obliged my Father.'
>
> We all admired the noble Manliness of his reply. He continued. Sir Edward was surprised; he had perhaps little expected to meet with so spirited an opposition to his will.
>
> 'Where, Edward in the name of wonder (said he) did you pick up this unmeaning gibberish? You have been studying Novels I suspect.'
>
> Letter the 6th.

We may safely assume that portrait painters and their clients had also been studying novels.

So if everybody marries for love, what is it that makes a woman lovable? Put simply the answer to this question is beauty and virtue. One might think that portraiture, having so much to do with externals, would concentrate on beauty and leave virtue to the poets and writers of dedications, but this is not the case. The whole thrust of serious portraiture, especially in the second half of the century, is to suggest both these qualities, even to the extent that a purely beautiful portrait, if at all ostentatious or flashy, is sometimes regarded as compromising its own and its sitter's virtue. Hoppner, after spending years thinking of something really damaging to say about Sir Thomas Lawrence, finally came up with this: 'The ladies of Lawrence show a gaudy dissoluteness of taste, and

sometimes trespass on moral as well as professional chastity.' Another contemporary put it more epigrammatically: 'Phillips [Thomas Phillips 1770-1845] shall paint my wife, and Lawrence my mistress.'[6] The reason a brilliantly painted and glamorous portrait might be considered suitable only for a kept woman is that the principal female virtue of the age was modesty.

The type of portrait particularly stigmatised for its absence of professional (as well as every other kind) of chastity was that of the Restoration, especially the series of 'Court Beauties' by Sir Peter Lely, of which his *Elizabeth Hamilton, Comtesse de Grammont* (*c.*1663) (*FIG.* 64) is an example. According to Hazlitt in 1824, 'they look just like what they were – a set of kept-mistresses, painted, tawdry, showing off their theatrical or meretricious airs and graces, without one trace of real elegance or refinement, or one spark of sentiment to touch the heart'.[7] The phrase 'a spark of sentiment to touch the heart' is a reasonable summary of what Georgian Society looked for in the portrait of a lady. It is not likely to have concerned Lely much. His voluptuous *Comtesse de Grammont* wears a

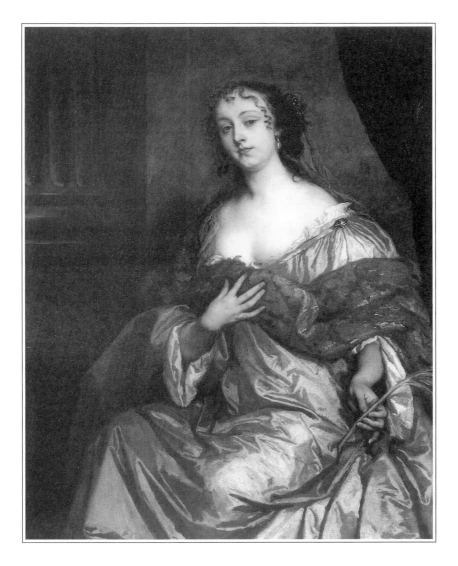

Fig. 64
LELY
*Elizabeth Hamilton, Comtesse de Grammont c.*1663
REPRODUCED BY GRACIOUS
PERMISSION OF HER MAJESTY THE
QUEEN

characteristic low-cut Arcadian dress, with breasts almost exposed, the head tipped back, lower lip pouting provocation, and a languid, heavy-lidded, sleepy expression. She has assumed 'all the graces in fashion', listed by Olivia in Wycherley's *The Plain Dealer* (1676) as 'the languishing eye, the hanging or pouting lip'. (Act II, scene 1)

The setting of this portrait is obviously imaginary. The nearest real event it corresponds to would be a fashionable lady's levée when, sitting up in bed and draped in a loose night-gown, she would receive her friends. This sort of behaviour began to shock even at the threshold of the Georgian age. Addison describes attending such a levée where the lady's 'Hair appeared in a very nice Disorder, as the Night-Gown which was thrown upon her Shoulders, was ruffled with great Care. For my part, I am so shocked with every thing that looks immodest in the Fair Sex, that I could not forbear taking off my Eye from her when she moved in her Bed, and was in the greatest Confusion imaginable every time she stirred a Leg or an Arm'. (*The Spectator*, no. 45, 1711)

Addison's remarks are part of a general reaction against the moral and sexual laxity of the Restoration Court. The moral majority started to feel outrage at the licence of the Restoration almost while it was still happening. The character of Olivia in Wycherley's *The Plain Dealer* of 1676 viciously satirises this new prudishness. It can further be seen in such works as Edward Cooke's *Just and Seasonable Reprehension of Naked Breasts and Shoulders* of 1678, which warns, among other things, that 'there is always danger in attentively looking upon a naked Breast'. Societies for the reformation of manners were being founded in the 1690s.[8] Further purification (or increase in prudery, depending upon your point of view) continued steadily throughout the century, so that by 1770 society had something approaching a 'Victorian' attitude to feminine chastity. In *Mansfield Park* of 1818, Jane Austen describes an adulterous affair involving a young bride – the staple diet of Restoration Comedy – as 'too horrible a confusion of guilt, too gross a complication of evil, for human nature, not in a state of utter barbarism, to be capable of!' (Chapter 46)

All this is bound to affect portraiture. Pope gives us an idea of how Lely's *louche* glamour-portraits (see *FIG.* 64) might be regarded in the reign of George II:

> *Lely on animated Canvas stole*
> *The sleepy Eye, that spoke the melting soul.*
> *No wonder then, when all was Love and Sport,*
> *The willing Muses were debauch'd at Court;*
> *Imitations of Horace,* Ep. II, i, ll. 149-52.

Sleepiness is obviously a sign of imperfect vigilance, of a yielding disposition. A 'melting soul' is another name for an available body. A few years earlier Hogarth had expressed similar bourgeois revulsion in his *A Harlot's Progress* Plate 3, of 1731 (*FIG.* 65). The harlot at her midday levée is a parody of Restoration portraiture. In the background the knotted bed-hanging and the attentive servant are both perversions of Baroque trappings. The triangular form of the figure, the zig-zagging knots of highlight on her silk night-gown, her exposed breast, her tipped-back

head, her smirk and literally sleepy eye – all these things echo Lely's *Comtesse de Grammont* (*FIG.* 64). Hogarth's point is two-fold: his harlot has gone astray by aspiring beyond her station, but equally Lely's Court Beauties are themselves harlots in all but name.

At the time of Hogarth's *A Harlot's Progress* portraits of this type were no longer being painted, yet for the next decade or so there was no very pronounced image to take its place. Portraitists of the 1730s and 40s seem to have been content with a sort of Bowdlerised version of Lely and Kneller – the same formal conventions without the sex-appeal. Hudson's *Jane Hollings, Mrs Champernoune* of *c.*1747 (not illustrated), for example, has Lely's imposing triangular outline, pouting smile and snaking highlights. The dress and setting are contemporary rather than Arcadian, which makes the depth of shadow somewhat inappropriate; we find ourselves wondering why Mrs Champernoune doesn't call for candles. But this shadow, creeping over the figure like airborn soot, is intended to convey a venerable 'old-master' dignity.

Fig. 65
HOGARTH
A Harlot's Progress, Plate 3 1731
FITZWILLIAM MUSEUM,
CAMBRIDGE

Meaningless darkness, pompous conventional dignity, and the 'authority' of the old masters, these are things that are banished from portraiture in the 1750s, at least for a while. We have already seen that Hogarth is their sworn enemy; so, also, in a more urbane style, is Allan Ramsay. In his *Dialogue on Taste* of 1755 he contrasts two imaginary disputants, Lord Modish and Colonel Freeman. The latter, Ramsay's own mouthpiece, at one point proposes an experimental way of judging a picture's value: 'Your Lordship has only to hide yourself behind the screen in your drawing-room, and order Mrs Hannah to bring in one of your tenant's daughters, and I will venture to lay a wager that she shall be struck with your picture by La Tour, and no less with the view of your seat by Lambert, and shall, fifty to one, express her approbation by saying, they are *vastly natural*.'[9] Everything about this exchange is 'enlightened': aesthetic judgement by means of an uneducated and therefore unprejudiced jurer, her common-sense criterion of 'naturalness', and the particular artists she singles out – Lambert and Maurice Quentin de la Tour. There is a type of portraiture to go with Colonel Freeman's liberal aesthetic, what the art historian Duncan Macmillan calls the 'empirical portrait'.[10] During the 1750s Ramsay forged a new image for women in portraiture: alert, intelligent, and communicative, yet 'natural' and unpompously elegant. His *Lady Susan Fox-Strangways* of 1761 (*FIGS* 2 and 66) is a fine, though late, example of the type. It is as if fresh air and daylight have flooded into the world of Hudson's *Mrs Champernoune*, with new manners and a new look to match. The pose, with its linking arms, is natural, 'probable' and intimate, as Lady Susan leans forward, tilts her head and half smiles at the viewer. The light has an even, misty softness, especially over the face, creating an atmosphere around the figure, echoed by the delicate greyish colour range.

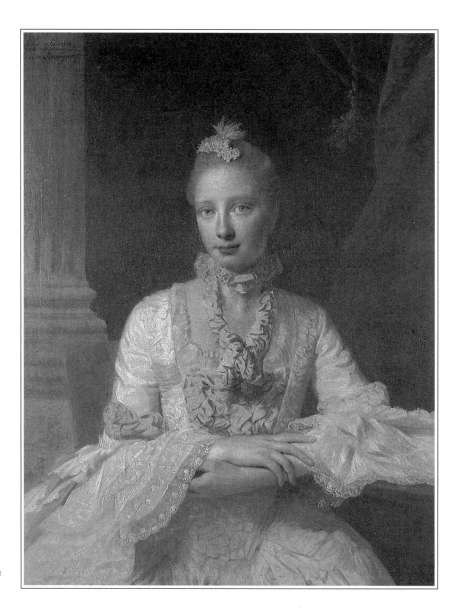

Fig. 66
RAMSAY
Lady Susan Fox-Strangways 1761
FROM A PRIVATE COLLECTION

Many of these things are similar to those already observed in Ramsay's portraits of men, such as *Lord Drummore* (*FIG.* 54), only here the 'natural' has nothing downright about it; it is all refinement – the caressing lock of hand and arm, the patterned, transparent gauze of lace, the glimpse of fluted ionic. It is for this reason that Ramsay was regarded as pre-eminent in the portrayal of women. Horace Walpole writes in 1759:

> *He [Ramsay] and Mr Reynolds are our favourite painters and two of the very best we ever had . . . Mr Reynolds and Mr Ramsay can scarce be rivals, their manners are so different. The former is bold and has a kind of tempestuous colouring; yet with dignity and grace; the latter is all delicacy. Mr Reynolds seldom succeeds in women, Mr Ramsay is formed to paint them.*[11]

The empirical portrait is especially appropriate for an enlightened sitter such as the writer, critic and hostess, Elizabeth Montagu – 'Queen of

the Blue-Stockings'. In Ramsay's 1762 portrait (*FIG. 68*) she is shown turning to an imaginary interlocutor with raised eyebrows and a slight smile, resting her elbow upon David Hume's *History of Great Britain*, a classic text of the Enlightenment. However remarkable the female writers of Georgian England may have been, as novelists, critics or correspondents, there was evidently little respect at the time for feminine intelligence. There is, however, a trickle of comments suggesting that women might be rational beings; Addison, for example, regrets that their 'Amusements seem contrived for them rather as they are Women, than as they are reasonable Creatures'. (*The Spectator,* no. 10, 1711) A similar view is expressed by Ramsay himself, when Lady Modish complains of being excluded from his *Dialogue on Taste*, and asks why women are addressed 'as if we were incapable of being entertained by any thing but trifles'.[12] But Abbé

Fig. 67
NATTIER
Queen Marie Leczinska 1748
CHÂTEAU DE VERSAILLES

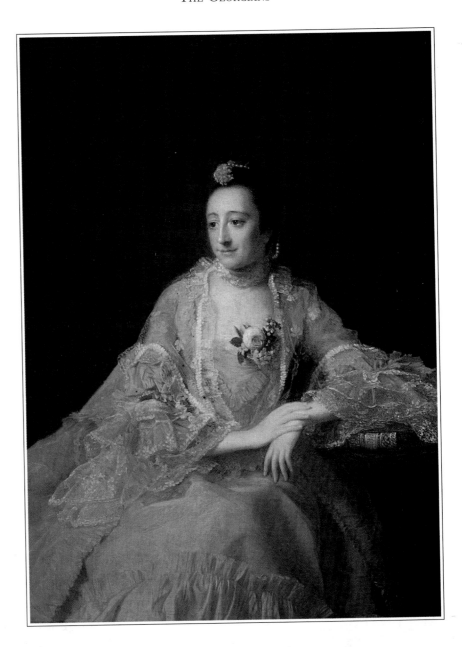

Fig. 68
RAMSAY
Elizabeth Montagu 1762
PRIVATE COLLECTION

Fig. 69
REYNOLDS
*Catherine Moore, later Lady
Chambers* 1752
THE IVEAGH BEQUEST, KENWOOD,
ENGLISH HERITAGE

Le Blanc is probably only being just when he claims that the English 'think the fair sex are made only to take possession of their hearts, and seldom or never to afford any amusement to their minds. They prefer the pleasure of toasting their healths in a tavern, to that of chatting with them in a circle'.[13] We have already learnt from his *Dialogue* that Ramsay admired French portraiture: the French look which he has given to his *Elizabeth Montagu* (*FIG.* 68) suggests Le Blanc's Gallic ideal of chatting in a circle, in the *salon* of an intellectual Parisian hostess. If *Elizabeth Montagu* is set beside a French portrait, for example Nattier's *Queen Marie Leczinska* of 1748 (*FIG.* 67), one can see the same smiling, informal animation, the same triangular outline and simple background, the close grey-peach colour range and the cloudy complexities of lace and gathered silk.

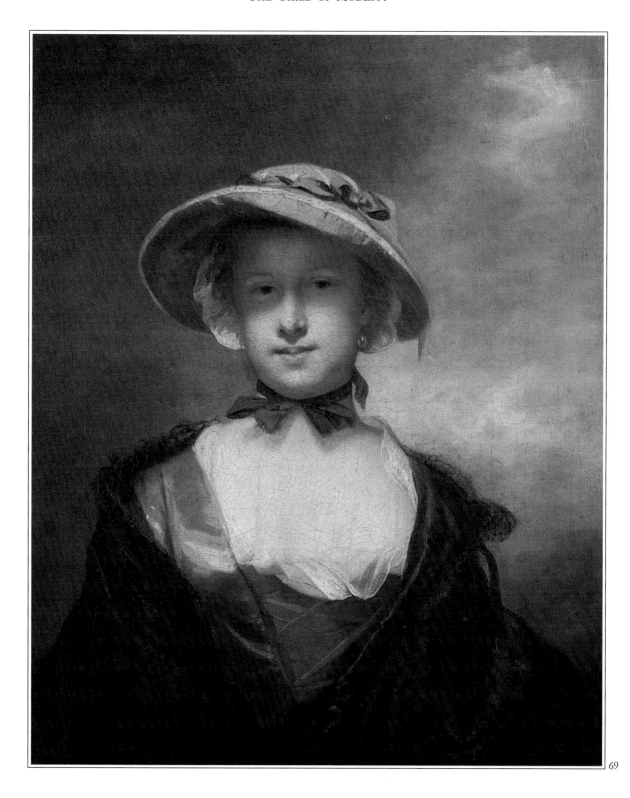

69

Reynolds' *Catherine Moore* (*FIG.* 69) shows that already in 1752 he had a distinctive vision in female portraiture, independent of Ramsay's evolution of the 'natural' portrait. Reynolds, on his return from studying in Italy, had met the sitter in Paris, with her future husband the architect William Chambers; perhaps the portrait's romantic sky is a reminiscence of fluffy blue backgrounds in French pastels. But, characteristically, Reynolds has looked past the immediate currents of eighteenth-centry art to the work of his beloved Rembrandt. The *Saskia* (Dresden Gallery) (*FIG.* 70), though its whereabouts at the time cannot be securely traced, provides the best point of comparison. In both works light collects in pools, spreading like droplets on blotting paper from centres around the sitter's mouth and chest. Both portraits use shadow, glare and refected light to reshuffle the usual pattern of features: the delineation of the brows, eyes and top of the nose is lost in the hat's shadow and in a diffuse reflected glow. On the lower part of the face the bridge of the nose and the crease above the upper lip are apparently 'steamed off' by a misty light, in Reynolds' case a light with a dappled pattern echoing the clouds behind. In both faces a simper is made mysterious by a light at once caressing and veiling. Perhaps it was a work like *Catherine Moore* that Northcote had in mind when he wrote of finding in Reynolds' portraits an 'atmosphere of light and shade' and 'a vagueness that gives them a visionary and romantic character, and makes them seem like dreams or vivid recollections of persons we have seen'. It is this that reminds Northcote of Rembrandt's work.[14]

Fig. 70
REMBRANDT
Saskia 1633
GEMÄLDEGALERIE ALTE MEISTER
– STAATLICHE KUNSTSAMMLUNGEN
DRESDEN

We have already seen in the first chapter that one of the snags of being a portrait painter is that you cannot afford to ignore fashion. For women, in the 1750s and early 60s, Ramsay is the fashion. So in these years, even with *Catherine Moore* (*FIG.* 69) behind him, Reynolds, is obliged, at least partially, to succumb. His *c*.1760 portrait of Kitty Fisher (*FIG.* 71), with its pose derived from *Lady Fox-Strangways* (*FIG.* 66), would have been yet more Ramsay-like had Reynolds finished it, adding all the intricacies demanded by lace cuffs and shawls. Even at this stage of the work, however, one can see distinctive Reynolds traits, especially on the only finished part, the head, which is drawn in simplified arcs of circles and moulded in a thick skin of smooth impasto, and which seems to lean forward out of the picture frame. This last effect suggests an intimacy, a confidential *tête-à-tête*, as it would be called, between the sitter and viewer, which is made sweetly beguiling by Kitty Fisher's looking up at us with tilted head and melting smile, cocooned in a soft light. With an even greater proximity and without its faint coyness, this image would approach the 'forewardness' deliberately adopted by Reynolds for his *Mrs*

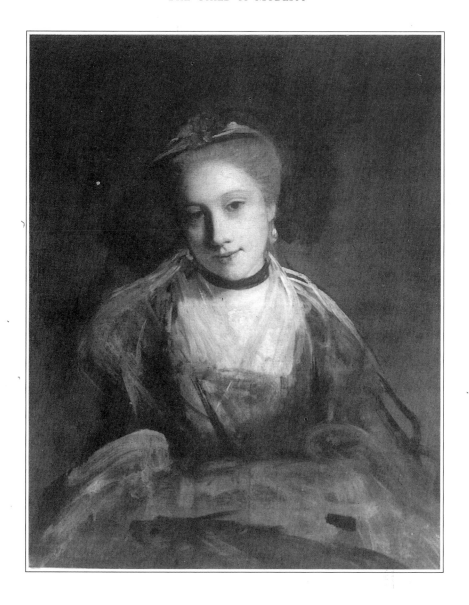

Fig. 71
REYNOLDS
Miss Kitty Fisher c.1760
PRIVATE COLLECTION

Abington as 'Miss Prue' of 1771 (*FIG.* 72). This famous comic actress is shown in the part of the country *ingénue* in Congreve's *Love for Love*. The moment depicted is probably Act II, scene II, where Miss Prue is taught a kind of wordly catechism in flirtation by Tattle. Reynolds has suggested her ill-bred directness, her 'hoydenish simplicity', by hanging her over a chair-back and putting her thumb in her mouth.[15]

The Countess of Blessington could be reasonably described as the Regency equivalent of Elizabeth Montagu – a successful writer, critic and hostess. Yet Lawrence's 1822 portrait of her (*FIG.* 73) takes its posture and its mood from the portraits of such intellectually unremarkable women as Lady Fox-Strangways and Kitty Fisher (*FIGS* 66 and 71). In itself, there is nothing surprising about this, except that there are other developments in portraiture which make the later image more yieldingly (even erotically) sentimental. Lady Blessington's costume is glossy and elegant, but simpler than either of the earlier sitters': the ermine of her rank is laid

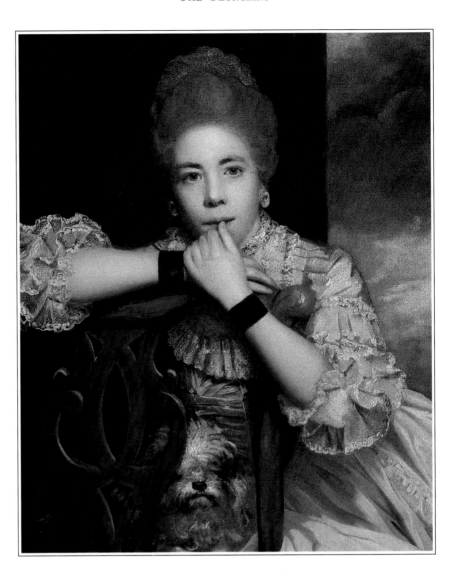

Fig. 72
REYNOLDS
Mrs Abington as 'Miss Prue' 1771
YALE CENTER FOR BRITISH ART,
PAUL MELLON COLLECTION

NIVELON

aside, her dress is modestly white and Lawrence has blurred away its top edge as if the skin ran on down to naked white breasts. We look down on the Countess of Blessington even more steeply than on Kitty Fisher, and from where we stand her seated figure has an obliging, submissive air. Lawrence further animates the engaging attention seen in Lady Susan and Kitty Fisher; his sitter looks up with tilted head and coy smile, her arms unlocking, hands just parting and held away from the waist to emphasise its slimness. The posture manual of François Nivelon recommends that when ladies curtsey they should link arms across the breast in a posture very similar to this: the 'inside of the Hands should be opposed to the breast, the Fingers being easy and a little separated, the Wrists must bend inwards, but not so much as to make the arms appear Lame', and so on. This action, intended to convey 'Humility and Respect', must be especially confirmed by the eyes, which are to be 'gradually raised' with 'becoming Modesty'.[17] Altogether the Countess of Blessington is far more intimate than intellectual, more obliging and seductive than alert or

witty. We are to regard her in much the same spirit as did her friend Lord
Byron:

> *Beneath Blessington's eyes*
> *The reclaimed Paradise*
> *Should be free as the former from evil;*
> *But if the new Eve*
> *For an Apple should grieve,*
> *What mortal would not play the Devil?*
>
> *Impromptu, 1823.*

Cunningham's remark about Lawrence's work also applies here: 'over all
his ladies, he sheds a soft splendour of colour, which, like sunshine in
dew, is as pleasant as lustrous; the eyes of his women are all mildness and
love.'[18]

To understand this type of image one must consider the views of the
other side concerning the question of female intelligence, the anti-
rational sentimentalists, who gain rather than lose ground through the

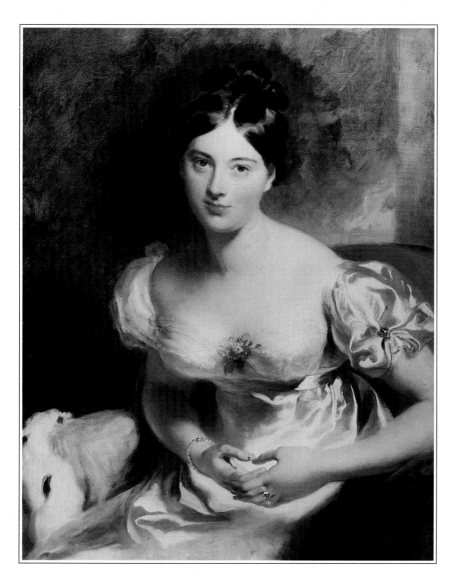

Fig. 73
LAWRENCE
Margaret Power, Countess of
Blessington 1822
REPRODUCED BY PERMISSION OF
THE TRUSTEES OF THE WALLACE
COLLECTION

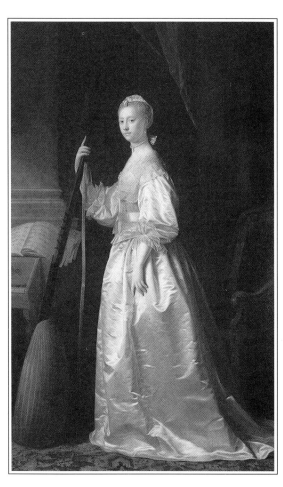

Fig. 74
RAMSAY
Lady Mary Coke 1762
PRIVATE COLLECTION

century. A typical view is given by William Melmoth, whose creation, Amasia, 'never said, or attempted to say, a sprightly thing in all her life; but she has done ten thousand generous ones', as if the two things were related![19] He goes on to describe the wise but modest Hortensia whose 'uncommon strength of understanding has preserved her from that fatal rock of all female knowledge, the impertinent ostentation of it'.[20] Mrs Barbauld in her much later *Legacy for Young Ladies* of 1826 thinks it 'desirable for women to be able to give spirit and variety to conversation by topics drawn from the stores of literature', but concludes that 'in no subject is she required to be deep, – of none ought she to be ignorant'.[21] According to this view, whatever sense the sex may be allowed is to be deployed solely for the entertainment and consolation of men. The important ingredient of female conversation is thus not wisdom but cheerfulness. According to Thomas Gisborne, writing in 1797, 'in powers adapted to unbend the brow of the learned, to refresh the over-laboured faculties of the wise, and to diffuse, throughout the family circle, the enlivening and endearing smile of cheerfulness, the superiority of the female mind is unrivalled'.[22] This, of course, presupposes a wise brow to unbend. What of women married against their will to rich, but stupid, husbands? William Hayley implores them not to sulk ...

> *But, with a lively sweetness, unopprest*
> *By a dull Husband's lamentable jest,*
> *Their constant rays of gay good-humour spread*
> *A guardian glory round their idiot's head.*
>
> *The Triumphs of Temper,* 1781, Canto V, ll. 549-52

One feels the poet to have been sadly in need of such a wife. The Countess of Blessington's husband was not an idiot, but her portrait (*FIG.* 73) seems to imply a man as viewer, for the entertainment of whom she is turning the glory of her constant rays of gay good humour.

Much more important than intellect as an ornament to the 'fair sex' is the possession of what were called 'accomplishments'. Fanny Burney sums up neatly what this means: 'Lady Honoria had received a fashionable education, in which her proficiency had been equal to what fashion made requisit; she sung a little, played the harpsichord a little, painted a little, worked a little, and danced a great deal.' (*Cecilia,* 1782, Book VI, Chapter II) But young ladies must be careful to cultivate their talents just so far and no further – 'a little music, a little drawing, and a little dancing; which should all ... be but slightly pursued, to distinguish a lady of fashion

from an artist'. (*Camilla*, Book I, Chapter VI) It is important, for example, for a girl to play the harpsichord or harp, but she must be careful not to make herself ridiculous, like Mary in *Pride and Prejudice*, by too pedantic an application. The ideal would be Sophia Western, at the harpsichord, soothing her drunk father to sleep with his favourite ballads rather than the demanding modern compositions of Mr Handel, or Anne Elliot playing the piano unobserved so that others could dance. (*Tom Jones*, Book IV, Chapter 5; *Persuasion*, Chapter 8)

One of the most stately depictions of the accomplished lady musician is Ramsay's *Lady Mary Coke* of 1762 (*FIG. 74*). It is unusual, for Ramsay, in its formal dignity, its detailed background and its obvious reference, in the costume and its treatment, to Van Dyck.[23] But Van Dyck is not the only model; there are echos here of the modest workmanship of Dutch genre painting, which Ramsay would have admired for its 'naturalness'. Gerard Terborch is the particular model (see *FIG. 75*), who took Van Dyck's sheen of satin and gave it a crisp brilliance, as if creased silver-paper had been stuck to the canvas. Terborch also suggested depth by using 'focus' rather than perspective, with an intense hyper-clarity for the nearest objects and an increasingly dark, cloudy treatment of the background, as if seen through fine grey dust. All these features occur in *Lady Mary Coke*; even the simplified face, in soft and pearly half-focus, and the bass thorebo remind the viewer of Terborch's glimpses of Dutch high life. *Lady Coke* accidentally points upwards with her right hand, a conventional gesture to indicate the divine inspiration which, by all accounts, her playing was sadly in need of.

The inspiration for Gainsborough's 1760 portrait of the wife of his friend Philip Thicknesse (*FIG. 76*), is again Van Dyck, but here the metallic brilliance of gathered silk is blended, almost coagulated, by light and by sketchy brushwork. Mrs Thicknesse, who was a novelist as well as a brilliant amateur musician, is shown as a kind of protectress of music, with scores and instruments. For this Gainsborough's inspiration is Maurice Quentin de la Tour's portrait of Madame de Pompadour (*FIG. 77*), with instruments, volumes and a portfolio, as a universal patroness of all the arts. *Mrs Thicknesse* may be an example of that 'professional unchastity' which Hoppner later complained of in Lawrence's work; it may have crossed the shadowy line between the modest and the ostentatious. Some contemporaries evidently found in it something too obtrusively French, something flashy or indelicate – more Mary Crawford and her harp, than Anne Elliot and her piano. Mrs Delany wrote of the painting at the time that it was 'a most extraordinary figure, handsome and bold; but I should be sorry to have any one I loved set forth in such a manner'.[24]

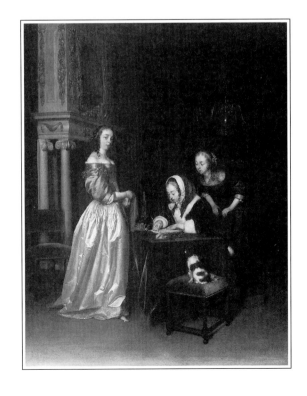

Fig. 75
GERARD TERBORCH
Curiosity
THE METROPOLITAN MUSEUM OF
ART, NEW YORK, THE JULES
BACHE COLLECTION

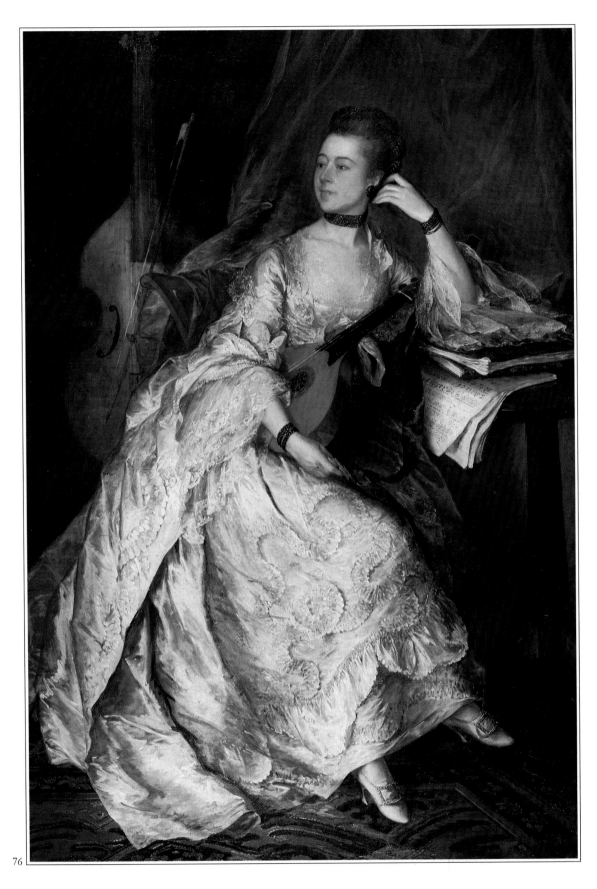

76

There were other occupations for ladies which were less 'bold', which had less scope for ostentation. The only one to graduate from being a mere accomplishment to being a positive virtue (or at least a symbol of Virtue) was needlework. In 1738 Gerard de Lairesse recommends that the portrait of a *'young and sober Virgin'* should be accompanied by an allegory of Neatness with 'an embroiding frame and its furniture', besides emblems such as 'Business, shunning Idleness, Pride and Gluttony'.[25] It is difficult to see how the most assiduous plying of the needle can divert a young woman from Gluttony, but the passage invokes the virtues of Industry and Modesty with a kind of logic. Later in the century Lady Bute

Fig. 76
GAINSBOROUGH
Ann Ford, Mrs Philip Thicknesse
1760
CINCINNATI ART MUSEUM,
BEQUEST OF MAY M. EMERY

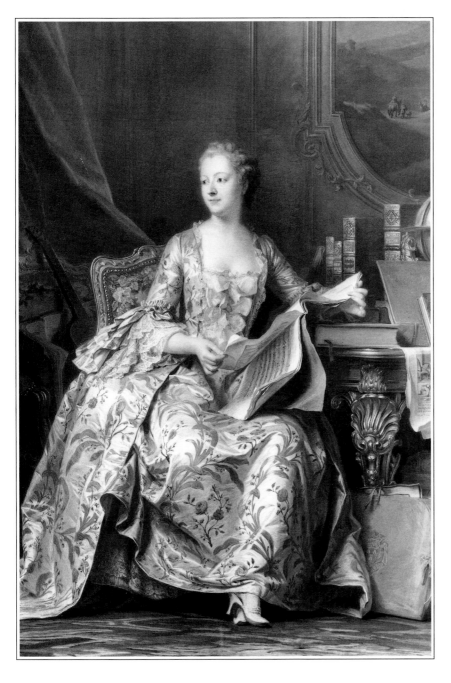

Fig. 77
MAURICE QUENTIN DE LA
TOUR
Madame de Pompadour
MUSÉE DU LOUVRE

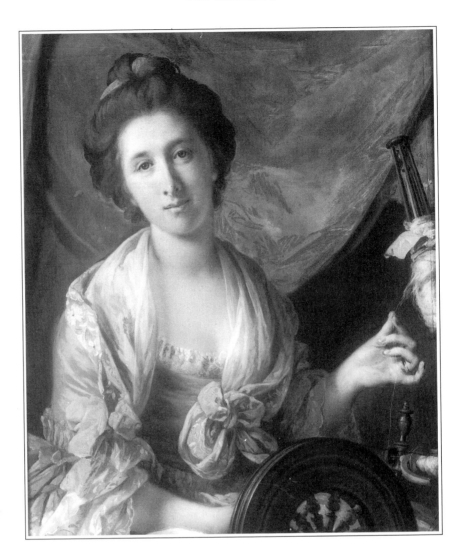

Fig. 78
FRANCIS COTES
Lady Hoare Spinning 1766-70
THE NATIONAL TRUST,
STOURHEAD

earnestly recommends to her daughter, though she has '*several* accomplishments' for her amusement, 'not to neglect the less genteel employment of *good housewifery*'; for '*sensible* men are more likely to have serious thoughts of young ladies whom they observe to be neatly dressed, unaffected in behaviour, with good humour, and *attentive to economy*, than of indolent and accomplished beauties!'[26]

Out of this pool of virtues Francis Cotes chooses industry and good humour for his pastel of Lady Hoare (1766-70) (*FIG. 78*), smiling as she looks up from her work at a spinning wheel, with characteristically intimate proximity. Presumably this was commissioned to hang as a pair with Cotes' pastel of her husband, who holds a crayon and drawing paper: the female art of weaving is seen to complement the male art of design. There is even an echo of the myth of Pandora, the woman endowed by the gods with all useful feminine arts, including Pallas Athene's contribution, the art of weaving, which, according to James Barry, enables her to perform her 'respectable matrimonial duties'.[27] For this reason the distaff here is an emblem of virtuous femininity.

Many years later, in 1780, Horace Walpole commissioned Reynolds to depict his 'three fair neices', the Ladies Waldegrave (*FIG.* 79). 'They are embroidering and winding silk,' he writes of the result. 'I rather wished to have them drawn like the Graces adorning a bust of the Duchess as the Magna Mater – but my ideas are not adopted.'[28] Walpole is being flippant, but he inadvertently points out that there *are* characteristics of the Three Graces in the three girls. Each turns to the one next to her, making an unbroken ring of glances, and their communal work – the fact that they are helping each other – is suggestive of the Graces' sisterly friendship. The association of such work with sisterly affection is an aspect of its general meaning that Jane Austen cunningly turns on its head in *Sense and Sensibility*. At the height of their rivalry, Elinor helps the venemous Lucy Steele with her filigree basket, so that the 'the two fair rivals' appear 'seated side by side at the same table, and with the utmost harmony engaged in forwarding the same work'. (Chapter 23) Just like the *The Ladies Waldegrave* (*FIG.* 79) in fact. Only the reader knows that their inaudible conversation is (on one side at least) the purest extract of malice.

Walpole's mention of 'the Three Graces' reminds us that this group portrait could have been a grand affair on the lines of Reynolds' *Three Ladies Adorning a Term of Hymen* (Tate Gallery). The setting of columns, landscape and a continuous shoulder-high pedestal is as dignified and as unspecific as the grandest portrait background. But here it is like a stage set which remains the same whatever scene is being played, for in front Reynolds has created with a few 'props' – a table, some chairs – the illusion of a cosy, domestic interior. This draughty compromise of an 'open interior' is also used in Lawrence's nocturnal *Countess of Blessington* (*FIG.* 73) where a deep blue sky behind the sitter's head suggests the summer night beyond the candlelight of a Blessington *soirée*.

Walpole remarks elsewhere of Reynolds' *The Ladies Waldegrave* that his 'journeyman, as if to distinguish himself, has finished the lock and key of the table like a Dutch flower-painter'.[29] This is surely not an assistant's idea: though the figures themselves are rendered in simplified forms, an intricate Dutch look on the table is a domestic characteristic and an oblique reference to the delicate workmanship of the sisters' embroidery.

The lowered eyes of the Waldegrave sisters, their marble skin, their white dresses, all imply a becoming bashfulness and purity. They draw forth admiring gazes unconsciously, doubting their own powers of allurement 'with all the modest charms of sweet distrust', to quote again from Willian Hayley. (*The Triumphs of Temper*, Canto VI, l. 150) Another reason for the ostentatiously finished lock-and-key of the table also relates to modesty, for a locked drawer is a traditional emblem of virginity.

The connection between embroidered work and modesty can probably be seen most clearly in Reynolds' *c.*1766 portrait of a woman famed for her domesticity, Mary, Duchess of Richmond (*FIG.* 80).[30] With her hair tightly plaited and wearing the simplest of coats, the sitter is shown working assiduously at her sampler, in what appears to be candlelight. She requires no allegorical accompaniment of Neatness – she is almost an allegory herself. In her *Evenings at Home* of 1794 Mrs Barbauld imagines a young girl's Choice of Hercules, with Dissipation and Housewifery

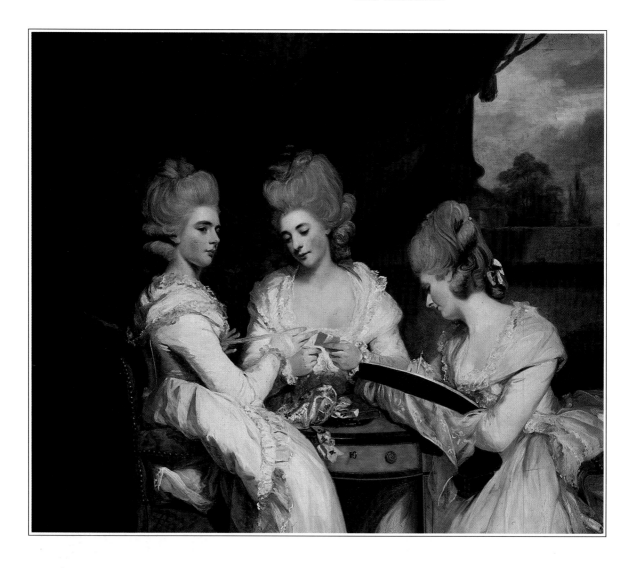

Fig. 79
REYNOLDS
The Ladies Waldegrave 1781
NATIONAL GALLERY OF SCOTLAND

competing for her attention. Housewifery wears a 'close habit of brown stuff ... her smooth hair under a plain cap. Her whole person was dressed perfectly neat, and clean. Her look was serious, but satisfied; and her air was staid and composed'. She holds a distaff and work-basket, while other 'implements of female labour' hang around her waist. She cannot promise the hesitant Miss Hercules much fun, but what she can promise is that she will win 'the esteem of all who thoroughly know [her]'.[31] 'Housewifery' here is modelled on a tradition of allegorical figures, carrying a variety of names. Humility is one, who appears in a 1766 collection of emblems with a 'dress and coat of Brown' and with her eyes turned down.[32] Another is Simplicity, that 'offspring of modern poetry', described by an anonymous poet in 1773:

> *Come, with thy pleasing robe of heathy brown,*
> *Of wollen manufacture trimly dight,*
> *Which flows indeed, and scarcely flows, adown,*
> *And not a fold misleads the steady sight.*
>
> *Morning,* 11, 9-12.[33]

118

Whichever name you might choose to attach to her, it is clear that the Duchess of Richmond (*FIG.* 80) belongs to this tradition: her coat is of simple wool, remarkably foldless and brown, she holds implements of female labour, she looks down, and has about her that modest, staid contentment which commands esteem. According to Henry Brooke, 'finery

Fig. 80
REYNOLDS
Mary, Duchess of Richmond
*c.*1766
From Goodwood House by
Courtesy of the Trustees

may dazzle, it may awe, but cannot possibly excite the smallest pittance of affection'; *this* requires what we see here, 'that ornament of a clean simplicity' which intimates a 'deeper purity'.[34]

The modest feminine virtues all collect together in a poem of 1781, which has already been frequently cited: William Hayley's *The Triumphs of Temper*. Written as a kind of modern answer to the satirical view of women in the *The Rape of the Lock*, it picks up the one serious passage in Pope's poem, his praise of good humour (*The Rape of the Lock*, V, ll. 16-34), to extol the virtues of cheerfulness at considerably greater length. The 'Temper' of the title means, of course, good or even temper. The heroine Serena's dogged good humour is put to the test by her gouty father and other little trials, but the dominant principle of her life, 'her wish to please', stays firmly in place (Canto I, l. 60). Her 'temper' is then 'seasoned' with Pope-inspired allegorical visions of Spleen, Sensibility and such like. At last she is rewarded by falling in love with and marrying a young poet, who is:

Fig. 81
ROMNEY
Miss Honora Sneyd as Serena
c. 1780
COUNTESS OF SUTHERLAND
COLLECTION

The gallant FALKLAND, rich in inborn worth,

but also:

By Fortune blest, and not of abject birth;

which is just as well. (Canto VI, ll. 415-6) The moral of the story is that:

> *'VIRTUE'S an ingot of Peruvian gold,*
> *SENSE the bright ore, Potosi's mines unfold;*
> *But TEMPER'S image must their use create,*
> *And give these precious metals sterling weight.'*
>
> Canto VI, ll. 513-6

The efficacy of the poem was vouched for by Emma Hart in 1791: 'Tell Hayly I am allways reading his *Triumphs of Temper*; it was *that* made me Lady H. [Lady Hamilton], for God knows I had for 5 years enugh to try my temper, and I am affraid if it had not been for the good example

Serena taught me, my girdle wou'd have burst, and if it had I had been undone; for Sir W. [William Hamilton] more minds temper than Beauty.'[35] Byron was less enthusiastic; he writes of Hayley:

> His style in youth or age is still the same,
> For ever feeble and for ever tame.
> Triumphant first see 'Temper's Triumphs' shine!
> At least I'm sure they triumph'd over mine.
>
> English Bards and Scotch Reviewers, ll. 313-6.

Romney did several paintings to illustrate his friend's poem; *Miss Honora Sneyd as Serena* in *c*.1780 (*FIG.* 81) treats the episode when Serena sits up all night to finish Fanny Burney's *Evelina*:

> Sweet Evelina's fascinating power
> Had first beguil'd of sleep her midnight hour:
> Possest by Sympathy's enchanting sway,
> She read, unconscious of the dawning day.
>
> Canto I, ll. 69-72.

Romney's painting shows a candle, behind which the sun is seen to rise. It is also characterised by an almost minimal simplicity in all the elements: the background bare, the dress white, almost without folds, and the outline of the figure without a flourish.

Perhaps influenced by Hayley, George Romney extends this mode of absolute simplicity to all his female sitters during the 1770s and 80s. The poet imagines Venus addressing one such image, a Romney portrait (*c*.1776) of Lady Warwick:

> Sweet model of my chaster power!
> Simplicity and grace thy dower!'[36]

Chastity, Simplicity and Grace: a trinity of cardinal female virtues which can be seen in most of Romney's half-lengths of this period, whether semi-mythological, like *Lady Hamilton as Ariadne* (1785) (*FIG.* 82) or not, like *Mrs Jelf Powys* of 1786 (*FIG.* 84). The attitudes here are pensive: Lady Hamilton looks down thoughtfully, with hands together as if in prayer; Mrs Powys interrupts her reading, closes the book next to her heart, and muses on its contents, with thumb on chin.[37] As the example above from *The Triumphs of Temper* suggests, reading is for women connected with tender sympathies. It is assumed that they will read romances, for these, it was believed, 'breathed a spirit favourable to female virtue, exalted the respect for chastity, and inspired enthusiastic admiration of honour, generosity, truth, and all the noble qualities which dignify human nature.' (Maria Edgeworth, *Belinda,* Chapter XXVI) Both sitters wear dresses of pure white, with prominent girdles round the waist, which remind the viewer of the cestus of Venus, or the knotted girdles in allegories of *Virginity* (see *FIG.* 85), to be loosed on the wedding night.[38] The most striking thing, again, is the bland smoothing out of the trimmings in both dresses (especially Mrs Powys' hem), and the very few, very faint folds, leaving wide areas of unmodulated white (especially below Emma Hamilton's hands).

It is noticeable in *Mrs Powys*, and in many portraits towards the end of the century, that the sitter's cheeks burn with a spot of bright red, how-

Fig. 83
REYNOLDS
Mrs Scott of Danesfield 1786
THE NATIONAL TRUST,
WADDESDON

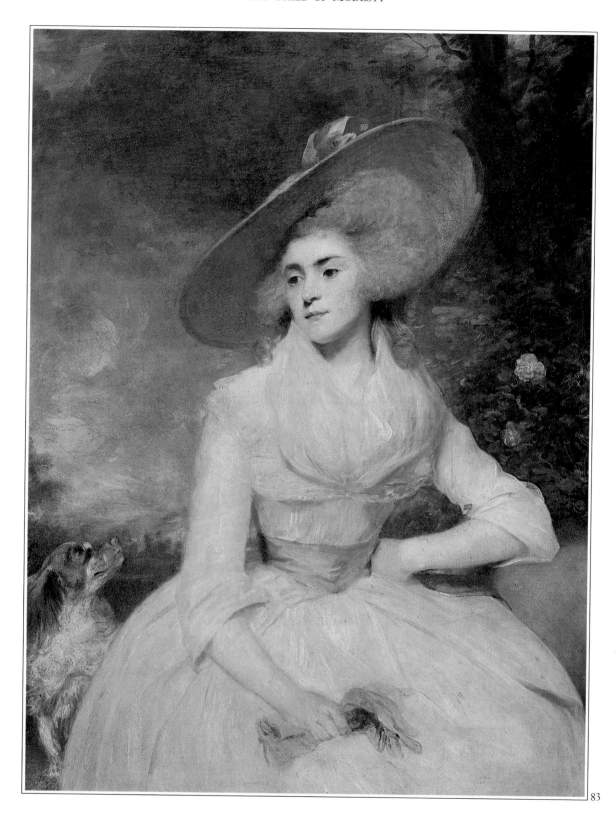

83

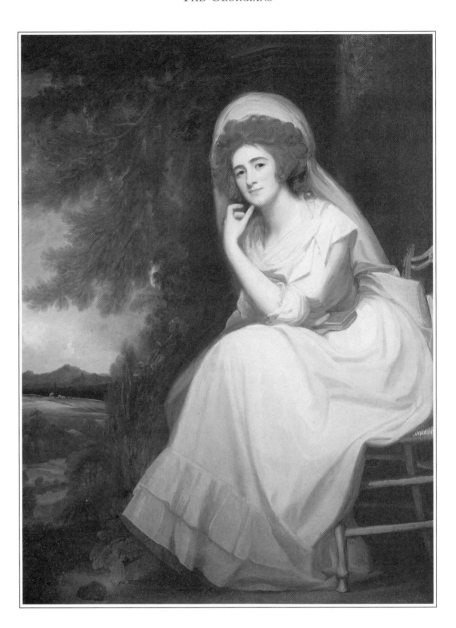

Fig. 84
ROMNEY
Mrs Jelf Powys 1786
PRIVATE COLLECTION –
SWITZERLAND

ever white the skin is elsewhere. A high colour is indicative of health, but here its chief purpose is to show the sitter's tendency to blush. Throughout the century the skin of the desirable heroine's face is described as a thin veil, liable at a moment's notice to flush up. This is because blushing is a sign of modesty. The mini-treatise on the blush, which interrupts the (admittedly not very gripping) narrative of *The Fool of Quality* (1767-70), is best left to speak for itself. The blush, Henry Brooke writes, is not to be confused with the 'flushing of desire, or the reddenings of anger, or any such like turbulent and irregular emotions'. (The portraits of this section are calculatedly serene and dreamy.) It is rather from the 'foundation of virtue' that this flush – 'this sweet confusion in the soul and in the countenance' – comes. 'A delicate virtue is like a delicate chastity, that will blush to have been seen, or even suspected to have been seen within the

suburbs of Drury [the red-light area]'. What follows is perhaps more to the point in portraiture: 'Humility will blush to be found in the presence of those whom it reveres . . . whose favourable opinion it wishes to merit . . . it is that shamefacedness so grateful to God and man, and which, in scripture, is called the most becoming cloathing and best ornament of a woman'.[39] (In fact in Scripture it is a meek and quiet spirit that is called the best ornament of a woman (I Peter 3: 3,4), but humility and shame-facedness better served Brooke's turn.) The blush is the body-language of virtue; it is, according to another writer, 'a hint of something more than human; it comes forth as the emanation of an intrinsic purity and loveliness, and diffuses through the human form a tinge of the angelic nature'.[40]

Rather as, in the fifties, Reynolds had had to imitate Ramsay's informal depiction of women, so, in the eighties, he was obliged to imitate his much younger rival, Romney, to keep abreast of the fashion for his work. His *Mrs Scott of Danesfield* of 1786 (*FIG.* 83), with its simple white dress and dreamy expression, is a famous example. Reynolds, if anything, takes the 'minimal' simplicity of Romney even further: the outline is clear, and the palette is restricted to brown, blue and (predominantly) white. As in Romney's work, the fussiness of textures is smothered, the fabrics are almost without frills, folds or seams, and a bland mass of hair runs onto the hat, to make an area of grey. The difference between *Mrs Scott* and *Mrs Powys* (*FIG.* 84) is that the former is utterly unsculptural. The flat de-sign is strongly marked, and there is little attempt to create three-dimensions, on the dress or the background. Reynolds has coupled simple clarity with a yielding softness of effect, in the cloudy hair, the suggestive scrubbing of the background, and the silky-transparent leather of the gloves. The model for this sort of melting clarity, as well as the spectrum of brown to blue in the background, is Rubens' *Hélène Fourment with her Children* (Louvre) (*FIG.* 124).

The most beautiful example of the cult of simplicity is Henry Raeburn's *Isabella McLeod, Mrs James Gregory* of *c.* 1798 (*FIG.* 86). A similar-ity in pose and triangular outline invites com-parison with Ramsay's *Elizabeth Montagu* (*FIG.* 68) of nearly forty years earlier. In some ways little has changed, there is the same in-formal pose, simple background and alert ex-pression. But between the two there is a revo-lution in sensibility: in the later painting the cheeks glow, the expression is more pensive than communicative and the heart of the figure is picked out by a significant pool of light. Rae-burn smooths down the dress to a soapy white-ness, the very opposite of Ramsay's scrupulous intricacy. Like Lawrence, Raeburn is careful,

Fig. 85
'Virginity' from the
Iconologia of Cesare Ripa, 1709
CAMBRIDGE UNIVERSITY LIBRARY

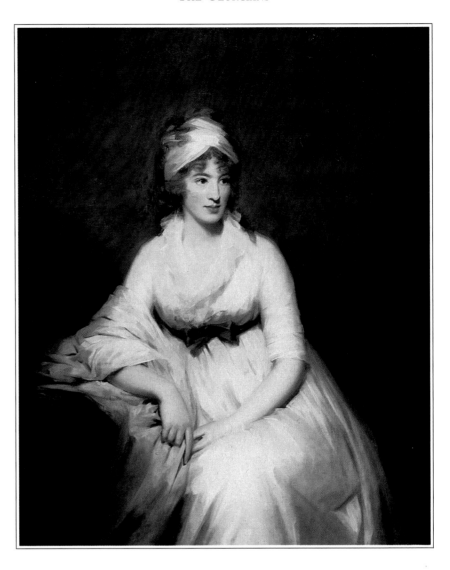

Fig. 86
RAEBURN
Isabella McLeod, Mrs James Gregory c.1798
THE NATIONAL TRUST FOR
SCOTLAND, FYVIE CASTLE

on the chest, to run the pale skin into the pure white of the drapery. This effect of one substance suggests marble sculpture, as does the smooth tubular arms and the parallel folds of the dress, with their hint of thigh underneath. In one way the painting is atmospheric, gauzy and transparent like Ramsay's. But the forms which can be intimated through this hazy medium are now simplified, idealised and 'purified' like alabaster.

CHAPTER 7

THE OFFSPRING OF NATURE

The heroine of these memoirs, young, artless,
and inexperienced, is
 No faultless Monster, that the World ne'er saw,
but the offspring of Nature, and of Nature in
her simplest attire.
 Fanny Burney, *Evelina*, 1778, Preface.

JOSEPH WRIGHT OF DERBY'S PORTRAIT OF THE REVEREND D'EWES COKE (1780-2), out sketching with his wife and a distant relation, Daniel Coke M.P. (*FIG.* 89), would seem to fit most comfortably with portraits of other 'men of feeling'. It conveys the kind of philosophical, sentimental enjoyment of the countryside that one sees in Wright's *Sir Brooke Boothby* (*FIG.* 49), painted at about the same time. It is appropriate therefore that the Revd. Coke has one arm affectionately around his wife's shoulders, while they all discuss the (probably tenuous) resemblance between his drawing and the scene. And yet the most important figure in this group, perhaps, is Mrs Coke, who has two functions immediately recognisable from the traditions of portraiture. One is as a Muse or Sybil, holding the portfolio like a tablet of stone and dangling a Michelangelesque hand. In this rôle her pointing is an inspiring command, directing her husband's art. Her other rôle is simpler: with her green dress and luxuriant brown hair, she is the 'spirit of nature' in the group. Embraced by her husband and seeming to rest her hand on their friend's shoulder, she is, like Nature, the source and object of tender feelings.

This group portrait relates ultimately to a tradition of paintings, part-portrait, part-landscape, that celebrate the ownership of land. Considering the century as a whole one sees in this tradition a transformation by which the dignity of the land-owning gentleman is increasingly tempered by his wife – by some indefinable sympathy believed to exist between her and the landscape. To begin with there are examples of the portrait of ownership at its simplest, one might almost say crudest, such as Arthur Devis's *Robert Gwillym of Atherton with his Family* (1745-7)

(*FIG.* 87).[1] As this country squire points out his domain, his expansive gesture covers in equal measure his trees, formal lawns and house, his steward hurrying over with a letter, and also his wife and children. Though popular, Devis's small portrait-landscapes would never have been regarded as comparable with the life-size portraits of Ramsay and Reynolds; by the 1760s they would have seemed to be no more than a provincial, country-bumpkin means of self-advertisement.

Gainsborough's career began in provincial Sudbury, with small-scale landscape-portraits in this mode, the most famous of which is his *Mr and Mrs Andrews* of 1748-9 (*FIG.* 90). Like Robert Gwillym, Mr Andrews introduces a kind of inventory of his estate, with corn, sheep, donkeys and forestry all carefully included. The fields are clearly marked and the trees part conveniently to give a glimpse of the local church, as if inviting Mr Andrews to explain the precise limits of his domain. The landscape has another meaning too: it is an emblem of Mr Andrews' latest possession – his wife. The improbable cereal cricket-square, planted in the middle of a grazing field, symbolises Mrs Andrews' anticipated fruitfulness in giving

Fig. 87
ARTHUR DEVIS
Robert Gwillym of Atherton and his Family 1745-7
YALE CENTER FOR BRITISH ART

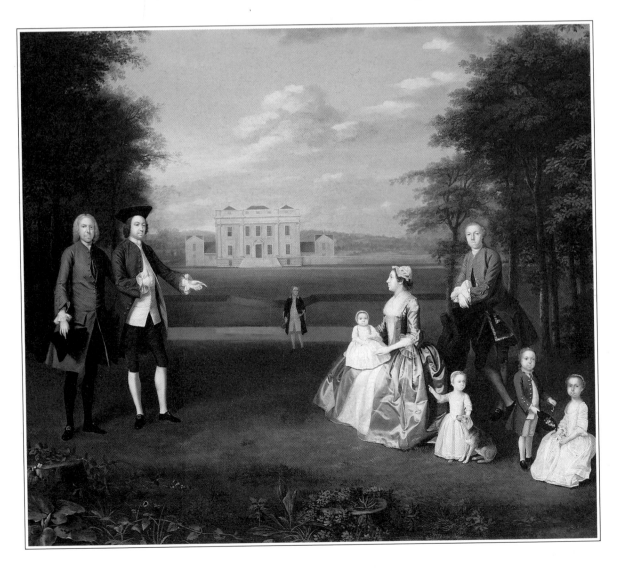

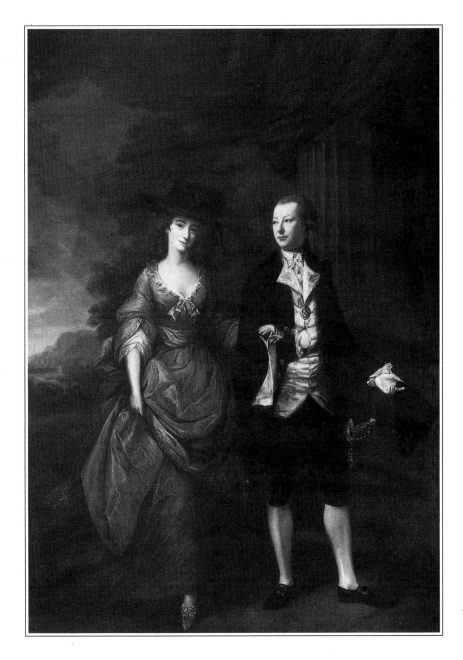

Fig. 88
NATHANIEL HONE
1st Lord and Lady Scarsdale 1761
THE NATIONAL TRUST,
KEDLESTON HALL

him an heir.[2] A recently-shot pheasant, which Gainsborough never com-
pleted, lies on her lap; like the bird, Mrs Andrews has been hunted and
'brought down' by her swaggering consort. This doesn't look much like a
sentimental love-match. Mr Andrews' courtship probably resembled that
mentioned in a letter to *The Spectator,* no. 142, 1711: 'The Gentleman I am
Married to made Love to me in Rapture, but it was the Rapture of a
Christian and a Man of Honour, not a Romantick Hero, or a Whining
coxcomb', a formula which has carried the fame of the British Lover
throughout the world!

Though the landscape may be symbolic there is no sense of any more
intangible integration between it and the figures. The only common

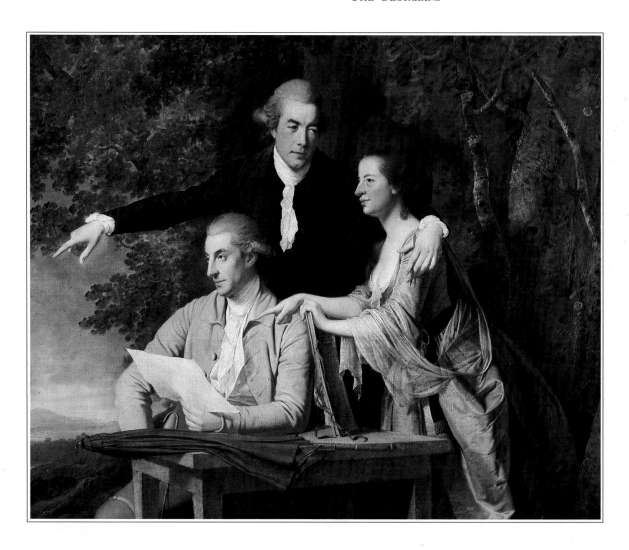

Fig. 89
WRIGHT OF DERBY
*Revd d'Ewes Coke with his Wife
Hannah and Daniel Parker Coke,
M.P.* 1780-2
DERBY MUSEUMS AND ART
GALLERY

ground is of a decorative, ornamental type: in the green tendril-pattern of the wrought-iron seat – a man-made imitation of nature. Then, more subtly, there is a rhyme between the trunk and roots of the tree behind Mr Andrews, and his gnarled-looking legs and silvery coat. Similarly Mrs Andrews' dress, when examined closely, seems to have patterns like a cloudy sky. But these things do not suggest a communion of man and nature; they suggest that *both* man and nature have been turned into art.

Another popular convention, shuffling similar elements into a different arrangement, is what could be called the 'carrying over the threshold' portrait. In *Lord and Lady Scarsdale* of 1761 (*FIG.* 88) by Nathaniel Hone, a wife is being led by her husband under the giant columns of a portico, against a wide landscape. The architecture, as always, is imaginary, yet it is sufficient to imply the recently inherited and rebuilt Kedleston Hall and its parklands, the estate of which she is to become mistress.

Romney's *Sir Christopher and Lady Sykes* (*FIG.* 6), begun in 1786, employs the same elements, with a cunning piece of rôle reversal. Instead of Sir Christopher leading his wife into the ionic portico, she leads him out, into the landscape. This partly alludes to his improvement of the Sledmere

estate: in the distance we glimpse an 'eye-catcher' and avenues of newly-planted firs, for which the paper he holds could indicate further plans. But we are left in no doubt that while he has a professional interest in the land, for her it is her natural province. Her hair catches the wind and seems to entangle with the leaves behind, while, seconded by her dog, she looks up appealingly at her husband to tempt him away from his work. In contrast, his pose is erect and stiff, seen in a strict, formal profile; this, like his glasses and papers, suggests a seriousness which becomes a man in his station, but which might develop into *hauteur* did it not yield to the softening influence of a wife.

Romney's painting is occasionally called the 'Evening Walk', a title given earlier this century by analogy with Gainsborough's so-called *Morning Walk* painted a year before it (*FIG.* 91). As this nicknaming implies, the two portraits invite comparison. Both, for example, show a tall, elegantly slim and haughty young man with a clear outline and contrasted with his surroundings (by colour in Romney and tone in Gainsborough). In both the woman seems more yielding in pose, and seems to be closer to the landscape. Here the similarities end. Everything in Romney is smooth and clear, while almost everything in Gainsborough is fleecy-rough and vaporous. Romney's two figures are clearly outlined, slotting together with an air-tight join, and surfaces, even details such as hands or cravat, are made of simple, smooth bars of bright colour. The only atmospheric invasion occurs on Lady Sykes' silk which, like a half-polished metal, reflects the sandy floor, and has been crinkled to make carefully-spaced highlights. The sheen of this dress derives ultimately from Van Dyck, but Van Dyck seen through the eyes of Peter Lely: the pattern has been simplified and the shine dulled to produce a more solid-

Fig. 90
GAINSBOROUGH
Mr and Mrs Andrews 1748-9
REPRODUCED BY COURTESY OF
THE TRUSTEES, THE NATIONAL
GALLERY, LONDON

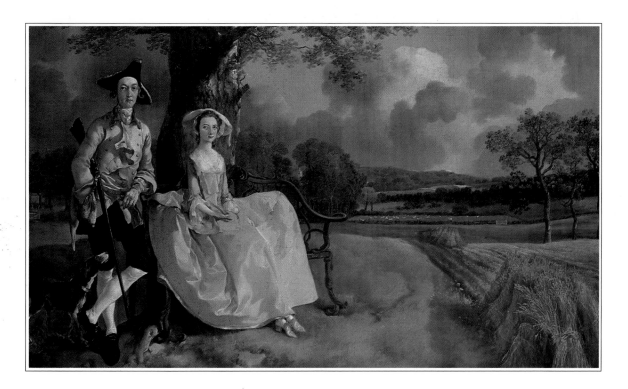

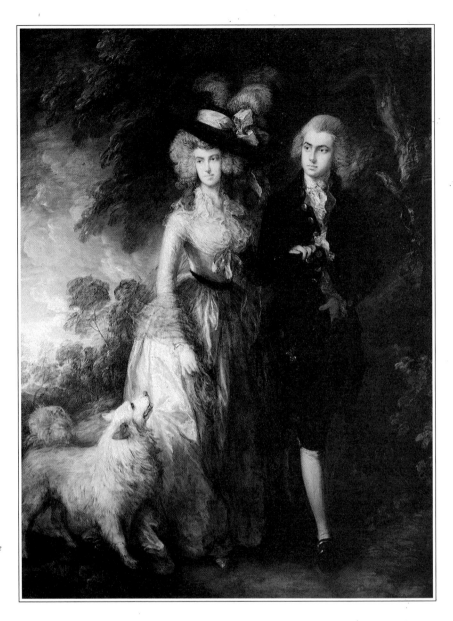

Fig. 91
GAINSBOROUGH
*Mr and Mrs William Hallett, 'The
Morning Walk'* 1785
REPRODUCED BY COURTESY OF
THE TRUSTEES, THE NATIONAL
GALLERY, LONDON

looking mass. Mrs Hallett's dress also recalls Van Dyck, but differently interpreted. Here is all sheen without substance; the silvery highlights almost float over the surface in long ribbons of paint. The figure doesn't make a simple block; the right side is swallowed in shadow, while some of the details on the left are misted over by light. The figure as a whole is broadly massed in light and shadow, and yet insubstantial. This is particularly to be observed in front of the original, because Gainsborough has left the brown underpaint exposed to render the shadows. Over this layer he has employed a technique called 'scumbling': lighter paint is scrubbed over, either thin and transparent, or, if thick, trailed in long thread-like tendrils which seem to hover, wispily, over the brown. It is this sort of portrait that Hazlitt had in mind when he referred to a Gainsborough figure looking like a 'vision breathed on the canvas'.[3]

The reason for this vaporization is to involve Mrs Hallett in the landscape, so that she can seem its spirit, the genius of the place. Her colours are those of the landscape: ribbons, green like the leaves; dress, silver like the sky; hair and lace, blue-grey like the distant trees. Gainsborough's immaterial brushwork is also ideal for confusing and blending the materials he is depicting. Mrs Hallett's shadows run onto the same underpaint-browns of the earth floor; similarly, the lace over her bodice and round her arms runs onto the sky, and is made up of a cloudy scrub of paint, like the far trees.

Setting the pair in landscape implies discreetly that Mr Hallett owns land, but the viewer is left to concentrate on an amorous country stroll, a tender young man and his wife in tune with nature. The scene recalls the evening walk on his estate which becomes a nuptial idyll for the poet's friend, Lord Lyttleton, in Thomson's *The Seasons* (1746):

> *Perhaps thy loved Lucinda shares thy walk,*
> *With soul to thine attuned. Then Nature all*
> *Wears to the lover's eye a look of love;*
> *And all the tumult of a guilty world,*
> *Tossed by ungenerous passions, sinks away.*
> *The tender heart is animated peace;*
> *And, as it pours its copious treasures forth*
> *In varied converse, softening every theme,*
> *You, frequent pausing turn, and from her eyes,*
> *Where meekened sense and amiable grace*
> *And lively sweetness dwell, enraptured drink*
> *That nameless spirit of ethereal joy,*
> *Inimitable happiness! which love*
> *Alone bestows, and on a favoured few.*
>
> *Spring*, ll. 936-49.

The happiness of love, not the pride of possession: this is the moral of Gainsborough's portrait.

As this portrait implies, for a woman to love nature, to be seen in nature, or to be the 'offspring of nature', is the surest sign of her virtue. This is one of the most constant, but elusive, themes of eighteenth-century literature as well as portraiture. A familiar and subtly-revealing expression of the idea occurs in Jane Austen's *Pride and Prejudice* (Chapters VII and VIII). Jane Bennet is taken ill at Mr Bingley's Netherfield Hall; Elizabeth Bennet walks three miles, alone, early in the day *and* in wet weather to visit her. She arrives 'with weary ankles, dirty stockings, and a face glowing with the warmth of exercise'. To Bingley's scheming and artificial sisters this seems 'nonsensical'; they gloat over her 'almost wild' appearance, 'her hair so untidy, so blowsy', 'her petticoat, six inches deep in mud'. The men are more sensible: the dirty petticoat quite escaped Mr Bingley's notice; he thought she looked 'remarkably well'. Mr Darcy thought her eyes 'were brightened by the exercise'. It is Mr Bingley who gives the moral: her action, he says, 'shows an affection for her sister that is very pleasing'.

'Nature' is the issue in this passage, appearing in the guise of a three-mile walk and some mud. We encounter again the blushing, 'transparent' face, 'glowing' to proclaim the virtues of nature, as the eyes do by shining, and the hair by fluttering. What are these virtues, specifically? In this case sisterly love, a 'natural' feeling.

The episode is laced with gentle irony: we have to acknowledge that in nature there is such a thing as mud, and that it comes off on clothes. Jane Austen is a merciless de-mystifier of sentimental cultural fads, even if, as in this case, she is broadly in sympathy. She is the first to bring nettles into her landscapes. (*Love and Freindship*, Letter the 13th) When Marianne, in *Sense and Sensibility*, seeks 'luxurious solitude' in a place where 'the trees were the oldest, and the grass was the longest and wettest', the prosaic result is that she catches cold! (Chapter 42) But the convention she is mocking can be found, without irony, in countless half-forgotten romances of the period. Consider for example the almost daily activity of Adeline, the heroine of Mrs Radcliffe's *The Romance of the Forest* (1791), 'whose mind was delicately sensible to the beauties of nature' (Chapter I):

> She walked pensively into the forest. She followed a little romantic path that wound along the margin of the stream, and was overhung with deep shades. The tranquillity of the scene, which autumn now touched with her sweetest tints, softened her mind to a tender kind of melancholy, and she suffered a tear, which, she knew not wherefore, had stolen into her eye, to tremble there unchecked. She came to a little lonely recess, formed by the high trees; the wind sighed mournfully among the branches, and as it waved their lofty heads scattered their leaves to the ground. She seated herself on a bank beneath, and indulged the melancholy reflections that pressed on her mind.
>
> Chapter VII.

No mud or nettles here, no need to wrap up for fear of catching cold. No need to feel melancholy either, for once installed in a so-called 'lonely' grotto the heroine is bound to be interrupted by a young man, anxious to fall in love with her. Simply by being there she becomes lovable, but the trembling tear clinches it!

Portraiture is neither susceptible of Jane Austen's irony, nor guilty of Mrs Radcliffe's excess, and yet examples such as Gainsborough's *The Linley Sisters* of 1772 (*FIG.* 92), express the same attitudes. Adeline in *The Romance of the Forest* was a poetess; 'when her mind was tranquilized by the surrounding scenery, she wooed the gentle muse'. (Chapter III) Similarly here the score and guitar remind us that both Linleys were accomplished professional musicians, especially the elder sister, Elizabeth, who had a considerable career as a singer till she married the dramatist Sheridan. As often occurs in portraiture, the attributes of music are accompanied by a loving, 'harmonious' pose.

Elizabeth's affectionate lean on Mary's shoulder also suggests 'nature'; the same natural affection as that of her namesake in *Pride and Prejudice*. As in *The Romance of the Forest* the heroines' feelings are excited by the landscape: Elizabeth becomes dreamy and contemplative, Mary sweet-tempered. They seem to have become part of the landscape, or to have been transformed into dryads, personifying it. Their dresses are sky-blue

Fig. 92
GAINSBOROUGH
Elizabeth and Mary, the Linley Sisters 1772
DULWICH PICTURE GALLERY

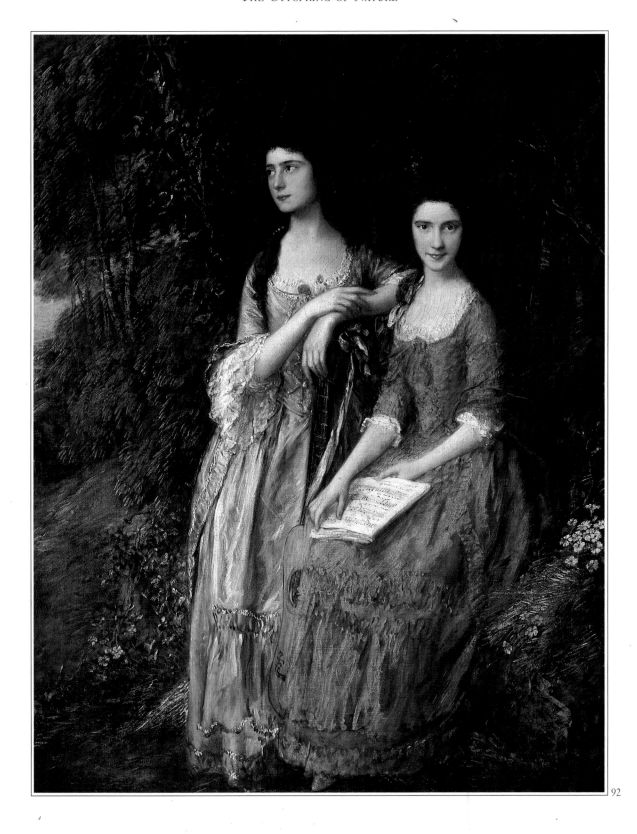

92

and autumn-brown; the frills are not smoothed out but deliberately 'roughened up' by a loose, free brushwork. Mary's dress especially echoes the rough, hooked streaks of paint on the grasses, branches and sprays of leaves. The dress and the bank run onto one another, as if both were stitched into some coarse, matted tapestry. Then a finer thread binds the hair to the leaves. The landscape doesn't really recede, even on the left, so that the foliage seems to surround the figures, wrapping them in an enclave, like Mrs Radcliff's 'little lonely recess'.

Gainsborough gives his dryads a particular effect of intimacy, by having Mary seem to lean forward, almost *through* the frame, as she looks straight at us and smiles. This is done by making the whole painting like an oval field of vision. The edges, as if seen out of the corner of the eye, are loose and rough; the centre is smoother and more carefully focused. Roughness makes the objects at the edges seem flat and bound together (as if in a tapestry), whereas the centre has a three-dimensional rounding of the heads, a contrast of light and dark, and a *detachment* from the back-

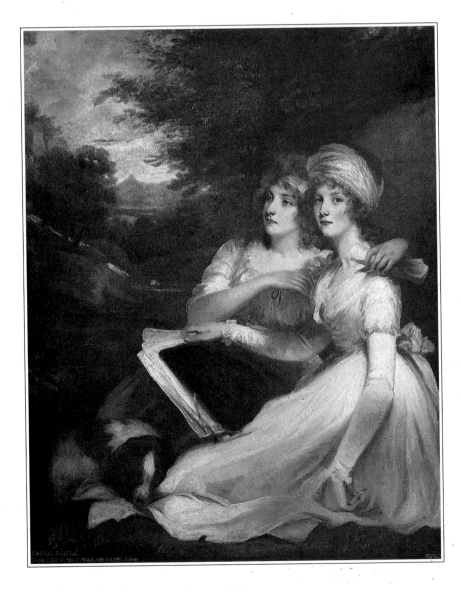

Fig. 93
HOPPNER
The Frankland Sisters 1795
NATIONAL GALLERY OF ART,
WASHINGTON, ANDREW W.
MELLON COLLECTION

ground. Forms seem thus to grow and to emerge forwards from the surrounding flatness, with the smiling face marking what Cézanne called the 'culminating point'.

Gainsborough later quarelled with the Royal Academy because they hung his pictures much higher than the five and a half feet which he considered ideal.[4] This is principally because this delicate emerging effect can only really work if the sitter's and the viewer's heads are roughly at the same level. It is what Gainsborough has in mind when he writes to Garrick, probably in the same year as *The Linley Sisters* (*FIG.* 92): 'if you let your Portrait hang up so high, only to consult your Room, and to insinuate something over the other Door, it never can look without a hardness of Countenance and the Painting flat, it was calculated for breast high and will never have its Effect or likeness otherwise'.[5] The Dulwich Gallery fortunately follow Gainsborough's instructions, with the result that Mary Linley 'consults' and 'insinuates' with us, not the far wall.

Looking closely at the faces of these two Linley sisters or Mrs Hallett (*FIGS* 92 and 91), you would not think that Gainsborough needed to worry about a 'hardness of countenance'. They are almost ghostly in their immaterial softness, especially when framed by such rough undergrowth. This effect is a development of the pastel-softening already encountered. The particularity of Gainsborough is that he uses thinned-down paint in longer strokes, and, though there are no real outlines, these are combed out in a pattern like fur. In *The Linley Sisters* (*FIG.* 92) this immaterial physiognomy is set off by a brilliantly precise flash of highlight in the eyes, to suggest Adeline's trembling tear. Gainsborough's friend Uvedale Price later discussed softness as an aspect of beauty. He imagines taking the effect to an extreme in the face a woman:

> *If we go on still farther and suppose hardly any mark of eyebrow; – the hair, from the lightness of its colour, and from the silky softness of its quality, giving scarce any idea of roughness; – the complexion of a pure and almost transparent whiteness, with hardly a tinge of red; – the eyes of the mildest blue, and the expression equally mild, – you would then approach very nearly to insipidity, but still without destroying beauty; on the contrary, such a form, when irradiated by a mind of equal sweetness and purity, united with sensibility, has something angelic, and seems farther removed from what is earthly and material.*[6]

Price could almost be describing all Gainsborough's late portraits of women which, he would feel, convey something 'removed from what is earthly' – something angelic.

A very similar combination, tenderly caressing sisters within a natural enclave, can be seen in *The Frankland Sisters* of 1795 by John Hoppner (*FIG.* 93). In this portrait there is also a dog, as there is in the *Morning* and *Evening Walks* (*FIGS* 91 and 6). It was commonly believed that animals were attracted by the 'natural' woman, an idea made familiar by Henry James's *Portrait of a Lady*. Animals become the means by which a woman's general feeling for nature may be channelled into love. The advantage of the dumb animal is that it enables the heroine to reveal her soundness of

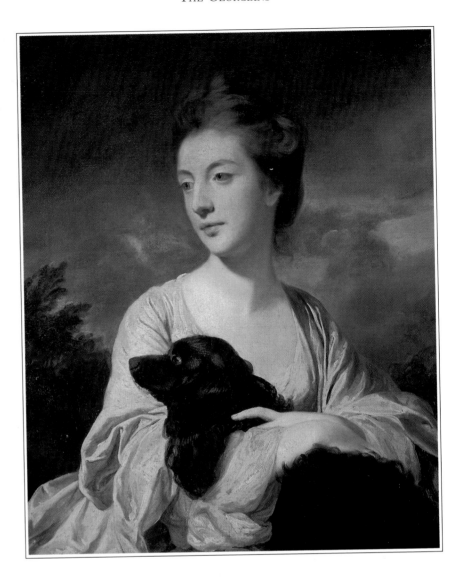

Fig. 94
REYNOLDS
Lady Charles Spencer c.1766
FROM GOODWOOD HOUSE BY
COURTESY OF THE TRUSTEES

Fig. 95
GAINSBOROUGH
Mrs 'Perdita' Robinson 1781
REPRODUCED BY PERMISSION OF
THE TRUSTEES OF THE WALLACE
COLLECTION

feeling without knowing she is being looked at. Otherwise she might seem forward, or, worse still, she might just be putting it on. A striking example of an accidental demonstration of character involving a dog occurs in Fanny Burney's *Cecilia* of 1782. Having settled his affection on the heroine, with a dog's special intuition, Fidel is allowed to stay with her during her cruel separation from Mortimer Delvile. Fidel is often the recipient of weeping confidences, for with him 'her tenderness and her sorrow found . . . a romantic consolation'. One day she says to him, 'Go, then, dear Fidel, carry back to your master all that nourishes his remembrance. Bid him not love you the less for having some time belonged to Cecilia; but never may his proud heart be fed with the vain-glory of knowing how fondly for his sake she has cherished you!' (Book VI, Chapter XII) Luckily there is no need for Fidel to go anywhere, for Mortimer has just arrived and overheard the whole speech! Mortimer himself draws the conclusion: 'to behold the loved mistress of my heart, . . . caressing an animal she knew to be mine, . . . and sweetly recommending to him

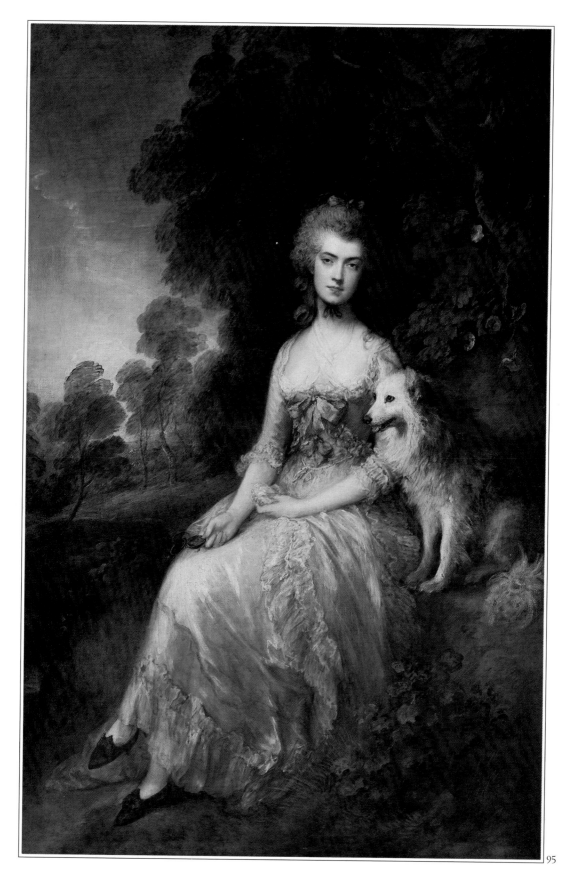

95

fidelity ... Little, indeed, had I imagined with what softness the dignity of Miss Beverley was blended, though always conscious that her virtues, her attractions, and her excellencies would reflect lustre upon the highest station to which human grandeur could raise her'. (Book VII, Chapter I) This last sentence perfectly expresses the humility of the ideal woman: according to contemporary notions of status they are only 'raised' to the highest station, not born there; and it is through 'softness' that they reflect lustre upon it.

Reynolds' *Lady Charles Spencer* of *c.* 1766 (*FIG.* 94), a pair to the *Duchess of Richmond* (*FIG.* 80), is exactly the sort of image Fanny Burney might have had in mind for her Cecilia, showing as it does a woman unconsciously parading her loving loveliness by caressing a dog. By doing this Lady Charles Spencer appears to identify with her pet, which she resembles in her long, high-arched nose, big soulful eyes and glossy hair. Not very flattering, you might think, but, as Mary Wollstonecraft noted, 'Gentleness, docility, and a spaniel-like affection are ... consistently recommended as the cardinal virtues of the sex.'[7]

Gainsborough's 1781 portrait of the actress Mrs Robinson (*FIG.* 95) fulfils all the expectations of this chapter: she sits by her dog, in a gentle glade, looking winningly out of the painting, head on one side, and fingering a portrait of her lover, the Prince of Wales. The story of their affair is told with amusing acidity by the Duchess of Devonshire: 'Her *agaceries* were soon level'd at the young Prince, and she especially *lorgnee'd* him in the part of *Perdita* [in *The Winter's Tale*], which, as it was afterwards suppos'd to be the name by which he call'd her, she was distinguish'd by it in all the public prints and the P. of Wales by that of *Florizel*.'[8] These *noms d'amour* evoke the world of Shakespeare's Romance play, with cottage courtship, abandoned princess and disguised prince. The name 'Perdita' ('lost one') acquired added significance when the Prince deserted Mrs Robinson in 1782. This portrait was painted before that, but even here Gainsborough has played on the poignancy of the part, in the pleading expression, panting fidelity of the dog and lonely rural setting.

Mrs Robinson is clearly thinking about her lover, perhaps even looking out for him. Her attitude therefore proclaims her feelings of love and esteem. According to Burke, 'When we have before us such objects as excite love and complacency, the body is affected: ... The head reclines something on one side; the eyelids are more closed than usual, and the eyes roll gently with an inclination to the object, the mouth is a little opened, and the breath drawn slowly, with now and then a low sigh: the whole body is composed, and the hands fall idly to the sides. All this is accompanied with an inward sense of melting and languor. These appearances are always proportioned to the degree of beauty in the object, and of sensibility in the observer'. (*The Sublime and Beautiful*, 1757, Part IV, Section XIX) There is no doubting Mrs Robinson's sensibility, for she demonstrates almost all of Burke's tell-tale signs.

This portrait, and the fact of Mrs Robinson being called 'Perdita' in the first place, are of a piece with a sentimental fashion for tragic, deserted

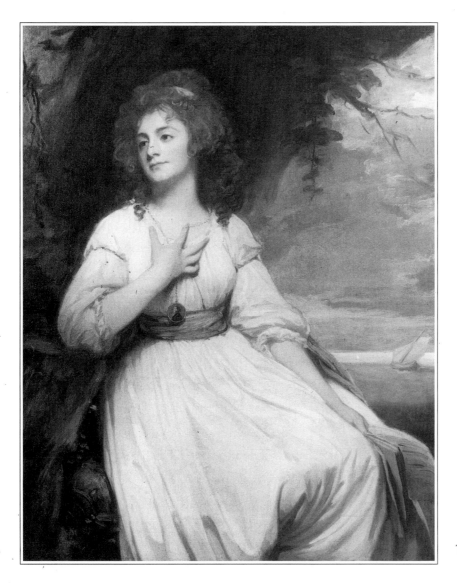

Fig. 96
ROMNEY
Mrs Crouch 1786
THE IVEAGH BEQUEST, KENWOOD
HOUSE, ENGLISH HERITAGE

heroines. Adeline, in *The Romance of the Forest*, is abandoned by her
parents and forced upon the protection of the unworthy La Motte; Fanny
Burney's *Cecilia* is an orphan, and her *Evelina* an abandoned daughter. In
painting there are similarly pitiful examples: the abandoned Maria, mad
for love, in Sterne's *Sentimental Journey* is depicted by Joseph Wright of
Derby and Angelica Kauffmann. Romney's 1787 portrait of the actress
and singer, Mrs Crouch (*FIG. 96*), belongs to the same fad.[9] Alone, on a
desert shore, she sits pressing her hand to her heart, in token of love,
while a medallion of her husband trails over her fingers. Mr Crouch was a
naval lieutenant, which is presumably the reason for the single boat sail-
ing away behind, leaving his wife to pine with most becoming wistful-
ness. For, as Burke explains, 'The beauty of women is considerably
owing to their weakness, or delicacy', so that 'Beauty in distress is much
the most affecting beauty'. (*The Sublime and Beautiful*, 1757, Part III, Sections IX
and XVI)

97

The most famous dryad of all in portraiture is Gainsborough's 1785-6 portrait of the elder Linley sister, Elizabeth, as Mrs Richard Brinsley Sheridan (*FIG. 97*). Her hair, profuse and irregular, catches the breeze, and waves about, like the thickly laden branches above. The pink of her dress, her russet hair and blue girdle seem to have been refined from fainter colours to be found in the autumnal countryside. Her gauze scarf and shadows merge with the landscape, while fronds and grasses grow over the lower part of her dress, as if wanting to be stitched onto it. Her figure has a loose, negligently elegant air, ornamented not with the intricate artificialities of stitchery but, like the landscape behind, with the profuse, varied and delicately rough embroidery of Nature.

Other examples in this chapter suggest that the landscape here has echoes of the gentleman's park, stretching away behind its mistress. It is important to recall that at this time the conception of the park, and of landscape in general, was changing as a result of an aesthetic movement called the 'Picturesque'. Landscape is now a stimulus to feeling, and feelings are more acutely excited as the scenes become wilder, more precipitous and remote. By a kind of instinct the 'feeling woman' seeks out and loves these picturesque scenes, as Elizabeth Bennet longs to explore the windings of a narrow walk by a stream and a rough coppice-wood at Pemberley. (*Pride and Prejudice,* Chapter XLIII) This roughness is the principal characteristic of 'picturesque' beauty which, in a park like Pemberley, would mean varied trees and shrubs, broken ground, even rocks and 'wildernesses'. Mrs Sheridan sits upon a rock, surrounded by briars and coarse grasses; the trees are of various tints and the landscape falls away into misty woodland.

The Picturesque is related to another cult of late eighteenth-century Britain: the cult of Sensibility. One Mrs Peddle, in 1789, provides a working definition of this quality: 'Sensibility! – What is it?' she asks, 'Is it not that delicate perception of natural and moral beauty, which the Creator has implanted in the soul to exalt its happiness, and awaken its noblest passions?'[10] The origin of this cult dates back to the 1760, when Sterne wrote: 'Dear sensibility! source inexhausted of all that's precious in our joys, or costly in our sorrows! thou chainest thy martyr down upon his bed of straw, and 'tis thou who lift'st him up to HEAVEN.' (*Sentimental Journey,* 1768, The Bourbonnais) In this passage Sterne could be referring to the sensibility of either sex, but for most people this virtue was peculiarly feminine. It was in fact the very soul of femininity. William Hayley describes the 'texture of the Female brain' thus:

By Nature's care in curious order spread,
This living net is fram'd with tender thread; . . .
Within the centre of this fretted dome,
Her secret tower, her heaven-constructed home,
Soft Sensibility, sweet Beauty's soul!
Keeps her coy state, and animates the whole,

The Triumphs of Temper, 1781,
Canto I, from ll. 166-73

Fig. 97
GAINSBOROUGH
Elizabeth Linley, Mrs Richard
Brinsley Sheridan 1785-6
NATIONAL GALLERY OF ART,
WASHINGTON, ANDREW W.
MELLON COLLECTION

The specially British character of Sensibility can be vouched for by Rousseau's list of virtues for his ideal girl, Sophie. She is to have the pride of a Spaniard, the temperament of an Italian, and the sensibility of an English girl.[11] Sensibility means the capacity to feel refined emotions. This can mean feeling grief, pity, joy, or the effects of beauty, particularly the beauties of natural scenery. But these things are really trial-runs for the chief feeling of all – love.

It is the association of this quality with Rousseau that finally gives it a bad name after the French Revolution, though it doesn't fall out of fashion as dramatically as its male equivalent. But even feminine indulgence of feeling can seem to threaten the structure of society, which depends so much on prudence and on resisting everything French. This is how George Canning, in 1798, described Sensibility, this 'sweet child of sickly Fancy' brought over from France by Rousseau:

–Taught by nice scale to mete her feelings strong;
False by degrees, and exquisitely wrong;
–For the crushed beetle first, –the widowed dove,
And all the warbled sorrows of the grove;–
Next for poor suff'ring guilt; –and last of all,
For parents, friends, a king and country's fall.
New Morality.[12]

'Poor suff'ring guilt' must refer to tragic 'fallen women' like 'Perdita' Robinson (*FIG.* 95), whom the over-tender might be inclined to pity too much and blame too little. 'A king and country's fall' refers, of course, to the wars with France. To our minds it is an interesting association of ideas that couples unpatriotic indifference with excessive sexual tolerance. It is ironic that the most familiar embodiment of the ideal of sensibility now is Marianne in Jane Austen's *Sense and Sensibility*, which belongs (in part at least) to the reaction *against* the fad after the Revolution. As usual the common-sense problem with sensibility is most brilliantly put by Jane Austen: the heroine of *Love and Freindship* meets a girl

who was then just seventeen – One of the best of ages; but alas! she was very plain and her name was Bridget . . . Nothing therfore could be expected from her – she could not be supposed to possess either exalted Ideas, Delicate Feelings or refined Sensibilities–. She was nothing more than a mere good-tempered, civil and obliging young woman; as such we could scarcely dislike her – she was only an Object of Contempt–.
Letter the 13th.

Sensibility was not yet out of fashion in 1783: at the Royal Academy exhibition of that year, it is certainly the quality which would have suggested itself to visitors in front of Gainsborough's *Mrs Sheridan* (*FIG.* 97). A clearer idea of what this elusive quality might look like can be gained from Hayley's *The Triumphs of Temper*, where Serena actually encounters an allegorical impersonation of Sensibility in a dream. Sensibility has an 'expressive radiance' and 'richer roses . . . on her cheek', as if 'she felt in every vein / A blended thrill of pleasure and of pain' (Canto V, ll. 181-4): Mrs Sheridan similarly arches her brows, blushes, begins to smile and inclines her head most meltingly. Sensibility, like Mrs Sheridan, is gilded by

Nature 'With rich luxuriance tender, sweetly wild'. (Canto V, ll. 216-9) Sensibility shows her fine feelings by fussing over the 'tender plant Mimosa', 'anxious to survey / How the feeling fibres own her sway'. (Canto V, from ll. 222-6) Likewise Mrs Sheridan seems to be a distillation of the mood of the landscape, tremulously poised between smiling luxuriance and dusky, autumnal melancholy.

Finally we are told that Sensibility keeps a 'coy state' (Canto I, l. 173): Mrs Sheridan too sits modestly on the ground, like a Virgin of Humility. This modest timidity is another aspect of sensibility, and is the most striking characteristic in Fanny Burney's description of Mrs Sheridan herself:

> *She is really beautiful; her complexion a clear, lovely, animated brown, with a blooming colour on her cheeks; her nose, that most elegant of shapes, Grecian; fine luxurious, easy-sitting hair, a charming forehead, pretty mouth, and most bewitching eyes. With all this her carriage is modest and unassuming, and her countenance indicates diffidence, and a strong desire of pleasing, – a desire in which she can never be disappointed.*[13]

98

CHAPTER 8

THE HISTORICAL STYLE

*When a portrait is painted in the Historical Style, as it is neither an exact minute
representation of an individual, nor completely ideal, every circumstance ought to
correspond to this mixture. The simplicity of the antique air and attitude, however much
to be admired, is ridiculous when joined to a figure in a modern dress.*
Reynolds, *Discourse V*, 1772.[1]

I
F REYNOLDS WERE ASKED WHICH WAS THE FIRST OF HIS PORTRAITS TO
meet these requirements, he would probably have pointed to his *Eli-
zabeth Gunning, Duchess of Hamilton and Argyll* of 1759 (*FIG.* 98). He
sent this work to the first real British art exhibition, at the premises
of the Society for the Encouragement of Arts, Manufactures and Com-
merce, which opened in April 1760 – the most influential portrait for the
most important exhibition of the age. More than any of his previous
works, this puts into practice Reynolds' theoretical system of aesthetics;
indeed it could almost be seen as their demonstration piece. His ideas first
appeared in print during the year he was working on this canvas, in a
series of three numbers of his friend Dr Johnson's periodical *The Idler*,
nos. 76, 79 and 82 of 1759. Some things which are mere hints in these
brief articles can be fleshed out by reference to Reynolds' later *Discourses*
delivered annually as President of the Royal Academy from 1769-90. The
point of departure for his ideas is a familiar one: painting should, he feels,
be seen as an intellectual not manual skill, 'for the painter of genius can-
not stoop to drudgery, in which the understanding has no part; and what
pretence has the art to claim kindred with poetry, but by its powers over
the imagination?' (*The Idler*, no. 79) The type of painting which exerts these
'powers over the imagination' Reynolds calls the Grand or Great Style.
There is a range of characteristics belonging to this style, but the overrid-
ing principle is given by the phrase, quoted above from the *Fifth Discourse*
of 1772, 'the simplicity of the antique air and attitude'. To attain this
simplicity a 'minute attention' to the representing of natural objects must
'be carefully avoided'. For feats of detailed imitation can only

Fig. 98
REYNOLDS
*Elizabeth Gunning, Duchess of
Hamilton and Argyll* 1759
LADY LEVER ART GALLERY, PORT
SUNLIGHT

counteract his [the great artist's] purpose by retarding the process of the imagination'. (*The Idler*, no. 79) A handful of artists get it right, the unassailable 'right hand file' as Lawrence calls them: the sculptors of antiquity, Michelangelo, Raphael, and some later exponents of the same tradition.[2] It is on these that students should fix their sights. They should not even be ashamed to 'borrow' poses or ideas from their works; on the contrary, an epic quotation from one of the right sources is a positive virtue. But a taste for anything less – for modern art or local fashions – must be accounted vulgar error and prejudice: 'the whole beauty and grandeur of the art consists, in my opinion, in being able to get above all singular forms, local customs, particularities, and details of every kind.' (*Discourse III, 1770*)[3] So strongly did Reynolds hold this that he considered British artists were to be congratulated: lacking a strong local tradition, they would have nothing to 'unlearn'. (*Discourse I, 1769*)[4]

The important thing to remember here is that admiration for Raphael *et al* and admiration for, say, Rubens are different not in degree but in kind. Daniel Webb writes in 1760: 'I have rarely met with an artist, who was not an implicit admirer of some particular school, or a slave to some favourite manner. They seldom, like gentlemen and scholars, rise to an unprejudiced and liberal contemplation of true beauty.'[5] Unlike Rubens, however, the artists of the Grand Style are *not* regarded as belonging to a 'particular school'; instead they are seen as helping their disciples towards that 'liberal contemplation of true beauty'.

The novelty of Reynolds' ideas can best be appreciated by comparing his *Duchess of Hamilton* (*FIG.* 98) with Ramsay's *Lady Louisa Conolly* (*FIG.* 99), a portrait of almost exactly the same date, and one which Reynolds may consciously have been challenging.[6] Both portraits show a young woman in landscape, leaning on a Classical ornamental structure and staring dreamily off-stage. But here the similarities end. Lady Louisa wears a modern formal dress, with an intricate pattern of lace, gathers and furbelows, all scrupulously painted. (Yet the effect is not fussy, as it often is in lesser hands, for Ramsay has characteristically softened the shadows with a dusty grey haze.) The shape of the figure, especially the stiff triangle of the dress held out on hoops, is the shape of the costume, not of the anatomy: in this sense the sitter is a tailor's dummy, though Ramsay has hovered some faint shadows to suggest the legs.

The Duchess of Hamilton, by contrast, has shrugged off the only unequivocally modern part of her dress – her Ducal ermine – to reveal a 'bedgown' underneath. This simple wrap-around, or something like it, was actually worn in the eighteenth century for informal occasions, particularly for receiving visitors in the morning before dressing for dinner. But for Reynolds this is the type of modern dress that has 'the least marked character about it' and is therefore the most suitable for art.[7] Its advantages are explained in the *Seventh Discourse* of 1776:

> *He therefore who in his practice of portrait-painting wishes to dignify his subject, which we will suppose to be a lady, will not paint her in the modern dress, the familiarity of which alone is sufficient to destroy all dignity . . . [he] therefore dresses his figure something with the general air of the antique for the sake of dignity, and preserves something of the modern for the sake of likeness.*[8]

Reynolds did not invent the 'paintable' antique costume. In 1738 Lairesse recommends '*mixing the Fashion with what is Painter-like*; as the great *Lely* did, and which is called the Painter-like or antique Manner', characterised by 'a loose airy Undress, somewhat savouring of the Mode, but in no wise agreeing with the ancient *Roman* Habit'.[9] Not everyone shared Lairesse's enthusiasm for this paintable garb: some ridiculed Kneller's 'graceful robe which was so elegantly disposed that the wearer could not walk across the room without dropping it off'.[10] The Duchess of Hamilton's robe is wearable, but it has also the 'picturesque' qualities of the timeless, Classical drapery that is indispensable to the Historical Style. It has no intricacies, nothing the mechanical tailor could do better than the poetical painter. It has a pattern, but it is not the pattern of stitches; rather it is that of folds, Classical folds running in simple vertical flutes down the figure. Similarly the shape of the figure is that of anatomy, not costume. The dress does open out at the bottom, a little like Lady Louisa's, to make a kind of 'stand', but the rounded forms of the body and legs are clearly visible inside. For, as Richardson explains, 'howsoever a Figure is clad, This General Rule is to be observ'd, *That neither must the Naked be lost in the Drapery, Nor too conspicuous*'.[11] In the same way Reynolds pushes the ermine aside to liberate the outline of the trunk, right up to the shoulders. The viewer is made aware of two contours to the figure: an 'outer' triangle of empty drapery, and an 'inner' bulb, full to billowing with the body inside. The figure as a whole arches over in a leisurely fashion, seeming to follow Reynolds' advice, 'Take care to give your figure a sweep or sway.'[12]

In 'the highest and most dignified' style of painting, Reynolds believed that it had so close a relation to *sculpture* as to be 'almost the same art operating upon different materials'. (*Discourse X,* 1780)[13] So here *The Duchess of Hamilton* (*FIG.* 98) seems half way to becoming a work of sculpture: her dress and pale skin are almost marble-white and her rounded outline, hugged by her left arm, reminds one of the block of marble from which the figure is carved. It is Classical sculpture that Reynolds chiefly recommends, seen reflected here in the pattern of the drapery, and an adjustment of the proportions of the anatomy. The Duchess has a very high waist, a delicate chest and narrow shoulders, set above elongated and inflated stomach and thighs. Though following Classical principles, this degree of distortion could never in fact be found in Greek or Roman statuary. It derives, rather, from a later Renaissance and even Mannerist tradition – not so much Praxiteles as Parmigianino, from whom, according to Northcote, Reynolds learned 'that grace which so eminently distinguished his female portraits'.[14]

This grace also coincides, conveniently, with the distortions of eighteenth-century costume, seen in *Lady Louisa Conolly* (*FIG.* 99) where the chest is trussed up into as small a compass as possible, and ample hips are suggested by a voluminous skirt held out on hoops. These rigors of female dress were the subject of frequent attacks during the century. Rather like the rules of deportment, people found this 'contraction of waist, pressure of hips, swellings and unnatural disfigurations of necks, breasts, paps etc' to be just that – unnatural.[15] This is also Goldsmith's

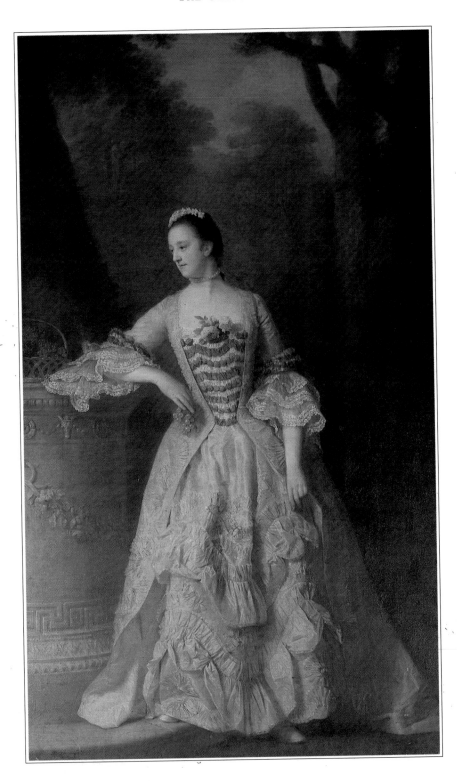

Fig. 99
RAMSAY
Lady Louisa Conolly 1759
FROM A PRIVATE COLLECTION

view when in 1757 he writes, 'to well-proportioned figures, that dress is best adapted which discovers the beauty of the limbs'.[16] This is the direction fashion eventually took, at least in the view of a social historian in 1810: 'The Ladies have at length, much to their honour, thrown aside

those hateful attempts to supply Nature's deficiences or omissions, the false breasts, pads, and bottoms; and now appear in that native grace and proportion which distinguishes an English-woman: the Hair ... in the manner adopted by the most eminent Grecian sculptors; and the form appears through their snow-white draperies in that fascinating manner which excludes the least thought of impropriety.'[17] This description is borne out by Raeburn's 1798 portrait of Mrs Gregory (FIG. 86), who wears real as opposed to studio dress, but of a loose, unpadded simplicity obviously anticipated by the Duchess of Hamilton's paintable bedgown (FIG. 98). Even at the time this transformation of fashion was widely credited to the artists: according to his son, Romney's work influenced public taste in its move towards 'a more simple and graceful mode of dress, approaching nearer to the Grecian'.[18]

The pattern of shadow running down the side of the Duchess of Hamilton's face and neck (FIG. 98), widening and narrowing but never breaking, recalls the sweeping, simplified draughtmanship of the 'Great Style'. Effective though this shading may be, it does not make for a scrupulous likeness, especially when compared to Ramsay's brighter colour and greater intricacy of feature. It is not surprising that Reynolds was famous for unrecognisable portraits. Both figures are set in an evening garden; Reynolds suggests atmosphere by a contrast between the white of the brilliantly-lit figure and the deepening blue of the evening sky, while Ramsay does the same by a subtle variation of midtones and a close pink-grey colour range, the grey thickening slightly with distance.

Reynolds' use of emblematic accessory is also more historical than Ramsay's. Lady Louisa has been gathering grapes, a bunch of which she holds next to her womb like a premonition of fertility. On the Duchess of Hamilton's plinth there is a glimpse of a shadowy relief showing the Judgement of Paris, while behind her some doves drink at a fountain. The winner of Paris' golden apple for the most beautiful goddess was Venus, whose emblem is a pair of doves. The sitter is thus flatteringly identified as Venus. (This was not the first nor the last time that this famous society beauty was likened to a goddess.)[19]

There is another device which suggests that this portrait may have been intended by Reynolds almost as a treatise on Female Beauty. In his *Enquiry*, Burke discusses 'Gradual Variation' as one of the characteristics of Beauty. (Part III, Section XV) This he sees particularly in the swell and taper of form in the bodies of birds.

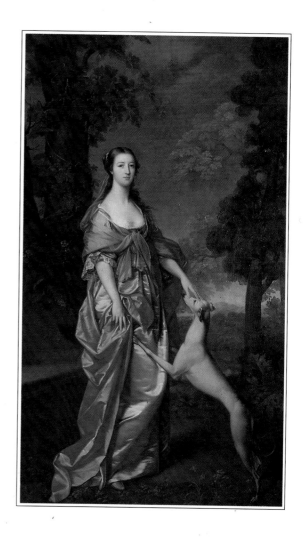

Fig. 100
GAVIN HAMILTON
Elizabeth Gunning, Duchess of Hamilton and Argyll 1752-3
IN THE DUKE OF HAMILTON'S COLLECTION

'In this description', he continues, 'I have before me the idea of a dove; it agrees very well with most of the conditions of beauty. It is smooth and downy; its parts are (to use that expression) melted into one another; you are presented with no sudden protuberance through the whole, and yet the whole is continually changing. Observe that part of a beautiful woman where she is perhaps the most beautiful, about the neck and breasts; the smoothness; the softness; the easy and insensible swell; the variety of the surface, which is never for the smallest space the same' and so on.

The implication of this passage, clearly, is that the neck and breasts of a beautiful woman are dove-like. This is certainly Reynolds' inference, for not only does his Duchess of Hamilton (*FIG.* 98) draw special attention to these features of *female* beauty, but he also gives her this bird's mottled white markings, and the outline gently tapering (even on the face) towards the point of a beak-like (but becoming) nose. Reynolds uses the same ornithological identification a few years later in his *c.*1765 portrait of Kitty Fisher.[20]

There are other images of this sitter, Elizabeth Gunning, before and after she became the Duchess of Hamilton, which help to put Reynolds' revolutionary portrait in context. Something of a precedent is supplied by the 1752-3 portrait by the Neo-Classical history painter, Gavin Hamilton (*FIG.* 100). Strictly speaking the sitter is here dressed in Van Dyck costume, the very opposite of Classical dress.[21] But a scarf covers the lace and frills of the bodice, an improbably large shawl falls off her back, and the lower dress has been given a high-ridge fold to reveal the thigh and knee – all elements suggestive of the simple, sculptural patterns of the 'painter-like' or antique dress. The way the sitter pats an eager greyhound in a landscape reminds the viewer of Diana the Huntress. She is also goddess of the moon, which Elizabeth Gunning's pale, round face seems to impersonate as it rises against the sky, while the sun sets.

The 1767 portrait of the Duchess by Francis Cotes (*FIG.* 101) shows the influence of both the earlier examples of Gavin Hamilton and Reynolds (*FIGS* 100 and 98). Below the girdle the figure is characteristically inflated with a hard, yet rolling 'V' pattern of pleats, the signature of Classical sculpture. Like Reynolds, Cotes has given his figure a rounded outline, suggestive of the smooth volume of polished stone; this is especially so with the 'inner' green mass, describing the figure, but it is also seen in the 'outer' pink one, the expansive and ornamental drapery. These brighter colours echo Gavin Hamilton's work, as does the texture of the drapery, intriguingly poised between the soft gloss of silk and the hard sheen of marble.

As previously there is here an example of poetic identification. The sun sets behind the figure, which means that the prominent sunflowers turn their gaze towards a new, brighter sun, also seen against the sky – the Duchess's face.[22] To liken beauty to the sun is a conventional poetic compliment.

Architecture is obviously an appropriate adjunct to so heavy and 'carved' a figure. The duchess seems to draw up to herself, from the simple geometric masses of the balustrade and steps, the quality of stone. A giant urn is a common accompaniment to women in portraits in the

'Grand Style'; the urn beside the duchess is the female counterpart to the column or columns seen in male portraits (see *FIG.* 1). Just as these latter suggest the 'noble house', supported by generations of eldest sons, so an urn suggests the vessel – or womb – from which these eldest sons emerge. Women are sometimes matched with columns, but this is rare, for their rôle in the dynastic process is auxiliary: no title less than a crown can be inherited from the female line.

Francis Cotes died unexpectedly in 1770, leaving Reynolds without his principal rival. A few years later, in 1775, Cotes' vacated studio was taken over by another promising young painter, just returned from the obligatory study-trip to Italy – George Romney.[23] Apart from saving money on refurbishment, to take over a colleague's studio is an easy way of gaining notice, for it means that fashionable people know where to find you. This is even more effective if you paint in a style comparable with that of the previous tenant. Romney's *Mrs Scott Jackson, later Lady Broughton*, painted in *c.*1772 (*FIG.* 103), shows him working in the Grand Style, but inclining to Cotes' rather than Reynolds' interpretation of it. This is an obviously sculptural figure with familiar anatomical distortions, including a thigh as long as the chest and head put together! Lady Broughton's

dress, though conforming roughly to the triangular shape of the trailing formal dress of the period, is either an informal wrap-around or the painter's invention.[24] It has a marble geology with folds that are deeply indented, but which minimally overlap, so that the valleys have the same rolling, 'carved-out' appearance as the tubular ridges. As in Cotes' *Elizabeth Gunning* (*FIG.* 101) the giant, principal folds have a metallic stiffness, and a tautness and angularity to contrast with the body intimated underneath. Yet the drapery is painted, like Cotes' drapery also, with bright, pastel tints and even contains shot-coloured highlights to confuse the eye with a silky-marble gloss.

Gainsborough regarded the fashion for semi-informal, semi-Classical dress in portraiture with unconcealed irritation. He would have relished the paradox that, to us at least, nothing has dated as irretrievably as this 'timeless' fad. 'I am very well aware,' he writes in 1771, 'of the Objection to modern dresses in Pictures, that they are soon out of fashion & look awkward; but as that misfortune cannot be helpd we must set it against the unluckiness of fancied dresses taking away Likenesses, the principle beauty and intention of a Portrait.'[25] In another letter of the same year (1771) he warms to his theme:

Fig. 103
ROMNEY
Mrs Thomas Scott Jackson c.1772
NATIONAL GALLERY OF ART,
WASHINGTON, ANDREW W.
MELLON COLLECTION

nothing can be more absurd than the foolish custom of painters dressing people like Scaramouches, and expecting the likeness to appear . . . [this is to make] a handsome face be overset by a fictitious bundle of trumpery of the foolish Painter's own inventing. For my part . . . I have that regard for truth, that I hold the finest invention as a mere slave in Comparison, and believe I shall remain an ignorant fellow to the end of my days, because I never could have patience to read Poetical impossibilities, the very food of a Painter; especially if he intends to be KNIGHTED in this land of Roast Beef, so well do serious people love froth.[26]

Whatever his personal opinions, a portraitist is obliged to swim with the current to some extent, as Gainsborough did with his *Viscountess Ligonier* of 1770 (*FIG.* 102), painted just a year before this letter. The porte-crayon and other artistic 'props' refer to the fact that Lady Ligonier was an amateur draughtswoman.[27] Gainsborough has looked to Van Dyck for the swirling smoky shadows of this interior, and the gash of red, glowing round the silhouette of the dancing nymph like a pagan halo; but the sitter's costume is a version of the popular Classical undress. As usual her standard wrap, with loosely-tied girdle, conforms roughly to the shape of formal dress, but with the voluminousness of full 'antique' hips, rather than modern hoops. A Reynolds-style costume may have been foisted upon him, but this doesn't mean that Gainsborough has to adopt Reynolds' style of painting. *His* views on the 'simplicity of the antique' are, again, forthright. Writing of the *Fourth Discourse*, he asserts:

Fig. 102
GAINSBOROUGH
Penelope, Viscountess Ligonier 1770
HENRY E. HUNTINGTON LIBRARY
AND ART GALLERY, SAN MARINO

Every one knows that the grand style must consist in plainness and simplicity, and that silks and satins, Pearls and trifling ornaments would be as hurtfull to simplicity, as flourishes in a Psalm Tune; but Fresco would no more do for Portraits than an Organ would please Ladies in the hands of Fischer [a virtuoso performer on the oboe]; there must be variety of lively touches and surprizing Effects to make the Heart dance, or else they had better be in a Church — so in Portrait Painting there must be a Lustre and finishing to bring it up to individual Life.

Undated Letter, *c.* 1772.[28]

In her pose Lady Ligonier lacks the 'plainness and simplicity' of the other portraits in this section: she sways her hips, with hands turned back into the body – one up, one down – as in a country dance. And in the execution there is plenty of 'Lustre and finishing' and 'lively touches and surprizing Effects'. The pattern of folds and even the girdle's knot are more complex and less sculptural than Reynolds' work, while the scumbled white highlights seem racing and impermanent, as if painted with dextrous rapidity while the dress is shaken in a dance. The surroundings, too, are livelier: the

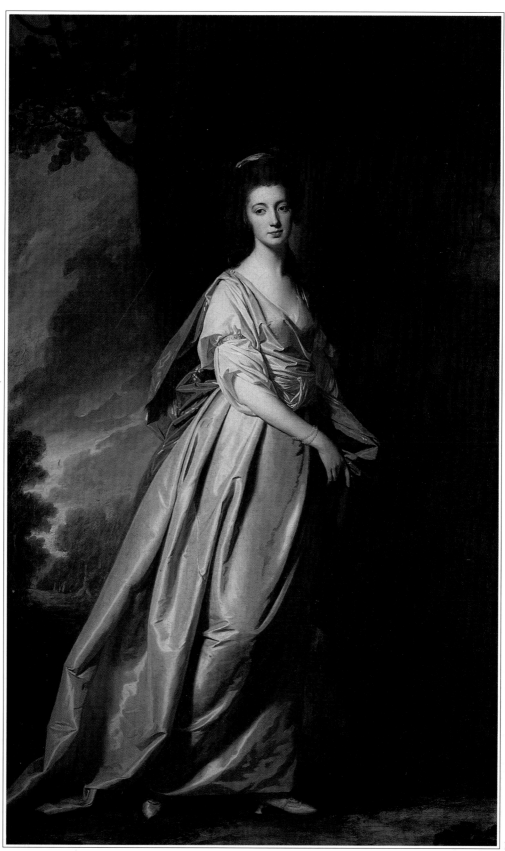

103

pedestal, for instance, with its gilding catching the light, seems more ornamental than architectural, if compared with the Duchess of Hamilton's (*FIG.* 98).

However many imitators entered the field, eagerly like Romney or, like Gainsborough, reluctantly, this manner remained Reynolds' domain. Almost every year, at the Society of Artists or at the Royal Academy, he exhibited at least one of these full-length, Classically-draped women in landscape. His 1777-9 portrait of Jane, Countess of Harrington (*FIG.* 104) is the epitome of the type. The drapery is downright impossible: the Countess couldn't walk a yard without tripping, swathed in this giant, pink bed-cover. It shows perfectly the contrast between ornamental drapery, tumbling over the arms, floor and balustrade, and moulding drapery, blown flat against the figure to reveal its flame-like contour of swelling thighs and tapering shoulders. The folds are here smoother and clearer than in the *Duchess of Hamilton* (*FIG.* 98), but unlike Romney's folds they have only the pattern and not the texture of stone. At first sight the Countess of Harrington appears to be issuing a command, with an unfeminine gesture based on the *Apollo Belvedere* (*FIG.* 27). In fact this portrait was probably intended as one of a pair, with the sitter referring us deferentially to her husband's likeness, hanging to her right, though this latter picture was not supplied until 1783.

What is the intention with portraits like these? What do they suggest about their sitters? The simple answer is given by Reynolds himself in a passage quoted above: this is the way to 'dignify' the subject. One could say perhaps that this is the formal portrait of the later eighteenth century, but without the formal dress. Ideas of rank, power and dynasty are conveyed while, at the same time, artists are released from the laboured details and hampered compositions occasioned by ermine and coronets – by that 'stiffness in full dress that always cruelly militates against the artist in spite of his best endeavours'.[29] Hoppner said of an imaginary Reynolds portrait of the Duchess of Devonshire that he 'would not need the regalia of nobility to paint her out a Duchess'.[30]

The Spectator, no. 144 of 1711 contains an interesting contrast between two sorts of feminine beauty: one *Eucratia* is all softness and 'tender fear' – her portrait would fit very well into the previous two chapters. But another has a beauty which is 'commanding: Love towards *Eudosia* is a Sentiment like the Love of Glory. The Lovers of other Women are soften'd into Fondness, the Admirers of *Eudosia* exalted into Ambition'. Her portrait might look something like the *Countess of Harrington* (*FIG.* 104).

It should be remembered, also, that the rage for this sort of portrait, in the 1770s, comes at a time when the interiors of country houses were increasingly being decorated with casts of antique statues, and painted panels illustrating full-dress classical scenes by Angelica Kauffmann and her husband, Antonio Zucchi. The taste was for all-of-a-piece Classicism, sometimes of great simplicity and austerity. The balustrade and urn in the *Countess of Harrington* (*FIG.* 104) are of the giant scale of some contemporary houses, while the expanse of sweeping, smooth turf and clumped trees suggests the heroic simplicity of Capability Brown's vast Classical parklands.

If there is a particular virtue associated with this antique disguise it is probably Chastity, the chief characteristic of the 'modest dames of antiquity', as Mary Wollstonecraft calls them.[31] A virtuous country wife is teased by a town flirt, in *The Spectator*, no. 254 of 1711, for being so silly as to think Portia and other Roman wives to be brighter examples than their cynical modern counterparts. 'I wish it may never come into your Head,' she continues, 'to imitate these antiquated Creatures so far, as to come into Publick in the Habit as well as Air of a *Roman* Matron.'[32]

Reynolds calls this genre of portraiture the 'Historical Style', and yet makes no further mention of History. Gainsborough, in his letter (of 1771) quoted above, seems to assume, without really providing the links in the chain, that 'dressing people like Scaramouches' leads naturally to reading 'Poetical impossibilities'. As they are supposed to be the 'very food of a painter', 'Poetical impossibilities' are presumably mythological stories or allegories; but why should they belong so inevitably with fancy dress? The answer is that Classical dress is a sort of blank page, waiting for some significance to be written upon it. Even more than is generally the case in eighteenth-century portraiture, this sort of portrait can become the vehicle for ideas normally expressed in History Painting.

We have already seen how this can happen in the three portraits of the Duchess of Hamilton (*FIGS* 98, 100 and 101), with their allusions to Venus in the Reynolds, to Diana in the Gavin Hamilton, and to the Sun in the Francis Cotes. An earlier Reynolds portrait of the Countess of Harrington (*FIG.* 105, exhibited in 1775) contains an allusion similar to that in Cotes' picture (*FIG.* 101). The Countess, like the Duchess, has the bright orb of her face against a dawn sky, like the rising sun framed by a sweep of clouds: in her morning ramble she has become Aurora, the goddess of Dawn. According to Cesare Ripa's *Iconologia*, Aurora should be shown in art, like the Countess, as a young and beautiful girl of rosy complexion. He suggests that she should wear, among other trappings, a dress of white, red and orange to evoke the colour changes in a dawn sky, and that she should scatter flowers, to signify that they open their petals at the first touch of the sun. In Reynolds' portrait the Countess's dress is white, fringed with orange-brown and pale red; she carries a garland and at her feet a carpet of flowers appears to spring up, as if by magic. Ripa also quotes a Homeric reference to Aurora as 'veiled with yellow'. In her right hand the Countess holds a golden-brown veil, embroidered with stars, which she has lowered from her face, as the stars and dawn-mists vanish with the rising of the sun.[33]

Like the Countess here, and so many other virtuous heroines, Aurora is prone to blush.[34] This is because the blood in a young girl's cheek is like the red flush of a dawn sky, an image most memorably developed in Byron's *Don Juan*, Canto II, 1819:

> *And Haidée met the morning face to face;*
> *Her own was freshest, though a feverish flush*
> *Had dyed it with the headlong blood, whose race*
> *From heart to cheek is curb'd into a blush,*
> *Like to a torrent which a mountain's base,*
> *That overpowers some Alpine river's rush,*

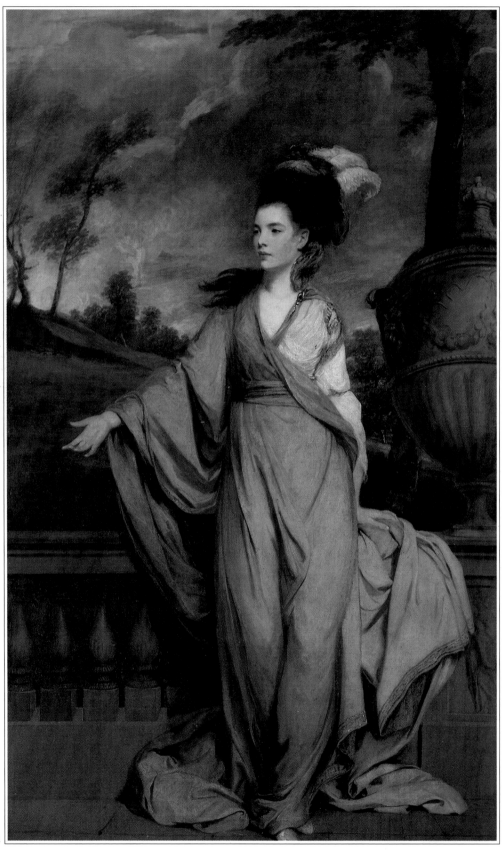

104

Checks to a lake, whose waves in circles spread;
Or the Red Sea – but the sea is not red.

And down the cliff the island virgin came,
And near the cave her quick light footsteps drew,
While the sun smiled on her with his first flame,
And young Aurora kiss'd her lips with dew,
Taking her for sister; just the same
Mistake you would have made on seeing the two,
Although the mortal, quite as fresh and fair,
Had all the advantage, too, of not being air.

Stanzas CXLI, CLXII.

Another example of the wit with which Reynolds animates this adaptible convention of the 'historical portrait' is his *Mrs Lloyd* of 1776 (*FIG.* 106). She is shown in woodlands, dappled by sunlight, to suggest all the general virtues of Nature mentioned in the previous chapter. Here the setting has a particular meaning because Mrs Lloyd is carving her husband's name in the trunk of a tree, a parading of true-love reminiscent of Rosalind's in *As You Like It*.[35] Reynolds may have got this idea too from a fancy portrait by Francis Cotes, exhibited at the first Society of Arts exhibition of 1760, *Anne Sandby as 'Emma the Nut-Brown Maid'* hanging a 'fragrant wreath' of her lover's hair on a tree, an episode from Matthew Prior's *Henry and Emma*.[36] In Reynolds' woodland romance we can only read the beginning of the name – *Llo* – in the bark; this can of course spell *Llove*, as well as *Lloyd*!

'Damn him! How various he is!' Gainsborough is supposed to have complained about his rival, Reynolds.[37] When one considers his portraits in this one historical mode one appreciates the grounds for Gainsborough's professional frustration. We have already seen two totally different portraits of the Countess of Harrington (*FIGS* 104 and 105). The second 1777-9 example (*FIG.* 104) may be further compared with Reynolds' *Lady Bampfylde* of 1777 (*FIG.* 108). Here the sitter wears an almost possible dress (if the hem were taken up a foot), where the usual patterns of sculpture are still just perceptible in the gauzy, soft fabric. The 'antique air' is fainter, and the suggestion of Classical statuary is transmitted through the more supple medium of Rubens, whose influence is seen in the transparent folds of the dress and the snaking fingers.

Lady Bampfylde (*FIG.* 108) is integrated into the landscape in a way that the Countess of Harrington (*FIG.* 104) is not. She leans, not on a plinth but on a conveniently cuboid piece of stone by a grove. She catches the same light as her surroundings and her legs are swallowed in the same darkness. Such dappling, as in *Mrs Lloyd* (*FIG.* 106), is an indication of her 'belonging' within Nature. Her gauzy brown veil trails over her and the stone beside her, resembling some natural growth – an effect familiar

Fig. 105
REYNOLDS
Jane Fleming, Countess of Harrington 1775
BELONGING TO THE EARL OF HAREWOOD

Fig. 104
REYNOLDS
Jane Fleming, Countess of Harrington 1777-9
HENRY E. HUNTINGTON LIBRARY AND ART GALLERY, SAN MARINO

Fig. 106
REYNOLDS
Joanna Leigh, Mrs R. B. Lloyd
1776
PRIVATE COLLECTION

Fig. 107
'Purity' from the
Iconologia of Cesare Ripa, 1709
CAMBRIDGE UNIVERSITY LIBRARY

from Gainsborough's work. Unlike the Countess of Harrington, her gesture is not one of command, and she looks down demurely. Lady Bampfylde wears white, she has a flower at her breast and seems to be leaning forward to pick a stem from a prominent clump of lilies. A woman in a white dress with lilies – these are all elements in conventional allegories of *Purity*. One further attribute of *Purity*, at least according to Ripa, is a 'sun' on her stomach, which is usually represented in art by a species of badge with prongs (*FIG.* 107).[38] In this literal form such a hyroglyph would be cumbersome and absurd in this only semi-allegorical context: so, with typical wit, Reynolds has reinterpreted it as the brilliant pool of light with its centre on the figure's stomach.

A similar pool of light strikes the breast of Lady Catherine Pelham-Clinton as, dressed in white, she feeds some chickens (1781) (*FIG.* 110). Another attribute of allegorical figures of *Purity*, visible in the Ripa illustration though seldom shown in art, is that she should be feeding a white chicken (*FIG.* 107). This is because lions, though usually courageous beasts, are afraid of chickens, particularly white ones![39] Dr Livingstone never ventured into the interior without one! Reynolds would be unlikely to take such an allegory very seriously, except as a witty, tongue-in-cheek attribute of a young girl. It should be remembered, however, that though this particular allegory would probably not be on the tip of anyone's tongue, the *idea* of allegory in general was much more familiar in the eighteenth century than it is today. Even if it was disapproved of, the habit of reading allegorically was ingrained. Early in the century Shaftesbury recommends the painter not to include extraneous objects, for the audience will read them as if emblematic, while towards the end of the century Fuseli pronounces 'all ornament ought to be allegoric'.[40]

For a young lady to impersonate an allegory is not unknown: in 1788 a Mrs Egerton attended a masquerade as *Curiosity*, in a dress embroidered over with eyes and ears.[41] She probably copied her dress from *Curiosity*, plate 235 of Jefferys' immensely popular *Collection of Dresses of Different Nations* (1757 and 1772). This is one of thirteen allegorical costumes in the collection, all based on Cesare Ripa.[42] Another which a masquerader might have chosen (and which these sitters *have* chosen) is *Virtue* (plate 232) with a white dress, blue mantle and larger version of the gold sun on the breast (*FIG.* 109).[43] However this is as likely to be Reynolds' idea as the sitter's: he is said to have delighted in Jacob Cats' *Book of Emblems* as a child, and in his *Seventh Discourse* argues for the appropriateness of

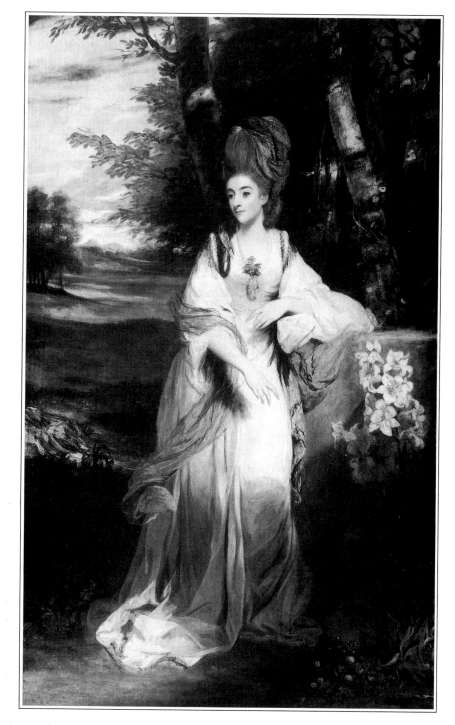

Fig. 109
'Virtue' from the
*Collection of Dresses of Different
Nations of Jefferys,*
1772
THE BRITISH LIBRARY

Fig. 108
REYNOLDS
Catherine Moore, Lady Bampfylde
1777
THE TATE GALLERY, LONDON

allegory in painting. It is able to produce a 'greater variety of ideal beauty, a richer, a more various and delightful composition, and gives to the artist a greater opportunity of exhibiting his skill'.[44] The idea of the emblematic spotlight also occurs in his 1774 portrait of Dr Beattie, where the sitter himself describes the allegorical accompaniment as depicting 'Prejudice, Scepticism, and Folly, who are shrinking away from the *light*

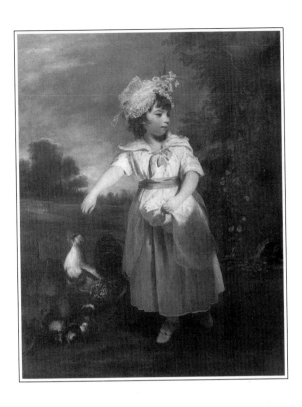

Fig. 110
REYNOLDS
Lady Catherine Pelham-Clinton
1781
THE EARL OF RADNOR
COLLECTION

that beams on the breast of the Angel' (my ital-ics).[45] Such an unnatural device is no more than would be accepted in poetic language, in such phrases as 'let your bosoms glow with the en-thusiasm of virtue', which similarly alludes to an allegory of *Virtue* (FIG. 109).[46] Even the absurd white chicken crops up elsewhere in English art (see *FIG.* 131).

Raeburn's romantic portrait of Mrs Scott Moncrieff (*FIG.* 4), perhaps loosely suggested by Reynolds' *Miss Catherine Moore* (FIG. 69), has a pool of brilliant light centred on the white heart – an obvious echo of Purity's sunburst (*FIG.* 107). This is especially striking because the light seems to be revealed by the scarlet robe being pulled open. The reason is that Mrs Scott Mon-crieff has 'bared her breast', she has nothing to hide: underneath her brilliant red velvet she wears simple white; beneath the dark of her robe her breast shines bright. Raeburn's por-traiture has the moral x-ray vision which Hay-ley finds in Romney's *Serena*:

He has imparted to th'ideal fair
Yet more than beauty's bloom, and youth's attractive air,
For in his studious nymph th'enamour'd eye
May thro' her breast her gentle heart descry,
See the fond thoughts, that o'er her fancy roll,
And sympathy's soft swell, that fills her soul.[47]

The idea in Raeburn comes with an almost disconcerting suggestion of nudity in the clinging white dress. There is an obvious overlap between the erotic and the virtuous – between the naked because pure (in allego-ries of *Truth*, for example) and the just plain naked. A similar mixture of prurience and high moral tone is to be detected in Pope's reference to the beautiful Duchess of Queensbury:

'Tis well – but, Artists! Who can paint or write,
To draw the Naked is your true delight:
That Robe of Quality so struts and swells,
None see what Parts of Nature it conceals.
Th'exactest traits of Body or of Mind,
We owe to models of an humble kind.
If QUEENSBURY to strip there's no compelling,
'Tis from a Handmaid we must take a Helen.

Moral Essays, Epistle II,
To a Lady of the Characters of Women, 1735, 11. 187-94.

Fig. 111
HOPPNER
Lady Charlotte Campbell as Aurora
1796
INVERARAY CASTLE COLLECTION,
TRUSTEES OF THE TENTH DUKE
OF ARGYLL

Reynolds' *Lady Charles Spencer* of c.1775 (FIG. 10) is another example of his use of allegory, redeemed by wit. Lady Spencer returns from a ride, her red hunting dress dappled with evening light and her face catching a transfiguring dollop of light, like a Baroque saint experiencing a vision. She dreamily caresses her grey horse's head, which suggests general

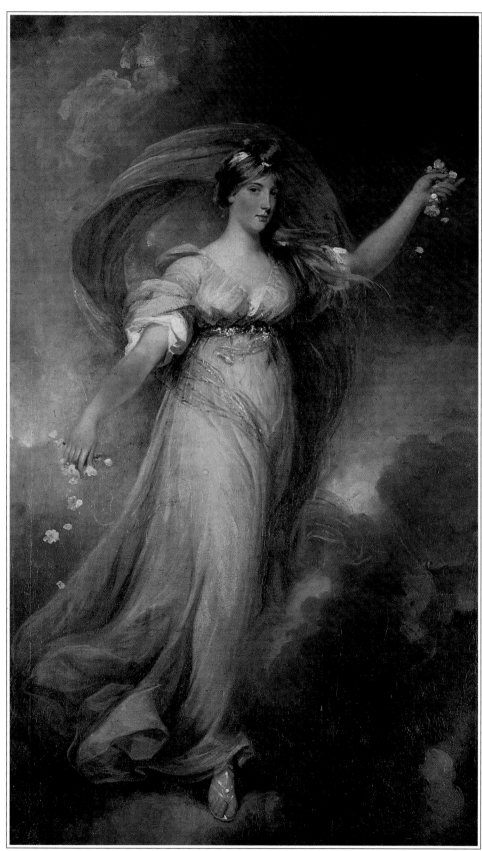

111

good nature, but also reminds the viewer of allegories of *Virginity*, in which a young woman cradles a unicorn's head in her lap. (This is because unicorns, though usually wild, allow themselves to be captured by virgins.)

Hoppner's *Lady Charlotte Campbell* (*FIG.* 111) would seem to fit comfortably into this context. Like Reynolds' first *Countess of Harrington* it depicts the sitter as Aurora, in her yellow dress, scattering flowers. But Hoppner's figure is taking the part rather more seriously: instead of engaging in an ordinary country stroll, susceptible of this further identification, she puts the matter beyond doubt by prancing on clouds in a pose borrowed from Guido Reni's famous ceiling fresco of the same subject. The allegory in the *Countess of Harrington* (*FIG.* 105) is a nuance or clue planted by the wit of the painter, to be detected by that of the viewer. The same could even be said of the more recognisably Olympian *Duchess of Hamilton* (*FIG.* 98). In *Lady Campbell* (*FIG.* 111), however, the allegory is obtrusive: she is either Aurora or nothing. The boundary between the two types may seem to us a blurred one, but the eighteenth-century viewer would have recognised it. In this case, however, when Hoppner's portrait was exhibited in 1796 one reviewer felt that 'the beauty of Lady Charlotte Campbell reconciles us to the allegory'.[48] This explicitly mythological portrait certainly requires a new chapter.

Chapter 9

If Folly Grows
Romantic

Let then the Fair one beautifully cry,
In Magdalen's loose hair and lifted eye,
Or drest in smiles of sweet Cecilia shine,
With simp'ring Angels, Palms, and Harps divine;
Whether the Charmer sinner it, or saint it,
If Folly grows romantic, I must paint it.

Alexander Pope, *Moral Essays, Epistle II,*
To a Lady of the Characters of Women, 1735, ll. 11-16.

E HAVE ALREADY SEEN A FINE EXAMPLE OF WHAT POPE WOULD call a 'sinner sainting it' in Lely's *Comtesse de Grammont* (*FIG.* 64). The Comtesse holds what is, for a *décolletée femme fatale*, a most inappropriate emblem – the palm of martyrdom. But the fashion for portraits in which a sitter is shown in mythological or even religious disguise, was past by the time Pope was writing. Few of his contemporaries would have disagreed with him, that this is a flimsy as well as foolish way to celebrate a woman's character. For Pope these mythological guises – so easily adopted, so obviously inappropriate – only go to show that underneath women have 'no Characters at all'. (l. 2)

Yet, in spite of Pope, the mythological portrait revives. We find not just the subtle allusion, giving the finishing touch to an image, as in the *Duchess of Hamilton* (*FIG.* 98) and others in the previous chapter, but portraits with myth in their title, such as Reynolds' *Lady Sarah Bunbury Sacrificing to the Graces* (*FIG.* 112) of 1765. Why did fashionable young ladies again hanker after this discredited genre? Or, as Pope might have put it, why did folly again grow romantic? What about Addison, for example, and his advice concerning the shunning of 'Pagan Agents' and 'School-boy Tales', quoted above in connection with warriors? In the same paper he laments that 'a Poem on a fine Woman . . . turns more upon *Venus* or *Helen*, than on the Party concerned', which is exactly Pope's objection. And yet there is a postscript, for Addison permits some significant exceptions to his rules: in mock-heroics he feels 'Heathen Mythology is not only excusable but graceful'; and for the 'Female Poets in this Nation', he

somewhat patronisingly grants that they should 'be still left in full Possession of their Gods and Goddesses, in the same manner as if this Paper had never been written'. (*The Spectator*, no. 523, 1712) So, though there are no fully mythological or historical *male* portraits, female sitters as well as female poets are by and large left 'in possession of their Gods and Goddesses', by their obliging painters.

However, even during the revival, which really begins in the 1760s, the rumbles of derision do not cease. A year after Reynolds painted *Lady Sarah Bunbury Sacrificing to the Graces*, his friend Goldsmith included an episode in *The Vicar of Wakefield* where the family make fools of themselves by commissioning an absurd mismatch of mythologies for a group portrait, on a canvas too large to fit in their house. (Chapter XVI) Even Lady Sarah's portrait provoked the tart remark from Mrs Thrale that the sitter 'never *did* sacrifice to the Graces . . . she used to play cricket and eat beefsteaks'.[1]

It is wrong to imagine Reynolds blundering on in this mode, unaware that even his friends were laughing behind his back. There are two aspects of eighteenth-century life which suggest that these images are slightly more self-aware than we might think, and that Reynolds might be sharing rather than provoking Goldsmith's joke. The first is *gallantry*. Edward Edwards writes in 1808 that it was with this portrait of Lady Sarah that Reynolds 'introduced into his portraits a style of gallant compliment'.[2] Gallantry is a routine form of flattery directed towards 'the fair sex' and accepted as a matter of course; it is grossly hyperbolic and relies heavily on 'Pagan Agents', as this snippet from Fanny Burney suggests: 'he took my hand, and ran on saying such fine speeches and compliments, that I might almost have supposed myself a goddess, and him a pagan paying me adoration.' (*Evelina*, Volume I, Letter XXIII) Mary Wollstonecraft reserves her most bitter attacks for what she calls the 'libidinous mockery of gallantry'.[3] Yet it is obvious from the diaries and novels of the period that, though palpably insincere, gallantry is not always regarded as positively meretricious. This is because, in the right hands, it is delivered with a certain tongue-in-cheek, steering a mid-course between insulting the recipient's person and insulting her intelligence. Edward Gibbon furnishes a good demonstration piece: in a letter of 1792, he writes of the Duchess of Devonshire that she is 'less severe than Minerva, more decent than Venus, less cold than Diana, and not quite so great a vixen as the ox-eye Juno. To express that infallible mixture of grace, sweetness, and dignity, a new race of beings must be invented, and I am a mere prose narrator of matter of fact'.[4]

Lady Sarah has become a member of this 'new race of beings', closely related to the old Olympians, in a painting which exhibits the same well-mannered tongue-in-cheek as Gibbon's letter (*FIG.* 112).[5] It is a 'gallant compliment' not meant very seriously, but not mocking either. For the very element of tongue-in-cheek pre-empts ridicule. Just as no woman would be expected to believe the habitual gallantry showered upon her, so nobody is supposed to think here that Lady Sarah is 'taken in' by her own apotheosis. She is playing a part and she knows it. Which brings us to the other important aspect of eighteenth-century social life: the

Fig. 112
REYNOLDS
Lady Sarah Bunbury Sacrificing to the Graces 1765
ART INSTITUTE OF CHICAGO,
W. W. KIMBALL COLLECTION

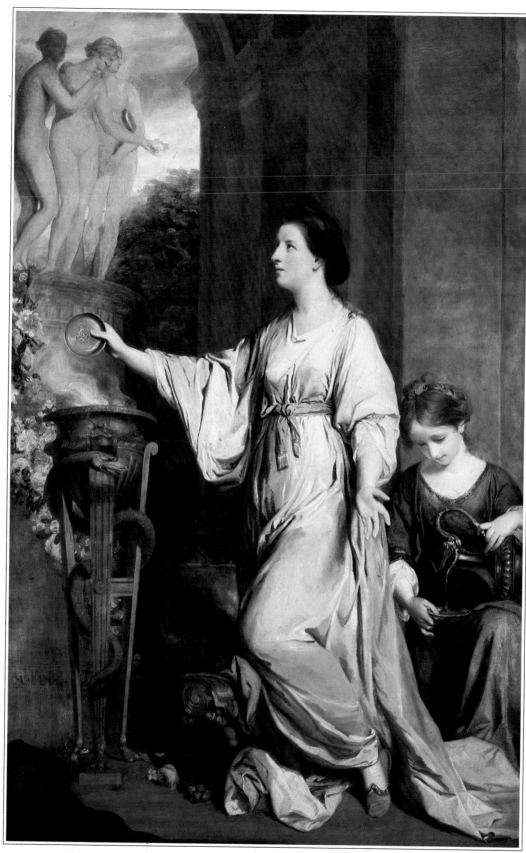

112

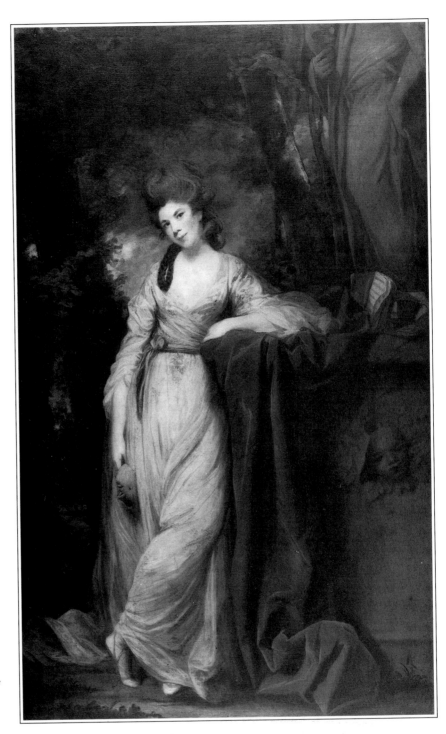

Fig. 113
REYNOLDS
Mrs Abington as The Comic Muse
1764-5
THE NATIONAL TRUST,
WADDESDON

popularity of play-acting. Country houses could easily be adapted for amateur theatricals; the trials of mounting such performances are described by Fanny Burney in her diaries and Jane Austen in *Mansfield Park*. Lady Sarah Bunbury herself was a tolerable actress, who 'gained great applause' playing opposite the future statesman, Charles James Fox, a year after this portrait.[6]

In other works of this nature Reynolds makes the element of play-acting even more prominent. This is only to be expected in his *Mrs Abington as the Comic Muse* of 1764-5 (*FIG.* 113), for the sitter is a professional actress, but in the much later portrait of Sophia Musters 'as Hebe' (1785) (*FIG.* 114), the complicity between sitter and 'audience' is very similar to that called for by Mrs Abington's portrait. Mrs Musters, by comparison with Hoppner's similarly cloud-borne *Lady Campbell* (*FIG.* 111), has the same advantage as Byron's Haidée, that of not being air. With her direct stare and saucy smile, and with a certain directness in the painting of the face – a simplicity of contour and a confident smudging of detail – her expression is lifted out of the timeless world of mythology and the 'Grand Style' of art, and brought into the midst of a Georgian parlour-game.

Another theatrical activity, which is usually considered now only as a costume parade, is the masquerade. This form of entertainment persisted throughout the century, amid howls of protest at its alleged immorality; but after public masquerades had been suppressed in 1756, their place was taken by private ones, which were by and large disappointingly innocent diversions.

A masquerade is primarily a fancy-dress ball, with two refinements: you are not supposed to recognise anybody until they 'unmask' at midnight (or some other appointed hour), and you are expected to 'sustain' your chosen character in both speech and behaviour. Fanny Burney's diary gives a detailed description of a private masquerade in 1770. She herself is dressed in a Persian outfit, which gives the Captain who is to escort her a 'fine opportunity for gallantry': he invents an elaborate story for her new persona, relating how she was 'incarcerated by the Grand Seignor as part of the Seraglio, and made prisoner by the Russians in the present war', and so on. She concedes in her diary that, 'to say the truth, those whimsical dresses are not unbecoming'. At the masquerade itself there are Nuns, Punches, Witches, Huntsmen, Shepherds, Harlequins, Gardeners, Persians, Turks, Friars, and a Merlin, 'who spoke of spells, magick and charms with all the *mock heroick* and bombast manner which his character could require'. This admirably sustained part, and a Dutchman speaking amusingly fabricated high Dutch, are contrasted with a shepherdess, whose 'trifling conversation' was 'full as clever as her choice of so hackneyed and insipid a dress led one to expect'. Finally all unmask and the old turn young and the young old, 'in short, every face appeared different from what we expected'.[7] It is striking how important a part *acting* and amateur dramatic invention, as opposed to mere costume, play in the entertainment, whether it be the captain's gallant flights of fancy or the Merlin's mock-heroic.

The most common complaint about masquerades is that people fail to 'support' their characters.[8] The same could also be said of the portraits in masquerade dress around the middle of the century. Works of the 1740s such as Ramsay's *Catherine Paggen as Diana* (Virginia Museum of Arts) are the forerunners of later mythological portraits, but they remain no more than 'costume pieces'. It is Reynolds who 'moved the contemporary love for masquerades from the assembly room to the studio'.[9] Unlike Catherine Paggen, Lady Sarah Bunbury and Sophia Musters are sustain-

ing their parts admirably (*FIGS* 112 and 114): Lady Sarah casts her eyes up with a fine religious swoon, while Mrs Musters smiles winningly as Hebe. It is a staple of eighteenth-century fiction that the parts chosen at masquerade reflect the characters of those doing the choosing. After much deliberation Hayley's Serena goes to a masquerade as a village maid (Canto II, ll. 209-20), and in Fanny Burney's *Cecilia* (1782) we find, at a masquerade, an extended premonition of the plot of the rest of the novel, with every character revealing his real self by his disguise. (Book II, Chapter III) We must assume that the same is true here. Sophia Musters' part is easy to decode: Hebe is the goddess of Youth, which naturally implies a springtime beauty; she is also the bearer of Jupiter's cup, the replenishment of which implies good cheer. (Jupiter is here represented by his eagle.) It is not surprising that Hebe is a name frequently attached to young beauties in gallant tittle-tattle of the period.[10]

Lady Sarah, on the other hand, is not identified as anyone in particular, though her action is 'historical'. In a semi-kneeling posture she looks up adoringly at the three Graces, while pouring her sacrifice – a libation – into a brazier. The statue of the Graces seems to be melting into life, their tight ring opens, as if to include Lady Sarah, while one offers her a wreath.[11] Her sacrifice has evidently been received favourably. The Graces, the attendants of Venus, are personifications of Grace and Beauty. In the eighteenth century the word 'graces' was commonly used to denote that graciousness or charm of behaviour, dress and deportment which should animate mere beauty of feature.[12] As Lord Chesterfield, an expert on the subject, explains in a letter of 1748:

> *I have known many a woman, with an exact shape, and a symmetrical assemblage of beautiful features, please nobody; while others, with very moderate shapes and features, have charmed everybody. Why? because Venus will not charm so much, without her attendant Graces, as they will without her.*[13]

To 'sacrifice to the Graces' was itself a colloquial phrase meaning to take steps to acquire these pleasing manners: 'Dear Boy:' writes Chesterfield to his clumsy son, 'I must from time to time, remind you of what I have often recommended to you, and of what you cannot attend to too much; *sacrifice to the Graces*.'[14] Reynolds' meaning is obvious: Lady Sarah has perfect beauty both of feature and of manner, she is a Venus *with* 'attendant Graces', since she has sought and been granted that gracious character and those beguiling ways that charm everyone.

There is another incidental characteristic of the 'Grand Style' of painting, at least according to Reynolds, and this is an absence of distinctiveness, as if the painting were executed by a well-trained Neo-Classical committee! This is a characteristic that may perhaps be detected, in some measure, in his *Duchess of Hamilton* (*FIG.* 98). At the next level down, however, in Reynolds' aesthetic scheme there are the inferior, but nontheless attractive, categories of painting which do have pronounced individualities. So, for example, painters such as Rubens, Veronese, Rembrandt and even Poussin, though they are some of Reynolds' favourites, are not of the highest rank, precisely because they are so unmistakable. This is strictly a fault but, like the faults of men, it is becoming when it appears

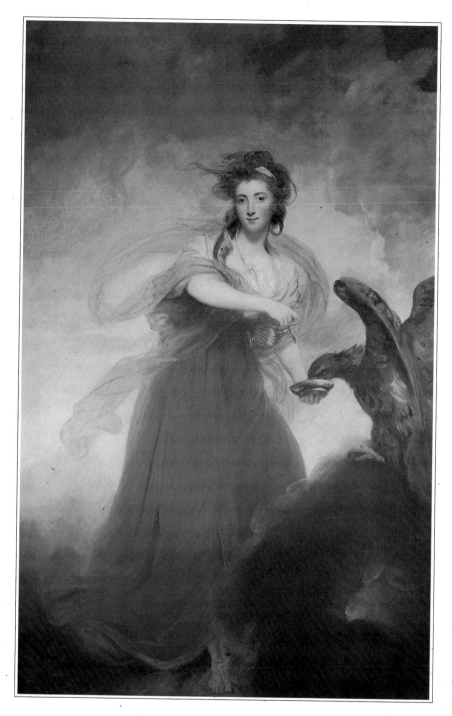

Fig. 114
REYNOLDS
Sophia Musters as Hebe 1785
THE IVEAGH BEQUEST, KENWOOD
HOUSE, ENGLISH HERITAGE

'to be the natural growth, and of a piece with the rest of their character'. Reynolds invents names for these less-than-perfect styles: Veronese is an example of the 'ornamental' style, Rubens of the 'original or characteristic' style, and so on. (*Discourses IV and V*, 1772)[15] Both *Lady Sarah* and *Sophia Musters* (*FIGS* 112 and 114) belong loosely to the 'Grand Style': they contain Classical allusions, they are simply draped to reveal the anatomy, and *Lady Sarah*, in addition, contains a clear echo of sculpture in the way

the colour drains out of the upper part of the figure, leaving it marble-white.[16] Yet they both have elements of these inferior, more characteristic styles, involving carefully-selected 'flavours' from this second rank of old masters.

The key-note of *Lady Sarah Bunbury Sacrificing to the Graces* (*FIG.* 112) is the enacting of devotion. The period of art most famous for this emotion is the Italian Baroque. Accordingly, as the art historian David Mannings has shown, Reynolds looks to Guido Reni for the up-turned eyes, panting mouth and marble-turned cheek and neck (without much jaw-bone between), while the general lay-out comes from Pietro da Cortona's *S. Bibiana Refusing to Sacrifice to Idols.*[17] From the same church as the Cortona fresco, S. Bibiana in Rome, Reynolds has remembered Bernini's statue of the saint (*FIG.* 115), from which he has derived the arrangement of the dress and its handfuls of loose 'wobbling' folds. Not just the sitter, then, but the whole painting has adopted a sort of fancy dress, to give a comical Italian Baroque feel to Lady Sarah's part. Her gesture with her left hand, as if she is petitioning the Graces on our behalf, is also typical of the interceding saints on Baroque altar-pieces. So intimate with the Graces is she, it implies, that she can afford even to put in a good word for her friends as well.

Sophia Musters as Hebe borrows directly from the principal exponent of Reynolds' 'ornamental' style – Veronese. Reynolds greatly admired Veronese's *Perseus and Andromeda*, though he was simultaneously dismayed and impressed that so much of the principal figure was in half shadow. He has this to say on this subject in his *Eighth Discourse* of 1778: 'Thus, whether the masses consist of light or shadow, it is necessary that they should be compact and of a pleasing shape . . . Veronese took great liberties of this kind. It is said, that being once asked, why certain figures were painted in shade, as no cause was seen in the picture itself; he turned off the enquiry by answering, "*una nuevola che passa,*" a cloud is passing which has overshadowed them.'[18] A cloud is passing Sophia Musters as well as Andromeda, so that nine-tenths of her body is in shadow, a daringly flat figure suddenly given relief by its extremity catching the light.[19] These lower shadows make a 'pleasing shape', largely through the confounding of the thick clouds with the billowing dress, in the same way that higher up the light chest, head, wind-swept hair and shawl all echo the bright fluffy clouds. The conventional view of shading, in the period, held that light outlines should be set off by a dark background and vice-versa.[20] Reynolds disagrees: in his view, 'the fewer the outlines are which cut against the ground, the richer will be the effect'.[21] Similarly in colour: instead of a contrast, Reynolds feels

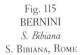

Fig. 115
BERNINI
S. Bibiana
S. BIBIANA, ROME

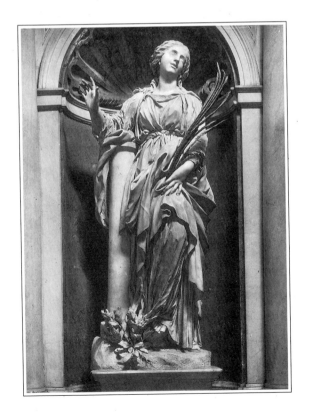

that 'the ground must partake of the colour of the figure', as occurs here in the all-over plums and pinks, another means of swallowing the figure with cloud.[22] The whole is like the work of another Venetian master, Tintoretto, of which Reynolds writes: 'that her figure might not appear like a dark inlaid figure on a light ground, her face is light,' her hair masses with the ground'.[23] In *Sophia Musters* both the dark dress and the light hair 'mass with the ground'.

In one respect Lady Sarah and Sophia Musters (*FIGS* 112 and 114) are utterly unlike masquerade figures, and that is in the small matter of costume! Contemporary accounts do mention Classical impersonations at masquerades – Minervas, Dianas, 'Roman Matrons' – but the more popular costumes are exotic, fanciful or humorous. The reason for this is obvious: a simple sheet gives ample scope for a painter, but not for a wealthy young lady wishing to show off at a special occasion. These are not toga parties! As has been shown by the exhaustive researches of the costume specialist, Dr Aileen Riberio, the most common form of fancy dress in the period was called 'Van Dyck' dress, and was usually copied from a Rubens portrait of his wife, then in Sir Robert Walpole's collection, now in the Gulbenkian.[24] This was more elaborate than ordinary eighteenth-century formal dress, not less so.

Hudson's 1757 portrait of the Duchess of Ancaster (*FIG.* 116) gives an example of Van Dyck costume; in the background can be seen the Rotunda, a giant hall built for public masquerades at the Ranelagh Gardens, in imitation of the Pantheon in Rome. As in Rubens' portrait of his wife, the Duchess of Ancaster wears a plumed hat, an assymmetrical chain over a tight bodice, loose oversleeves tied in a bow, and lace cuffs. Her dress is of satin with a bunched-up overskirt, and she carries a feather. The only difference is that instead of an open bodice and stiff ruff-like collar, the Duchess wears layers of lace frills and a choker like a small ruff.[25]

For all its documentary interest Hudson's portrait is desperately prosaic, without glamour or ideas. For most visitors the masquerades at Ranelagh or Vauxhall were far from prosaic. Evelina's reaction was a common one: 'Well, my dear Sir, we went to Ranelagh. It is a charming place, and the brilliancy of the lights, on my first entrance, made me almost think I was in some inchanted castle, or fairy palace, for all looked like magic to me.' (*Evelina*, Volume I, Letter XII) 'Inchantment', 'fairy palace', these things belong to the world of Romance. The connection extends also to costume, for Van Dyck costume could as well be called 'Romantic'

Fig. 116
HUDSON
Mary Panton, Duchess of Ancaster
1757
GRIMSTHORPE AND DRUMMOND
CASTLE TRUST

173

costume. There is the precedent of the visual arts: Van Dyck costume re-calls Rubens' famous *Garden of Love*, a paradise of chivalrous courtship, obviously reminiscent of the 'inchanted castles' of medieval romances. A tradition arises from this work, best seen in Watteau's *Fête Champêtre* compositions, showing exotically-dressed figures dallying in ornamental parks, who appeared to Hazlitt like 'the fairy inhabitants of a scene in masquerade'.[26] Contemporaries immediately recognised the manner of Watteau, though 'Watteau far outdone', in Gainsborough's *The Mall, St. James Park*, of 1783 (*FIG.* 117).[27] A simple promenade of fashionable ladies in contemporary dress is transformed by a pool of light, a theatre of trees and a vaporous touch into a modern *fête champêtre*; the lone soldier, almost the only male, clutches his heart, struck by multiple beauty, like some latter-day Actaeon, stumbling upon the sporting attendants of Diana.

'It is the fashion now to make romances rather than balls,' Horace Walpole claims in 1773.[28] One of these real, as opposed to painted, 'romances' or *fêtes champêtres* was held in 1774 to celebrate the marriage of Lord Stanley at his country villa in Surrey. This was like any other

private masquerade, except that it took place in the country, and out of doors or in a temporary 'Pantheon', decorated with 'romantic paisage' painted by a Covent Garden scene painter. Masques, songs, dances and other entertainments were laid on, all sharing the theme of pastoral romance, appropriate for Hymenean celebrations.[29] Lord Stanley and his future wife, the master and mistress of the occasion, were not dressed as one might expect as shepherd and shepherdess, but as 'Reubens' and 'Reubens' wife', in other words in Van Dyck dress.

There are further literary associations of this costume, for in the popular mind it became confused with Shakespearian or what was called 'old English' dress.[30] There *were* accurately reproduced costumes from the Elizabethan and Tudor age, but they were rare; more common was the English dress of the 1630s, recorded by Van Dyck, and passing muster for

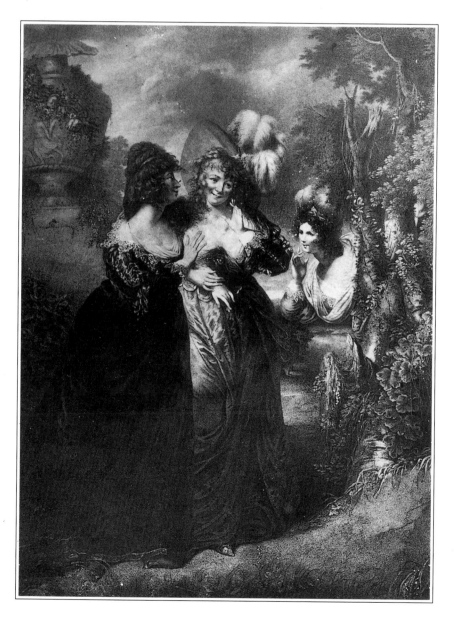

Fig. 118
THE REVD WILLIAM
PETERS
Much Ado About Nothing
1789-90

that of the previous century. This, of course, means that Van Dyck costume must have evoked the age of Shakespeare's romantic comedies, Sidney's pastorals, and Spencer's chivalric epic – the last age of romance. Shakespeare himself is shown in unadjusted Van Dyck dress in Rysbrack's statue, now in the British Museum, and so are his characters, at least in the comedies, as we can see from William Peters' illustration for *Much Ado About Nothing (FIG. 118)*.

Richard Cosway's 1792 miniature of the Prince of Wales's mistress, Mrs Fitzherbert *(FIG. 119)*, is a rare example in which the 'old English' characteristics of Van Dyck costume are made explicit. For the dress may be Van Dyckian, but the treatment, by contrast, recalls the earlier miniatures of Nicolas Hilliard and Isaac Oliver. There is an effect of a dense, tapestry-like embroidery all over the surface, as intricate and as anti-perspectival as Elizabethan art. The pattern of foliage dominates, picked up in the head-dress and lace, but even the swirls of the dress are linear, unsculptural flourishes, and the clustered curls of Mrs Fitzherbert's hair, against her glowing, oval face, with barely outlined features, constitute a generic quotation from Isaac Oliver's work. Such intricacy, with its Elizabethan associations, suggest a kind of Gothick Revival in portraiture and costume, with the same romantic associations as the Gothick architecture of Fonthill or Strawberry Hill. Certainly the oak leaves in Mrs Fitzherbert's hair, the bosky setting and especially the turned-down book are all emblems of pastoral romance: she is reading one, and seems to impersonate a spirit of the woods, such as an errant knight might encounter.

It is not surprising that Gainsborough took to Van Dyck fancy dress more than to any other. He is supposed to have said, on his death-bed, 'We are all going to Heaven, and Vandyke is of the party.'[31] His *The Honourable Mrs Graham* of 1777 *(FIG. 120)* has slight Elizabethan references in its spikey ruff-like collar and pointed waist-line, but otherwise in costume and treatment it is consciously Van Dyckian.[32] The pair of giant columns provide a suitably enobling counterpart to the figure; they also suggest a setting of intricate garden architecture. With the failing light, the overgrowing ivy and the masquerade costume, this suggests the 'inchanted' gardens of a *fête champêtre*, and thus lends to the sitter the qualities of a Viola, a Rosalind or a heroine of romance.[33] For Gainsborough has sought to revive the world of Van Dyck rather than merely to copy his style. Hallmarks are here to be recognised, but they are subtly transformed. Here, for example, there are elements of the background that could be found in Van Dyck, but never such as to make the fully-realised, moody setting we see in this idyllic recess of parkland. Also evident is Van Dyck's famous gloss of silks which tends, in the originals, to stand out against the background, a polished metal sheet, like the dress in Hudson's *Duchess of Ancaster (FIG. 116)*. Gainsborough keeps it quite as sharp in places, but crumples it tighter to justify a freer brushwork, capable in other places of brilliant imprecision, a means of running together gatherings, slashings, frills and lace. The loosely scumbled arms are examples of this, especially the sitter's left arm, where the shadow further helps to fray softly the edges of the costume. The result is that, for all its gloss, the figure blends with its setting.

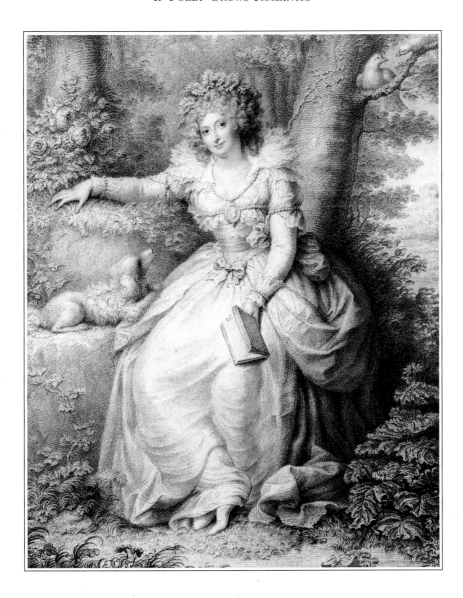

Fig. 119
J. CONDÉ after RICHARD
COSWAY
Mrs Maria Fitzherbert 1792
FITZWILLIAM MUSEUM,
CAMBRIDGE

Unlike Van Dyck, Gainsborough has kept his bright colours more for the background of this portrait – especially the sky with its blues and yellows – than for the figure. It is as if Gainsborough complements the figure's *textural* brilliance in grey and white with the *colouristic* brilliance of the surroundings. It was a commonplace in the eighteenth century to criticise Gainsborough for 'overcolouring'. In a review of the 1772 Royal Academy exhibition, one writer complained of his 'too glowing' colours, and another of his throwing 'a dash of purple into every colour from his pencil'; in this respect he is compared unfavourably with the 'modest colouring of Sir Joshua Reynolds'.[34] (In fact it is easier to see the 'too glowing' colours and the ubiquitous purple in *The Honourable Mrs Graham* than in *The Linley Sisters* (*FIG.* 92) which was in that exhibition.) Certainly Gainsborough seems to have taken the criticism to heart; in a letter to David Garrick, he uses analogies with music and with the glare of footlights for the actor's benefit:

120

*It appears to me that Fashion . . . will have
its run like a runaway Horse; for when Eyes
and Ears are thoroughly debauch'd by Glare
and Noise, the returning to modest truth will
seem very gloomy for a time; and I know you
are cursedly puzzled how to make this retreat
without putting out your lights, and losing the
advantage of all our new discoveries of trans-
parent Painting etc, etc. How to satisfye your
tawdry Friends, whilst you steal back into the
mild Evening gleam and quiet middle time.
Now I'll tell you my sprightly Genius how
this is to be done – maintain your Light, but
spare the poor abused Colors, til the Eye rests
and recovers – Keep up your Music by sup-
plying the place of* Noise *by more Sound,
more Harmony & more Tune, . . .* [35]

The advice contained in this letter could be
Gainsborough's manifesto for his last decade of
painting.

This new sensibility in Gainsborough's work
may best be illustrated by a comparison of *Mrs
Graham* with his *Duchess of Richmond* of approxi-
mately ten years later (1786-7) (*FIGS* 120 and 121).
The arrangement is the same, but now the
ornamental urn and plinth of a pleasure park
are so overgrown as to be almost overwhelmed
by wild nature. The formal garden 'repos-
sessed' by nature is a favourite picturesque
image:

> *But here, once more, ye rural muses, weep.*
> *The ivy'd balustrades, and terrace steep;*
> *Walls, mellow'd into harmony by time,*
> *O'er which fantastic creepers used to climb.*
>
> Richard Payne Knight,
> *The Landscape*, 1795, II, ll. 167-70.

The Duchess is in contemporary not Van Dyck or masquerade dress,
though the flicker of brushwork on her frilly collar suggests a lace ruff,
and the style of the whole is sufficiently Van Dyckian to evoke the
romantic pastoral. Like *Mrs Fitzherbert* (*FIG.* 119) the Duchess is a spirit of
nature, perhaps a dryad. The key-note is her hair, profuse and untended
like the surrounding branches, and of a brilliant chestnut red, like the
turning landscape – an emblem of Autumn.

Perhaps more than any other of Gainsborough's portraits, the *Duchess
of Richmond* represents the stealing back 'into the mild evening gleam'.
There is a mildness of colour and of light. As Gainsborough himself
recommends he has 'spared the poor abused colours': the highest chro-
matic pitch – in the red of the hair or in the greeny-turquoise of the dress
– is almost as strong as in any of his earlier colours, but here the colours
are intrinsic to the landscape, and so carefully anticipated in the blues,

Fig. 120
GAINSBOROUGH
The Hon. Mrs Thomas Graham
1777
THE NATIONAL GALLERY OF
SCOTLAND

greens and russets of the foliage and sky that there is no suggestion of tawdriness. As he did in his *Mrs Robinson* (FIG. 95), Gainsborough has painted the moment when evening turns into night and the colour begins to drain out of the land. Even in this dense umbrageousness the pale separation of colour is comparable to what one would expect in a clear sky at this late hour, with warm browns to the right and cooler greens and blues to the left.

This suggests that colour is really an aspect of light which, in this painting, is the more crucial vehicle of its mood. In the letter quoted above, Gainsborough mentions 'the advantage of our new discoveries of transparent painting'. This refers to works executed by Gainsborough on glass, and displayed in a special box with a single candle behind. An evocative luminosity would presumably have resulted from the flickering candle spreading a small pool of light *through* the central objects, which would be ringed by darkness. In the Duchess of Richmond's portrait light flickers over one side of the figure, and rapidly gives out, suggesting the same effect of a candle-flame gleaming through the canvas. Though the tone of the painting is much darker than in Mrs Graham's portrait there is one spot where Gainsborough has 'maintained his light'. Even the shadows have a dull luminosity, which clears as the eyes grow accustomed to it and suggests the darkened glass of Gainsborough's transparencies.

It is not surprising to read, in the memoirs of a fellow-artist, Ozias Humphry, that Gainsborough worked by candlelight: 'his painting room,' we are told, '– even by day a kind of darkened twilight – had scarcely any light, and I have seen him, whilst his subjects have been sitting to him, when neither they nor the pictures were scarcely discernible'.[36] From this come Gainsborough's twilight effects: for it is not enough just to paint dark shadows, the artist needs also to record the distortions of perception brought about by bad light. One of these is that distance, perspective and the distinctness of bodies all become indecipherable, so that here the trees become a dark silhouette, with only an isolated glimpse of distance and nothing to detach the figure from the engulfing shadows. Similarly, if there is not enough light to explore the intricacies of objects, they become generalised and appear to the viewer in simpler and larger configurations. In the *Duchess of Richmond* there are passages of highlighted intricacy on her dress, but the background foliage has coalesced in the shadows into great flaky handfuls. Reynolds draws attention to similar effects when he discusses Gainsborough's working method: 'By candle-light, not only objects appear more beautiful, but from their being in a greater breadth of light and shadow, as well as having a greater breadth and uniformity of colour, nature appears in a higher style; and even the flesh seems to take a higher and richer tone of colour.' (*Discourse XIV*, 1788)[37] It is easy to paint a dark picture; it is more difficult to make the eyes of the viewer blink and peer, in a recognition of the experience of shadow-clouded sight.

To convey this 'breadth of light and shadow', as Reynolds calls it, Gainsborough employs a far greater breadth of handling than in *Mrs Graham* (FIG. 120). All those who saw him at work in later life agree that

Gainsborough used very long brushes. Six feet long, as J. Smith claimed, must be an exaggeration, but the background of the *Duchess of Richmond* (*FIG.* 121) suggests the long touch.[38] The harmony of effect also depends on Gainsborough's habit of working on all parts of the painting at once, which Reynolds commended, and of contemplating his work from a surprising distance, which Ozias Humphry felt gave him the 'power of giving the masses and general forms of his models with the utmost exactness'.[39] All these elements – the crepuscular draining of colour, the dusky vision and the broad handling – help to convey the moody atmosphere that saturates the background, clings to the figure, and belongs with the dreamy far-away gaze and half-smile.

By these means Gainsborough has suggested the Duchess of Richmond's modest, demure and mellow virtues, already encountered in Reynolds' earlier portrait of the same lady (*FIG.* 80) and fulsomely proclaimed in her Obituary:

> *A woman whom neither titles could dazzle nor pains depress, who bore her honours so modestly upon her, that, while her dignity enforced respect, her gentleness inspired love.'*
>
> Gentleman's Magazine, 1796.[40]

A literary parallel to the discreetness of Gainsborough's late portraits comes in Fanny Burney's *Evelina* of 1778. In a passage very similar to Gainsborough's letter to Garrick, quoted above, and which could almost be taken as contrasting the *Duchess of Richmond* with *Mrs Graham*, Lord Orville describes his future wife, the Evelina of the title: 'She is not, indeed, like most modern young ladies, to be known in half an hour; her modest worth, and fearful excellence, require both time and encouragement to shew themselves. She does not, beautiful as she is, seize the soul by surprise, but, with more dangerous fascination, she steals it almost imperceptibly.' (Volume III, Letter XIV)

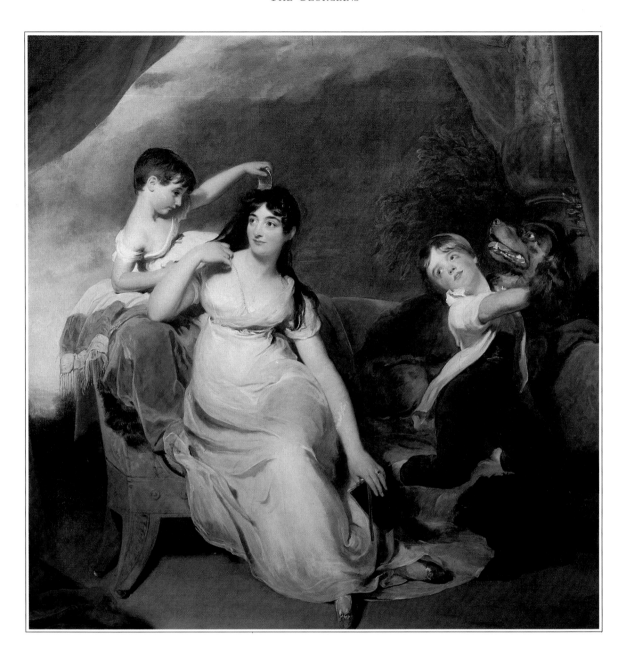

Fig. 122
LAWRENCE
*Mrs Henry Baring with two of her
Children* 1821
COLLECTION OF BARING
BROTHERS AND CO. LTD.,
REPRODUCED BY PERMISSION OF
THE DIRECTOR OF BARING
BROTHERS AND CO. LTD.

THIS PICTURE OF DOMESTIC HAPPINESS

Belinda . . . was intently copying Westall's sketch of Lady Anne Percival and her family, . . . 'What a charming woman, and what a charming family!' said Mr Vincent, as he looked at the drawing; 'and how much more interesting is this picture of domestic happiness than all the pictures of shepherds and shepherdesses, and gods and goddesses, that ever were drawn!'

'Yes,' said Belinda, 'and how much more interesting this picture is to us, from our knowing that it is not a fancy-piece; that the happiness is real, not imaginary: that this is the natural expression of affection in the countenance of the mother; and that these children, who crowd round her, are what they seem to be – the pride and pleasure of her life!' . . .

Belinda's eye was caught by an engraving of Lady Delacour in the character of the comic muse . . .

'What a contrast!' said Mr Vincent, placing the print of Lady Delacour beside the picture of Lady Percival, 'What a contrast! Compare their pictures – compare their characters – compare –'

Maria Edgeworth, *Belinda*, 1801, Chapter XVIII.

A RARE EXAMPLE IN GEORGIAN FICTION OF THE ART-HISTORIAN'S favourite compare-and-contrast exercise, this passage speaks for itself! Something more should be said about Lady Delacour, whose offending portrait as the Comic Muse would presumably resemble that of Mrs Abington (*FIG.* 113). She is a brilliant and beautiful lady of the highest society, but wild, prodigal and cruelly indifferent to her boorish husband. She has a disfiguring wound, caused by her pistol misfiring during a duel, one of her madcap and *masculine* escapades. She has been convinced by a quack that she is dying of cancer, has become addicted to pain-killing laudanum, and neglects her daughter, Helena, who is looked after by Lady Percival, a milk-sop with lots of children of her own. Finally Lady Delacour sees the error of her ways, discovers she is not dying of cancer, gives up laudanum, has her daughter back and makes friends with Lady Percival. The moral of the story is given on the last page, as Lord Delacour leads his daughter Helena by the hand: 'There!' the narrator exclaims, 'quite pretty and natural!' (Chapter XXXI) Lady Delacour's vice – found in her dressing as a man, and even in her wasting away with imagined cancer and real laudanum – is unnaturalness. Once she reforms, Nature is appeased and her physical recovery is instantaneous and inevitable.

Lady Delacour had been to a masquerade as the Comic Muse before she had her portrait painted in this guise. Evidently to Maria Edgeworth and her readers there is something frivolous and delusive about both the masquerade and the mythologised portrait. Like Lady Delacour's fast set, they are gay and seductive, but soulless. Belinda's own objection is

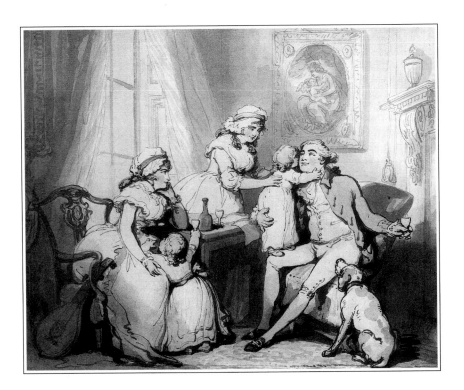

Fig. 123
ROWLANDSON
The Happy Family 1786
BY COURTESY OF THE LEGER
GALLERIES, LONDON

essentially the same as Pope's: such portraits are enactments, 'fancy-pieces', whereas the portrait of Lady Percival depicts the true state of affairs. She had encountered the family in just such a situation only a few chapters earlier: 'They found Lady Anne Percival in the midst of her children, who all turned their healthy, rosy, intelligent faces towards the door, the moment that they heard their father's voice. Clarence Hervey was so much struck with the expression of happiness in Lady Anne's countenance, that he absolutely forgot to compare her beauty with Lady Delacour's.' (Chapter VIII) The latter, in strict point of feature, is of course superior!

The portrait of Lady Percival and her family, a drawing by Westall, would be one of the many images in the Regency period depicting almost maniacally happy families. Rowlandson's pen and watercolour sketch of 1786, *The Happy Family* (FIG. 123) or *The Married Man* as it is called in a print, though tongue-in-cheek, gives us some idea of how it might have looked. It has all the essential ingredients of the type: attention-seeking infants, being embraced by their *father* as well as their mother, grinning grown-ups, doting wife, lots of sunshine, and a scattering of symbols like the lute for Harmony, the painting of a suckling Venus for Love, and the adoring dog for fidelity. It is about scenes such as this that Maria Edgeworth writes: 'Those who unfortunately have never enjoyed domestic happiness, such as we have just described, will perhaps suppose the picture to be visionary and romantic; there are others – it is hoped many others – who will feel that it is drawn from truth and real life. Tastes that have been vitiated by the stimulus of dissipation might, perhaps, think these simple pleasures insipid.' (Chapter XVI) Such monsters will turn with

some relief to a more *risqué* treatment of the same theme in Charlotte Smith's *Desmond* of 1792. Here the idealised passion between hero and heroine, which one expects of a romantic novel, is a guilty one involving a young mother of three – who is *not* a widow, at least not till the final chapters.

The cult of the happy family is best seen in Lawrence's *Mrs Henry Baring with two of her Children*, exhibited in 1821 (*FIG.* 122), which lacks only one element, the solicitous father – he once stood behind the sofa, but was painted out. There is a reference here to a mythological fancy dress, for Mrs Baring's Classical proportions are followed by a reasonably sculptural white dress; her daughter tending her hair immediately reminds the viewer of the *Toilet of Venus*, and her own gesture recalls Diana reaching for an arrow. But Mrs Baring is not vain, nor is she acting; she is engaged upon an innocent and intimate game with her child. Combing her mother's hair is for the daughter an expression of love, and it is typical of the period that she does something usually left to servants. Other characteristic ingredients in this idyll of the hearth are firstly that the figures are throwing themselves around: their bodies loll and twist; their heads are cast back or craned forwards; the daughter perches on the back of the sofa; the son tumbles off the front, as he wrestles with his dog. The happiness of the scene is conveyed through the children's tumbling about. Secondly Mrs Baring is semi-reclining so as to be roughly on a level with her children.

Like Rowlandson's, this scene is brilliantly sunlit, though here this is conveyed as much by bright colour as bright light. From the 1770s onwards there was increasingly a trend towards clearer, purer colours: this is perhaps the 'runaway-horse' fashion that Gainsborough refers to in his letter to Garrick quoted in the last chapter, and which his late work so consciously turns its back on. Lawrence, on the other hand, reached maturity in its hey-day, and was sometimes criticised for his 'glare in the colouring'.[1] According to a John Opie lecture of 1807, pictures should make their effect by 'the opposition of *colours* in subjects of a gay, and to the opposition of *light and shadow* in subjects of a graver or grander cast.'[2] We have already seen a grave 'light-and-shadow' subject by Lawrence (*Lord Mountstuart*) (*FIG.* 34); this is a gay coloured one.

Connoisseurs in the eighteenth century agreed that, for this gay style, the budding colourists should look to the works of Rubens: for his colours were the brightest and clearest and the least mixed with the brush.[3] It was also noticed that Rubens laid his colours out in harmonious 'polarities', almost like a spectrum. In his work, Reynolds notes, 'the brightest colours possible are admitted, with the two extremes of warm and cold, and those reconciled by being dispersed over the picture, till the whole appears like a bunch of flowers.'[4] 'Warm' and 'cold' are jargon-words, much used in the period: 'warm' means oranges, reds and browns; and 'cold' or 'cool' means anything with blue in it, even a tinge in greys or greens. The reconciliation Reynolds mentions is achieved by separating these two polarities across the picture – warm on one side, cool on the other – in an effect that resembles the separation of colour in an evening sky. John Burnet suggests in 1827 that Rubens' method of colouring

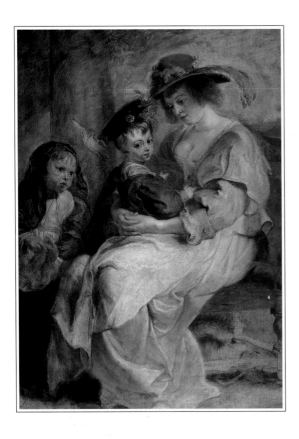

flesh is founded on the principle of the 'delicate aerial tints' to be observed at sunset, implying an almost prismatic separation of colour.[5] This is the effect that Lawrence seeks for this portrait, as can be seen by comparison with Rubens' *Hélène Fourment and her Children* (*FIG.* 124).

In 1838 a painter's handbook divides colourists into the *Bianchi* and the *Neri* (the 'Whites' and the 'Blacks'): the latter favour old-master brown, while the former contend that, since 'Light is the origin, or immediate cause of *colour*', its effects can be represented by 'introducing *colour* in lieu of those *tints* which in nature appear neutral' – bright light is to be suggested by bright colour. At the head of this sect are Rubens, Van Dyck and Lawrence.[6]

In these portraits (*FIGS* 122 and 124) two of the *bianchi* show how natural sunlight may be depicted. In both paintings, especially at the centre, there is plenty of white light – the source of all colour. Around the centre are disposed contrasting ranges of cool grey, blue and green colours on the one hand, and red, violin-orange and brown colours on the other. None of these colours stands on its own, each reinforces its immediate neighbour, as they all run and bleed into one another. In the background of both paintings there is a blue sky, seen improbably past a sofa, columns and Baroque flags. Such a spectrum of separated warm and cool colours seen against the sky evokes an atmospheric, evening light, even if there is only a slight suggestion of sunset.

'Ah, I shall never be able to paint like that!' the eight-year old Lawrence is supposed to have said, in front of a Rubens in Corsham House.[7] It was about *this* time that Reynolds underwent a conversion in his thinking about colour, turning away from the sombre, aristocratic brilliance of Van Dyck to the daylight homeliness of Rubens. A crucial painting in this infatuation with Rubens is *Lady Cockburn and her Three Sons* of 1773 (*FIG.* 125), another response to the Louvre *Hélène Fourment* (*FIG.* 124). Reynolds' reds and golds are duskier than Rubens', but obviously part of a warm spectrum, disposed around a white sunburst on Lady Cockburn's breast, at the centre of the picture, and to be contrasted with the glimpses of blue in the sky. 'It ought . . . to be indispensably observed,' Reynolds advises a few years later, 'that the masses of light in a picture be always of a warm mellow colour, yellow, red, or a yellowish-white; and that the blue, the grey, or the green colours be kept almost entirely out of these masses, and be used only to support and set off these warm colours; and for this purpose, a small proportion of cold colours will be sufficient.' (*Discourse VIII*, 1778)[8] Reynolds also takes from Rubens a softness in the description of forms: his lines are never straight but rather *over-rounded*, especially for

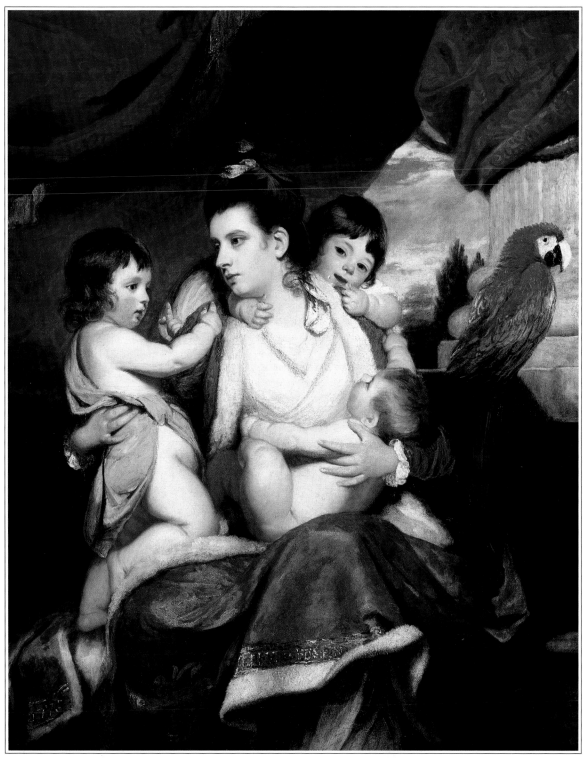

125

the babies, and the light falls in large dappled areas without sudden contrasts of light and dark. There is little perspective, but instead the surface is built up with different textures of paint, not shiny but of a creamy-wax half-polish, yieldingly thick and soft. This work must have seemed a new departure for Reynolds and for British art: when it was brought to the Royal Academy Exhibition of 1775, the 'sweetness of the conception, and the splendour of the colouring' so struck the other painters that they broke into spontaneous applause.[9]

Reynolds' meaning is very similar to Lawrence's (*FIG.* 122): *Lady Cockburn* is an image of adoring, preoccupied motherhood. A print made from the painting is entitled *Cornelia*, after the Roman patrician matron who, when asked why she wore no jewellery, pointed to her children and said, 'These are my jewels!'[10] Unlike most previous portraits, the sitter is distracted from looking at the viewer by her eldest son, a 'natural' effect emphasised by the middle boy staring mischievously out at us, as he clambers over her back and threatens to strangle her. The youngest child clings, in an obviously suckling position, to his mother's breast, covered for modesty, but in a suggestive creamy-white. As is often the case with Reynolds, these ideas ride on discreet visual allusions. The two nearer children, both improbably naked, are obviously reminiscent of the infant John the Baptist, pointing to heaven, and the Christ Child, which of course makes Lady Cockburn a Madonna, born to different circumstances. Considered all together, the children here recall depictions of *Charity*, which often have this air of comical, cuddly rough-and-tumble. For Charity is traditionally a homely virtue, often contrasted, as in Bernini's *Tomb of Urban VIII*, with more elevated, dignified virtues such as *Justice*.

The rumbustious, uninhibited, even 'unposed' nature of *Lady Cockburn* can best be appreciated by comparison with Reynolds' *Elizabeth, Countess of Pembroke and her Son, George, Lord Herbert* of ten years earlier (1764-5) (*FIG.* 126). Here too the mother figure does not look out at us, but the reason is very different: instead of Lady Cockburn's slightly flustered attention to the holy lispings of her little Saint John, there is here a deliberate moving aside to let the heir take the stage. Even the Countess's affection is shown in discreet, formal endearments. Lord Herbert, on the other hand, looks out directly; not mischievously, but with a childish gravity. At one level this is dynastic: a giant column stands behind, and for, the as yet diminutive heir. There are other more general differences to be detected in attitudes towards children. Obviously Lord Herbert is older than Lady Cockburn's sons, but he must be approximately the same age as the Baring boy (*FIG.* 122). To put the matter crudely, he is considerably better behaved than all of them! Another telling point is that he is reading to himself (he even keeps the place so that he can resume, once the sitting is over); Mrs Baring holds a book, but has evidently concluded that she cannot make reason or instruction audible above this hubbub. Finally Lord Herbert, unlike the other children, is dressed in a scaled-down replica of the adult costume of the period, and is being 'presented' to us.

What is it that makes the later Cockburn and Baring children so different from Lord Herbert? The simple answer is *Émile*. Rousseau's

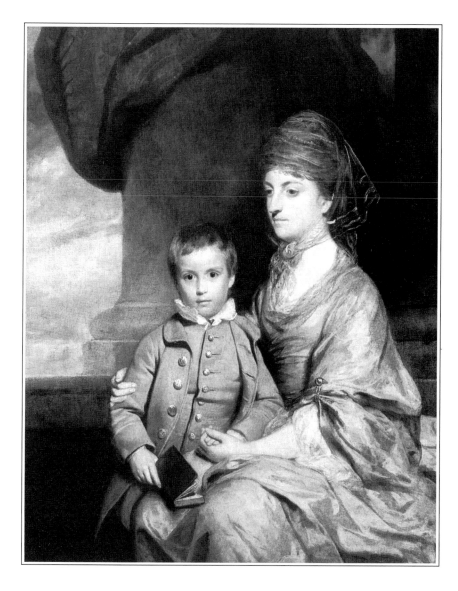

Fig. 126
REYNOLDS
*Elizabeth, Countess of Pembroke
with her son, George, Lord Herbert*
1764-5
COLLECTION OF THE EARL OF
PEMBROKE, WILTON HOUSE

educational tract was published in 1762 and translated into English in 1763; it was regarded by the writer Thomas Day as second only to the Bible.[11] Its arguments are hard to summarise, but the jist could be given by saying that Rousseau wished children to be brought up as one might cultivate a tree: without pruning it, or forcing it to grow up a frame, but with the most constant attention to help 'Nature' produce a full, strong tree. Rousseau's arguments have many subtle ramifications, which we will come across in connection with a wide variety of portraits of children. Already certain features can be traced back from the paintings to their source in Rousseau. Maria Edgeworth's description of Lady Percival and related portraits echo Rousseau's exclamation: *Il n'y a point de tableau plus charmant que celui de la famille.*[12] This remark is made while urging mothers to nurse their own children in order to establish bonds of natural affection between them. According to Rousseau, in houses where a wet-nurse is employed '*le naturel s'éteint dans tous les coeurs; l'intérieur des*

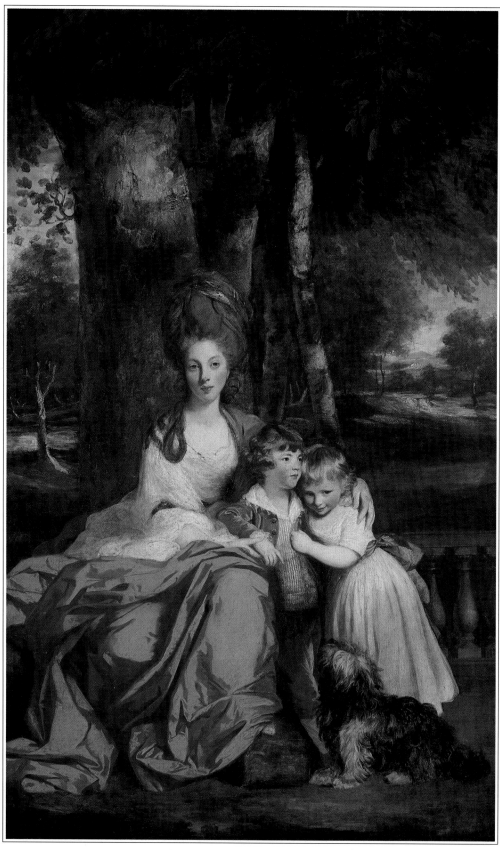

127

maisons prend un air moins vivant; le spectacle touchant d'une famille naissante n'attache plus les maris, n'impose plus d'égards aux étrangers; on respect moins la mère dont on ne voit pas les enfants.[13] By the 1770s and 80s, French visitors noted with approval 'the maternal tenderness of the *English* Ladies of all ranks', which included a readiness to breast-feed.[14]

Even Lady Delacour succumbed: 'It was the fashion at this time for fine mothers to suckle their own children: so much the worse for the poor brats. Fine nurses never made fine children. There was a prodigious rout made about the matter; a vast deal of sentiment and sympathy, and compliments and inquiries; but after the novelty was over, I became heartily sick of the business.' (*Belinda*, Chapter III) The reference to breast-feeding in *Lady Cockburn* (FIG. 125) is therefore deliberate, and belongs with mothers being seen 'in the thick of it' with their children, with every manifestation of love, rather than showing a rational and decorous partiality, like the Countess of Pembroke (FIG. 126).

There are other small but significant features. The Baring boy is wearing the type of unconstricting clothing, including modern-style trousers, recommended by Rousseau to encourage healthy, vigorous limbs (FIG. 122). Energetic activity is even more apparent in the dog-tussle – what Mary Wollstonecraft might call one of those 'harmless gambols that exercise the feet and hands, without requiring very minute direction from the head'.[15] The dog further suggests that the boy is part of, not divorced from, Nature. The boy's cheeks glow with health, like those of Lady Percival's children. Another detail of significance is the turned-down book. Rousseau's method is avowedly anti-bookish: he feels that the type of learning they contain serves only for precocious and artifical displays of uncomprehending rote-learning.

One of the few books Rousseau does allow is *Robinson Crusoe*: indeed one of the constant questions of subsequent Rousseauian literature in England is, 'How does your education prepare you for the desert island?' – which looks like setting the field for a one-in-a-million catch! The rationale for this is that Defoe shows a man learning how to do things for himself: in the same way a boy can learn about concepts (especially in natural science) not from precept, but from his own immediate experience, from first principles. In Geography children should make a map of their local village, not learn where China is; in astronomy they should find their way out of a wood, by using the direction of the setting sun; and so on. Mr Percival in *Belinda* has got it right: 'from the merest trifles he could lead to some scientific fact, some happy literary allusion, or philosophical investigation'. (Chapter XVI) Mrs Baring's daughter is learning about adornment by tending her mother's hair (FIG. 122) – a much more useful lesson than the book could have taught. The mother on the same level as her children also expresses the Rousseauian idea of equality between teacher and pupil, discovering principles from *their* experiences. The final characteristic in these portraits is the general unrulyness. This is something which Rousseau condoned rather than intended, but which became associated in the popular mind with children, especially 'self-willed' English children, brought up according to his liberal principles.[15] This is the age when the spoilt brat makes its first appearance in literature,

Fig. 127
REYNOLDS
Elizabeth, Lady Delmé and her Children 1777-9
NATIONAL GALLERY OF ART, WASHINGTON, ANDREW W. MELLON COLLECTION

seconded by that 'most rapacious of human beings', as Jane Austen calls her, the 'fond mother, in pursuit of praise for her children'. (*Sense and Sensibility*, Chapter 21) A further exchange from *Sense and Sensibility* gives a salted view of scenes such as that presented by the Baring family:

> 'I have a notion,' said Lucy, 'you think the little Middletons rather too much indulged [an understatement!] . . . for my part, I love to see children full of life and spirits; I cannot bear them if they are tame and quiet.'
> 'I confess,' replied Elinor, 'that while I am at Barton Park, I never think of tame and quiet children with any abhorrence.'
>
> Chapter 21.

We have already seen in Rousseau and Maria Edgeworth how the mother excites more admiration that the mere lady of fashion; so in art one might expect adjustments to maternal portraits, even those in the Grand Style. At first glance Reynolds' *Lady Elizabeth Delmé and Children* of 1777-9 (*FIG.* 127) resembles his statuesque *Countess of Harrington* (Huntington) of approximately the same date (*FIG.* 104). There are many features in common: the balustrade, the rolling parkland, and the sculptural figure. Indeed, with the eye being caught first by the carved-looking drape falling over Lady Delmé's knees, the whole group reads as an imposing Renaissance marble, of pyramidal outline. There is an echo of the device in sculpture whereby the viewer's attention is positively drawn to the fact that several figures are carved from *one* block. This is especially favoured in Madonnas, where it is a metaphor for the mother and child being of one flesh. Lady Delmé's two children slot snugly into a rounded outline, mirrored on the other side by her voluminous and polished hips and thighs. The same device is used in another contemporary idyll, the 1778 portrait of Sir William Pepperrell and his family by the American painter, John Singleton Copley (*FIG.* 128). As Jules Prown has noted, there are characteristics of a Holy Family in the central group here; a specific source could be Jacopo Sansovino's marble *Madonna* in S. Agostino, Rome.[17]

Looked at more carefully these grand and imposing façades seem to yield and to invite. The clothes Lady Delmé and her children are actually wearing, rather than throwing over their knees, are softer, more mundane and contemporary (*FIG.* 127). The mother's direct smiling gaze, and the daughter's half-frightened fascination with her dog, are further anecdotal mitigations of Classical dignity. But it is especially through the backgrounds that these images of power and wealth are softened, 'naturalised'. In *Lady Delmé* instead of a giant urn or a column, as in *The Pepperrell Family* (*FIG.* 128), there is a massive tree trunk to convey the same idea of the solid dynastic support, with the smaller trunks of saplings to stand for the children. Unlike the *Countess of Harrington* (*FIG.* 104) there is a dappled light falling over the group, made up of large splodges of sunshine filtered through trees. The family seem to be in the thick of a copse on their estate, which makes the fragment of balustrade slightly out of place.

A similarly improbable mixture of Nature and architecture occurs in *The Pepperrell Family* (*FIG.* 128), where a carpet has been spread out on the

lawn near some giant columns and drapes. The intense lighting over the figures, and also the dappled grass behind, again suggests sunlight, as if the figures have been posed outside, not just in front of a landscape screen in the studio (see *FIG.* 7). The sunshine, the vigorous activity and the uninhibited affection of the children are things already encountered, as is the cheeky grin over the shoulder of the little girl, the only one (with the dog) to have noticed our presence.

One should be wary of generalising about happy families, but in Georgian portraiture at least they are almost always self-absorbed, and especially so here, where even Mr Pepperrell doesn't pay the viewer any attention. He stands in a stock pose of the period, but instead of looking out, as is usual, his attention is turned away by his insistent baby son. Rousseau felt that the father should participate in the family, the education of his children being his special, almost sacred, task. This is the other side of the coin from breast-feeding: '*Ne nous étonnons pas qu'un homme dont la femme a dédaigné de nourrir le fruit de leur union, dédaigne de l'élever.*'[18] Although this baby Pepperrell is not strictly of educatable age, the portrait is typical of the period in stressing the paternal involvement of the 'new man'. It is also part of Rousseau's conception that the loving 'natural' mother engenders bonds between siblings: so, in *Lady Delmé* (*FIG.* 127), the brother protects his sister, under the auspices of the larger maternal embrace.[19] Lady Pepperrell's little girl positively fights to look after the baby (*FIG.* 128), while the middle children play skittles, squashed together with such a perfect harmony that at first glance they only seem to have one right arm and one left arm between them, like Siamese twins.

One of the reasons why *Émile* was so influential was that it purported to be a narrative as well as an educational tract: *ou de l'éducation* is only its subtitle; the principal title refers to the hero, an imaginary character being brought up by the author. In the event the episodes are no more than exempla of the various theories, and are isolated amidst chapters of precept. But in England in the last quarter of the eighteenth century these fragments of narrative are expanded into full Rousseauian novels, about and for children, the most famous of which are Henry Brooke's *The Fool of Quality* (1767-70), Thomas Day's *Sandford and Merton* (1783-9) and Mrs Inchbald's *Nature and Art* (1796). The formula they adopt is to double the cast-list by contrasting an ideal Émile-substitute, with his artificial, spoilt opposite. The one will be a haughty, cowardly show-off, the other a sturdy, generous lad, full of essential knowledge, but who, if questioned upon some matter of book-learning in a drawing room, will appear an idiot. As the stories progress the little toff finds that he too could have a good heart, if only he would give his unconstricted limbs more exercise.

As any summary immediately makes clear, the decent boy is always of a lower social station than the spoilt brat. Rousseau is an egalitarian: his educational process aims to *prevent* the formation of what, in his view, is the most useless of human beings – the gentleman. In a world where gentlemen are the only people to educate their children at all, this doesn't seem on the face of it to be a doctrine that is going to catch on. Nor did it, in France, before the Revolution; but in England it was easier to see

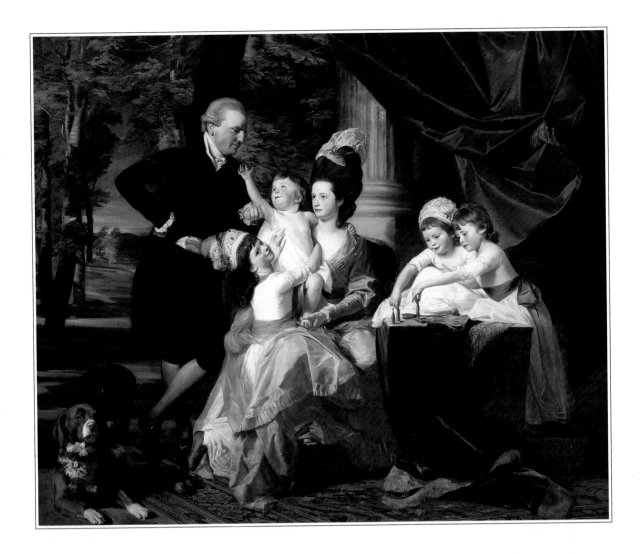

Fig. 128
COPLEY
Sir William Pepperrell and his Family 1778
NORTH CAROLINA MUSEUM OF ART, RALEIGH, PURCHASED BY FUNDS FROM THE STATE OF NORTH CAROLINA

Rousseau's hostility as directed towards the enslaved and enslaving *French* aristocracy. In the Land of the Free Rousseau's disciples evolve a compromise: they elaborate upon the wonders of the British constitution, to reassure the reader that the fundamental idea of subordination is a sound one, and at the same time suggest that it is a salutary lesson for high-born children to *play* at being country lads, so as eventually to fill their exalted station without insolence. Louis-Sébastien Mercier, a French visitor in the 1780s, noted the simplicity of English children's dress, their habit of mixing with inferiors and generally their unconsciousness of the advantages of their birth. He goes on to tell, with somewhat aghast admiration, how Prince Henry became an ordinary cadet in the Navy and even got in a fist-fight with one of his fellow lads.[20] The plucky Prince took it in good part and made up afterwards. The young masters in *Sandford and Merton* and other such novels, are less sporting, but similar incidents are presented as trials sent to cure them of their imperiousness (a vice Rousseau seeks above all to prevent in his charge). At the same time the young master's father, a nobleman whose right to command is not

called into question, is a sympathetic figure, approving of his son's in-structive humiliations.

A drubbing by a cow-herd is not an event that is going to appear in portraiture, but the notion of temporary egalitarianism does. One in-stance is Alexander Nasmyth's portrait of the 3rd Earl of Rosebery of *c.* 1787 (*FIG.* 129). As in Devis's *Gwillym Family* (*FIG.* 87), we are shown Lord Rosebery's family, his parklands and his seat (the name of which – Barnbougle Castle – unfortunately never came to the attention of Thomas Love Peacock). But in the centre the Earl leads his son by the hand, explaining some point of elementary botany, like an ideal Rous-seauian father. The boy, Archibald John, later the fourth Earl, wears a sort of loose boiler-suit, and holds a rake in his hand, to go with his miniature barrow and spade behind. Cultivating a small patch of garden, so as to enjoy the fruits of your own exertion, is a fundamental concept for Rousseau and his followers. On the part of a young gentleman it re-presents a major and deliberate act of condescension; he must behave like a manual labourer. Yet at the same time it is not felt to be at all incon-gruous, in this portrait, that his father should still be sporting the star of the Garter, an emblem of his rank.

Reynolds' 1788 portrait of Master Henry Hoare, called *The Young Gar-dener* (*FIG.* 130), is evidence of exactly the same idea. While still in his skirts, the young master is learning to drive in the spade, with his peasant straw hat and his toy barrow. The labour might be demeaning, but at least the pose is heroic (and appropriate): it derives from the antique statue, of which there was a cast in the Royal Academy, then thought to

Fig. 129
ALEXANDER NASMYTH
Neil, 3rd Earl of Rosebery with his Family c.1787
IN THE COLLECTION OF THE EARL OF ROSEBERY, DALMENY HOUSE, EDINBURGH

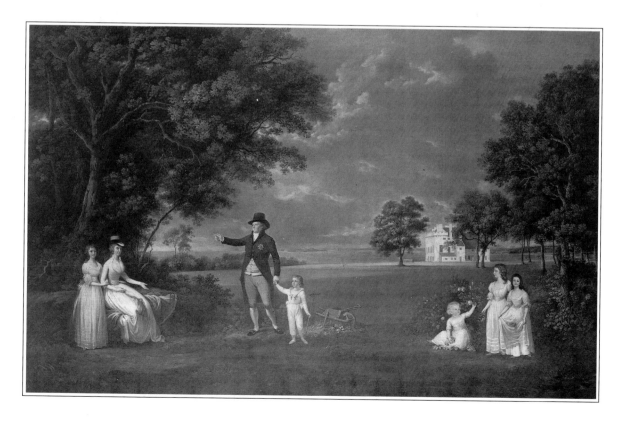

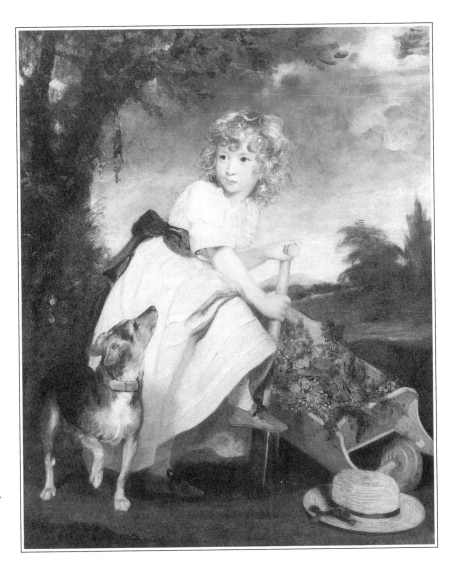

Fig. 130
REYNOLDS
*Master Henry Hoare, 'The Young
Gardener'* 1788
TOLEDO MUSEUM OF ART, GIFT
OF MR AND MRS GEORGE W.
RITTER

represent Cincinnatus, the Roman hero called away by patriotic duty from his retirement at the plough.[22]

It is probably an old assumption that well-born children should grow up *through* the class-system, learning first the lessons the common people teach best, and finally those that only a gentleman understands. It is ironic that Rousseau so despised the wet-nurses through whom, partly, this came about. There has always been a vernacular element to childhood, the world of nursery rhymes, rural ballads and folk heros. It is probably in this context that Raeburn's *Macdonald Children* of c. 1800 (*FIG. 132*) should be understood. The rugged setting, the loose clothes and the children's healthy, smiling energy are all typical of the late eighteenth century, as is the curious tandem of the two elder boys, like that in the *Pepperrell Family* (*FIG. 128*). Life, it implies, is one long three-legged race of fraternal love! The activity, for which one lends the left arm and the other the right, must be some kind of Scottish song-and-dance routine, all whoops, snapped fingers and folksy gaiety.

There are good reasons given by Rousseau and his followers for teaching boys elementary husbandry, even if the threat of the desert island does not seem imminent. There is no similar justification given for girls, and yet it is far more common in portraiture for them to figure as colourful rustics. This is a tradition of which Rousseau is more a symptom than a cause. We have already encountered it in Reynolds' *Lady Catherine Pelham-Clinton* (*FIG.* 110), as a tongue-in-cheek allegory of *Purity*. A very similar device occurs in Reynolds' 1764 portrait of Lady Mary Leslie tending lambs, the traditional symbols of *Innocence* (*FIG.* 133).[22] Lady Mary kneels in an attitude of devotion and embraces a noisily bleating example, on a kind of natural altar, reminding one (as Ripa also does) of the image of Christ as the Lamb of God.[23] Her physiognomy has also been adjusted, incidentally, to demonstrate lamb-like traits. The pastoral setting here,

Fig. 131
REYNOLDS
The Cottagers 1788
DETROIT INSTITUTE OF ARTS,
GIFT OF MRS K. T. KELLER

and in *Lady Pelham-Clinton*, is partly a picturesque way of 'working in' the symbolic animal, but it is also because *Innocence* and *Purity* were more associated with the humble shepherdess than the noble lady. The humble setting itself is a symbol, less specific than the lambs, but clearly understood nonetheless.

The most thorough-going expression of these ideas is Reynolds' *The Cottagers* of 1788 (*FIG.* 131), a portrait of Mrs Macklin, with her daughter and a friend, playing peasant on the threshold of a rustic cot. One feeds chickens, another brings in a basket of wheat, while the mother busies herself at the spinning wheel. These are the three ages of woman, with a virtue appropriate to each: a girlhood of *Purity* (those lion-taming chickens again); a womanhood of *Fruitfulness,* symbolised by wheat, and a maturity of *Domestic Economy*. The difference between this image and Lord Rosebery's botany lesson is that a grown woman is obliged to partake in the

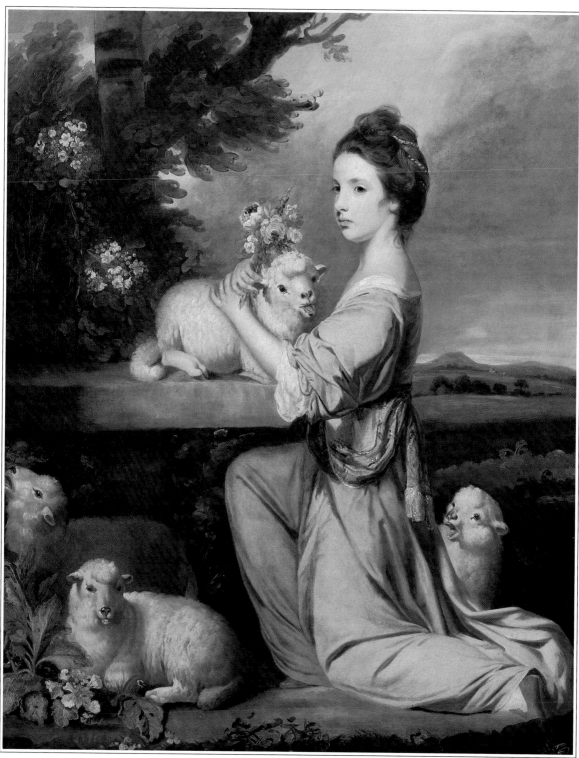

133

same game. It is not just part of the growing process; throughout her life, a woman should bring the spirit of the cottage to whatever rank it has pleased fortune or her husband to elevate her. A contemporary reviewer linked this painting with an episode in James Thomson's *Autumn* of 1746 (ll. 177-310), which tells how a financially ruined noble girl, called Lavinia, lives happily in a cottage and is wooed by a rich but uncorrupted land-owner.[23] This passage is a pre-Rousseau example of what might be called the 'Patient Griselda' fetish in the period: the notion of an ideally obedient and virtuous wife to be plucked, uncontaminated, from the cottage. Later in the century there seems no limit to this unreasonable fad. 'The romantic sound of love and a cottage', writes Fanny Burney in *Camilla*, 'she considered such a habitation but as a bower of eglantine and roses, in which she might repose and be adored all day long.' (Book IX, Chapter II) The beautiful Duchess of Devonshire appeared as a housemaid at a masquerade in 1786 and 'with wit and broom absolutely swept everything before her'; Mrs Graham (the sitter for *FIG.* 120) is shown in the same guise in an unfinished Gainsborough in the Tate.[25] In France, at the Château de Rambouillet, Marie Antoinette built a Neo-Classical dairy for herself in her *Jardin anglais*, where she could play at dairy-maids.[26] Back in England, the Marquess of Exeter actually married an innkeeper's daughter while staying incognito, and brought her back to Burghley House, which gave her quite a turn!

Rousseau may not be responsible for all this, but his description of Sophie, the pre-ordained and ideal wife for Émile, certainly didn't help. He never says so in so many words, but it is difficult not to conclude that he considered women to be *so* inferior, that society's placing a fine Lady above her coachman was the grossest example of its corruption of the natural order. Certainly in the Rousseauian novel in England it is always the mother who is responsible for her son's arrogance and vanity, and who most resists his naturalising education.

Maria Edgeworth's *Belinda* has elements of the Rousseauian tract, but in one respect it criticises the master, by offering a *reductio ad absurdum* of the Griselda syndrome, which is of general relevance to portraits such as Reynolds' *The Cottagers* (*FIG.* 131). The hero Clarence Hervey 'read the works of Rousseau' and 'was charmed with the picture of Sophia, when contrasted with the characters of the women of the world with whom he had been disgusted; and he formed the romantic project of educating a wife for himself.' (This is, incidentally, exactly what the author of *Sandford and Merton* did.) Fortunately, while riding in the wilder parts of the New Forest, Clarence found a remote cottage with a young girl 'watering the rose-trees', who looked as if she might do:

> [She] did not appear to Clarence like any other young girl that he had ever seen. The setting sun shone upon her countenance, the wind blew aside the ringlets of her light hair, and the blush of modesty overspread her cheeks when she looked up at the stranger. In her large blue eyes there was an expression of artless sensibility with which Mr Hervey was so powerfully struck that he remained for some moments silent, totally forgetting that he came to ask his way out of the forest.
>
> Chapter XXVI.

Once secured, Virginia (for so she is called) is handed over to another woman for education, moved to another cottage and forbidden to see anyone except her master. He has high hopes, for, he tells himself, she has sensibility, 'the parent of great talents and great virtues; and evidently she possesses natural feeling in an uncommon degree: it shall be developed with skill, patience, and delicacy; and I will deserve before I claim my reward.' The results are admirable, 'What a difference', thought he, 'between this child of nature and the frivolous, sophisticated slaves of art!' He even has her portrait taken, as Virginia in St Pierre's *Paul and Virginia*. This shows her alone in a remote landscape, probably something like Romney's *Mrs Crouch* (FIG. 96), with 'so much sweetness, so much innocence, such tender melancholy in this countenance'. (Chapter XIV) The real Virginia's 'simplicity and naiveté . . . relieved him, after he had been fatigued by the extravagant gaiety and *glare* of her ladyship's [Lady Delacour] manners'. The latter makes a fine acquaintance, but his Virginia 'promised security to his domestic happiness'. Trouble looms when Clarence meets Belinda and, much to his surprise, begins to find his pupil a bit 'insipid'. But, as Virginia has never met any other man, and is so full of sensibility, he has come to assume that she's in love with him and begins to question how he may decently get out of it. By a remarkable stroke of luck she has fallen in love with someone else, though she hasn't actually *met* anyone else. A new-comer to the Georgian Age might wonder how this is done. But, upon reflection, it comes as no surprise to learn that she has fallen in love with a portrait! (*Belinda*, Chapters XXVI and XXXI).

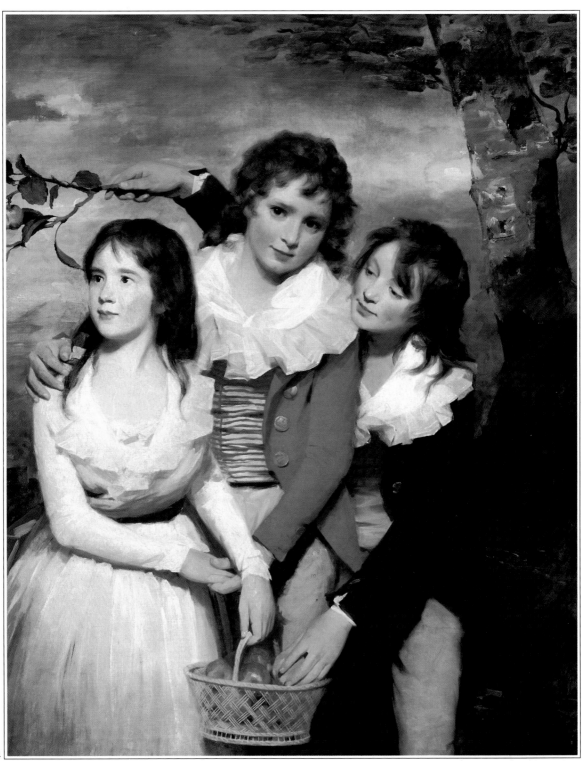

134

Chapter 11

The Human Blossom Blows

Meantime a smiling offspring rises round,
And mingles both their graces. By degrees
The human blossom blows; and every day,
Soft as it rolls along, shows some new charm,
The father's lustre and the mother's bloom.

Thomson, *Spring*, ll. 1145-9.

THESE LINES FROM THOMSON'S *THE SEASONS* HELP TO INTERPRET THE almost universal formula in early eighteenth-century children's portraits, which can be seen in *Edward Harley, Earl of Oxford, and his sister Sarah*, attributed to Bartholomew Dandridge of c. 1737 (*FIG*. 135). The setting is idyllic, half-way between a garden and an ornamental park, with balustrade, urn and serried poplars, suggesting not so much a real parkland as a 'magic garden', which is the carefree domain of childhood. There are prominent flowers: on the stalk, in the basket, in Sarah's lap and strewn on the ground. Flowers are a common accompaniment to beauty and youth, but with children they are obligatory for they carry the special meaning of Thomson's phrase, 'human blossom blows'. The idea hinges on the fact that while those in the prime of life have blossom*ed*, children are blossom*ing*, or 'blowing' to use Thomson's poetic word. Human life is traditionally described as 'Blossom and Decay' and children belong securely to the blossoming part: they are still maturing, and thus, it is hoped, improving all the time.

If we look at this portrait through late eighteenth-century eyes, the figures begin to look like puppet-adults. Henry's first remark upon meeting his cousin William, in Mrs Inchbald's *Nature and Art* of 1796, is: '"A little man! as I am alive, a little man! I did not know there were such little men in this country! I never saw one in my life before!"' (Chapter XI) In exactly the same way, according to Mercier in around 1780, an English boy sees a French one as a *'petit monsieur'* rather than a boy: for the English boy is 'stout, round, half-naked, his hair neglected in a natural fashion and dressed in a sailor-suit', while the French boy is 'thin, pale,

Fig. 134
RAEBURN
*The Paterson Children c.*1790
The National Trust, Polesden Lacey

203

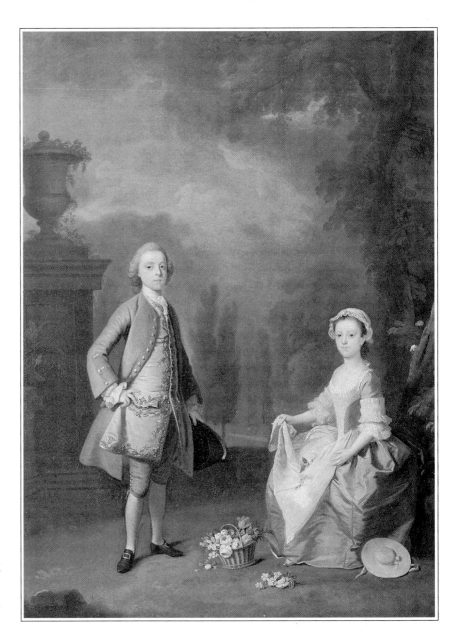

Fig. 135
DANDRIDGE
Edward Harley, 4th Earl of Oxford,
and his Sister Sarah
c. 1737
COLLECTION OF EDWARD HARLEY
ESQ

with hair powdered white, of little thin slender legs and walking stiffly, like a puppet'.[1] According to this view, the English have taken Rousseau to heart: for it is his constant complaint that traditional education produces pseudo-adults – superficially clever but profoundly lacking in understanding – rather than real children, who are the reverse. This is what has made William 'a foolish man, instead of a wise child, as nature designed him to be'. (*Nature and Art,* Chapter IX) *Edward Harley* (*FIG.* 135) is a 'little man' in costume, pose and in his generally grave or affected demeanour. He even has the small head, narrow limbs, and slender proportions of a scaled-down adult, rather than a childish chubbiness.

Raeburn's *George, Robert and Margaret Paterson* of *c.*1790 (*FIG.* 134), shows children looking more like the English boy in Mercier's description

They are not half-naked or especially negligently coifed, but they have a healthy fullness of limb and stockier proportions – they could never be mistaken for little adults. They also wear specially-designed children's clothes: Pierrot-like ruffs, loose breeches and jackets. Children's faces are much broader than adults', and their features are at once larger and *less* distinctly marked. The bone structure is so covered in puppy-fleshiness that there is nothing to make a clear line or cast a clear shadow. Raeburn has given some marked outlines, espcially to the eldest, to augur adult good looks, but there is also a shadowless lack of distinctness about the two outer children, so that their faces seem uninterrupted pools of light.

The composition is also childish. Instead of setting the figures apart from each other and far back, dwarfed by their surroundings, as Dandridge has done, Raeburn has bunched his up together, suggesting the uninhibited physical intimacy of childhood. They are much closer to *us*, the viewer, almost as if they were all pushing forward competitively, so as not to be obscured by their siblings. The jostling, communicative and symmetrical threesome, planted squarely and only just out of reach beyond the frame, is deliberately the very antithesis of elegance. But then elegance and deportment – the outward-turning feet of Edward Harvey (*FIG.* 135) – were less important parts of upbringing in 1790 than they had been in 1740. Their place had been taken by the cultivation of the heart's affections.

There are some ways in which little has changed in the interval between these two portraits. The symbolism of the apples in Margaret Paterson's basket, for example, is the same as that of the flowers in Dandridge's picture: they stand for the 'ripening' children. In both portraits it is suggested, perhaps even assumed, that childhood is a preparation for maturity. This is seen in the eldest boy, reacting to his sister as if he were an adult, which is another way of saying as if he were her husband. In the earlier example this means a haughty, proprietorial boy, standing at a dignified distance, while his sister sits meekly by. In the later painting a more gallant young lover, smiling tenderly (almost coyly), stands close behind his sister, to hold her hand and rest his arm upon her shoulder. But this is exactly the sort of contrast one finds between portraits of husbands and wives of these two dates: between, say, *Mr and Mrs Andrews* and the *Revd. Coke and his wife* (*FIGS* 90 and 89).

It is an old idea that childhood and childish games are preparations for adult life. A correspondent to *The Spectator,* no. 500 of 1712, writes: 'when I see the motherly Airs of my little Daughters when they are playing with their Puppets, I cannot but flatter my self that their Husbands and Children will be happy, in the possession of such Wives and Mothers.' And in 1762 an anonymous poet writes:

> *The tender, watchful mother sits hard by,*
> *Knitting, awhile the girls raise up dirt-pie.*
> *O happy presage of their future lives,*
> *Useful in arts the boys, the girls domestic wives.*
>
> *Corydon's Farewell,*
> *on Sailing in the Late Expedition Fleet,* ll. 58-61.[2]

The peculiar position of husbandly authority which the brother can claim is expressed most clearly in Sarah Fielding's *The Governess* of 1749, when the juvenile heroine, Miss Jenny Peace, tells how her mother 'bid me remember how much my Brother's superior Strength might assist me in his being my Protector; and that I ought in return to use my utmost Endeavours to oblige him; and that then we should be mutual Assistants to each other throughout Life.' (The Life of Miss Jenny Peace.) A similar range of ideas is expressed in Romney's *The Clavering Children* of 1777 (*FIG.* 136). As always the brother is a husband-substitute, with his arm round his sister, leading her and his dogs off for a walk like a budding country gentleman. (Like the siblings the two dogs are chained together as a happy couple.) The only childish feature of his action is the fact that the dogs' lead, made for an adult, is too long for him. To gain proper control he is obliged to hold his arm out at full length. In addition to making an affectionate wife, Miss Clavering will make a solicitous mother; this we know from the tenderness with which she cradles the new-born

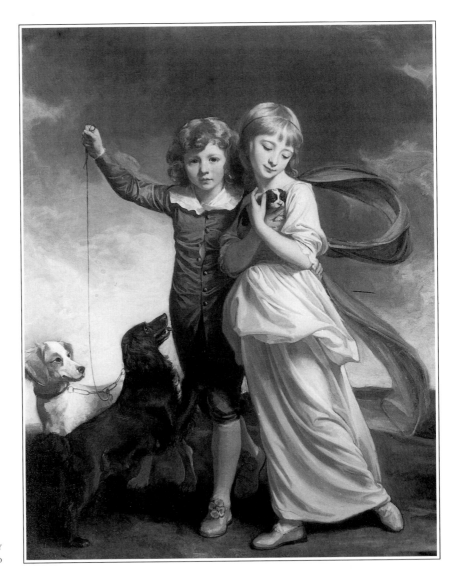

Fig. 136
ROMNEY
The Clavering Children 1777
HENRY E. HUNTINGTON LIBRARY
AND ART GALLERY, SAN MARINO

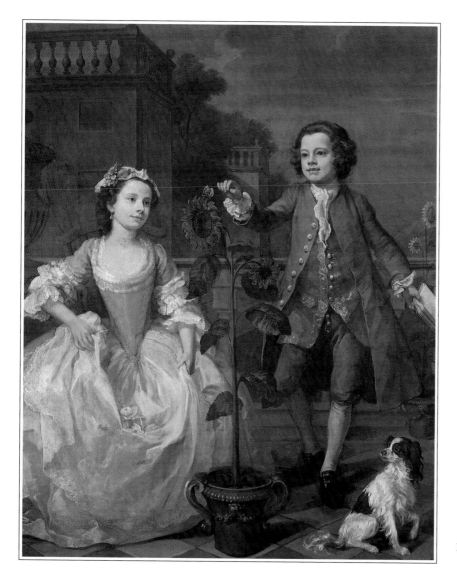

Fig. 137
HOGARTH
The Mackinnon Children 1742
NATIONAL GALLERY OF IRELAND,
DUBLIN

puppy, which she has snatched from the anxious bitch – impelled by a maternal instinct she cannot control!

Rousseau opposed the idea that childhood should be no more than a preparation for an adult life, which the pupil might very likely not survive to see. A proper childhood, enjoyed for it own sake, on the other hand, is not only fun at the time, but indirectly a sounder preparation for life. In spite of his views, imitation of adult life is too obvious and too ingrained a device in portraiture to be abandoned. It could perhaps be said, however, that in later examples, like the Raeburn painting, children *play* at being grown-up, rather than adopting the rôle solemnly – almost as a matter of right – Master Harley seems to (*FIG.* 135). And if the eldest Paterson boy is in training to be an ideal husband, at least the younger is acting like a proper brother (*FIG.* 134). He is tickling his sister (or perhaps pointing to something) with a sprig of apple tree, to distract her attention so that he may steal an apple from her basket.

A child stealing an apple reminds an orthodox Christian viewer of sin. Such an idea is quickly to be dismissed here, since everything suggests indulgence: a condoning – perhaps a positive welcoming – of boyish mischief. And yet Raeburn's inclusion of this motif is not accidental: it shows his awareness of a serious moralising tradition in portraits of children, which he is lightly 'turning off', to use a Reynolds phrase. Hogarth's *Mackinnon Children* of 1742 belongs, at first sight, with Dandridge's portrait (*FIGS* 137 and 135). Except for a rounding and widening of the features, the children look exactly like grown-ups: Master Mackinnon's affected gait and poised hand are almost parodies of the Nursery Dancing Class. They too make a husband-and-wife group, the woman seated, the man standing, and both *almost* looking at each other. Like the earlier portrait the setting, though predominantly architectural, evokes an exotic Italianate garden, with roof-terraces, balustrades and urns, as well as trees and potted flowers. It carries the familiar suggestion of an idyllic pleasure-garden of childhood, while the prominent sunflower suggests the blossoming of the children. Unfortunately it is impossible to consider blossoming without going on to consider decaying. Nathaniel Cotton's *To a Child of Five Years Old* introduces the idea of decay, following the same blossoming image of childhood as occurred in Thomson's *Spring*:

> Mark, my Polly, how the roses
> Emulate thy damask cheek;
> How the bud its sweets discloses –
> Buds thy opening bloom bespeak . . .
>
> But, dear girl, both flowers and beauty
> Blossom, fade, and die away;
> Then pursue good sense and duty,
> Evergreens! which ne'er decay.
>
> Stanzas 2 and 5.[3]

This is also the case in Hogarth's painting for there are petals from fallen flowers, not blooms, in Miss Mackinnon's lap. It is perhaps paradoxical that children, who have all their life ahead of them, should bring to mind the idea of transience. The important thing is that the children themselves don't look at it this way, it is a melancholy and retrospective reflection of adulthood. Carefree children also believe that they will be happy, while the philosopher, shaking his head, maintains that *worldly* happiness lies only in anticipation and that its secure attainment is a delusion. The traditional symbol for this idea is seen here in Master William Mackinnon reaching out to catch a butterfly, a brilliant but fragile thing that will flutter off, eluding his grasp. For John Bunyan:

> The Butter-Fly doth represent to me,
> The Worlds best Things at best, but fading be.
> All are but painted Nothings and false Joys,
> Like this poor Butter-Fly to these our Boys.[4]

The book Master Mackinnon holds turned away beside him suggests that education (especially of a devotional kind) will teach him to grasp the melancholy omens that surround him. This will persuade him to follow Cotton's and Bunyan's advice and to seek for heavenly, as opposed

to worldly joys. This divine quest is also alluded to, in the painting, in the sunflowers, traditional symbols of single-minded and unworldly devotion to God on account of their habit of turning to face the sun. 'This flower', a Dutch emblem book of 1697 tells us, 'teaches us to devote our services to One alone, to turn ourselves always towards God who is the sun of justice.'[5]

To us this painting shows a premature concern with these childrens' means of salvation, as well as showing Hogarth in a surprisingly orthodox emblematic vein. In fact it belongs with an obsession, in the seventeenth and early eighteenth century, with childhood sin. This arises probably because adult sin is a matter of course, but with children is more of a debatable issue and therefore more to be insisted upon. There are two sides to the question: one sees childhood as a time of innocence, while sin waits to come with experience. The opposing view is the orthodox Christian belief in Original Sin which states that, because of the Fall of Man, a baby is pre-programmed with sin, even at birth. A soberingly direct statement of this view comes with Janeway's *A Token for Children* of 1671-2, in which the kindly author reminds parents that children are 'not too little to die, not too little to go to hell'.[6]

An assortment of grave reflections of this nature should occur to the viewer who correctly contemplates Hogarth's *The Graham Children* of 1742 (*FIG.* 138). Again the framework is conventional and appears to set a bright, happy scene. The girls to the left of the painting are brightly-lit and highly-coloured; they are smiling and literally in the pink of health. They are awash with 'blossomings': there is a sumptuous Dutch-looking still life of fruit and flowers in the corner, and the girls wear flowers, especially roses, in their mob-caps; one has flowers embroidered on her dress and another holds cherries. These elements are often scattered in portraits, 'on hand' for the audience to make conventional poetic similies between them and the children, like the roses that 'emulate thy damask cheek' in Cotton's poem quoted above. Hogarth paints the similies himself. One reads of 'rosey lips and cheeks'; Hogarth paints plump, rounded, pouting mouths, the lips unfolding like petals, their colour and the blush on the cheeks identical with the pink of the roses. 'Cherry lips' is another common phrase; the baby's mouth makes two cherry-coloured round shapes, just like the real cherries she strains after. The image is particularly apt because of the children's game of 'bob-cherry', which involves catching a cherry with the mouth only, when it is either floating on water or hanging in the air.

Cherries held like this often occur in Renaissance religious paintings, where they symbolise eternal life. It is possible that this is the symbol Hogarth wishes, but it is more likely that he uses cherries simply to recall such paintings, and thus to suggest a Madonna and Child group. There is a similar allusion in the baby's cart, which has a wooden dove appearing to pull it. This, of course, makes it a chariot of Venus, and therefore makes Anne Maria, the baby, either Venus herself or, more likely, an infant attendant, one of Cupid's troupe. Cupid himself is present as a figurine above the clock. Everything, in short, suggests blossoming loveliness and the promise of love.

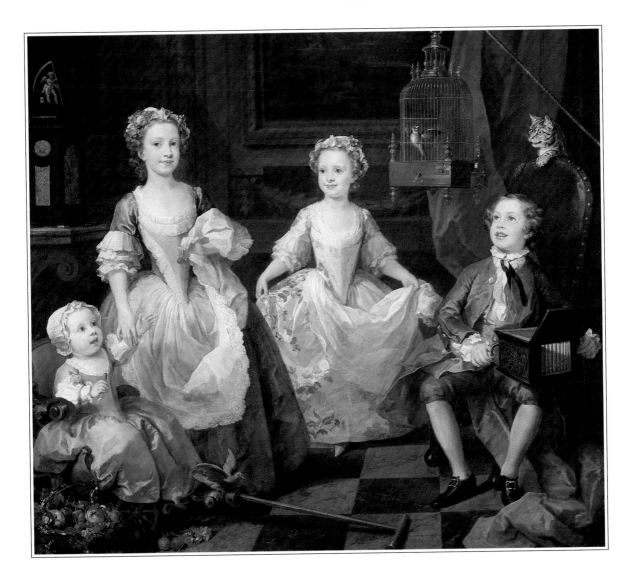

If one completes one of the snatches of quotation above, one is lead into the deeper recesses of this painting:

Let me not to the marriage of true mindes
Admit impediments, love is not love
Which alters when it alteration findes,
Or bends with the remover to remove.
O no, it is an ever fixed marke
That lookes on tempests and is never shaken;
It is a star to every wandering barke,
Whose worths unknowne, although his highth be taken.
Lov's not Times foole, though rosie lips and cheeks
Within his bending sickles compasse come.
Love alters not with his breefe houres and weekes,
But beares it out even to the edge of doome:
If this be error and upon me proved,
I never writ, nor no man ever loved.

Shakespeare, *Sonnet* no. 116.

The Cupid above the clock holds Father Time's 'bending sickle', which he has stolen, to express Shakespeare's vision of a love which outfaces Time. This idea would have been a commonplace, and yet we can be fairly sure that Hogarth means to illustrate this particular sonnet because of the 'rosie lips and cheeks', and the painting on the wall of a tempest at sea (an echo of the 'wandering barke'), with a tower above it like Shakespeare's 'ever fixed marke'.

The painting, we see, holds out a promise of the ultimate felicity: love 'even to the edge of doom'. But in so doing it reminds us (in the forms of the black clock, the sickle and the painting that lurks in the shadows behind the girls) of the darker forces threatening this ideal: Tempests and Time. For though 'the marriage of true mindes' is a possibility, the 'bending sickle' is a certainty, as some other gloomy poems and portraits of childhood have already reminded us. The real nature of the threat, however, is not Time but Sin, which is to be found on the other side of the painting. A cat, grinning maliciously, with blazing eyes and extended claws, mesmerises a terrified goldfinch in its cage. Well, as P. G. Wodehouse has pointed out, cats will be cats. What makes this image so sinister is the part played by the only boy in the painting, Richard Robert Graham. He also looks up at the cage, which hangs over his chair, and, with rather a toothy grin, sings to the goldfinch to the accompaniment of a bird-organ, a mechanical toy which chirrups when you turn the handle. On the side of the organ there is a little bronze relief of Orpheus playing his lyre to the animals and birds, an obviously appropriate piece of decoration. Orpheus had the power to tame and to rule all manner of wildlife, however fierce or shy. Master Graham is clearly attempting to charm the goldfinch in a similar way by the power of his music. An innocent game, you might think, except that there is an alarming (and of course deliberate) physiognomic similarity between the boy and the cat, perched just above him like his evil genius. They both have the same round face, staring eyes, turned-up nose, wide grin and, for a boy, curious effect of the upper lip curling up to meet the nose, like an animal's hare-lip. The boy and the cat are not identical, they merely symbolise the light and the dark side of the same phenomenon – the temptation of men. The little boy can 'charm the birds off the trees' – young men can do the same to girls; they can also destroy them like the cat. A similar moral for young ladies, about the dangers of temptation, is drawn from the tragic fate of a greedy cat in Gray's *Ode on the Death of a Favourite Cat, Drowned in a Tub of Gold Fishes* of 1748, a few years after this painting.

Like most of Hogarth's portraits this seems supremely tactless! It seems to imply that the Grahams' son and heir is a seducer in embryo. It is more likely that the painting was viewed as concerning boys in general, not Richard himself. As Fanny Burney's friend, Mr Crisp, reminds her in 1774: 'all men are cats, all young girls mice – morsels – dainty bits – Now to suppose when the mouse comes from her hole, that the generous, sentimental Grimalkin will not seize her, is contrary to all Nature and Experience, and even to the design and Order of Providence.'[7] God, it appears, moves in a mysterious way and the predatory Master Graham is part of the Divine Plan! Even so, it is certain that

Fig. 139
JONATHAN RICHARDSON
*Sir Nathaniel and Lady Curzon
with their surviving and deceased
sons*
THE NATIONAL TRUST,
KEDLESTON HALL

moralising of this type would never find its way into a portrait of the Graham parents. It is reserved exclusively for children, where the sitters are too young to complain, and towards whom at this date there was, in some quarters, a *habit* of moral severity, even on the part of parents.

It is clear from Richard Graham and his baby sister, Anne, that children may be considered as little angels or little devils. In his *Strolling Actresses Dressing in a Barn* of 1738 Hogarth includes two little boys dressed for the part of devils, and appropriately stealing a drink of beer. Shaftesbury, in an exercise in the association of ideas, lists the characteristics of boys, including sweet, pretty, innocent, a cupid or, alternatively, 'an urchin, half civil, demon cruel': a clear expression of the ambivalence contained in the casual phrases 'the little angel' and 'the little devil', which occur in the literature of the period.[8] But most artists dealing in commissioned portraits prefer to dwell upon little angels. This is partly the profit motive and partly because of an old tradition, seen here in Jonathan Richardson's *Sir Nathaniel Curzon and his Family* (*FIG.* 139), according to which children are shown posthumously in family portraits as angels in heaven. In this case John is shown sitting on clouds with a crown of Eternal Life in his hand.

Miss Frances Isabella Gordon was alive and well when, in 1786, Reynolds painted five of her in a ring as *Heads of Angels* (*FIG.* 141), her hair a soft Rubensian amber against a sky of swirling blue clouds and divine light shafts. The painting is a witty adaption of the multiple views of the same head one finds in preparatory drawings or oil-sketches. Reynolds has simply had to add wings to the neck to make the conventional head-on-wings of Baroque angels. But there is only a half-hearted attempt to disguise the intimate character of a child's portrait sitting: the singing pair on the upper right could perhaps pass muster as *putti* in an Italian altarpiece, but the face staring out at us just looks like an intrigued Scots girl. Other portraits in this genre, such as Beechey's *'Adoration' – Lady Giorgiana Bathurst* of 1801 (*FIG.* 140), stress the saintly innocence of the young sitter; Miss Frances Gordon's only obviously angelic characteristic is prettiness.

A rare example of a little devil, or at least a little Tartar, in commissioned portraiture is Reynolds' famous *Master Crewe as Henry VIII* of 1776

Fig. 140
SIR WILLIAM BEECHEY
Lady Louisa Georgiana Bathurst,
'Adoration' 1801
PRIVATE COLLECTION

Fig. 141
REYNOLDS
Miss Frances Isabella Gordon,
'Heads of Angels' 1786
THE TATE GALLERY, LONDON

(*FIG.* 142). The primary idea, of a boy adopting the pose and costume of Holbein's famous portrait of Henry VIII (*FIG* 143), is one of contrast. As Horace Walpole put it: 'Is not there humour and satire in Sir Joshua's reducing Holbein's swaggering and colossal haughtiness of Henry 8th. to the boyish jollity of master Crewe?'.[9] But the humour is more exquisite because there is an absurd similarity between the king and the boy, as well as an obvious contrast. Boys have some swaggering of their own, especially when allowed to play the villain – the Pirate King or the Indian Chief – as they long to do. Henry VIII is the pirate-king of any little delinquent's dreams, and Master Crewe carries off his implacable ruthlessness with a cheerful, swashbuckling air. The other absurdity is that Henry VIII, at least in Holbein's rendering, is extremely broad, short and tubby, and has a fleshy, oval moon of a face, just like a little boy in fact. Reynolds has only to flatten Master Crewe's nose slightly and accentuate the plump roundness of his cheeks, and the unflattering likeness emerges.

As the art historian David Mannings has noted, Henry VIII was a popular character for fancy dress at the time, but there is a further reason for the identification here:[10] Holbein is the sort of artist children might like. To Reynolds, Holbein would not be altogether worthy of serious emulation: his forms are too stiff and flat, and there is too much adherence to the intricate details of embroidered stuffs and jewellery (*FIG.* 143).[11] Portraits such as this *Henry VIII* lack the unobtrusive simplicity and sculpted Classical form of the 'Grand Style'. But the Grand Style is an acquired taste. Reynolds himself admits to having failed to appreciate the *Stanze* of Raphael on his first visit; this was the most humiliating experience of his life.[12] How can a child then be expected to appreciate this dignified restraint? Like all unsophisticated spectators, they enjoy obvious realism and a splendid brilliance of detail. Holbein is an ideal introduction.

This pandering to childish taste explains the curious paradox that Romney's *Clavering Children* (*FIG.* 136) is more like Reynolds than Reynolds is like himself. Miss Clavering's swaying pose, the sculptural gatherings and the flowing white pleats of her dress belong to Reynolds' Classical aesthetic, ideals which can be seen even more clearly in Romney's masterpiece, *The Gower Children* of 1776 (*FIG.* 146). The eldest daughter is again of Classical proportions and has a sinuous outline, loosely bound in pleats. She cradles her head with her arm, and caresses the tambourine like an abandoned dancer in a Bacchic relief, carved against the smooth stone of the pilasters behind. The younger girls are similarly Classical, in the wind-swept and movement-flung pleats of their loose dresses, and in their poised, floating movements, turning and swaying in and out. It is

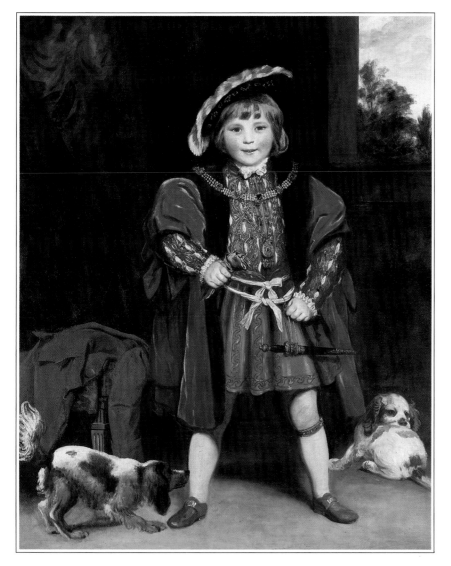

Fig. 143
HOLBEIN
Henry VIII
THE COLLECTION OF HIS GRACE
THE DUKE OF RUTLAND

Fig. 142
REYNOLDS
Master John Crewe as Henry VIII
1776
PRIVATE COLLECTION

not wholly an impersonal and timeless idyll, though: two at least of the children look out at us with the coy and more immediate directness of real children. The right-hand girl seems almost to be a younger and cheekier version of her modest elder sister, whose outline she barely clips. The other two girls look up more reverently to the same sister, as if to an ideal, a perfection of beauty and womanhood, to which they aspire. The cameo-like, 'antique' profile of the girl in red is a particularly fine example of Romney's succinct patterning of forms.

Reynolds never painted such an Arcadian Round, having observed that children do not sway and turn with this graceful control. They stand bolt upright, stiffly, even awkwardly, looking straight out at what catches their attention. In *Master Crewe* (*FIG.* 142) this is partly because of the appropriately 'stiff picture' by Holbein which it parodies, but the companion piece, *Miss Crewe* (*FIG.* 144) has exactly the same stilted posture, the body and face pointing directly outwards, and with no sense of contrived

'adult' deportment. Even the outline of the dress is a comically oversimplified tent-shape, in comparison to the gracefully tapering dresses wrapping around the ankles of the Gower children.

In the portraits of both the Crewe children one sees the way in which, as David Piper has pointed out, Reynolds paints *the sitting* when painting children rather than using the sitting to paint a person in some other context, as he would with adults.[13] A soldier is posed in the studio in order that he may be depicted on a battle-field; there is nothing of the sitting left in the final work. Master Crewe, on the other hand, is engaged in a splendid dressing-up game taking place in Reynolds' studio: we see his ordinary coat discarded on the stool behind, he laughs in triumph at his new disguise, while a puppy, incredulous at the transformation, sniffs to make sure. This is a cunning piece of child psychology on Reynolds' part for two reasons: firstly because being on show in general is an important part of a child's life; and secondly because the portrait sitting, a special case of being on show, would be a major event, an exciting new game. A

Fig. 144
REYNOLDS
Miss Frances Crewe 1775
PRIVATE COLLECTION

Fig. 145
REYNOLDS
Miss Theophila Gwatkin
'Simplicity' 1789
THE NATIONAL TRUST,
WADDESDON

sitting with Reynolds must especially have been a party: 'Oh! what grand rackets there used to be at Sir Joshua's when these children were with him!' Northcote recalls, 'He used to romp and play with them, and talk to them in their own way; and, whilst all this was going on, he actually snatched those exquisite touches of expression which make his portraits of children so captivating.'[14]

Another aspect of the drama of the sitting is Reynolds' realization that it is impossible to look at children for any length of time without them being aware that they are being looked at, and becoming self-conscious. This is clearly a problem with portrait-sittings, but one which most artists simply ignore or 'paint around'. Reynolds positively draws attention to it, as a special characteristic of childishness. *Miss Crewe* (*FIG.* 144) stares at us, wide-eyed, with an eager smile, anxious to please. In a more extreme example, *Miss Theophila Gwatkin* of 1789 (*FIG.* 145), we are to imagine that Theophila has been told where and how to sit, and to keep still; but she has become so overwhelmed with shyness that she has turned her face away as far as her neck will allow, without actually being disobedient and

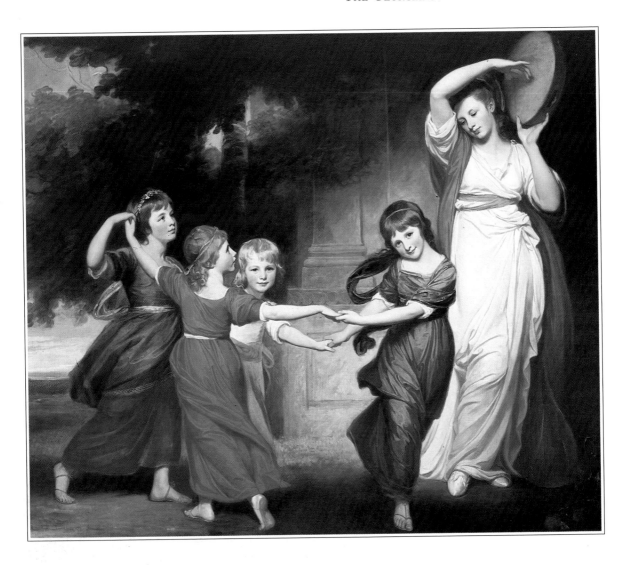

Fig. 146
ROMNEY
The Gower Children 1776
ABBOT HALL ART GALLERY,
KENDAL, CUMBRIA

Fig. 147
REYNOLDS
Lady Caroline Scott as 'Winter'
1777
IN THE COLLECTION OF THE
DUKE OF BUCCLEUCH AND
QUEENSBERRY KT.

changing her position. Such shyness was regarded as gauche in the earlier part of the century: Hogarth even recommended that girls' pigtails be secured to a harness on their back to prevent them from looking down when addressed by their elders.[15] To Reynolds it is sweet, an example of modesty, for which reason this portrait was entitled *Simplicity*.

It is this that makes the contrast between Reynolds' portrayal of Lord Herbert in the previous chapter and Dandridge's Edward Harley in this (*FIGS* 126 and 135). The latter sneers with adult superiority, while Lord Herbert looks straight, with a fearless steadiness, and yet with the frozen wide-eyed stare of a child fighting shyness under scrutiny. The comparison reminds one of Mary Wollstonecraft's observation: 'we now rarely see a simple, bashful boy, though few people of taste were ever disgusted by that awkward sheepishness so natural to the age, which schools and an early introduction into society, have changed into impudence and apish grimace.'[16]

Lady Caroline Scott as 'Winter' of 1777 (*FIG.* 147) provides a kind of summary of all the characteristics of Reynolds' portraits of children. Like

147

Miss Crewe this little girl, at once shy and excited, stands ludicrously four-square and direct: there is not the minutest detail on her person that departs from the frontal and the symmetrical. The winder landscape background is based on the work of the Dutchman, Aert van der Neer, and is another example of the sort of art Reynolds would not recommend to students of the Royal Academy, but which children love – decorative and detailed depictions of an every-day, recognisable world, full of birds and animals.[17] In fact, in his *Sixth Discourse* of 1774 Reynolds *did* partly endorse this type of art, when he claimed that lesser masters, especially Dutchmen like Jan Steen, 'though they cannot be recommended to be exactly imitated, may yet invite an artist to endeavour to transfer, by a kind of parody, their excellencies to his own performances.'[18] This is exactly what he himself was to do in this painting.

On Lady Caroline's face Reynolds has used direct sunlight and almost equally bright reflections off the snow and the bonnet to 'outflank' any possibility of shadow. This makes the face one almost unvaried blob of light, to suggest the springy, unformed features of childhood. No feature is described by shape, because there is no shadow to do so, with the result that they seem to be almost 'added', with a child-like simplicity: two pieces of coal for eyes, a stain of berries for the cheeks, a stick of charcoal and two dots for mouth and nose. With the pure white dress, the sentry-box posture, and round ball of light for the face, Reynolds has impersonated 'Winter' by the inspired joke of turning his sitter into a little snowman.

It is with paintings such as this in mind that Haydon wrote in 1813 of Reynolds:

> *his inimitable, unimitated children, who can approach? Raphael's children have the sedateness of age, Rubens' the plumpness of peasants, Titian's no doubt the elegance of nobility, but none, none have that exquisite sprightliness, that unthinking playfulness, that quizzing importance, full of tricks, full of fun, assuming the airs of men, tricked and flounced with feathers and trains, while their blue eyes and laughing little mouths belie to us their attempt at thinking, and divert, delight us at their delusions. If he had poetry any where, it was in his children . . .*[19]

Haydon's reaction to the 1813 retrospective exhibition of Reynolds' work is as good a place as any to cast the account of Georgian portraiture (though seeking a *balanced* view in any of Haydon's writings may seem Quixotic). The extract quoted above looks on the bright side; on his next visit he puts his finger on the worst thing that can be said of the period: 'In going this morning to the Reynolds gallery, they looked careless, slobbering, unfinished, in short, they are only beautiful sketches. Sir Joshua's mind triumphed over the ignorance of his hand. He knew effect, but his means of attaining it were inadequate; his breadth was emptiness.'[20] This view was also expressed during Reynolds' lifetime: the *Morning Chronicle* of 1773 complained of one of his works being 'finished in a slobbering, herum-skerum, unartist-like way.'[21] Even Northcote admits that his hero sometimes approaches the fault of 'spurious breadth . . . which looks flat and poor – a result produced by leaving out detail'.[22] The admirers of this effect call it 'breadth'; detractors call it 'slobber', or

what the Pre-Raphaelites later called 'slosh' after its originator Sir *Sloshua* Reynolds. Even the enthusiast must sometimes admit that the attention-seeking impact of Reynolds' simplification or Romney's 'breadth' are effects achieved at a cost. Contemplating the sterile wastes of impasto in passages of the *Clavering Children* or *Lady Catherine Pelham-Clinton* (*FIGS* 136 and 110) can induce a yearning for Ingres!

But, even according to Haydon, 'Sir Joshua's mind triumphed': the best thing that can be said about his and his contemporaries' art is that it is intelligent, and witty, and that it can balance a range of literary, symbolic and visual allusions with a self-conscious poise. One important thing about these tongue-in-cheek, semi-parodying devices is that they provide an elevated way of depicting the mundane. In the literature of the period – in *The Rape of the Lock, Tristram Shandy* or *Tom Jones* – one finds mock-heroic, mock-encyclopaedic, the parade of learning and allusion, all used as decoys to draw attention from the fact that the characters are in themselves people of small consequence. Belinda is just another court *belle*, Uncle Toby is a crank but otherwise undistinguished; and Tom Jones, by his very name, is just Mr Anyone. In the matter of rank, Lady Caroline Scott is clearly not just Miss Anyone, but in her portrait (*FIG.* 147) we see a dazzling range of devices to make up an image of childhood as utterly, even touchingly, ordinary as a photograph on a piano.

NOTES

CHAPTER 1

1. Williams 1831, I, p. 221.
2. Haydon 1950, p. 310.
3. Leslie and Taylor 1865, II, p. 401; Denvir 1983, p. 126.
4. Reynolds 1975, p. 304.
5. Whitley 1928-30, I, p. 160; Woodall 1963, p. 43; Hayley 1809, p. 123; Williams 1831, I, p. 221.
6. Barrell 1986, p. 77.
7. See Webb 1760, p. 31.
8. Chesterfield 1901, I, p. 340.
9. Shaftesbury 1969, p. 135.
10. Shaftesbury 1969, p. 112.
11. See, for example, Farington 1819, pp. 16, 69 and Vertue III, p. 123.
12. Le Blanc 1747, I, pp. 159-60.
13. Walpole 1782, IV, p. 1; Leslie and Taylor 1865, I, p. 43; Farington 1819, p. 15.
14. Rouquet 1970, pp. 15-16: see also Boydell 1805, p. 12.
15. Cunningham 1829-33, V, pp. 42-3.
16. Hudson 1958, p. 178
17. Rouquet 1970, p. 45.
18. Combe 1777, Introduction.
19. Northcote 1819, II, p. 65; Walpole 1937-83, XV, p. 47.
20. Rouquet 1970, p. 39.
21. See Delany 1861-2, I, p. 283.
22. Hazlitt 1930-4, XVIII, p. 109.
23. Cunningham 1829-33, I, p. 285.
24. See Waterhouse 1973, pp. 40-1.

25. See Lippincott 1983, p. 80.
26. Rouquet 1970, p. 39.
27. See Vertue III, pp. 111, 131.
28. Whitley 1928, I, pp. 4-5; see also Shebbeare 1755, II, p. 51.
29. Mannings 1977, p. 279.
30. See Vertue II, p. 135; de Piles 1706, p. 400.
31. Vertue I, p. 48; see Fleming 1961, pp. 22-5.
32. Edwards 1808, pp. 53-4; see also Mannings 1977, pp. 280-1.
33. Rouquet 1970, pp. 43-5.
34. Vertue III, p. 125. (We have preserved Vertue's spelling but tidied up some of his more eccentric punctuation.)
35. See Vertue III, p. 151.
36. Rouquet 1970, p. 45.
37. Vertue III, p. 80; see also III, pp. 75, 123.
38. Hogarth 1966-8, pp. 100-1; see also Vertue III, p. 123.
39. Lairesse 1738, p. 355.
40. Northcote 1819, I, p. 55.
41. Talley 1978, p. 747.
42. Whitley 1928, I, p. 104.
43. Woodall 1963, p. 119.
44. Vertue IV, pp. 27-8.
45. Rouquet 1970, pp. 38-9; Hoare 1810, I, III, pp. 7-8.
46. Burney 1842-6, II, p. 42.

47. Rouquet 1970, pp. 40-1.
48. Northcote 1819, I, p. 83.
49. Cunningham 1829-33, I, p. 327.
50. Vertue IV, p. 28.
51. Vertue II, p. 122.
52. Vertue I, p. 28 and II, p. 120.
53. Manners 1924, p. 103.
54. See Royal Academy 1986, p. 367.
55. de Piles 1706, p. 477.
56. Pasquin *Memoirs* 1796, p. 133.
57. Levey 1979, p. 25.
58. Vertue VI, p. 163.
59. Vertue IV, pp. 27, 28.
60. Pointon 1984, p. 198.
61. See Vertue IV, pp. 28-9, 169; Walpole 1937-83, XVIII, p. 467.
62. Hazlitt 1930-4, XII, p. 111.
63. Amelia Opie 1809, pp. 43-4; see also Hoare 1810, I, XIX, p. 12.
64. Stewart 1983, p. 17; Leslie and Taylor 1865, II, p. 32.
65. See Lippincott 1983, pp. 31-8.
66. Shebbeare 1755, II, p. 52.
67. Vertue III, p. 79; see also Rouquet 1970, p. 39.
68. Cotton 1859, p. 50.
69. Vertue I, p. 68.
70. Vertue II, p. 120.
71. Vertue III, pp. 54, 59.
72. Vertue III, p. 82.
73. Vertue III, p. 102.
74. Lippincott 1983, p. 33.

75. Lippincott 1983, p. 50.
76. Vertue III, p. 106.
77. Hogarth 1955, p. 217.
78. Hogarth 1955, pp. 216-7.
79. Rouquet 1970, p. 39.

80. Leslie and Taylor 1865, I, p. 48.
81. See Rouquet 1970, p. 38 and Shebbeare 1755, II, p. 52.
82. Northcote 1819, II, p. 127.
83. Cunningham 1829-33, II, p. 186.

84. See Denvir 1983, p. 183.
85. de Piles 1706, p. 304.
86. Vertue III, p. 110.
87. Hazlitt 1930-4, XVIII, pp. 107-8.
88. Piper 1957, p. 232.

CHAPTER 2

1. Hudson 1958, pp. 14-5.
2. Mercier 1982, pp. 152-3; see also Grosley 1772, II, p. 63 and Walpole 1937-83, XXXIX, p. 32.
3. Hayley 1809, p. 103 and Hoare 1810, I, III, pp. 16-17.
4. All information Vertue III, p. 85; Romney 1830, pp. 54, 150-1; Williams 1831, I, p. 77; Whitley 1928-30, I, p. 10; Smart 1952, p. 56; Waterhouse 1973, pp. 40-1; Mannings 1983, pp. 185-96; Lippincott 1983, pp. 76-86; Stewart 1983, pp. 187-9; Pointon 1984, p. 200.
5. Compare Ribeiro 1984, p. 88; and Turberville 1933, I, p. 296.
6. Williams 1831, I, p. 76.
7. Burney 1842-6, I, pp. 286-7; see also Whitley 1928, I, pp. 173-4.
8. Shaftesbury 1969, pp. 15-6 (*Prefatory Thoughts*).
9. Pilkington 1805, p. 451.
10. Pilkington 1805, p. 451.
11. Williams 1831, II, p. 282.
12. Farington 1819, p. 183.
13. Reynolds 1975, pp. 111-2.
14. Denvir 1983, p. 15.
15. Williams 1831, II, pp. 311-2.
16. Northcote 1819, I, p. 163.
17. All information Sandby 1862, I, pp. 33-44; Whitley 1915, p. 166; Turberville 1933, II, p. 38; Pointon 1984, pp. 188-9; Pears 1988, p. 127.

18. Barry 1809, I, p. 92.
19. Edwards 1808, p. 209.
20. Waterhouse 1973, p. 20.
21. Walpole 1937-83, XXIII, p. 211 (letter of 6 May 1770).
22. Johnson 1986, p. 82; see also Boydell 1805, p. iii.
23. Walpole 1782, IV, p. viii; Williams 1831, II, p. 345.
24. Cunningham, 1829-33, V, pp. 225-6.
25. Northcote 1819, II, p. 37; see also I, p. 55.
26. Walpole 1782, IV, p. 108.
27. Northcote 1819, II, p. 305, see also I, p. 65, and Pilkington 1805, p. 262 (under 'Hudson').
28. Northcote 1819, I, p. 54.
29. Northcote 1819, I, pp. 54-5.
30. Herrmann 1972, p. 71.
31. See Northcote 1819, II, p. 305; Hazlitt 1930-4, XI, p. 220, and Edwards 1808, pp. 184-5.
32. Northcote 1819, II, pp. 46-7.
33. Le Blanc 1747, I, p. 159.
34. See also Northcote 1819, I, p. 164.
35. Northcote 1819, II, p. 265.
36. See *Gentleman's Magazine*, vol. 58, p. 754; Whitehouse 1792, p. 5; Farington 1819, p. 241; Cunningham 1829-33, I, p. 314, etc.
37. Hazlitt 1930-4, XII, p. 204 (*The Plain Speaker*, no. XX, 1826).
38. Hazlitt 1930-4, XII, p. 115 (*The Plain Speaker*, no. XI, 1826).

39. Denvir 1983, p. 258.
40. Combe 1777, Introduction.
41. See Richardson *An Essay* 1719, pp. 45-6; Walpole 1782, IV, p. viii; Rossi 1810, p. 25 n. 8; Farington 1819, p. 135; Northcote 1819, II, p. 306; Leslie and Taylor 1865, II, p. 629.
42. Barry 1809, I, p. 553.
43. Knowles 1831, II, pp. 214-5.
44. Whitehouse 1792, p. 16.
45. Combe 1777, Introduction.
46. Foote 1752, p. 7.
47. Richardson 1715, p. 175.
48. Cunningham 1829-33, I, p. 315.
49. Burney 1842-6, II, p. 238.
50. Reynolds 1975, p. 50.
51. Moore 1967, p. 353.
52. See Hazlitt 1930-4, XII, pp. 110-1 (*The Plain Speaker*, no. XI, 1826).
53. Reynolds 1952, p. 66; see also Wendorf 1983, p. 110.
54. Hazlitt 1930-4, XI, p. 311; see also XVIII, pp. 79-80.
55. Reynolds 1975, pp. 79, 305; see also Hayley 1809, pp. 148-9 and Hazlitt 1830-4, XVIII, pp. 74-8.

CHAPTER 3

1. Richardson *A Discourse* 1719, p. 12.
2. Lairesse 1738, pp. 366-7.
3. Hayley 1809, p. 376 (*Epistle to Romney*, 1788); see also Webb 1760, p. 199; Barry 1809, I, pp. 467-9; Pevsner 1956, p. 22.
4. Walpole 1762-3, I, p. 48.
5. See also Melmoth 1754, pp. 298-300.
6. Denvir 1983, pp. 152-3.
7. See Hayley 1809, p. 377 (*Epistle to Romney*, 1788) and Barrell 1986, p. 29.
8. Nichols 1781, pp. 106-7.
9. See Piper 1957, p. 199.
10. See Reynolds 1798, III, p. 123.

11. Walpole 1937-83, XV, p. 47 (letter of 25 February 1759).
12. Wollstonecraft 1985, p. 106 (Chapter 2).
13. Northcote 1819, II, p. 55; compare Page 1720, p. 78.
14. Reynolds 1798, III, p. 149.
15. Reynolds 1798, III, p. 42.
16. Hickey 1975, pp. 278-9; Brooke 1767-70, II, p. 234.
17. Reynolds 1975, p. 72; but see also Mannings 1985, p. 320.
18. Richardson 1715, p. 155.
19. Whitley 1928, I, p. 175.

20. Combe 1777, p. 6.
21. Hayley 1779, p. 19.
22. Herrmann 1968, p. 657.
23. Melmoth 1754, p. 302.
24. Shaftesbury 1969, p. 43 (*Treatise II, A Notion of the Historical Draught*, 1713).
25. Walpole 1782, IV, p. 156.
26. This identification was suggested to me in conversation by Dr Malcolm Warner.
27. See Warner 1989, p. 15.
28. Hayley 1779, p. 18; Lonsdale 1987, p. 156.
29. See Levey 1979, p. 34, no. 12.

30. Ripa 1709, p. 5, *fig.* 18.
31. See Jarrett 1965, pp. 410-3.
32. Hayley 1779, p. 20.
33. Williams 1831, I, p. 197.
34. Chesterfield 1892, III, p. 1418.
35. Smart 1952, p. 158; Sheridan 1975, p. 340, n. 1.
36. Waterhouse 1953, p. 166; but see also Solkin 1986, pp. 44-6.

37. See Rump 1979, p. 164.
38. Reynolds 1975, p. 81.
39. Reynolds 1975, p. 160.
40. Reynolds 1975, p. 138.
41. Reynolds 1975, p. 60.
42. Shaftesbury 1969, p. 19 (*Treatise I, A Letter Concerning Design*, 1732).
43. Lairesse 1738, p. 363.

44. Hudson 1958, p. 26.
45. Reynolds 1798, III, p. 120.
46. Reynolds 1975, p. 179.
47. Armstrong 1901, p. 108.
48. Lonsdale 1987, p. 426.
49. Reitlinger 1961, I, p. 478.
50. Williams 1831, I, pp. 279-80.
51. Levey 1979, p. 32.

CHAPTER 4

1. See Pears 1988, pp. 17-8.
2. Smith 1792, I, pp. 70-1.
3. Jarrett 1965, p. 60.
4. Alberti 1955, p. 188.
5. See Le Blanc 1747, I, p. 19.
6. Smollett 1967, p. 130.
7. Jarrett 1974, p. 25.
8. Jarrett 1974, p. 24.
9. Ribeiro 1983, p. 13.
10. See also Cherry 1982, p. 297.
11. Chesterfield 1901, I, p. 140 (letter of 29 November 1745).
12. Smart 1965.
13. Chesterfield 1901, II, p. 100 (letter of 8 January 1751).
14. Nivelon 1737, Plate I (Men); see also Hammelmann 1968; Mannings 1975 and Simon 1987, pp. 72-6.
15. Lonsdale 1987, p. 545.
16. Burney 1907, I, p. 337.

17. Shaftesbury 1969, p. 151 (*Treatise IV, Plastic Art*, 1712).
18. Reynolds 1975, p. 48 (*Discourse III*, 1770).
19. Leslie and Taylor 1865, II, pp. 31-2.
20. See Ribeiro 1983, pp. 94-5.
21. Chesterfield 1901, I, p. 57 (letter of 5 November 1739).
22. Burney 1907, I, p. 22 (10 August 1768).
23. Chesterfield 1901, I, p. 128 (letter of 1742).
24. Brooke 1767-70, I, p. 96.
25. Hazlitt 1930-4, XI, p. 306.
26. Willey 1986, p. 61.
27. Willey 1986, p. 11.
28. Rousseau 1966, p. 197, n.
29. Mackenzie 1987, p. vii.
30. Brooke 1767-70, I, p. 223; see also Bocage 1770, I, p. 38.

31. Hayes 1980, p. 116, no. 103.
32. Le Blanc 1747, I, pp. 64-5.
33. Smollett 1967, p. 57.
34. Smollett 1967, p. 97.
35. Shaftesbury 1969, p. 151 (*Treatise IV, Plastic Art*, 1712).
36. Gaunt 1971, no. 148.
37. See Macmillan 1986, pp. 75-6.
38. See also Grosley 1772, I, pp. 141-5.
39. All Shaftesbury 1732, II, pp. 344-5; Willey 1986, p. 63.
40. Shaftesbury 1732, II, p. 370.
41. Gaunt 1971, no. 119.
42. Willey 1986, p. 237.
43. Rousseau 1966, p. 372.
44. Cummings 1968, p. 660; see also Walpole 1937-83, X, pp. 133-4.
45. Smith 1792, II, pp. 221-2.
46. Smith 1792, II, p. 247.
47. See Macmillan 1986, Chapter VI.

CHAPTER 5

1. Williams 1831, II, p. 319.
2. Chesterfield 1901, I, pp. 179-80 (letter of 9 October 1747).
3. Hogarth 1955, p. 217.
4. Ireland 1791, I, p. cxix.
5. Lonsdale 1987, p. 511.
6. Hogarth 1955, p. 212.
7. Vertue III, p. 126.
8. See Yale Center 1983, p. 106.

9. See Vertue VI, p. 151.
10. Omberg 1974, p. 3.
11. Omberg 1974, p. 60.
12. Vertue III, p. 157.
13. Reynolds 1798, III, pp. 147-8.
14. Lairesse 1738, p. 356.
15. Rouquet 1970, p. 67.
16. See Vertue III, p. 109.
17. All Rouquet 1970, pp. 35-7.

18. Edwards 1808, pp. 106-7.
19. Vertue III, p. 96.
20. Smart 1971, p. 15.
21. Miles and Simon 1979, Introduction, p. 18.
22. Armstrong 1901, pp. 71, 111.
23. Gordon 1986, p. 68.
24. Fletcher 1901, p. 74.
25. See Farington 1819, p. 22.

CHAPTER 6

1. Wollstonecraft 1985, p. 150.
2. Lippincott 1983, pp. 64-5.
3. Barbauld 1826, p. 43.
4. Brooke 1767-70, III, p. 207.
5. Mercier 1982, p. 158.
6. Cunningham 1829-33, V, p. 247 and VI, p. 185.
7. Hazlitt 1930-4, X, p. 38.
8. Cooke 1678, p. 15; Stewart 1983, p. 45.

9. Ramsay 1762, pp. 56-7.
10. Macmillan 1986, Chapter II.
11. Walpole 1937-83, XV, p. 47 (letter of 25 February 1759).
12. Ramsay 1762, p. 27.
13. Le Blanc 1747, I, p. 33.
14. Hazlitt 1930-4, XI, p. 198.
15. See Leslie and Taylor 1865, I, p. 227.
16. Burney 1842-6, II, p. 201.

17. Nivelon 1737, Plate I (Women).
18. Pilkington 1857, p. 301.
19. Melmoth 1754, p. 104.
20. Melmoth 1754, p. 151.
21. Barbauld 1826, pp. 44, 53.
22. Gisborne 1797, p. 22.
23. Smart 1952, p. 108.
24. Delany 1861-2, III, p. 605 (letter of 23 October 1760).
25. Lairesse 1738, p. 367.

26. Delany 1861-2, VI, pp. 496-7; see also the dedication of Sarah Fielding's *The Governess* 1749; Cowper's *The Task* 1785, IV, 11. 150-68 and Peddle 1789, pp. 59-62.
27. Barry 1809, II, pp. 144, 153.
28. Walpole 1937-83, XXIX, p. 46 (letter of 28 May 1780).
29. Walpole 1937-83, XXIX, p. 285 (letter of 10 February 1783).
30. Bocage 1770, I, pp. 29-30.
31. Barbauld 1794, pp. 289-91 (*The Female Choice*).
32. Boudard 1766, II, no. 94.
33. Lonsdale 1987, p. 617.
34. Brooke 1767-70, II, pp. 273-4.
35. Chamberlain 1910, p. 168.
36. Romney 1830, p. 144.
37. See Colnaghi 1986, p. 87, no. 35.
38. Ripa 1709, p. 79, no. 316; see also Stewart 1983, pp. 50-1.
39. Brooke 1767-70, II, pp. 100-4.
40. Webb 1760, p. 73.

CHAPTER 7

1. Yale Center 1980, p. 50.
2. Johnson 1986, p. 71.
3. Hazlitt 1930-4, XI, p. 291.
4. Woodall 1963, p. 29, (letter of 10 April 1784); see also Whitley 1915, p. 215.
5. Woodall 1963, p. 77, (letter of *c.* 1772).
6. Price 1794, p. 177.
7. Wollstonecraft 1985, p. 118.
8. Devonshire 1955, p. 290.
9. See Dorment 1986, p. 350.
10. Peddle 1789, p. 94.
11. Rousseau 1966, p. 527.
12. Lonsdale 1987, pp. 828-9; see also Gisborne 1797, pp. 34-5.
13. Burney 1907, I. p. 212.

CHAPTER 8

1. Reynolds 1975, p. 88.
2. Williams 1831, II, p. 295.
3. Reynolds 1975, p. 44.
4. Reynolds 1975, p. 16.
5. Webb 1760, p. 18.
6. See Royal Academy 1986, p. 197.
7. Ribeiro 1984, pp. 243-4.
8. Reynolds 1975, p. 140.
9. Lairesse 1738, pp. 345, 347; see also Richardson 1715, pp. 185-6.
10. Denvir 1983, p. 135.
11. Richardson 1715, p. 185.
12. Northcote 1819, II, p. 63.
13. Reynolds 1975, p. 175.
14. Gwynn 1898, p. 220.
15. Shaftesbury 1969, p. 117 (*Treatise IV, Plastic Art,* 1713).
16. Goldsmith 1966, I, p. 19 (*Monthly Review,* May 1757).
17. Malcolm 1810, II, p. 355.
18. Romney 1830, pp. 195-6.
19. See Montagu 1906, I, p. 288 and Bleackley 1907, p. 24.
20. Waterhouse 1941, plate 102.
21. See Ribeiro 1984, p. 166.
22. Smart 1971, p. 30.
23. Hayley 1809, p. 61.
24. Compare Ribeiro 1984, p. 186, fig. 102.
25. Woodall 1963, p. 51.
26. Woodall 1963, p. 51-3.
27. See Hayes 1975, p. 216, no. 76.
28. Woodall 1963, p. 95-7.
29. Whitley 1915, p. 173.
30. Whitley 1915, p. 232.
31. Wollstonecraft 1985, pp. 237-8.
32. See also Cowper's *The Task,* 1785, IV, 11. 168-73.
33. Ripa 1611, pp. 39, 68.
34. See Ripa 1611, pp. 39, 68; see also Pasquin *A Critical Guide,* 1796, p. 10; Brooke 1767-70, V, p. 195 and Barrett 1814, I, p. 31.
35. Royal Academy 1986, p. 275.
36. See Johnson 1976, pp. 64-5, no. 96.
37. Waterhouse 1973, p. 10.
38. Ripa 1709, p. 63, no. 253.
39. Ripa 1709, p. 63.
40. Shaftesbury 1969, p. 57 (*Treatise II, Hercules,* 1713); Knowles 1831, III, p. 127, no. 166.
41. Ribeiro 1984, p. 298.
42. Jefferys III and IV, 1772, pp. 34-9 and plates 226-38.
43. Jefferys III and IV, 1772, p. 37 and plate 232.
44. Leslie and Taylor 1865, I, p. 13; Reynolds 1975, p. 129.
45. Beechey 1835, I, p. 223.
46. Peddle 1789, p. 34.
47. Hayley 1809, p. 95.
48. Bennett 1985, p. 202.

CHAPTER 9

1. Royal Academy 1986, p. 224; see also Melmoth 1754, pp. 6-7, Rouquet 1970, p. 70, Hayley 1809, p. 344 and Cunningham 1829-33, I, p. 314.
2. Edwards 1808, p. 189.
3. Wollstonecraft 1985, p. 232.
4. Gibbon 1956, III, p. 289 (letter of 8 November 1792).
5. See Moore 1967, p. 350.
6. Coke 1889-96, I, pp. 44-5.
7. Burney 1907, I, pp. 70-7.
8. See *The Spectator,* no. 14, 1711, and *Cecilia* Book II, Chapter III.
9. Altick 1985, p. 27.
10. See Melmoth 1754, p. 238.
11. Warner 1989, p. 8.
12. See Webb 1760, p. 29.
13. Chesterfield 1901, I, pp. 291-2 (letter of 18 November 1748).
14. Chesterfield 1901, I, p. 211 (letter of 9 March 1748).
15. Reynolds 1975, pp. 63-4, 68, 84-6.
16. See Warner 1989, p. 8.
17. Royal Academy 1986, pp. 224-5.
18. Reynolds 1975, pp. 63-4, 161.
19. See Graves and Cronin 1899-1901, II, p. 683.
20. See de Piles 1743, p. 167.
21. Reynolds 1798, III, p. 154; see also *Discourse V,* Reynolds 1975, p. 81.
22. Reynolds 1798, III, p. 153.
23. Leslie and Taylor 1865, I, p. 70.
24. Ribeiro 1984, pp. 138, 144.

25. All information derived from Ribeiro 1984, p. 151.
26. See Ribeiro 1984, p. 249; Hazlitt 1830-4, X, p. 23.
27. Whitley 1915, p. 211.
28. Ribeiro 1984, p. 257.
29. Ribeiro 1984, pp. 93-101.

30. Ribeiro 1984, pp. 308-12.
31. Whitley 1915, p. 306.
32. Ribeiro 1984, pp. 308, 407 n. 94.
33. See Ribeiro 1984, p. 156.
34. Whitley 1915, p. 87.
35. Woodall 1963, p. 75.
36. Whitley 1915, p. 391.

37. Reynolds 1975, p. 251.
38. Whitley 1915, p. 247.
39. Reynolds 1975, p. 251; Whitley 1915, pp. 247, 392.
40. Graves and Cronin 1899-1901, II, p. 823.

Chapter 10

1. Bury 1838-9, III, p. 92.
2. John Opie 1809, pp. 103-4.
3. See Howard 1838, p. 86; John Opie 1809, p. 161; Reynolds 1798, II, pp. 397-8.
4. Reynolds 1798, III, p. 156.
5. Burnet 1827, p. 19.
6. Howard 1838, pp. 83-6; see also Reynolds 1798, II, p. 346.
7. Williams 1831, I, p. 62.
8. Reynolds 1975, p. 158.
9. Cunningham 1829-33, I, p. 279.

10. Royal Academy 1986, pp. 159-60, no. 88.
11. Nicolson 1968, I, p. 101; Coveney 1967, p. 46.
12. Rousseau 1966, p. 51.
13. Rousseau 1966, p. 47.
14. Bocage 1770, I, p. 30; see also Mercier 1982, p. 111.
15. Wollstonecraft 1985, p. 127.
16. Grosley 1772, II, p. 63; Nicolson 1968, I, p. 5.

17. Prown 1966, II, p. 266.
18. Rousseau 1966, p. 51.
19. Rousseau 1966, p. 52.
20. Mercier 1982, pp. 112-3.
21. Baretti 1781, p. 20.
22. See Ripa 1611, p. 255.
23. Ripa 1611, p. 255.
24. Graves and Cronin 1899-1901, II, p. 604.
25. Whitley 1928, I, p. 325.
26. Honour 1977, p. 163.

Chapter 11

1. Mercier 1982, p. 112.
2. Lonsdale 1987, p. 505.
3. Davison 1973, pp. 285-6.
4. Bunyan 1724, p. 41.
5. Emblèmes 1697, pp. 142-4 (Devise LXIII).
6. Coveney 1967, p. 44.
7. Burney 1907, I, p. 280.
8. Shaftesbury 1969, p. 98.
9. Walpole 1782, IV, p. ix, n.

10. Royal Academy 1986, p. 269.
11. See Reynolds 1798, II, p. 346 and Beechey 1835, I, pp. 121-2.
12. Leslie and Taylor 1865, I, p. 43; see also Reynolds 1975, p. 277 (Discourse XV, 1790).
13. See Piper 1957, pp. 199-200.
14. Fletcher 1901, p. 78.
15. Hogarth 1955, pp. 154-5.
16. Wollstonecraft 1985, p. 280.

17. See National Gallery of Art, Washington 1985, p. 532, no. 469.
18. Reynolds 1975, p. 110.
19. Haydon 1960-3, I, pp. 307-8.
20. Haydon 1960-3, I, p. 310.
21. Whitley 1928, I, p. 288; see also Rouquet 1970, pp. 45-6 and Pasquin Memoirs 1796, p. 71.
22. Fletcher 1901, p. 55.

BIBLIOGRAPHY

ADDISON, Joseph; Sir Richard Steele and others: *The Spectator* (ed. G. G. Smith), 4 vols, London 1945.

ALBERTI, Leon Battista *Ten Books on Architecture* (reprint of the 1755 English edition, ed. J. Rykwert), London 1955.

ALTICK, Richard D. *Painting from Books*, Columbus, Ohio 1985.

ANDERSON, H. P. and SHEA, J. S. *Studies in Criticism and Aesthetics, 1660-1800*, Minneapolis 1967. See also MOORE.

ANON *A Candid Review of the Exhibition*, London 1780.

ANON *More Lyric Odes to the Royal Academicians*, London 1785 and 1786.

ANSTEY, Christopher *The New Bath Guide*, London 1766.

ANTAL, Frederick *Hogarth and His Place in European Art*, London 1962.

ARMSTRONG, Sir Walter *Sir Joshua Reynolds*, New York and London 1900.

ARMSTRONG, Sir Walter *Sir Henry Raeburn*, New York and London 1901.

ARMSTRONG, Sir Walter *Sir Thomas Lawrence*, London 1913.

ASHTON, Geoffrey 'Sir Thomas Lawrence', *Connoisseur*, CCIII, no. 815, January 1980, pp. 44-9.

ATKINSON, Thomas *A Conference between a Painter and an Engraver*, London 1736.

AUSTEN, Jane *Sense and Sensibility*, 1811 (written 1798); *Pride and Prejudice*, 1813 (begun 1796); *Mansfield Park*, 1814; *Emma*, 1816; *Northanger Abbey*, 1818 (written 1794-9); *Persuasion*, 1818. Juvenilia such as: *Love and Freindship*, 1792; *Lady Susan*, 1794; *Lesley Castle* collected in *The Works of Jane Austen*, ed. R. W. Chapman, 6 vols, O.U.P. 1954, volume VI.

BARBAULD, Anna Letitia *Lessons for Children*, London 1787-8.

BARBAULD, Anna Letitia and Dr Aikin *Evenings at Home*, Dublin 1794.

BARBAULD, Anna Letitia *Hymns in Prose for Children*, London 1781.

BARBAULD, Anna Letitia *A Legacy for Young Ladies*, London 1826.

BARETTI, Joseph (Giuseppe) *A Guide through the Royal Academy*, London 1781.

BARRELL, John *The Political Theory of Painting from Reynolds to Hazlitt*, New Haven and London 1986.

BARRETT, Eaton Stannard *The Heroine*, 3 vols, London 1814.

BARRY, James *Works* (ed. E. Fryer), 2 vols, London 1809.

BEECHEY, Henry William *The Literary Works of Sir Joshua Reynolds with a Memoir of the Author*, 2 vols, London 1835.

BELSEY, H. 'A Visit to the Studios of Gainsborough and Hoare', *Burlington Magazine*, CXXIX, 1987, pp. 107-9.

BENNETT, Shelley M. 'Anthony Pasquin and the function of Art Journalism in late Eighteenth-Century England', *British Journal for Eighteenth-Century Studies*, VIII, no. 2, 1985, pp. 197-207.

BLEACKLEY, Horace *The Story of a Beautiful Duchess*, London 1907.

BOCAGE, Anne Marie Lepage, Madame Fiquet du Bocage *Letters concerning England, Holland and Italy*, 2 vols, London 1770.

BOUDARD, J. B. *Iconologie*, 3 vols, Vienna 1766 (Garland Reprint 1976).

BOYDELL, Josiah *Suggestions Towards Forming a Plan for the Encouragement, Improvement, and Benefit, of the Arts and Manufactures in the Country, on a Commercial Basis*, London 1805.

BRITISH MUSEUM *Gainsborough and Reynolds in the British Museum* (catalogue of the exhibition), 1978.

BROOKE, Henry *The Fool of Quality*, 5 vols, London 1767-70.

BROWN, Iain Gordon 'Alan Ramsay's Rise and Reputation', *The Walpole Society*, L, 1984, pp. 209-47.

BUNYAN, John *Divine Emblems: or, Temporal Things Spiritualized*, 9th ed., London 1724.

BURKE, Edmund *A philosophical enquiry into the origin of our ideas of the sublime and beautiful*, 1757.

BURKE, J. *English Art 1714-1800*, Oxford 1976.

BURNET, John *A Practical Treatise on Painting*, London 1827.

BURNEY, Frances *Evelina*, 3 vols, 1778; *Cecilia*, 5 vols, 1782; *Camilla*, 5 vols, 1796.

BURNEY, Frances *Diary and Letters of Madame D'Arblay 1778-1840* (ed. Charlotte Barrett), 7 vols, London 1842-6.

BURNEY, Frances *The Early Diary of Frances Burney 1768-1778* (ed. A. R. Ellis), 2 vols, London 1907.

BURY, Lady Charlotte *Diary Illustrative of the times of George the Fourth*, 4 vols, London 1838-9.

BUSCH, Werner 'Bemerkungen zu Reynolds' *Kunstchronik*, vol. 39, no. 8, 1986, pp. 277-85.

BUTTERY, David 'George Romney and the Second Earl of Warwick', *Apollo*, CXXIV, no. 294 (new series), August 1986, pp. 104-9.

CATS, Jacob *Zinne- en minne-beelden*, Amsterdam 1729.

CAW, Sir James L. 'Allan Ramsay, Portrait Painter, 1713-1784', *The Walpole Society*, XXV, 1936-7, pp. 33-81.

CHAMBERLAIN, Arthur B. *George Romney*, London 1910.

CHERRY, Deborah and HARRIS, Jennifer 'Eighteenth-century portraiture and the seventeenth-century past: Gainsborough and Van Dyke', *Art History*, V, no. 3, 1982, pp. 287-309.

CHESTERFIELD, Philip Dormer Stanhope, 4th Earl of *Letters and Characters* (ed. J. Bradshaw), 3 vols, 1892.

CHESTERFIELD, Philip Dormer Stanhope, 4th Earl of *The Letters of the Earl of Chesterfield to his Son* (ed. C. Strachey), 2 vols, London 1901.

CLELAND, John *Memoirs of a Woman of Pleasure (Fanny Hill)*, 2 vols, London 1749.

COKE, Lady Mary, *The Letters and Journals of Lady Mary Coke* (ed. J. A. Home), 4 vols, Edinburgh 1889-96.

COLNAGHI, P. and D. *The British Face: A view of Portraiture 1625-1850*, London 1986.

COMBE, William *A Poetical Epistle to Sir Joshua Reynolds, Knight and President of the Royal Academy*, London 1777.

COOKE, Edward *A just and seasonable reprehension of naked breasts and shoulders*, London 1678.

CORMACK, Malcolm 'The Ledgers of Sir Joshua Reynolds', *The Walpole Society*, XLII, 1968-70, pp. 105-69.

COTTON, William *Sir Joshua Reynolds's Notes and Observations on Pictures*, London 1859.

COVENEY, Peter *The Image of Childhood*, London 1967.

COWPER, William *The Task*, 6 books, 1785.

CROWN, Patricia 'Portraits and Fancy Pictures by Gainsborough and Reynolds: contrasting images of Childhood', *British Journal for Eighteenth-Century Studies*, VII, no. 2, 1984, pp. 156-67.

CULLEN, Fintan 'Hugh Douglas Hamilton: "painter of the heart"', *Burlington Magazine*, CXXV, no. 964, 1983, pp. 417-21.

CUMMINGS, Frederick. 'Boothby, Rousseau, and the Romantic Malady', *Burlington Magazine*, CX, no. 789, 1968, pp. 659-66.

CUNNINGHAM, Allan *The Lives of the most Eminent British Painters, Sculptors, and Architects*, 6 vols, London 1829-33.

DAVISON, Dennis *The Penguin Book of Eighteenth-Century English Verse*, Harmondsworth 1973.

DAY, Thomas *Sandford and Merton*, 3 vols, London 1783-9.

DELANY, M. *Autobiography and Correspondence of Mary Granville, Mrs. Delany* (ed. Lady Llanover), 6 vols, London 1861-2.

DE MARLY, Diana 'The Establishment of Roman Dress in Seventeenth-Century Portraiture', *Burlington Magazine*, CXVII, no. 868, 1975, pp. 443-51.

DENVIR, Bernard *The Eighteenth Century: Art, Design and Society, 1689-1789*, London 1983.

DEVONSHIRE, *Georgiana, Extracts from the Correspondence of Georgiana, Duchess of Devonshire* (ed. Earl of Bessborough), London 1955.

DORMENT, Richard *British Painting in the Philadelphia Museum of Art*, London 1986.

EARLAND, Ada *John Opie and his Circle*, London 1911.

EDGEWORTH, Maria *Belinda*, 3 vols, London 1801.

EDWARDS, Edward *Anecdotes of Painters who have resided or been born in England*, London 1808.

EMBLEMES *Emblèmes ou Devises Chrétiennes* (printed A. Schouten), Utrecht, 1697.

FARINGTON, Joseph *Memoirs of the Life of Sir Joshua Reynolds*, London 1819.

FARINGTON, Joseph *The Farington Diaries*, 16 vols (I-VI ed. K. Garlick and A. McIntyre, VII-XVI ed. K. Cave), London and New Haven, 1978-85.

FIELDING, Henry *Joseph Andrews*, 1742; *Tom Jones*, 1749.

FIELDING, Sarah *The Governess*, 1749.

FLEMING, John 'Sir John Medina and his "Postures"', *Connoisseur*, CXLVIII, July 1961, pp. 22-5.

FLETCHER, Ernest *Conversations of James Northcote R.A. with James Ward on Art and Artists*, London 1901.

FOOTE, Sam *Taste, A Comedy of Two Acts*, London 1752.

FOSS, Michael *The Age of Patronage: The Arts in Society 1660-1750*, London 1971.

GARLICK, Kenneth *Sir Thomas Lawrence. A Complete Catalogue of the Oil Paintings*, Oxford 1989.

GATTY, Hugh 'Notes by Horace Walpole, Fourth Earl of Orford, on the Exhibitions of the Society of Artists and the Free Society of Artists, 1760-1791', *The Walpole Society*, XXVII, 1938-9, p. 55-88.

GAUNT, William *The Great Century of British painting: Hogarth to Turner*, London 1971.

GAUNT, William *Court Painting in England from Tudor to Victorian Times*, London 1980.

GIBBON, Edward *The Letters of Edward Gibbon* (ed. J. E. Norton), 3 vols, London 1956.

GIBBON, Edward *Memoirs of My Life* (1794) (ed. B. Radice), Harmondsworth 1984.

GILPIN, William *Three Essays: on picturesque beauty; on picturesque travel; and on sketching landscape*, London 1792.

GISBORNE, Thomas *An enquiry into the duties of the Female Sex*, London 1797.

GOLDSMITH, Oliver *Collected Works* (ed. A. Friedman), 5 vols, Oxford 1966.

GORDON, Dillian *British Paintings: the National Gallery Schools of Painting*, London 1986.

GRAVES, Algernon and CRONIN, William Vine *A History of the Works of Sir Joshua Reynolds*, 4 vols, London 1899-1901.

GRAVES, Algernon *The Royal Academy of Arts, a complete dictionary of contributors and their work from its foundation in 1769 to 1904*, 8 vols, London 1905-6.

GROSLEY, Pierre Jean *A Tour to London, or New Observations on England* (trans. Thomas Nugent), 2 vols, London 1772.

GWYNN, Stephen *Memorials of an Eighteenth-Century Painter, James Northcote*, London 1898.

HAMMELMANN, H. A. 'A Georgian Guide to Deportment', *Country Life*, CXLIII, no. 3715, May 1968, pp. 1272-3.

HARRIS, James *Three treatises*, London 1744.

HAYDON, Benjamim Robert *The Autobiography and Journals of Benjamin Robert Haydon* (1853, ed. M. Elwin), London 1950.

HAYDON, Benjamin Robert *The Diary of Benjamin Robert Haydon* (ed. W. B. Pope), 5 vols, Cambridge, Mass. 1960-3.

HAYES, John *Thomas Gainsborough*, London 1975.

HAYES, John *Thomas Gainsborough* (catalogue of the Tate Gallery exhibition), London 1980.

HAYLEY, William *Epistle to Admiral Keppel*, London 1779.

HAYLEY, William *The Triumphs of Temper*, 6 cantos, London 1781, 3rd ed.

HAYLEY, William *The Life of George Romney, Esq.*, London 1809.

HAZLITT, William *The Complete Works* (ed. P. P. Howe), 21 vols, London and Toronto 1930-4.

HERRMANN, Frank *The English as Collectors; A Documentary Chrestomathy*, London 1972.

HERRMANN, Luke 'The Drawings by Sir Joshua Reynolds in the Herschel Album', *Burlington Magazine*, CX, no. 789, 1968, pp. 650-8.

HICKEY, William *The Memoirs of William Hickey* (ed. Peter Quennell), London and Boston 1975.

HIGHMORE, Joseph *Essays, Moral, Religious, and Miscellaneous*, 2 vols, London 1766.

HILLES, F. W. (see REYNOLDS).

HOARE, Prince *Academic Annals*, London 1805.

HOARE, Prince *The Artist*, 2 vols, London 1810.

HOGARTH, William *The Analysis of Beauty [1753], with the rejected passages from the Manuscript Drafts and autobiographical notes* (ed. J. Burke), Oxford 1955.

HOGARTH, William *An Apology for Painters* (ed. M. Kitson), *The Walpole Society*, XLI, 1966-68.

HOLBROOK, Mary 'Painters in Bath in the Eighteenth Century', *Apollo*, XCVIII, no. 141 (new series), November 1973, pp, 375-84.

HONOUR, Hugh *Neo-Classicism*, London 1968.

HOWARD, Frank *Colour as a Means of Art*, London 1838.

HUDSON, Derek *Sir Joshua Reynolds. A Personal Study*, London 1958.

INCHBALD, Elizabeth *The Child of Nature*, 1788; *A Simple Story*, 1791; *Nature and Art*, 2 vols, 1796.

IRELAND, John *Hogarth Illustrated*, 2 vols, London 1791.

IRWIN, David *English Neoclassical Art*, London 1966.

JACKSON-STOPS, Gervase (see NATIONAL GALLERY OF ART, WASHINGTON).

JARRETT, Derek *Britain, 1688-1815*, London 1965.

JARRETT, Derek *England in the Age of Hogarth*, London 1974.

JEFFERYS, Thomas *A Collection of the Dresses of Different Nations, Antient and Modern. Particularly Old English Dresses*, 4 vols, 1757 and 1772.

JOHNSON, E. D. H. *Paintings of the British Social Scene from Hogarth to Sickert*, London 1986.

JOHNSON, Edward Mead *Francis Cotes*, Oxford 1976.

JOHNSON, Samuel *The Idler*, 15 April 1758-5 April 1760, reprinted in *The Idler and the Adventurer*, Yale Edition of the Works of Samuel Johnson, vol. II, New Haven and London 1963.

JOHNSON, Samuel *The History of Rasselas, Prince of Abissinia*, 1759.

KERSLAKE, John *Early Georgian Portraits* (National Portrait Gallery), 2 vols, London 1977.

KITSON, Michael 'Gainsborough Observed', *Apollo*, CXII, no. 225 (new series), November 1980, pp. 351-2.

KNIGHT, Richard Payne *The Landscape: a Didactic Poem in three books*, London 1794.

KNOWLES, John *The Life and Writings of Henry Fuseli*, 3 vols, London 1831.

LAIRESSE, Gerard de *The Art of Painting in all its Branches* (trans. J. F. Fritsch), London 1738.

LAIRESSE, Gerard de *The Principles of Drawing*, London 1733-9.

LAVATER, Johann Kaspar *Essays on Physiognomy* (trans. T. Holcroft), 3 vols, London, 1789.

LAYARD, George Somes *Sir Thomas Lawrence's Letter-Bag*, London 1906.

LE BLANC, Jean Bernard, Abbé *Letters on the English and French Nations*, 2 vols, London 1747.

LESLIE, Charles Robert and TAYLOR, Tom *The life and times of Sir Joshua Reynolds with notices of some of his contemporaries*, 2 vols, London 1865 .

LEVEY, Michael *Sir Thomas Lawrence 1769-1830* (catalogue of the National Portrait Gallery exhibition), London 1979.

LIPPINCOTT, Louise W. *Selling Art in Georgian London: the Rise of Arthur Pond*, London and New Haven 1983.

LONSDALE, Roger *The New Oxford Book of Eighteenth-Century Verse*, Oxford and New York 1987.

MCKAY, W. D. and ROBERTS, W. *John Hoppner, R.A.*, London 1909.

MACKENZIE, Henry *The Man of Feeling* (1771), Oxford 1987.

MACMILLAN, Duncan *Painting in Scotland. The Golden Age* (Talbot Rice Centre and Tate Gallery), London 1986.

MALCOLM, James Peller *Anecdotes of the Manners and Customs of London*, 2 vols, London 1810.

MANNERS, Lady Victoria and WILLIAMSON, G. C. *Angelica Kauffmann RA: Her life and her Works*, London 1924.

MANNINGS, David 'A Well-Mannered Portrait by Highmore', *Connoisseur*, CLXXXIX, no. 760, June 1975, pp. 116-19.

MANNINGS, David 'At the Portrait Painter's – How the painters of the eighteenth century conducted their studios and sittings', *History Today*, XXVII, 1977, pp. 279-87.

MANNINGS, David 'Notes on some eighteenth-century portrait prices in Britain', *British Journal for Eighteenth-Century Studies*, VI, 1983, pp. 185-96.

MANNINGS, David 'Reynolds, Hogarth and Van Dyck', *Burlington Magazine*, CXXVI, no. 980, November 1984, pp. 689-90.

MANNINGS, David 'Shaftesbury, Reynolds and the Recovery of Portrait-Painting in Eighteenth-Century England', *Zeitschrift für Kunstgeschichte*, vol. 48, no. 3, 1985, pp. 319-28.

MELMOTH, William *The Letters of Sir Thomas Fitzosborne, on Several Subjects*, 4th ed., London 1754.

MERCIER, Louis-Sébastien *Parallèle de Paris et de Londres, c.1780* (ed. C. Bruneteau and B. Cottret), Paris 1982.

MILES, Ellen and SIMON, Jacob *Thomas Hudson 1701-1779. Portrait Painter and Collector* (catalogue of the Kenwood House exhibition), London 1979.

MILLAR, Sir Oliver *Sir Peter Lely* (catalogue of the National Portrait Gallery exhibition), London 1978.

MITCHELL, Charles 'Three Phases of Reynolds's Method', *Burlington Magazine*, LXXX, no. 467, February 1942, pp. 35-40.

MONTAGU, Elizabeth *Elizabeth Montagu, The Queen of the Blue-Stockings. Her Correspondence from 1720 to 1761* (ed. E. J. Climenson), 2 vols, London 1906.

MONTAGU, Elizabeth *Mrs. Montagu, 'Queen of the Blues'; her letters and Friendships from 1762-1800* (ed. R. Blunt), 2 vols, London 1923.

MOORE, Robert E. 'Reynolds and the Art of Characterization', *Studies in Criticism and Aesthetics 1660-1800* (ed. H. P. Anderson and J. S. Shea), pp. 332-57, Minneapolis 1967.

MORRISON, Thomas *A Pindarick Ode on Painting, addressed to Joshua Reynolds*, London 1767.

MORITZ, Carl Philipp *Travels of Carl Philipp Moritz in England in 1782*, London 1795.

MUSSER, J. F. 'Sir Joshua Reynolds's Mrs Abington as "Miss Prue"', *The South Atlantic Quarterly*, Spring 1984, pp. 176-92.

NATIONAL GALLERY OF ART, WASHINGTON *The Treasure Houses of Britain* (catalogue of the exhibition, ed. Gervase Jackson-Stops), New Haven and London 1985.

NICHOLS, John *Biographical Anecdotes of William Hogarth*, London 1781.

NICOLSON, Benedict *Joseph Wright of Derby*, 2 vols, New York and London 1968.

NIVELON, François *The Rudiments of Genteel Behaviour*, London 1737.

NORTHCOTE, James *The Life of Sir Joshua Reynolds*, 2 vols, 2nd ed., London 1819.

OMBERG, Hildegard *William Hogarth's Portrait of Captain Coram, Studies in Hogarth's Outlook around 1740*, Uppsala 1974.

OPIE, Amelia *A Memoir of John Opie* (published with the following, but separately paginated), London 1809.

OPIE, John *Lectures on Painting* (with the *Memoir* by Amelia Opie, above), London 1809.

ORMOND, Richard (ed.) *Dictionary of British Portraiture*, 4 vols, National Portrait Gallery, London 1979-81.

PAGE, Thomas *The Art of Painting*, Norwich 1720.

PARSONS, Dr James 'Human Physiognomy Explained', *Philosophical Transactions of the Royal Society*, vol. 44, part I, 1746.

PASQUIN, Anthony (i.e. John Williams) *The Royal Academicians. A Farce*, London 1786.

PASQUIN, Anthony *A Critical Guide to the Exhibition of the Royal Academy for 1796*, London 1796.

PASQUIN, Anthony *Memoirs of the Royal Academicians. Being an Attempt to Improve the National Taste*, (published with *A Liberal Critique on the Present (1794) Exhibition of the Royal Academy*), London 1796.

PATTISON, Robert *The Child Figure in English Literature*, Athens, Georgia 1978.

PAULSON, Ronald *Hogarth: His Life, Art and Times*, 2 vols, New Haven and London 1971.

PAULSON, Ronald *Emblem and Expression*, London 1975.

PAULSON, Ronald 'The Aesthetics of Mourning', *Studies in Eighteenth-Century British Art and Aesthetics* (ed. R. Cohen), Berkeley, Los Angeles and London 1985.

PEARS, Iain *The Discovery of Painting. The Growth of Interest in the Arts in England, 1680-1768*, New Haven and London 1988.

PEDDLE, Mrs. *Rudiments of taste. In a series of letters*, London 1789.

PEVSNER, N. *The Englishness of English Art*, London 1956.

de PILES, Roger *The Art of Painting, (with 'An Essay towards an English School', by B. Buckeridge)* (trans. J. Savage), London 1706.

de PILES, Roger *The Principles of Painting*, London 1743.

PILKINGTON, Matthew *The Gentleman's and Connoisseur's Dictionary of Painters*, London 1770.

PILKINGTON, Matthew *A Dictionary of Painters* (ed. Henry Fuseli), London 1805.

PILKINGTON, Matthew *A General Dictionary of Painters* (ed. A. Cunningham), London 1857.

PIPER, David *The English Face*, London 1957.

POINTON, Marcia 'Portrait-Painting as a Business Enterprise in London in the 1780s', *Art History*, VII, no. 2, June 1984, pp. 187-205.

POPE, Alexander *The Poems of Alexander Pope* (ed. J. Butt), London 1963.

PORTA, Giovanni Battista della *De Humana Physiognomonia*, Hanover 1593, (Italian translation *Della fisonomia dell'huomo*, Naples 1598).

POTTERTON, Homan 'Reynolds's Portrait of Captain Robert Orme in the National Gallery', *Burlington Magazine*, CXVIII, no. 875, 1976, p. 106.

PRICE, F. 'Imagining Faces: the later eighteenth-century Sentimental heroine and the legible, universal language of physiognomy', *British Journal of Eighteenth-Century Studies*, VI, 1983, pp. 1-16.

PRICE, Uvedale *An Essay on the Picturesque*, London 1794.

PROWN, Jules D. *John Singleton Copley*, 2 vols, Cambridge, Mass. 1966.

RADCLIFFE, Mrs Ann *The Romance of the Forest*, 3 vols, London 1791.

RAMSAY, Allan *A Dialogue on Taste*, London 1762 (1st ed. 1755).

REITLINGER, Gerald Robert *The Economics of Taste: the rise and fall of picture prices, 1760-1960*, vol. I, London 1961.

REYNOLDS, Sir Joshua *The Works of Sir Joshua Reynolds . . . to which is prefixed an account of the life and writings of the Author, by Edmond Malone*, 3 vols, London 1798.

REYNOLDS, Sir Joshua *Letters of Sir Joshua Reynolds* (ed. F. W. Hilles), Cambridge, Mass. 1929.

REYNOLDS, Sir Joshua *Portraits. Character sketches of Oliver Goldsmith, Samuel Johnson, and David Garrick, together with other MSS of Reynolds recently discovered among the private papers of James Boswell* (ed. F. W. Hilles), New York, Toronto and London 1952.

REYNOLDS, Sir Joshua *Discourses on Art* (ed. Robert R. Wark), New Haven and London 1975.

RIBEIRO, Aileen 'The Exotic Diversion, the Dress worn at masquerades in eighteenth-century London', *Connoisseur*, CXCVII, no. 791, January 1978, pp. 3-13.

RIBEIRO, Aileen *A Visual History of Costume: The Eighteenth Century*, London 1983.

RIBEIRO, Aileen *The Dress Worn at Masquerades in England, 1730 and 1790, and its Relation to Fancy Dress in Portraiture*, New York and London 1984.

RICHARDSON, George *Iconology*, 2 vols, London 1778.

RICHARDSON, Jonathan *An Essay on the Theory of Painting*, London 1715.

RICHARDSON, Jonathan *An Essay on the Whole Art of Criticism, as it Relates to Painting* (published with the work below as *Two Discourses*), London 1719.

RICHARDSON, Jonathan *A Discourse on the Dignity, Certainty, Pleasure and Advantage, of the Science of a Connoisseur* (published with the above as *Two Discourses*), London 1719.

RICHARDSON, Jonathan (sen. and jun.) *An Account of some Statues, Bas-Reliefs, Drawings and Pictures in Italy, France Etc.*, London 1722.

RIPA, Cesare *Iconologia*. First published Rome 1593. Among innumerable later reprints and translations, the Padua 1611 illustrated edition and the London 1709 illustrated translation are reprinted by Garland, New York and London, both in 1976.

ROGERS, Malcolm 'Some Beauties of Sir Peter Lely', *Connoisseur*, CC, no. 804, February 1979, pp. 106-113.

ROMNEY, Revd John *Memoirs of the Life and Works of George Romney*, London 1830.

ROSSI, Giovanni Gherardo de *Vita di Angelica Kauffmann*, Florence 1810.

ROUQUET, André *The Present State of the Arts in England*, London 1755 (Cornmarket Reprint, London 1970).

ROUSSEAU, Jean-Jacques *Emile, ou de l'éducation* (ed. M. Launay), Paris 1966.

ROYAL ACADEMY OF ARTS, *Reynolds* (ed. N. Penny) (catalogue of the exhibition), London 1986.

RUMP, Gerhard Charles *Kunst und Kunsttheorie des XVIII. Jahrhunderts in England: Studien zum Wandel ästhetischer Anschauungen 1650-1830*, Hildesheim 1979.

SANDBY, William *The History of the Royal Academy of Arts*, 2 vols, London 1862.

SAXL, F. and WITTKOWER, Rudolf *British Art and the Mediterranean*, London 1948.

SCHMID, F. 'The Painter's Implements in Eighteenth-Century Art', *Burlington Magazine*, CVIII, no. 763, 1966, pp. 519-21.

SHAFTESBURY, Anthony Ashley Cooper, 3rd Earl of *Characteristicks of Men, Manners, Opinions, Times*, 3 vols, 5th ed., London 1732.

SHAFTESBURY, Anthony Ashley Cooper, 3rd Earl of *Second Characters or the Language of Forms* (ed. B. Rand), New York 1969.

SHAWE-TAYLOR, Desmond *Genial Company: The Theme of Genius in Eighteenth-Century British Portraiture*, (Nottingham University Art Gallery and Scottish National Portrait Gallery, catalogue of the exhibition), 1987.

SHEBBEARE, John *Battista Angeloni: Letters on the English Nation*, [Angeloni is a fiction: the letters are not translated as claimed but written by Shebbeare], 2 vols, London 1755.

SHEE, Sir Martin Archer *Rhymes on Art*, 2nd ed., London 1805.

SHEE, Sir Martin Archer *Elements of Art*, London 1809.

SHERIDAN, Richard Brinsley *Plays* (ed. Cecil Price), London 1975.

SIMON, Robin *The Portrait in Britain and America*, Oxford 1987.

SMART, Alastair *The Life and Art of Allan Ramsay*, London 1952.

SMART, Alastair 'Dramatic Gesture and Expression in the Age of Hogarth and Reynolds', *Apollo*, LXXXII, no. 42 (new series), August 1965, pp. 90-7.

SMART, Alastair *Introducing Francis Cotes* (Nottingham University Art Gallery, catalogue of the exhibition), 1971.

SMITH, Charlotte, *Desmond*, 3 vols, London 1792.

SMOLLETT, Tobias *Humphry Clinker* (ed. A. Ross), Penguin 1967.

SOLKIN, David H. 'Great Pictures or Great Men? Reynolds, Male Portraiture and the Power of Art', *Oxford Art Journal*, vol. 9, 1986, pp. 42-9.

STERNE, Laurence *The Life and Opinions of Tristram Shandy*, IX vols, 1759-67; *A Sentimental Journey*, 1768.

STEWART, J. Douglas *Sir Godfrey Kneller and the English Baroque Portrait*, Oxford 1983.

TALLEY, M. Kirby 'Extracts from the Executors Account-Book of Sir Peter Lely, 1679-1691: An Account of the Contents of Sir Peter's Studio', *Burlington Magazine*, CXX, no. 908, 1978, pp. 745-9.

TATE GALLERY *Manners and Morals: Hogarth and British Painting 1700-1760* (E. Einberg and R. Jones) 1987.

TSCHERNY, Nadia 'Likeness in Early Romantic Portraiture'. *Art Journal*, vol. 46, no. 3, Fall 1987, pp. 193-9.

TURBERVILLE, Arthur S. (ed.) *Johnson's England*, 2 vols, Oxford 1933.

TYTLER, Graeme *Physiognomy in the European Novel*, Princeton 1982.

VERTUE, George 'The Note-books', *The Walpole Society*, XVIII (1929-30 Vertue I), XX (1931-2 Vertue II), XXII (1933-4 Vertue III), XXIV (1935-6 Vertue IV), XXVI (1937-8 Vertue V), XXIX (1940-2 Index), XXX (1948-50 Vertue VI).

VOLTAIRE, François Marie Arouet de *Lettres Philosophiques* first appearing as *Lettres écrites de Londres sur les Anglois et autres sujets*, London 1734 and *Letters concerning the English Nation*, London 1733.

WALPOLE, Horace *Anecdotes of Painting in England*, 4 vols, Strawberry Hill 1762-3.

WALPOLE, Horace *Anecdotes of Painting in England*, 3rd ed., 5 vols, London 1782.

WALPOLE, Horace *Correspondence* (ed. W. S. Lewis and others), 48 vols, New Haven and London 1937-83.

WARD, H. and ROBERTS, W. *Romney*, 2 vols, New York 1904.

WARNER, Malcolm 'The Sources and Meaning of Reynolds's *Lady Sarah Bunbury Sacrificing to the Graces*', *The Art Institute of Chicago Museum Studies*, XV, no. 1, 1989, pp. 7-19.

WATERHOUSE, Ellis K. *Reynolds*, London 1941.

WATERHOUSE, Ellis K. *Painting in Britain 1530 to 1790*, Harmondsworth 1953.

WATERHOUSE, Ellis K. *Gainsborough*, London 1958.

WATERHOUSE, Ellis K. *Reynolds*, London 1973.

WEBB, Daniel *An Inquiry into the Beauties of Painting, and into the Merits of the Most Celebrated Painters, Ancient and Modern*, London 1760.

WENDORF, Richard 'Ut Pictura Biographia. Biography and Portrait Painting as Sister Arts', in *Articulate Images. The Sister Arts from Hogarth to Tennyson* (ed. R. Wendorf), Minneapolis 1983, pp. 98-124.

WENDORF, Richard 'Hogarth's Dilemma', *Art Journal*, vol. 46, no. 3, Fall 1987, pp. 200-8.

WHITEHOUSE, John *An Elegiac Ode to the memory of Sir Joshua Reynolds*, London 1792.

WHITLEY, William T. *Thomas Gainsborough*, London 1915.

WHITLEY, William T. 'An Eighteenth-Century Art Chronicler: Sir Henry Bate Dudley, Bart', *The Walpole Society*, XIII, 1924-5, pp. 25-66.

WHITLEY, William T. *Artists and Their Friends in England 1700-1799*, 2 vols, London 1928.

WHITLEY, William T. *Art in England 1800-1837*, 2 vols, Cambridge 1928-30.

WILLEY, Basil *The Eighteenth-Century Background* (1st ed. 1940), London and New York 1986.

WILLIAMS, D. E. *The Life and Correspondence of Sir Thomas Lawrence*, 2 vols, London 1831.

WILLIAMS, John (see Anthony PASQUIN).

WIND, Edgar *Hume and the Heroic Portrait. Studies in Eighteenth-Century Imagery* (ed. J. Anderson), Oxford 1986.

WOLCOT, John (pseud. Peter Pindar) *Lyric Odes to the Royal Academicians for 1782*, London 1782.

WOLCOT, John *More Lyric Odes to the Royal Academicians*, London 1783.

WOLCOT, John *Lyric Odes to the Royal Academicians for 1785*, London 1785.

WOLCOT, John *Farewell Odes to the Royal Academicians for 1786*, London 1786.

WOLLSTONECRAFT, Mary *A Vindication of the Rights of Women* (1792), Penguin 1985.

WOODALL, Mary *Thomas Gainsborough*, London 1949.

WOODALL, Mary *The Letters of Thomas Gainsborough*, Ipswich 1963.

YALE CENTER FOR BRITISH ART *The Conversation Piece: Arthur Devis and his contemporaries* (E. D'Oench) (catalogue of the exhibition), 1980.

YALE CENTER FOR BRITISH ART *Rembrandt in Eighteenth Century England* (C. White, D. Alexander and E. D'Oench) (catalogue of the exhibition), 1983.

INDEX

Page numbers for illustrations are shown in italics.

ACKNOWLEDGEMENTS

I AM VERY GRATEFUL FOR THE ADVICE AND ENCOURAGEMENT AT EVERY STAGE OF MY work on eighteenth-century British portraiture that I received from an acknowledged expert in the field, Professor Alastair Smart. I have also benefitted from insights shared in conversation by colleagues and friends, including Nicholas Alfrey and Malcolm Warner, and from countless ideas suggested by past and present students at Nottingham University. Of the many others who have helped directly and indirectly to produce this book, I would like particularly to thank Roy North, Euan Cameron and Sarah Finch.

I have attempted as far as possible to avoid lengthy footnotes, which has sometimes prevented me from adequately acknowledging other writers, where my debt has been of a general rather than precise kind. Thus my first chapter owes a great deal to Robin Simon's similar treatment of the subject in his *The Portrait in Britain and America* of 1987 and to Marcia Pointon's 1984 article in *Art History* on portraiture as a business enterprise. My view of characterisation in portraiture (Chapter 2) was partly stimulated by Robert E. Moore's article on the subject in *Studies in Criticism and Aesthetics* (1967), and by Richard Wendorf's discussion of portraiture and biography in *Articulate Images* (1983). The exhaustive researches into costume and masquerades by Aileen Ribeiro provided all the information for my fleeting treatment of the same subjects. I have also drawn heavily upon that ultimate data-base for eighteenth-century portraiture – the 1986 Royal Academy *Reynolds* catalogue, compiled by David Mannings and Nicholas Penny, with many other contributors.

PICTURE CREDITS

The photographs were made and/or supplied by the following institutions and individuals (numbers refer to figures throughout):

Archivi Alinari – 27, 30, 33, 115; Art Institute of Chicago – 112; Beedle and Cooper Ltd – 39; Birmingham Museum and Art Gallery – 40; Bridgeman Art Library – 26; British Library – 109; British Museum – 7; Geremy Butler Photography – 122; Cambridge University Library – 12, 17, 85, 107; Castle Howard – 1; Cincinnati Art Museum – 76; A C Cooper Ltd – 3, 31, 64, 133; Colnaghi's – 84; Courtauld Institute – 5, 18, 56, 71, 81, 88, 110, 113, 116, 139, 140, 145; Mike Davidson – 41; Derby Museum and Art Gallery – 89; Detroit Institute of Arts – 131; Duke of Buccleuch and Queensberry – 44; Duke of Hamilton – 100; Duke of Rutland – 143; Earl of Harewood – 105; English Heritage – 69, 96, 114; Fitzwilliam Museum – 9, 52, 65, 119; Fotek – 42; Founders Society, Detroit Institute of Arts – 131; Frick Collection – 117; Keith Gibson – 43; Guinness Plc – 32; Edward Harley Esq – 135; Hunterian Art Gallery – 60; Huntington Library and Art Gallery – 102, 104, 136; Lady Lever Art Gallery – 98; Leger Galleries – 123; Paul Mellon Centre, London – 55; Metropolitan Museum of Art, New York – 75; National Gallery – 15, 16, 25, 35, 51, 90, 91, 125, 138; National Gallery of Art, Washington, Photographic Services – 93, 97, 103, 127; National Gallery of Ireland – 57, 137; National Gallery of Scotland – 4, 120, (Antonia Reeve) 46, 79; National Maritime Museum – 29, 82; National Museum of Wales – 21; National Portrait Gallery – 11, 48, 61; National Trust Photographic Library – 19, 83, 121, (John Bethell) 78, (Angelo Hornak) 132, 134; National Trust for Scotland – 86; North Carolina Museum of Art – 128; Pilgrim Press Ltd – 111, 147; Photo Studios Ltd – 22, 58, 59; Prudence Cuming Associates Ltd – 8, 80, 94; Edward Reeves – 45; Royal Academy of Arts – 142, 144; Scottish National Portrait Gallery – 28, 37, 38, 54, 129, (Tom Scott) 36; Service photographique de la Réunion des musées nationaux – 67, 77, 124; Sir John Soane's Museum – 63; Sotheby's – 14; Staatliche Kunstsammlungen Dresden – 70; Tate Gallery Publications – 23, 47, 49, 108, 141; Thomas Coram Foundation – 53; Tilzey Studios Ltd – 2, 99; Toledo Museum of Art – 130; University of Edinburgh (Joe Rock) – 62; Victoria and Albert Museum – 24; Wallace Collection – 50, 73, 95; Warburg Institute – 13; Wilton House – 126; Woodmansterne Ltd (Jeremy Marks) – 92, 146; Yale Center for British Art – 72, 87.